The Newspaper Designer's Handbook

Seventh Edition

BY TIM HARROWER AND JULIE M. ELMAN

WITHDRAWN

LIVERPOOL JMU LIBRARY

McGraw Hill

Connect Learn Succeed™

The McGraw·Hill Companies

McGraw Hill Connect Learn Succeed™

THE NEWSPAPER DESIGNER'S HANDBOOK: SEVENTH EDITION

Published by McGraw-Hill, a business unit of The McGraw-Hill Companies, Inc., 1221 Avenue of the Americas, New York, NY 10020. Copyright © 2013 by The McGraw-Hill Companies, Inc. All rights reserved. Printed in the United States of America. Previous editions © 2008, 2002, and 1998. No part of this publication may be reproduced or distributed in any form or by any means, or stored in a database or retrieval system, without the prior written consent of The McGraw-Hill Companies, Inc., including, but not limited to, in any network or other electronic storage or transmission, or broadcast for distance learning.

Some ancillaries, including electronic and print components, may not be available to customers outside the United States.

♲ This book is printed on recycled paper containing 10% postconsumer waste.

1 2 3 4 5 6 7 8 9 0 QDB/QDB 1 0 9 8 7 6 5 4 3 2

ISBN 978-0-07-351204-4
MHID 0-07-351204-4

Vice President & Editor-in-Chief: *Michael Ryan*
Publisher: *David Patterson*
Senior Sponsoring Editor: *Debra B. Hash*
Marketing Manager: *Angela R. FitzPatrick*
Project Manager: *Melissa M. Leick*
Design Coordinator: *Colleen Havens*
Cover & Interior Designer: *Julie M. Elman*
Photo Research: *Sonia Brown*
Buyer: *Nicole Baumgartner*
Media Project Manager: *Sridevi Palani*
Typeface: *9.7 / 12 Scotch*
Printer: *Quad/Graphics*

All credits appearing on page or at the end of the book are considered to be an extension of the copyright page.

Library of Congress Cataloging-in-Publication Data

Harrower, Tim.
 The newspaper designer's handbook / Tim Harrower, Julie M. Elman. — Seventh edition.
 pages cm
 Includes index.
 ISBN 978-0-07-351204-4
 1. Newspaper layout and typography. I. Elman, Julie M. II. Title.
 Z253.5.H27 2013
 686.2'252--dc23
 2012003901

For additional resources, visit the Online Learning Center at www.mhhe.com/harrower7.
This website features student and instructor resources to help enhance the learning experience.

This book is fondly dedicated to:

Tim's wife, Robin, 40%

Julie's husband, Jody, 40%

Assorted family, friends and pets, 20%

Contents

///////// **INTRODUCTION**

2 Preface
4 Quick history
6 Current trends
14 Digital news design

1 ////// **THE FUNDAMENTALS**

18 What it's called
20 Tools of the trade
21 Basic typography
26 The four basic elements
27 Headlines
30 Text
32 Photographs
34 Cutlines
38 Drawing a dummy
40 Broadsheet dummy
41 Tabloid dummy
42 Exercises

2 ////// **STORY DESIGN**

46 Stories without art
48 Mug shots
51 Text shapes
52 Photos on the page
53 Horizontal photos
56 Vertical photos
59 Dominant photos
61 The picture combo
70 Square photos
71 Exercises

3 ////// **PAGE DESIGN**

74 The grid
78 Pages without art
84 Pages with art
86 Modular design
88 Front page design
91 Page One: A case study
98 Making stories fit
100 Inside pages
102 Double trucks
104 Bad juxtapositions
105 Rules of thumb
106 Exercises

4 ////// **PHOTOS & ART**

110 Photo guidelines
111 Photo constructs
112 Compelling photos
118 Weak photos
120 From camera to page
121 Digital images
122 Sizing photos
123 Halftones & screens
124 Scanning images
126 Cropping photos
128 Stand-alone photos
129 The photo column
130 The photo page
134 Photo page guidelines
138 Studio shots
139 Photo illustrations
140 Illustrations
142 Risky business
143 Exercises

5 ////// **NUTS & BOLTS**

146 The flag
147 Logos & sigs
150 Liftout quotes
152 Decks & summaries
154 Bylines
155 Credit lines
156 Spacing
157 Rules & boxes
158 Refers, teasers & promos
159 Breaking up text
160 Jumps

6 ////// **GRAPHICS & SIDEBARS**

162 Alternative story forms
165 A.S.F. presentations
166 Fast facts
167 Bio boxes
168 Lists
170 Checklists
171 Q&A's
172 Quizzes
174 Polls & surveys
175 Quote collections
176 Charts & graphs
178 Tables
179 Ratings
180 Timelines
181 Step-by-step guides
182 Diagrams
184 Maps
186 Graphics packages
188 Package planning
190 Graphics guidelines
193 Graphics gallery

7 ////// **SPECIAL EFFECTS**

196 Bending the rules
198 The Stewart variations
202 Wraparounds & skews
204 Photo cutouts
205 Mortises & insets
206 Screens & reverses
208 Display headlines
210 Display headline guidelines
212 Color
214 Adding color to a page
216 Color guidelines

8 ////// **REDESIGNS**

220 Redesigning your newspaper
222 Evaluating your newspaper
224 Gathering examples
225 Compiling a shopping list
226 Building prototypes
228 Testing & promotion
229 Writing a stylebook
230 Launching & following up
231 Redesign gallery

///////// **APPENDIX**

236 Exercise answers
248 Glossary
254 Index
259 Acknowledgments
260 Credits

Introduction

So you want to design newspapers, or design them even better than you are now? Well, you've come to the right place. *The Newspaper Designer's Handbook* is exactly what you'll need to get you where you'll need to go.

Tim Harrower single-handedly produced the first edition of this visual journalist's driver's manual in 1989, and since then, it has remained a staple for newspaper designers everywhere. (Ask many professionals in the industry how they learned to piece together a newspaper page, and they'll most likely say "Harrower's book.")

There was, and is, no other book like it.

Within these pages, you will find numerous and current real-world examples, easy-to-follow instructions and all the lingo you'll need to at least sound like a pro from the get-go.

As a bonus, you'll also get a dose of that unique Harrower Humor to keep you chuckling along the way.

Julie M. Elman has jumped on board to redesign and update this newest edition with fresh examples from cover to cover—all while keeping intact the spirit and integrity of Harrower's voice and his attention to detail.

Harrower and Elman have been in those newsroom trenches themselves—visual journalizing for years at different newspapers.

And they loved every minute of it.

They know, firsthand, what it takes to create the real deal—a well-designed and compelling newspaper page—and now *you* will, too.

CHAPTER CONTENTS

▸ **Preface:**
An overview that sums up what's in this book2

▸ **Quick history:**
A fast look at newspapers' early beginnings 4

▸ **Current trends:**
The modern newspaper and its many sections 6

▸ **Digital news design:**
Taking newspapers from print to a digital platform.................14

Preface

Along, long time ago, people actually loved reading newspapers. Imagine. They'd flip a nickel to the newsboy, grab a paper from the stack and gawk at headlines that screamed:

SOLONS MULL LEVY HIKE BID!

They'd gaze lovingly at long, gray columns of type that looked like this—

And they'd say, *"Wow!* What a lot of news!"

Today, we're different. We swim in a media stream of websites, smartphones, giant TVs and sleek tablets. We collect data in a dizzying array of ways. We don't need long, gray columns of type anymore. We won't *read* long, gray columns of type anymore.

In fact, when we look at newspapers and see those long, gray columns of type, we say, *"Yow!* What a waste of time!"

Let's face it: Today's media consumers are spoiled. They want their news to be stimulating. Engaging. Easy to grasp. Instantly informative.

And that's where you come in.

If you can design stories that are inviting, informative and easy to read, you can—for a few minutes each day, at least—successfully compete with the relentless digital media onslaught we're drowning in. You can keep a noble American institution— the newspaper—alive for another day.

Because let's face it: To many people, printed newspapers are dinosaurs. They're big and powerful, but they're clumsy and slow-witted, too. And though they've endured for eons, it may be only a matter of time before they either become extinct, which happened to other popular forms of communication (remember smoke signals? The telegraph?). Or else they'll completely evolve into a new species—a portable, interactive newsgizmo tailored to your own tastes and interests. This has actually been heading our way for decades now, but most newsroom dinosaurs were too slow-witted to see it coming.

Preface

I AM NOT THE EDITOR OF A NEWSPAPER AND SHALL ALWAYS TRY TO DO RIGHT AND BE GOOD, SO THAT GOD WILL NOT MAKE ME ONE.

Mark Twain

Yes, the days of *ink-on-dead-tree* journalism may be numbered, but it's not dead yet. It's still a bazillion-dollar industry with tremendous influence and importance. So while the wizards at Apple and Google dream up slick new techno-gadgets, we'll continue to do our best with the basics: Ink. Paper. Lots of images, letters, lines and dots. A good designer can arrange them all smartly and with finesse, so that today's news feels familiar and yet ... new.

But where do newspaper designers come from, anyway? Face it: You never hear children saying, "When I grow up, my dream is to *lay out the Opinion page.*" You never hear college students saying, "I've got a major in rocket science and a minor in *sports infographics.*"

No, most journalists stumble into design by accident. Without warning.

Maybe you're a reporter on a small weekly, and one day your editor says to you, "Congratulations! I'm promoting you to assistant editor. You'll start Monday. Oh, and ... you know how to lay out pages, don't you?"

Or maybe you've just joined a student newspaper. You want to be a reporter, a movie critic, a sports columnist. So you write your first story. When you finish, the adviser says to you, "Uh, we're a little short-handed in production right now. It'd really help us if you'd design that page your story's on, OK?"

Now, traditional journalism textbooks discuss design in broad terms. They ponder vague concepts like *balance* and *harmony* and *rhythm.* They show award-winning pages from The New York Times or The Wall Street Journal.

"Nice pages," you think. But meanwhile, you're in a hurry. And you're still confused: "How do I connect *this* picture to *this* headline?"

That's where *The Newspaper Designer's Handbook* comes in.

This book assumes you need to learn the rules of newspaper design as quickly as you can. It assumes you browse newspapers once in a while, but you've never really paid attention to things like headline sizes. Or column logos. Or whether pages use five columns of text instead of six.

This book will introduce you to the building blocks of newspaper design: headlines, text, photos, cutlines. We'll show you how to shape them into a story—and how to shape stories into pages.

After that, we'll look at the small stuff (logos, teasers, charts and graphs) that make more complicated pages work. We'll demonstrate attention-grabbing gimmicks like subheads that help you break up long, gray columns of type—

YO! CHECK OUT THIS ATTENTION-GRABBING SUBHEAD

And then there are those useful bullets, of course, to help make short lists POP off the page:
▸ This is a bullet item.
▸ And so is this.
▸ Ditto here.

We'll even explore liftout quotes, which will give you ideas on how to put a little visual pizzazz to a quote from somebody famous—say, Mark Twain—to catch your reader's eye.

Yes, some writers will try *anything* to get you to read their prefaces. So if you made it all this way, ask yourself: Did the page design have much to do with it?

Our future? Over the years, many media experts insist that, no matter how advanced future civilizations may become, no matter how far technology advances, no matter how many gizmos there are out there, humans will still enjoy the look and feel of newspapers in their ink-stained hands. Think it's true?

Quick history

THE BEGINNINGS

Publick Occurrences, America's first newspaper, made its debut 300 years ago. Like other colonial newspapers that followed, it was printed on paper smaller than the pages in this book, looking more like a pamphlet or newsletter.

Most colonial weeklies ran news items one after another in deep, wide columns of text. There were no headlines and very little art (though it was young Ben Franklin who printed America's first newspaper cartoon in 1754).

After the Revolutionary War, dailies first appeared and began introducing new design elements: thinner columns, primitive headlines (one-line labels such as *PROCLAMATION*) and—this will come as no surprise—an increasing number of ads, many of them parked along the bottom of the front page.

The first Colonial printing presses couldn't handle large sheets of paper, so when Publick Occurrences was printed in Boston on Sept. 25, 1690, it was only 7 inches wide, with two 3-inch columns of text. The four-page paper had three pages of news (the last page was blank), including mention of a "newly appointed" day of Thanksgiving in Plimouth. (Plimouth? Publick? Where were all the copy editors in those days?)

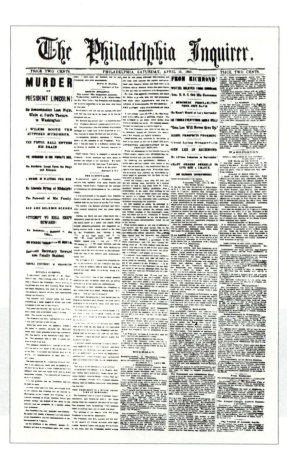

THE 19TH CENTURY

Throughout the 19th century, all newspapers looked pretty much the same. Text was hung like wallpaper, in long rows, with vertical rules between columns. Maps or engravings were sometimes used as art.

During the Civil War, papers began devoting more space to headline display, stacking vertical layers of deckers or decks in an endless variety of typefaces. For instance, the Chicago Tribune used 15 decks (or subheads) to trumpet its report on the great fire of *1871: FIRE! Destruction of Chicago! 2,000 Acres of Buildings Destroyed.*

The first newspaper photograph was published in 1880 by a paper called The Daily Graphic in New York.

Text heavy This 1865 edition of The Philadelphia Inquirer reports the assassination of President Lincoln with 15 headline decks. Like most newspapers of its era, it uses a very vertical text format: When a story hits the bottom of one column, it leaps to the top of the next to continue.

Quick history

THE EARLY 20TH CENTURY

By about 1900, newspapers began looking more like—well, like *newspapers*. Headlines grew bigger, bolder and wider. Those deep stacks of decks were gradually eliminated to save space. Page designs developed greater variety as news became departmentalized (*Crime, Foreign, Sports* and so on).

Big-city tabloids—those half-sheet papers packed with photos and sensational sledgehammer headlines—became more common in the early 1920s, when it was possible to send photographs through telephone lines.

As the years went by, papers kept increasing the traffic on each page, using ever more photos, stories and ads.

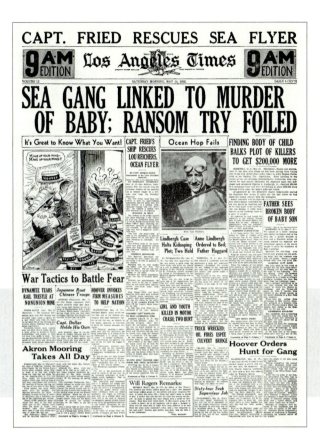

Packin' it in By the 1930s, most newspapers had the ability to run cartoons, photos and wide headlines, as we see in this 1932 edition of the Los Angeles Times. Note the number of stories on this page. For decades, American front pages commonly displayed 15-20 story elements. With those all-cap headlines, these pages gave readers a strong sense of urgency.

THE NOT-TOO-DISTANT PAST

By today's standards, even the handsomest papers from 50 years ago look clumsy and old-fashioned. Others, like the page at right, look downright ugly. Still, most of the current trends in page design were in place by the late '60s:
▸ more and bigger photos;
▸ more refined headline type (except for special feature stories and loud front-page banners);
▸ a move from 8- and 9-column pages to a standardized 6-column page;
▸ the addition of more space in the gutters between stories instead of rules.

As printing presses continued to improve, full-color photos became common in the early '80s, thus ushering in the modern era of newspaper design.

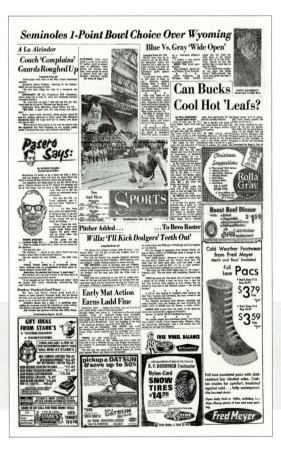

Before the era of "presentation desks" This 1966 sports page from The Oregon Journal is astoundingly bad—but to be fair, it's a typical example of mid-'60s design. The bizarre shapes of its photos and stories collide in a distracting jumble. After printing pages like these for years, editors finally realized that taking page design seriously might not be such a bad idea.

Current trends

Compared to the newspapers of yesteryear, today's news pages look lively and sophisticated. That's partly due to technological advances (in reproduction, for example). But today's editors also realize that readers are *inundated* by slickly designed media, from movies to websites to TV commercials to tablet publications. Sad to say, most consumers judge a product by the package it comes in. They simply won't respect a product—or a newspaper—that looks old-fashioned or is difficult to navigate.

To look fresh, clean and modern, newspapers now use:

▶ **Color.** Full-color photographs have become standard on section fronts across the country. Throughout the paper, you'll find color in ads and illustrations, in photos and graphics, and in logos and headers that organize pages to help guide readers.

▶ **Informational graphics.** Papers don't just report the news—they *illustrate* it with charts, maps, diagrams, quotes and fast-fact sidebars that make complex issues easier for readers to grasp.

▶ **Packaging.** Modern readers are busy. Picky. Impatient. So editors try to make every page as user-friendly as they can by designing briefs, roundups, scoreboards, promos and themed packages that are easy to find and quick to read.

▶ **Modular layout.** We'll explain this later. In a nutshell, it simply means all stories are neatly stacked in rectangular shapes.

In the past, newspapers were printed in a variety of sizes. Today, virtually all newspapers are printed either as *broadsheets* (large, full-sized papers like USA Today or The Huntsville Times, shown at right) or *tabloids* (half-sized papers like The National Enquirer—OK, maybe that's a bad example—or, say, The Boston Herald).

In the pages ahead, we'll examine current examples of (mostly) American newspaper design. Most of these are broadsheet pages, but remember: Whatever your paper's format, the same basic design principles apply.

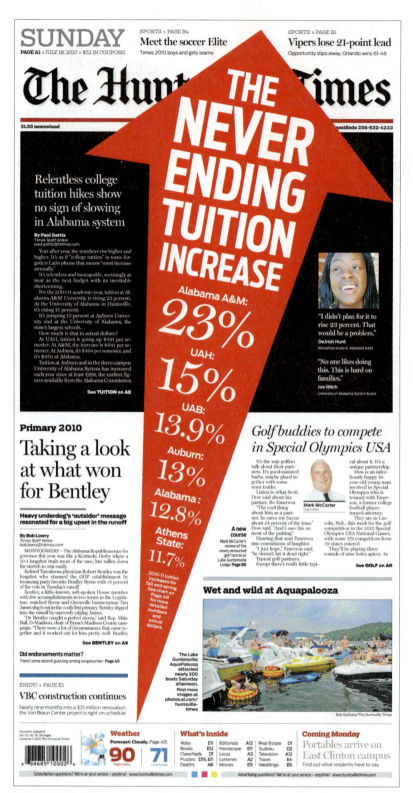

Staying flexible Some newspapers, like The Huntsville Times, frequently combine more traditional-style newspaper design with a magazine flair—and skip the templated look altogether. Here, the oversized arrow busts out of the black box to emphasize the sharp increase in tuition costs in Alabama. Making the arrow red draws even more attention to the urgency of this story.

Current trends

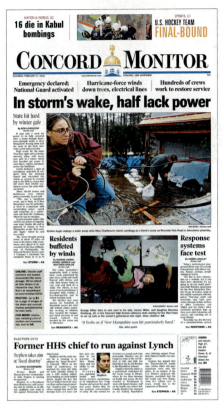

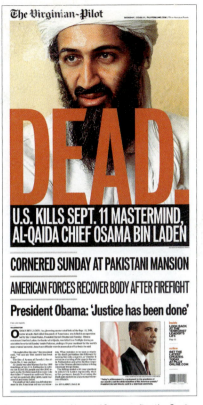

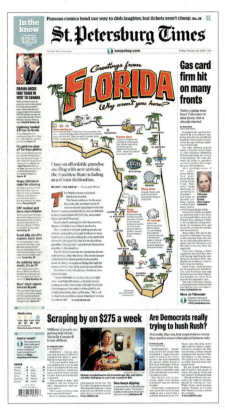

Packaging stories This page from the Concord Monitor offers the reader a variety of stories, photographs and promos. The elements are laid out in a *modular* style (more on that later). The 5-column lead photo gives the page more impact and signals to readers: Big News Day in this region.

Cranking it up Almost 10 years after the Sept. 11 attacks, United States forces killed al-Qaida's leader Osama bin Laden. On a short deadline, The Virginian-Pilot reworked its front page to accommodate a single story, large photo, huge headline and multiple decks.

Mixing it up Some newspapers, like the St. Petersburg Times, use part of the front page as a menu to tease readers to look inside the paper. Here, the left rail refers readers to a range of stories inside. Note how the centerpiece breaks away from style, yet fits the tone of the content and remains informative.

PAGE ONE DESIGN Today's Page One is a blend of traditional reporting and modern marketing that seeks to answer the question: What *grabs* readers? Is it loud headlines? Big photos? Juicy stories? Splashy colors? Or do readers prefer thoughtful, timely analyses of current events?

Hard to say, because readers are all different. Though newspaper publishers spend fortunes on reader surveys, they're still unsure what front-page format reaches readers the best. As a result, most papers follow one of these Page One design philosophies, based on what they think might work for their particular readership:

▸ **The traditional:** No fancy bells or whistles—just the top news of the day. (For tabloids, that means two to four stories; for broadsheets, four to six.) Editors combine photos, headlines and text—usually lots of text—in a sober, straightforward style.

▸ **The magazine cover:** These pages use big art and dynamic headlines to highlight a special centerpiece. In tabloids, this package dominates the cover (and may even send you inside for the text). In broadsheets, a front-page package is given lavish play, flanked by a few secondary stories—or maybe no other stories at all.

▸ **The information center:** Here, the key words are *volume* and *variety*. By blending graphics, photos, promos and briefs, these fast-paced front pages provide a window to what's inside the paper, a menu serving up short, appetizing tidbits to guide readers through the best of the day's entrees.

But the options don't end there. Some papers run editorials on Page One. Some add cartoons. Some print obituaries, calendars, contests—and more and more these days, ads. Almost anything goes, as long as readers use it, enjoy it and buy it.

Though newspaper publishers spend fortunes on reader surveys, they're still unsure what front-page format reaches readers the best.

Current trends

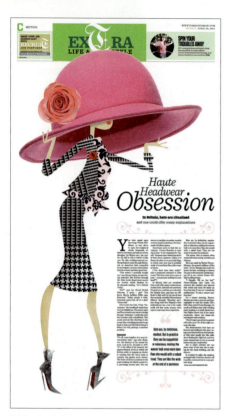

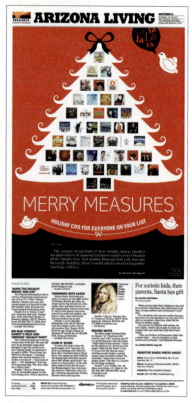

Whimsical At larger newspapers, feature coverage expands to include food, travel and fashion—topics that often receive a big splash. This section front from the Times of Oman features a fun illustration that runs the length of the page. The pink touches complement the overall style.

Eye-catching The centerpiece on this page from the Fayetteville Observer zeros in on a simple concept. The large image is dominant, and the typography is understated (in other words, not overly decorative). The secondary stories have visual hooks, so they don't get lost on the page.

Medley Popular feature pages provide lots of choices: lifestyle stories, columns, humor, entertainment. On this Arizona Republic page, there's a story on holiday CDs, briefs on regional events and an article on holiday gifts for autistic children and their parents.

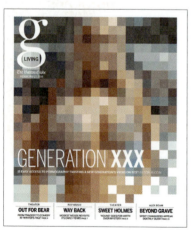

Conceptual Entertainment and lifestyle coverage is popular in tabloid-size publications, where big ideas have to come across in smaller packages. This cover for The Boston Globe's G living section refers to a story about how easy access to pornography is affecting a new generation's view on sex.

FEATURE PAGES AND SECTIONS As time goes by, feature sections become more popular—and their range gets more ambitious. Most feature sections offer a mix of:

▸ **Lifestyle coverage:** Consumer tips, how-to's, trends in health, fitness, fashion—a compendium of personal and social issues affecting readers' lives.

▸ **Entertainment news:** Reviews and previews of music, movies, theater, dance, books and art (including comprehensive calendars and TV listings). Juicy celebrity gossip is always popular, too.

▸ **Food:** Recipes, nutrition advice, new products for home and kitchen—all surrounded by coupon-laden advertising that shoppers clip and save.

▸ **Comics, columnists and crosswords:** From advice columns to Dilbert, from Hagar to the horoscope, these local and syndicated features have faithful followings.

Feature sections often boast the most lively, stylish page designs in the paper. It's here that designers haul out the loud type, play with color, experiment with unusual artwork and photo treatments.

Many feature editors liven up their front pages by giving one key story a huge "poster page" display. Editors at other papers prefer pages with more traffic, providing an assortment of stories, briefs, calendars and lists.

And while most papers devote a few inside pages to features, some bigger publications—those with plenty of writers and designers—produce daily-themed magazines: *Money* on Mondays, *Health & Fitness* on Tuesdays, *Food* on Wednesdays and so on.

Current trends

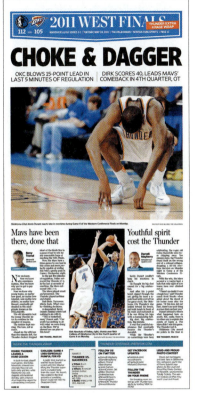

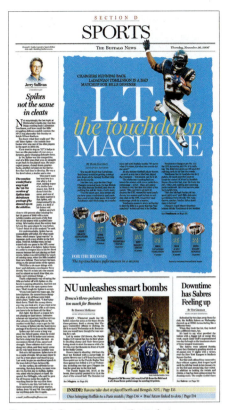

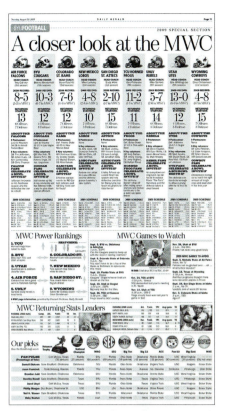

Lively Whenever big sporting events occur—the Super Bowl, a state championship—it's a golden opportunity to create special sections, design special logos, run jumbo photos. Note the mix of story/commentary/tidbits—all about one conference finals—on this page from the Oklahoman.

Organized Sports pages are the perfect venue for trying something a little different. No need to just stick with a straightforward photo on this page from The Buffalo News: why not turn this visual presentation about a San Diego Chargers running back into a visually informative graphic?

Detailed Publications also produce special inside pages, too. Some are themed pages that run regularly, while others profile athletes or commemorate milestones. This page, which ran in Brigham Young University's The Daily Universe, focuses on a regional football conference.

SPORTS PAGES AND SECTIONS Television seems to be the perfect medium for sports coverage. It's immediate. Visual. Colorful. Yet in many cities, many readers turn to newspapers for their sporting news. Why?

A good sports section combines dramatic photos, lively writing, snappy headlines and shrewd analysis into a package with a personality all its own. And while sports coverage usually centers around meat-and-potatoes reporting on games, matches and meets, a strong sports section incorporates a variety of features that include:

▸ **Statistics:** Scores, standings, players' records, team histories—true sports junkies can't get enough of this minutiae. It's often packaged on a special scoreboard page or run in tiny type called *agate*.

▸ **Calendars and listings:** Whether in small schools or big cities, fans depend on newspapers for the times and locations of sporting events, as well as team schedules, ski reports, and TV and radio listings.

▸ **Columnists:** Opinionated writers whom sports fans can love or loathe—the more outspoken, the better.

▸ **Inside poop and gossip:** Scores, injury reports, polls, predictions, profiles and analyses that aren't easily available anywhere else.

Sports pages (like features) offer opportunities for designers to run photos more boldly, to write headlines more aggressively—and to create dynamic graphics packages that capture the thrill of victory in a visual way.

Sports pages offer opportunities for the designer to run photos more boldly and write headlines more aggressively.

Current trends

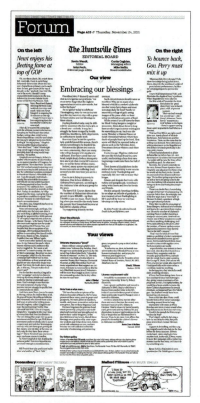

Informative This inside page from The Huntsville Times is a classic example of a modern editorial page. On it, you'll find the masthead (listing the paper's top editors), editorial cartoons, editorial columns and a handful of letters from readers.

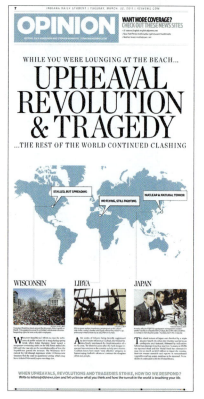

Parallel On this Opinion page from the Indiana Daily Student, editors decided to give a lot of play to three high-octane stories that happened while students were on spring break. Notice how each story is treated in the same way, visually, and yet they all fall under one umbrella headline.

High-impact Here's an example of an eye-catching opinion page design from the Sun-Sentinel. Like the examples on the left, this section features longer analysis pieces and touches on a range of topics. Inside, the reader will find editorials, letters to the editor and opinion pieces.

Nearly every newspaper sets aside a special page or two for backbiting, mudslinging and pontificating.

OPINION PAGES AND EDITORIALS Juxtaposing news and commentary is a dangerous thing. How are readers to know where cold facts end and heated opinions begin? That's why nearly every newspaper sets aside a special page or two for backbiting, mudslinging and pontificating. It's called the editorial page, and it's one of America's noblest journalistic traditions.

The basic ingredients for editorial pages are nearly universal, consisting of:

▶ **Editorials,** unsigned opinion pieces representing the paper's stance on topical issues;

▶ **Opinion columns** written by the paper's editors, by local writers or by nationally syndicated columnists;

▶ An **editorial cartoon,** an illustration that lampoons public figures or political policy;

▶ **Letters from readers,** and

▶ The **masthead,** which lists the paper's top brass (editors, publishers, etc.) along with the office address and phone number.

In addition—because editorial pages are often rigidly formatted—many papers run a separate opinion page (see examples above). These pages provide commentary and opinion, too, as they examine current issues in depth. And like sports and feature sections, they set themselves apart from ordinary news pages by using stylized headlines, interpretive illustrations and more elaborate design techniques.

Current trends

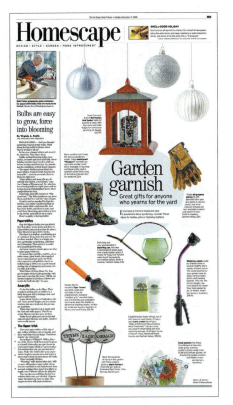

Home, etc. The Homescape section in The San Diego Union-Tribune covers a lot of ground under the general theme of home: design, style, garden and home improvement. Note how the centerpiece story is treated: through a number of pullouts and visuals, instead of a typical narrative story.

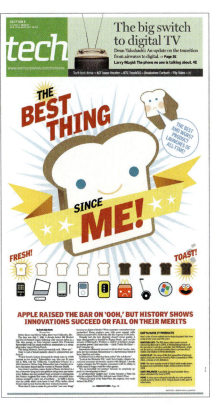

Tech talk Technology pervades every aspect of our lives, so it's not uncommon to find tech stories and sections in many newspapers. This page, from The San Jose Mercury News, uses colorful visuals to illustrate which innovations have withstood the test of time—and which ones ended up as … toast.

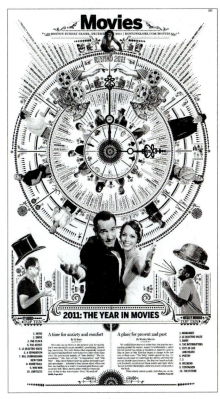

Movie mania So many movies, so little time. This Boston Globe movie page is meant to be read and studied. To maintain continuity, the visual style for the section front was similar to what you see here on this inside page. Amid all the color in this newspaper, the black-and-white presentation stands out.

THEMED PAGES AND SECTIONS In the old days—say, 25 years ago—many newspapers simply shoveled all their stories into four big blocks: news, sports, features and business. (Many dull newspapers still do.)

But smart editors realize that if you cram everything into those *news-sports-features-business* blocks, lots of good stories will fall through the cracks. They've learned that readers have a broad range of interests, and that special-interest pages provide a way to satisfy those readers while attracting advertisers, too.

Take a tour of modern American news publications and you'll find smartly format-ted weekly themed pages on such topics as:

Automobiles	Environment	Movies	Senior citizens
Auto racing	Ethics	Music	Shopping
Boating	Gambling	Nightlife	Skiing
Books	Gardening	Outdoors	Television
Celebrities/gossip	Golf	Pets	Transportation
Children/families	Health/fitness	Pro wrestling	Travel
Classical music	Hiking/biking	Relationships	Videos and
Computers	Hobbies	Religion	DVDs
Computer games	Home decorating	Rock music	Visual arts
Crime and safety	Hunting/fishing	Technology	Volunteering
Dance	Local history	Schools	Weather
Dieting	Military affairs	Science	Websites

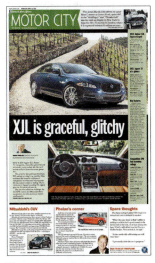

Vroom It's no surprise that The Detroit Free Press would have a section called Motor City. Here, information about different auto-related stories is divided up into chunks that are easy to follow.

Current trends

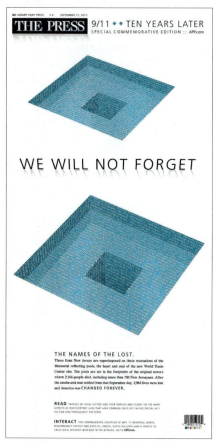

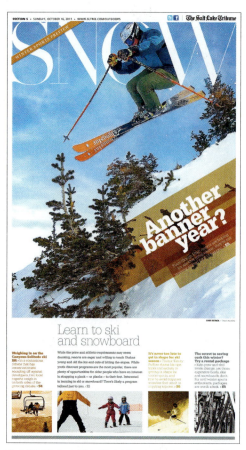

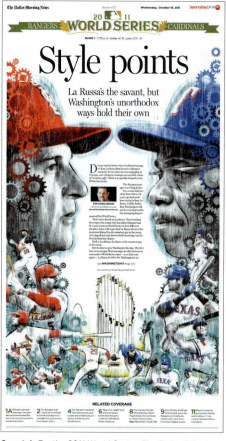

Dramatic There are some days that just require a special front—and the 10th anniversary of Sept. 11, 2001, is one of those times. A clean graphic accompanied by a simple message sets the somber tone on this page from The Asbury Park Press.

Outside the box This Winter Sports Preview in The Salt Lake Tribune starts out with a snowy bang by featuring a skier flying down the slope—and right over the giant word SNOW at the top of the page. The angled headline adds to the dynamic nature of this page.

Special For the 2011 World Series, The Dallas Morning News pulled out all the stops and turned to an elaborate and illustrative style that presented a more analytical perspective of the two teams that were about to face each other on the field.

Special projects give you an opportunity to experiment with new forms of storytelling, type treatments, page layouts and photography.

SPECIAL TOPICS AND SECTIONS As we mentioned previously, newspapers often settle into dull, predictable routines from issue to issue, repeating the same standard formats day after day. (Fortunately, a little predictability is good: It keeps readers happy and editors sane.)

But opportunities often arise for producing special sections with unique design formats. These include:

▶ **Previews** of big events published in advance (*2012 World Series* or *Family Fun at the County Fair!*). These recycle photos and statistics from years past and offer readers calendars, maps and other helpful guides.

▶ **Special reports** that wrap up news events that just occurred (*9/11: Ten Years Later,* or *That Championship Season: The Green Bay Packers*). For major sports events, these special sections are often printed and distributed to stadium spectators just moments after the Big Game concludes.

▶ **Special enterprise packages** on serious topics or trends (*Cybercrime, The Homeless, How You Can Save Our Planet*). These are often investigative stories that take a team of reporters, photographers and designers weeks—or months—to assemble. They frequently run as a series in the daily paper, after which they're repackaged and reprinted in a special section.

Special projects like these are an enormously rewarding form of journalism. Better yet, they give you an opportunity to experiment with new forms of storytelling, type treatments, page layouts and photography.

Current trends

DOWNSIZING THE PRINTED PAGE

Newspapers, once so powerful and profitable, now face an uncertain future. As readers and advertisers steadily drift from newsprint to digital platforms, publishers feel enormous pressure to trim costs and boost circulation. But how?

One solution: downsizing. In many cities, newspaper staffs have gotten smaller over the past few years, and newspapers *themselves* have shrunk, too. To offset the rising cost of newsprint, most American newspapers are now an inch or two narrower than they were a decade ago.

Some publishers want to go even further. Many broadsheet papers are considering downsizing to a smaller size, both to save money and please readers, who often prefer the reduced-sized format.

In Europe, tabloids are enormously popular. Many respected broadsheets have redesigned into tabloids. Some, like The Guardian in London, switched, in 2005, to a size halfway between tabloids and broadsheets, called a *berliner*.

"The tabloidization of newspapers is a global phenomenon," says design consultant Mario Garcia. "It is, I believe, unstoppable."

Why? Readers prefer simpler storytelling and quicker messages in a smaller package, Garcia says. "In fact, more newspapers globally are going to a narrower web, and even in the U.S., the compact format is beginning to attract major attention." Additionally, he says, "the arrival of the iPad, and the impressive use of mobile devices to obtain information, all add to the reasons why compact is the way to go."

Not everyone agrees with that prediction, however.

"The 'unstoppable' phenomenon Garcia describes has not happened in the U.S.," says Alan Jacobson, another design consultant. "You must consider the impact on ad revenue per page. When newspapers sell by the column inch, they're reducing revenue per page on a shorter page."

Whatever the outcome, it remains a time of dramatic change for newspapers big and small. News design will continue evolving in the years ahead—even if it's just an inch—or pixel—at a time.

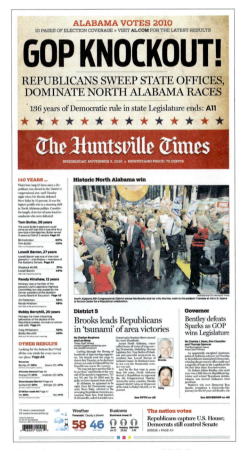

Broadsheet In covering elections in 2010, The Huntsville Times uses its large broadsheet format to run big headlines above the flag, a large photo, a couple of stories, and a handful of election results and promos.

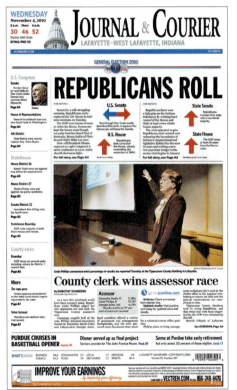

Berliner This format, used by the daily paper in Lafayette, Ind., is slightly smaller than the broadsheet at left. It's a handier size, but it doesn't provide as much room for news as the broadsheet format.

Tabloid As the available space gets smaller, less material fits—so tabloids run even fewer stories—or none at all out front. Many readers prefer this size and shape, however, because it's easier to handle.

The 3V: By retrofitting a press, it's possible to make a newspaper even more compact. Again, that means less space for stories and photos, but an even more handy size for readers. There are a few U.S. newspapers that are making the shift to this format in 2012. Learn more about this on Page 77.

To offset the rising cost of newsprint, many newspapers have shaved inches from the width of the paper, and some have reduced their size even more dramatically.

Years from now, we'll look back on today's Web and mobile news presentations and say, *"Ugh—how primitive."* (Much like your reaction to those old newspapers back on Pages 4 and 5.)

Yes, much of this digital world, when it comes to newspapers, is *still* in its infancy. Only a decade ago, most editors and publishers had no idea how to translate news pages onto a digital platform. They had to be dragged, kicking and screaming, into the new millennium.

Like fish learning to walk on land, newspapers are evolving and adjusting to this new terrain, and yet too many news sites still remain disorganized, unappealing and fail to generate sufficient profits. Yes, there is steady improvement. The next generation of journalists—that's *you*—will raise the standards even higher.

Digital journalism offers some obvious pros (or cons, depending on how you look at it) for readers and viewers (i.e., users):

▸ **Immediacy.** Stories, photos and videos can be posted as news breaks, then updated around the clock.

▸ **Flexibility.** Stories can change and grow, appear and disappear, from minute to minute. This can compromise accuracy—but then again, it means corrections can be made rather quickly.

▸ **Unlimited space.** In digital form, stories can run as long as necessary—which can be painfully boring. Space needs to be planned carefully, and reporters and visual journalists must enhance their coverage by being smart when linking to archived stories, supplemental data and outside commentary.

▸ **Interactivity.** Readers can comment on stories, debate issues, post videos and blogs of their own. The Web, especially, has made "citizen journalism" a reality.

▸ **Multimedia.** Audio, video, animated graphics—these storytelling devices vastly expand the news designer's toolbox.

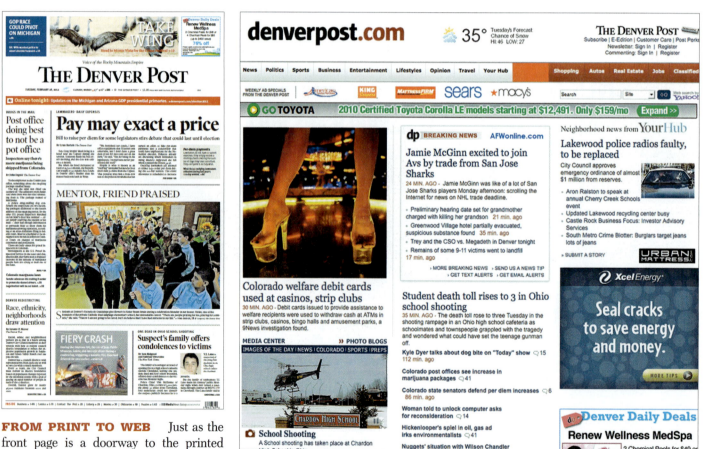

FROM PRINT TO WEB Just as the front page is a doorway to the printed newspaper, the home page is the gateway to the online version. With more and more newspapers relying on pre-formatted templates, however, the opportunity to make a unique visual impact online, on a daily basis, isn't really feasible. *Well-designed* in the world of the Web boils down to presenting key content in a functional and easy-to-navigate way.

On paper At left, we see five stories on this front page from The Denver Post, as well as a large stand-alone photo with an extensive cutline and a few refers (two on top, one at the bottom) to inside stories. There is one ad on this page. A limited index runs along the very bottom of the page, in relatively small type. Note the red band across the top with a refer to online updates on two presidential primaries. Many newspapers include references to online material, so they can keep readers fully informed long after the newsprint ink has dried.

Online Now let's take a look at denverpost.com's home page, above, that appeared on the same day as the printed version at left. Since this online page changes throughout the day, you'll notice that most of the stories here are different than the printed front page. And the "stories" are more like scannable headlines—users click on links to access other parts of the site for more in-depth information. Because this site (like most online newspaper sites) is templated, custom story design is limited to special projects, for the most part.

Digital news design

As far as the design goes, however, with any of these digital outcomes, you *don't* need pizazz. You *don't* need electronic bells and whistles.

You're a journalist, remember. A *storyteller.* You've got data to gather, organize, edit and deliver in more and more innovative and streamlined ways.

So move past the super-cool-for-supercool's-sake and think about what news-oriented websites and apps really need to be:

▸ **Informative.** That means providing a way to access useful and relevant news to users of the site or app and not push the whizbang gimmickry. Just like in print, the content must always drive the design.

▸ **Aesthetically appropriate and engaging.** That means understanding that every design choice that can be seen on the surface has an immediate first impression on the user, for better or worse.

▸ **Usable.** That means a clean, user-friendly interface, with stellar functionality, no matter what platform it's on. If users stumble over technology issues, or are unable to (quickly) find what they're looking for on a website or app, they will move on.

▸ **Quick.** That means the site, or the app, is speedy—whether you're clicking, swiping, scrolling or using your voice.

▸ **Credible.** That means the site, or the app, is as accurate as it can be and well-organized—and that users clearly "get" this immediately. Additionally, there should be an easy way for users to contact the people who played a role in creating and managing the site's content.

Creating these websites and apps requires the same solid understanding of typography and visuals that you need when creating pages for print, but the environment has shifted to one where *users* have more control. Whatever you produce, though, it's got to be inviting, informative and intuitively logical.

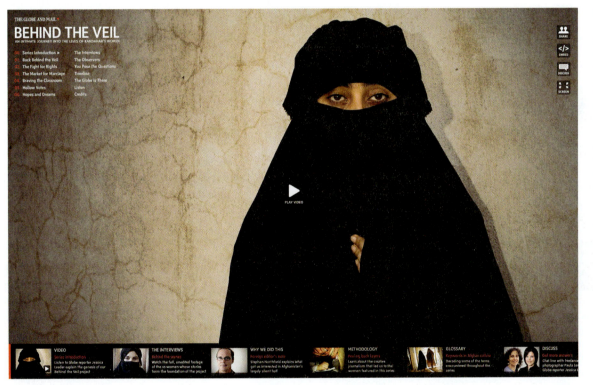

Extensive coverage
This six-part multimedia project, which ran on the Globe and Mail's website, explores the lives of women in Afghanistan. Through videos, roundtable podcasts with reporters, an interactive timeline and a section where readers posed their own questions, viewers got a more complete picture of the women who are featured here. Additionally, viewers could read one foreign editor's account as to why and how the series was created and understand how reporters gained access to their subjects.

View this project at *www.theglobeandmail.com/ news/world/behind-the-veil*

SPECIAL PROJECT DESIGN

Occasionally, newspapers tackle ambitious *enterprise stories* that explain current events, explore controversial issues or expose social injustices. In print, these projects are often packaged in multi-part series. Online, these projects are presented differently, too. They distinguish themselves in a few significant ways:

▸ **They look different.** Ordinary newspaper pages are consistently formatted. Special projects, however, can be designed to look unique. The headline treatment might be different—achieved by working with typography, color and the grid.

▸ **They require extensive planning.** Unlike the routine stories that are produced day to day, special projects may require weeks, even months of preparation and teamwork.

▸ **They rely more heavily on interactivity.** In most routine stories on the Web, *words* do the heavy lifting. For special online projects, however, multimedia becomes essential. In fact, some projects use slideshows of photos, videos, audio clips and interactive graphics so expertly and expressively that they require little written text—or sometimes *none at all.*

Digital news design

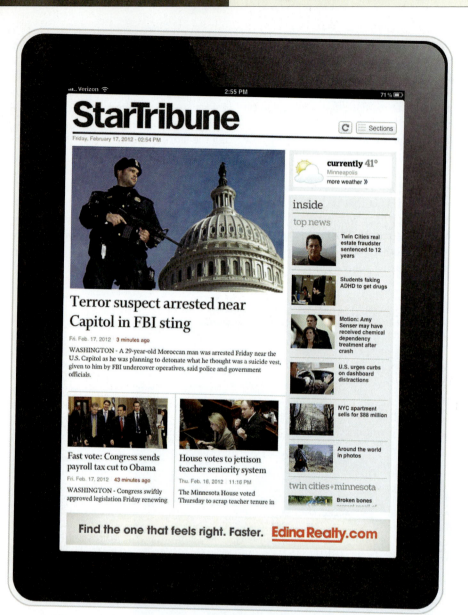

The tablet—the future? With swiping and scrolling on these portable and highly interactive devices, readers—or rather, *users*—can access the news (or just about anything) in multi-faceted ways. Design for newspaper apps is still in its early stages, though, and is constantly evolving.

Social media
More journalists are using these different types of interactive outlets, such as Twitter, Facebook, Wikipedia and YouTube, to find sources, gather information, tell stories and engage directly with users.

Mobile Smartphones mean catching up on the news while on the go, which more and more readers are doing, research shows. Breaking stories, longer narratives, sports scores, stock prices—anything you need to find, you can find here.

WHAT'S AHEAD

So, what does the future hold for journalism? Your guess is as good as ours: one study shows that many readers still want access to a printed newspaper that will keep them informed about their communities, and yet another one predicts that the only print newspapers that will survive will be the largest and the smallest ones—and everything in between will just die off.

One thing *is* certain: In this fast-moving, always-changing world of technology, every month, every week, every day—there's always something new on the horizon.

Increasingly, taking in the news is becoming more about *user experience* as readers shift between formats. Good design still applies here, as we've mentioned earlier, but what this really means has broadened significantly as we look at *how, when* and *where* users interact with digital products.

Digital design is rapidly becoming more fluid and *responsive** in its approach, which is one way to deal with the challenges of designing for all the different gadgets and screen resolutions out there. Instead of designing for just the Web or a mobile device, for example, designers are creating flexible interfaces that automatically adjust to a variety of platforms.

All this may seem scary and overwhelming, but remember: Whether you're printing photos on newsprint, or creating graphics for a computer screen or tablet, the same fundamental design principles apply. Information can be ugly and confusing and difficult to access—or it can be attractive and well-organized, and easy to navigate and understand.

As you'll learn over time, good design is good design—whatever medium you're working in.

The digital world What you see here on these few pages is a mere snapshot of how news is being presented these days. Things are changing so rapidly in this virtual world, however, that it would be futile to try to introduce any sort of digital how-to's here. To develop your own digital expertise, we recommend that you seek specialized training and take full advantage of the infinite number of resources available.

*The term *Responsive Web Design* is attributed to Ethan Marcotte (*http://unstoppablerobotninja.com/*). Marcotte was instrumental in developing the responsive-designed bostonglobe.com.

The fundamentals

music

Princess Anne High choral students, from left, Bristol Birt, 16, Nick Richardson, 16, Kellyn Hamilton, 16, and Brandon Robertson, 17, will perform songs from "W...

Time to get your Gleek or

'Glee' actor **Harry Shum Jr.** will perform at Pembroke Mall, culminating a weeks-long showcase of Beach youth fine arts groups.

cess Anne High Madrigals, the chorus, would perform songs from the Broadway smash "Wicked" in the slot directly before Shum hits center stage.

The Madrigals won't be the only performers showcasing their talents. Groups from other Virginia Beach public schools started performing at the mall Tuesday. Perfor...

"Jeff has a great ap... tion for the arts and ... to bring music to the ... Brewington said.
Ramsels said it took ... year in putting Shum's ...

As we observed in the Preface— you *did* read the Preface, didn't you? After all the work we put into it? Listen, it's not *nearly* as dull as it looks—you're probably eager to unravel the Mysteries of Page Design. But before you begin banging out prizewinning pages, you need to understand a few basics.

You'll need to learn some vocabulary. You'll need to become familiar with the tools of the trade. But most of all, you'll need to grasp the fundamental components of page design: headlines, text, photos and cutlines.

This book is designed so you can skip this chapter if you're in a hurry. Or you can just skim it and catch the highlights. So don't feel compelled to memorize *everything* immediately. But the better you understand these basics now, the more easily you'll be able to manipulate them later on.

To make this book handier to use, we've repeated the chapter contents in detail on every chapter's introductory page. And each section within this book is cross-referenced, too, with handy **LEARN MORE** tips in the upper-right corner of most pages. As you study each topic, you can jump around through the book to expand upon what you're learning.

CHAPTER CONTENTS

▶ **What it's called:**
A look at newspaper design components on two typical pages18

▶ **Tools of the trade:**
A quick tour of the old (pica poles) and the new (computers)20

▶ **Basic typography:**
An introduction to fonts, point sizes and type characteristics21

▶ **The four basic elements:**
Essential components (headlines, text, photos, cutlines) used to build pages26

▶ **Headlines:**
Types of headlines; weights and fonts; determining number of lines..................27

▶ **Text:**
Different types of type and how they're shaped into text..............................30

▶ **Photographs:**
The power of images and the three basic photo shapes....................32

▶ **Cutlines:**
Type treatments and basic options for placing cutlines on the page34

▶ **Drawing a dummy:**
How to create a dummy; elements needed for effective dummies38

▶ **Broadsheet dummy:**
A page dummy to use for design practice40

▶ **Tabloid dummy:**
A page dummy to use for design practice41

▶ **Exercises**42

What it's called

To succeed in the design world, you need to speak the lingo. In a typical newsroom, for instance, you'll find *bugs, bastards, dummies, refers* and maybe even *widows* and *orphans* in the *gutter*.

Sounds like we're talking smack here—but don't fret. These are all legitimate terms used in many newsrooms. Keep in mind, though, that not all newsrooms use the same jargon—for example, when describ-

ing the line that indicates what page the story continues on, some would say it's a *jump line* and others would call it a *hop*. What's listed below are some common terms you'll hear in many newsrooms.

Teasers
These promote different stories inside the paper (also called promos or skyboxes).

Flag or nameplate
The name of the newspaper.

Infographic
A diagram, chart, map or list that conveys data in a visual way.

Deck or subhead
A smaller headline that helps to add information to the main headline.

Display head
A snazzier headline treatment that adds drama or flair to special stories. Display heads are used sparingly on the front page.

Jump line
A line that indicates what page a story continues on.

Logo
A label with a visual used to refer to special stories or a series of stories.

Cutline
Information about a photo or an illustration (also called a caption).

Reverse type
Lighter-colored words set against a darker background.

Headline
The story's title or summary in large-enough type so it contrasts with the story text.

Refer
A brief reference to a related story elsewhere in the paper.

Mug shot
A small photograph of a person featured in the story.

Byline
The writer's name, often followed by the name of the publication he or she works for or other key credentials.

Initial cap
A large capital letter set into the opening paragraph of a special feature (also called a drop cap).

Label
Used for packaging special items such as graphics, teasers, briefs and columns.

Index
A directory of contents.

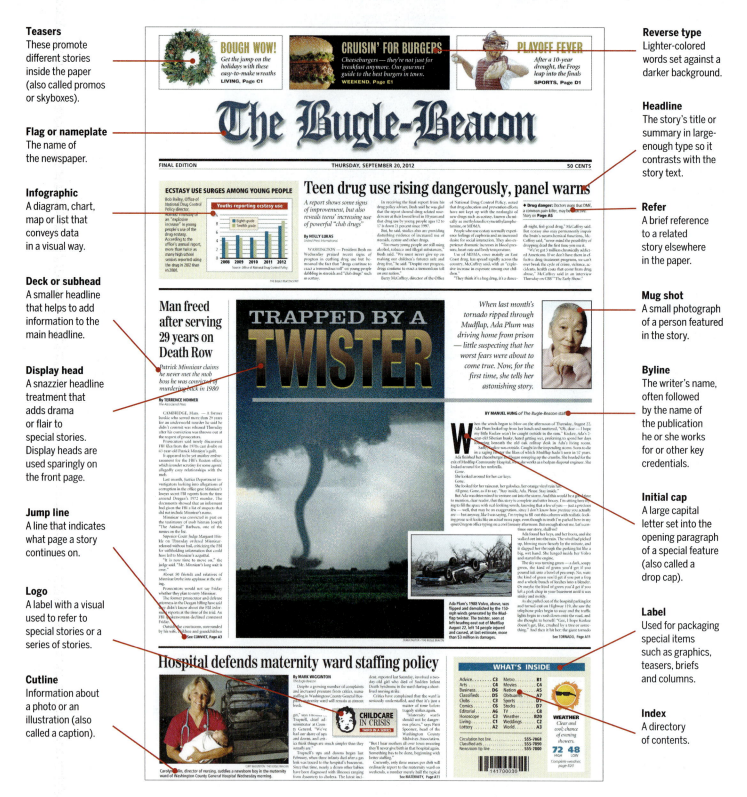

What it's called

As you can see, Page One is often loaded with visual and word devices designed to entice and keep readers interested in the page. Inside the paper, however, graphic elements become more subtle and less overtly visual. They're there to inform and guide readers, not sell papers. In terms of design, though, these inside pages are as carefully thought out at the section fronts (Page One, for example). Every element is handled with care so that when the page comes together, it looks visually interesting and easy to navigate. Here are some typical design elements used on inside pages—many of the same elements found on Page One.

Folio
A line showing the page number, date, paper's name, etc.

Jump line
The page number this story continues from.

Liftout quote
A quotation from the story given graphic emphasis (also called a pull quote or breakout).

Subhead
A boldface line of type used to organize the story and break up gray text. (This is sometimes called a bold lead-in.)

Gutter
The white space running vertically between elements on a page.

Bastard measure
Type set in a different width than the standard column measure.

Sig
A special label set into stories giving typographic emphasis to the topic, title, writer's name, etc. (also called a bug or logo).

Standing head
A label used for packaging special stories or features.

Jump headline
A headline treatment reserved for stories jumping from another page (styles vary from paper to paper).

Photo credit
A line giving the photographer's name (often adding the publication or wire service he or she works for).

Text
Type for stories set in a standard size and typeface, stacked in columns (or legs).

Sidebar
A related story, often boxed, that accompanies the main story.

Cutoff rule
A line used to separate elements on a page.

Cutout
A photo in which the background has been cut away (also called a silhouette).

F12 ■ THE SUNDAY OREGONIAN, JUNE 12, 1988

A BIG YEN FOR BASEBALL

Japan: Clubs hope when money talks, U.S. players listen

■ Continued from Page F1

"$5 million can only buy a small condominium in the Tokyo area, so it doesn't seem like much money to us."
Masaaki Nagino,
Central League planner

A nondescript player in the U.S. major leagues, Randy Bass became a superstar with the Hanshin Tigers.

WARREN CROMARTIE
Ex-Expo now a Japanese veteran

BILL MADLOCK
Worth more than $1 million

BILL GULLICKSON
Packing 'em in Tokyo

Not everyone likes Japan's best-loved team

By MICHIO YOSHIDA
The Associated Press

Is expansion in the works?

Drysdale's streak was highlight of 1968 — season of the pitcher

By LARRY BORTSTEIN

FOR THE RECORD

Don Drysdale (left) and Bob Gibson, shown during a joint appearance at a baseball game, dominated National League pitching in 1968. Drysdale pitched 58 consecutive scoreless innings, a major league record.

Tools of the trade

LEARN MORE
Scanning: *Importing art electronically.* **Page 124**

MEASURING THINGS

Using inches in newspapers is clumsy and imprecise. To be exact, designers use picas and points. There are *12 points* in *one pica, 6 picas* in *one inch*— or, in all, *72 points* in *one inch.*

1-point rule

12-point rule

Use **points** to measure type sizes and thickness of rules; use **picas** to measure lengths of rules and widths of text and photos; use **inches** to measure story lengths and depths of photos and ads.

TRADITIONAL TOOLS

News designers used to spend *lots* of time drawing boxes and lines, to show where everything was supposed to be placed on the page. This work is now done on computers, but you should be familiar with these tools and terms.

Calculator This was once used to figure out the size of photos and compute line lengths.

Pencil The plain old pencil was, and is, the best tool to use for sketching those first page ideas.

Grease pencil This tool was used for making crop marks on the photos themselves. These markings were easy to rub off with cloth.

Knife X-ACTO knives (a brand name) were once used for trimming photos, cutting stories and moving items around when pages were assembled—or "pasted up"—before printing.

Proportion wheel This gizmo was used to calculate proportions. For instance, if a photo was 5 inches wide and 7 inches deep, this wheel would show you how deep the photo would be if you enlarged it to any size.

Pica pole This ruler has inches down one side and picas down the other. You can see, for instance, that 6 picas equal one inch.

Way back in the Stone Age (the '80s and '90s), newspapers became pioneers in desktop publishing technology, and computers transformed every corner of the newsroom. As new media continues to evolve, it's essential for every journalist to possess a range of skills. They're indispensable for:

▸ **Writing and editing stories.** In most newsrooms, reporters and editors use networked computers to write, edit and file stories; to conduct interviews (via e-mail); to compose headlines; to search Internet databases and library archives.

▸ **Designing pages.** Today, all print publications are *paginated*—that is, pages are created digitally with desktop publishing software. (This book, for instance, was produced using Adobe InDesign.) Designing pages for a digital platform may require expertise in HTML5, CSS3, Javascript, ActionScript, content management systems and Web design software.

▸ **Producing photos and video.** Digital cameras and photo-processing software let you control every aspect of an image. Whether you're preparing photos for print, or posting videos online, you'll need skills in digital-production techniques (using Final Cut Pro, for example).

▸ **Creating illustrations and graphics.** Illustration software (such as Adobe Illustrator or Photoshop) allows designers to draw artwork in any style they choose. Even if you're not an artist, you can purchase stock images or subscribe to wire services that provide top-notch graphics you can use.

COMPUTER ACCESSORIES

To produce a professional-looking publication, you don't need a lot of high-tech toys. Here's the basic hardware that's essential in every newsroom:

Storage media Photos and page-design files can quickly fill up a computer's memory. That's why many newsrooms find alternative ways to archive images and pages once they've been published. Backing up files to a hard drive—especially one networked to all newsroom computers—usually provides a convenient and reliable storage option.

Scanner This device, used to reproduce photos or artwork digitally, scans images, after which you can adjust their size, shape and exposure on your computer screen.

Printer Every newsroom uses high-resolution laser printers: devices that output near-professional-quality type and graphics. Small papers may send these prints to the pressroom, but most papers use specialized typesetters for that.

Basic typography

LEARN MORE
Display heads: *Headlines for feature pages.* **Page 208**

Before we start examining headlines and text, we need to focus on type itself. After all, consider how many hours you've spent reading books, magazines and newspapers—in print and online—over the years. And all that time you *thought* you were reading paragraphs and words, you were actually processing long strings of *characters,* one after another. You're doing it now. Yet like most readers, you surf across these waves of words, oblivious to typographic details.

When you listen to music, you absorb it whole; you don't analyze every note (though some musicians do). When you read text, you don't scrutinize every character, either—but some designers do. They agonize over type sizes, spacing, character widths, line lengths. Because when you put it all together, it makes the difference between handsome type and ty**p**e t**H**at looks **li**k**e th**is.

All music starts with the 12 notes in the scale. All newspaper design starts with the 26 letters in the alphabet. If you want to understand the difference between Mozart and Metallica, you've got to ask, "How'd they do *that* with *those notes?*" If you want to understand the difference between good design and garbage, you've got to ask, "How'd they do *that* with *those letters?*"

Then For hundreds of years—since Johannes Gutenberg began printing Bibles in the 15th century—type was set by hand. Printing shops had composing rooms where compositors (or typesetters) selected characters individually, then loaded them into galleys one row at a time: a slow and clumsy process.

Now Over time, printers began using machines to set type. A century ago, Linotype keyboards created type slugs from hot metal. In the 1960s, phototypesetters began using film to print typographic characters. And today, computers make typesetting so cheap and easy, anyone can create professional-looking type.

A WORD ABOUT TYPOGRAPHY Designers spend decades, if not a lifetime, understanding the nuances of how to use type well. To move away from amateur hour into a more professional arena, here's a word (three words, actually) of advice: *Keep it simple.* The success of your page does not rest on the cool or funky typeface you just happened to download from a free font site. What matters most is *how* you use the type and how well it *communicates the content* of the story.

Observe how this ransom note bombards you with a variety of individual letter sizes, shapes and styles:

Uppercase boldface serif, 44 point

Lowercase, boldface serif, reversed (lighter color on darker background), 33 point

Lowercase cursive black, 44 point

Uppercase sans serif, bold extended, 18 point

Uppercase boldface sans serif, 60 point

Uppercase novelty serif, 44 point

Lowercase boldface sans serif, narrow, 44 point

Lowercase sans serif, 32 point

Lowercase sans serif outline, 40 point

Lowercase bold serif with drop shadow, 42 point

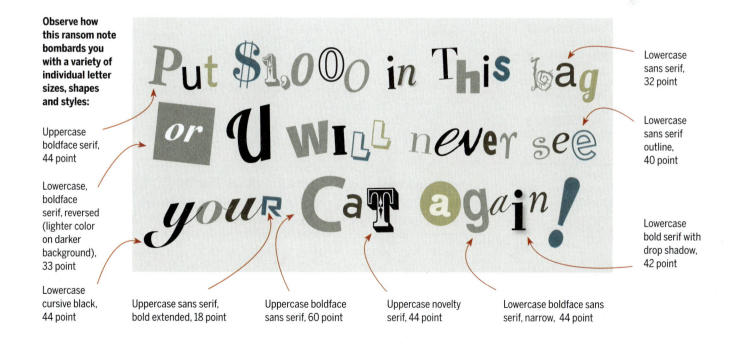

Basic typography

LEARN MORE
Pages with no art: *How to add variety.* **Page 78**

TYPE SIZE: HOW TO MEASURE IT

We measure type by *point size*—that is, the height of the font as calculated in points. (Points, you'll recall, are the smallest unit of printing measurement, with 72 points to the inch.) This sizing system originated in the 18th century, when type was cast in metal or wood. What's curious is this: Back in those olden days, a font's point size measured not the type characters but the printing block that *held* those characters.

Point size refers to the height of a font—or more specifically, the height of the slug that held the letters back in the days of metal type. Because those fonts were manufactured only in standard point sizes—9, 10, 12, 14, 18, 24, 30, 36, 48, 60, 72—those remain common type sizes today.

Sizing type is a slippery thing because point sizes don't always correspond to reality. A 120-point typeface, for example, is never *exactly 120* points tall. And what's more, the actual height of 120-point typefaces often varies from font to font.

To adjust the space between lines of type, printers added thin strips of lead below each row of wooden slugs. That's why, even today, the spacing between lines of type is called **leading**.

Notice the difference in leading between these lines of text.

TYPE FONTS AND FAMILIES

There are thousands of typefaces out there, with names like Helvetica and Hobo, Baskerville and Blippo, Lobster and Lucida Bright. Years ago, before printing became computerized, type foundries would cast each typeface in a variety of sizes. And each individual size of type was called a font:

This is a **font**—a complete set of characters comprising one specific size, style and weight of typeface, including numbers and punctuation marks. As you can see, this Helvetica Neue Condensed Bold font contains dozens of characters—and this font is just one member of the Helvetica Neue family.

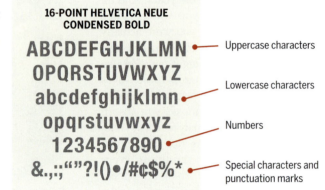

16-POINT HELVETICA NEUE CONDENSED BOLD

ABCDEFGHJKLMN OPQRSTUVWXYZ — Uppercase characters

abcdefghijklmn opqrstuvwxyz — Lowercase characters

1234567890 — Numbers

&.,:;""?!()•/#¢$%* — Special characters and punctuation marks

All the individual Helvetica Neue fonts are part of the large Helvetica Neue *family*. And many type families (like Helvetica Neue) include a variety of *weights* (light, regular, bold) and *styles* (roman, italic, condensed). Most type families are classified into two main groups: *serif* and *sans serif*.

Serif type has tiny strokes, or serifs, at the tips of each letter. The typeface at right is Garamond Regular.

Serif type families often include a wide variety of weights and styles. Times, however, is crafted in just two weights (regular and bold) and two styles (roman and italic).

14-pt. Times
14-pt. Times
14-pt. Times Bold
14-pt. Times Bold

Sans serif type ("sans" means "without" in French) has no serifs. The typeface at right is Gotham.

14-point Gotham Black
14-point Gotham Light Italic
14-point Gotham Condensed Medium

The Gotham family is one of many that are available in a wide range of weights (from light to extra bold) and styles (including regular, italic and condensed).

TYPE CATEGORIES

There are lots of different ways to classify typefaces. Basically, this means there are big, broad groups that all typefaces fall into, based on their historical backgrounds. Most newspaper designers stick with their newspaper's type style, though, so using a wide range of typefaces on a daily basis—picking out a typeface that "matches" the story of the day, for example—is usually not an option.

Where there is a sea, there are pirates.
script

CURIOSITY KILLED THE CAT, AND SAVED THE RAT.
decorative

A DAY WITHOUT SUNSHINE IS LIKE, YOU KNOW, NIGHT.
distressed

Type classifications can include **slab serif, script, decorative, distressed**, modern, **humanist, traditional** and **oldstyle**.

Basic typography

LEARN MORE
Refine text: *Tips on tracking and kerning.* **Page 24**

Troubleshooting

Throughout this book, you'll find answers to some of the more commonly asked questions about newspaper design fundamentals.

Q How many typefaces does a newspaper need? I'm hoping it's a lot, so I can really get creative.

There's no magic number when it comes to typefaces. In fact, there's no simple formula for type selection at all. With so many fonts so readily available these days, it's easy to mix and match typefaces until you find the combination that suits your paper's personality.

Some newspapers use only a couple of fonts, it's true. Some use dozens, but it results in chaos. So as a starting point, your shopping list should include:

▶ **An easy-to-read text type.** Find a font that's handsome and comfortable to read at small sizes. You don't need to use this font anywhere else—just for text.

▶ **A typeface or two for all your headlines.** If you want to run headlines in a variety of styles and weights, use a versatile family that offers plenty of variations.

You can designate different weights or styles for decks, liftout quotes, promos, etc.

▶ **A typeface for special touches**— section flags, for example. This is where much of your typographic personality will come from: those *accent* design elements scattered throughout your paper.

▶ **A typeface for special text.** Your sidebars, graphics, jump lines and cutlines need to look a little different from the standard text beside them. Again, find a family that offers a variety of bold, light and italic fonts.

As long as all your typefaces help organize material and guide readers through the stories in the newspaper, feel free to mix fonts until you find the right combination.

TYPE TERMINOLOGY It's a good idea to get to know the basic components of letterforms. Why? Well, think about what it's like to look underneath the hood of a car. The more you understand what's going on under there, the less intimidated you'll be to drive it (especially when it breaks down and you have to take it somewhere to get it fixed). Even if you aren't actually designing a typeface yourself, you'll need to know how type affects readability. There are many, many more type terms that aren't listed below, but this should get you started.

Serif The extra strokes at the end of letters.

Counter The space inside the letter (enclosed or not).

Ascender The part of the letter that extends beyond the body of the type.

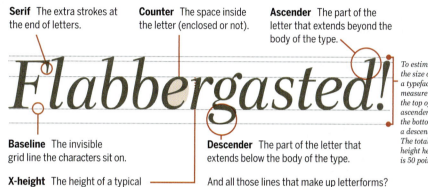

To estimate the size of a typeface, measure from the top of an ascender to the bottom of a descender. The total height here is 50 points.

Baseline The invisible grid line the characters sit on.

Descender The part of the letter that extends below the body of the type.

X-height The height of a typical lowercase letter that has no ascenders or descenders (such as the letter "e" or "r").

And all those lines that make up letterforms? They're called **strokes.** Some have serifs at the end of them, and some don't.

When it comes to **x-height,** things can get a little confusing. Typefaces with **tall x-heights** look bigger than those with **short x-heights**—even when their point sizes are identical. Take a look at the paragraphs on the right. See how Cochin looks smaller and quieter than Georgia? They're both 14-point type, but because the x-height of Cochin is smaller than Georgia's, the type appears to be smaller overall.

When considering which typeface to use for body copy, take a close look at the typeface's x-height. Ink on the press, plus the quality of newsprint could lead to issues with readability if the x-height is too small, especially when the letters are a smaller point size.

He was shocked to discover that Annabelle had a severe case of Anatidaephobia. He begged her to see a doctor, but she was so afraid of falling into the hands of a quack.

14-point Cochin

He was shocked to discover that Annabelle had a severe case of Anatidaephobia. He begged her to see a doctor, but she was so afraid of falling into the hands of a quack.

14-point Georgia

TYPE TREPIDATION? As you can see, some confusing variables come into play when it comes to type. But by learning as much as you can about typography, you'll be able to analyze and use type more effectively. For inspiration, seek out books, posters, websites, packaging, signage, maps—just about anything that has type on it. You'll see the good, the bad and the ugly. There's something to learn from all of it.

Basic typography

LEARN MORE
Display headlines:
tips and tricks. **Page 208**

Troubleshooting

Q **What's the best size and font to use for text, or body type?**

Remember, fonts vary greatly in their personalities *and* in their apparent sizes. Here, for instance, are three different samples of 9-on-10.8 text type (which means 9-point type with 10.8-point, or, in this case "auto," leading):

This is Minion. Its larger x-height makes it quite readable for bodies of text. This typeface's serifs aren't wispy thin, so it'll hold up when the ink from the press hits that flimsy newsprint paper. This typeface can also be used for headlines, too.

This is Georgia. Yikes! Is this really 9 points? Yes, it is. With its rather large x-height, it looks much bigger than other blocks of text set at the same point size. Georgia has long been considered a Web-safe font.

This is Garamond. Its shorter x-height makes it look smaller than the examples above. But it is still an elegant and readable typeface for text. Note that the counter spaces in letters are smaller here—which will make it harder to read on newsprint.

Since readers' eyes (and bodies) deteriorate as they age, consider how old your audience is. Student publications sometimes run 8-point text. But if you've got readers over the age of 50, take pity on them. Run tests (on actual newsprint) to find a typeface and size that readers of all ages can actually read.

It's OK to work with in-between sizes, too (for example, the body copy you're reading right now is set in 9.7-point Scotch Text, using 12 points of leading). Even the most incremental tweaks in typeface size and leading can make a big difference in readability.

TAILORING TYPE Using type right out of the computer is like wearing a suit right off the rack—it won't look its best until you tailor it a bit. By adjusting shapes and spaces of letters you can increase the type's efficiency, enhance its readability and dramatically alter its personality.

Point size: Changing the point size changes the height of a font. The bigger the size, the taller the type.

67-point type

134-point type

201-point type

18 points from one baseline to the next.

an example of leading between two lines

This is 24-point type with 18 points of leading (tight)

25 points from one baseline to the next.

an example of leading between two lines

This is 24-point type with 25 points of leading (normal)

42 points from one baseline to the next.

an example of leading

This is 24-point type with 42 points of leading (loose)

between two lines

Leading (pronounced *ledding*): This is the vertical space between lines of type—more specifically, it's the distance from one baseline down to the next. As you can see, leading can be *loosened,* adding more space between lines. Or it can be *tightened* to where ascenders and descenders touch or overlap. Like type itself, leading is measured in points.

TIGHT
Too tight tracking can make text difficult to read. There may be times when you use tight tracking in your text, though, for content that calls for a unique visual effect.

-50 units of tracking looks crowded

NORMAL
Normal tracking is used most of the time for most text. Sometimes you can "cheat" and tighten paragraphs (within reason) to make stories fit.

0 units of tracking (not too loose and not too tight)

L O O S E
Loose tracking can also make text difficult to read, and is rarely used with just lowercase letters, especially in a body of text.

80 units of tracking in the text (300 in label). Loose!

Tracking: Just as you can tighten or loosen the vertical spacing between lines, you can adjust the *horizontal space* between letters—though even the slightest changes in tracking can affect the type's readability.

Kern it.

No kerning: As the letters get bigger, the odd spaces between letter-pairs grow, too.

Kern it.

Now there's -65 units of kerning between the "k" and the "e" and -25 units of kerning in the word "it."

Kerning: Designers often get tracking and kerning confused. Kerning is when you adjust the *spacing between a pair of letters,* so that the spacing between them looks optically correct.

Basic typography

LEARN MORE
Liftout quotes: *How to make them work.* **Page 150**

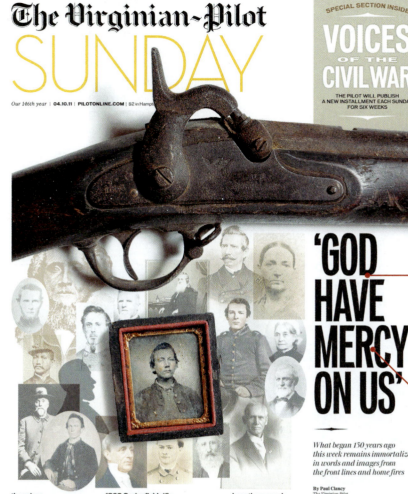

SPECIAL SECTION INSIDE

VOICES
OF THE
CIVIL WAR

THE PILOT WILL PUBLISH
A NEW INSTALLMENT EACH SUNDAY
FOR SIX WEEKS

The Virginian-Pilot
SUNDAY

Our 146th year | 04.10.11 | PILOTONLINE.COM | $2 in Hampton

'GOD HAVE MERCY ON US'

What began 150 years ago this week remains immortalized in words and images from the front lines and home fires

By Paul Clancy
The Virginian-Pilot

the voices
Today and for the next five Sundays, you'll be hearing from these people about their experiences during the Civil War. Their names are on Pages 10-11

1862 Springfield rifle
From the collection of Walter Lee Shepherd and Robert Edward Shepherd III, whose ancestor, Pvt. Matthew Wood Allen, served with the Portsmouth Light Artillery, also known as Grimes' Battery.

hear them speak
Listen to the voices and learn more about local Civil War history.
PilotOnline.com

This is about voices.
Voices that speak to us from a century and a half ago, when America went to war with itself. They echo from letters penned on battlefields to parents or wives or sweethearts, and from diaries written at kitchen tables and stashed among private papers. More than history textbooks, more than newspaper dispatches, more than official documents or speeches, they tell a vivid story of what the Civil War was like for those who lived through it and for many who did not.

Readers of The Virginian-Pilot responded enthusiastically to the newspaper's request for personal reflections, keepsakes and photographs of the period. Taken together with already-known artifacts and writings, these sinews of history enrich our understanding of what it was like in Hampton Roads during the conflict that began 150 years ago this week.

They illustrate the central fact of the Civil

See VOICES, PAGE 10

V.A.'S HANDLING OF TEST RESULTS BRINGS SUIT BY VET WITH CANCER

Jeffrey Drifmeyer

By Bill Sizemore
The Virginian-Pilot

HAMPTON

Just before turning 55 in 2003, Army veteran Jeffrey Drifmeyer went to the Hampton VA Medical Center for a routine colonoscopy. It discovered a polyp, an early warning sign of cancer.

But no one told Drifmeyer or his primary-care doctor, according to a federal lawsuit filed last month. Now he has terminal cancer that has spread to his liver.

He is suing the federal government for $2 million, alleging negligent care that has caused him lengthy hospital stays, ended his working career and shortened his life expectancy.

Drifmeyer, now 62, discovered the colonoscopy results only last year, when he retrieved his medical records from the VA center, according to the lawsuit. By then, he

See LAWSUIT, PAGE 7

FEDERAL BUDGET

Both sides call it a win

Obama, GOP swallow differences and avoid a government shutdown for now

not a done deal
Though only a stopgap, the deal is unlikely to be derailed. However, dissent over the agreement is present in both parties.

big money
It's the biggest annual spending cut in history, but it's a fraction of the total budget deficit.
Q+A, Page 8

what's next?
More issues likely will be brought into the debate as a fight looms over raising the debt limit and next year's budget.

By Andrew Taylor | *The Associated Press*

WASHINGTON

RIVALS IN a divided government, President Barack Obama and the most powerful Republican in Congress split their differences to stave off a federal shutdown that neither combatant was willing to risk.

Their compromise is the result of a battle pitting the enduring power of the presidential veto and the White House soapbox – despite a "shellacking" in the last election – against a strong-willed GOP House speaker.

The resulting measure will bleed about $40 billion from the day-to-day budgets of domestic

See FEDERAL BUDGET, PAGE 8

inside

TAXES AREN'T DONE?

Don't worry. Half the country is with you.

Temple Grandin on Smithfield.
BUSINESS

STAGING HELL

Church play aims to save souls.
MAGAZINE

partly sunny
High: low 70s.
Low: low 60s.
Details on the back page of Classifieds

At **my bank,** members know decisions are made in one place ...their office.

Bank of Dawn
—Dawn Glynn, President, TowneBank Chesapeake
Call me direct at 548-7215.

TOWNE BANK
The Best Bankers. Hometown Banking.

TWEAKING TYPE Here's the lowdown on leading, kerning and tracking—basically, what you need to know to really make you look like a pro. Leading, kerning and tracking give you more options to add contrast to a page and are just a few of the ways you can fine-tune type. Headlines, for example, are a good example of where "auto" settings simply won't cut it (most of the time). As the type grows in size, so do the awkward spaces between lines of text and certain pairs of letters. As a designer, you've got to *use your eye* and *intuition* to make things look and feel right. Take a look at this page on the left and notice the leading, kerning and tracking.

Bigger headline? Decrease the leading. As the headline increases in size, so does the spacing between each line of text. This can sometimes make it appear as if each line is separate. Tighter leading helps bring things together and the message is more instantly readable. Oftentimes, when the headline is in the bigger range (around 54 points to 100-plus points), the leading size will be less than the point size (for example, 110-point type with 90 points of leading). This is called *negative leading* (which is often a positive thing for designers working with headlines).

Bigger headline? Check the kerning. You'll often have to adjust the space between pair of certain letters so words appear more visually cohesive.

To track or not to track? It's optional. Take this kicker, for example. Does it *have* to be tracked out? Of course not. The extra tracking, though, gives this kicker some contrast, so it stands apart from the headline and subhead below it. It feels looser and more airy with that extra white space. Tracking can also be used within individual paragraphs—to tighten them up a bit so that widows will disappear into the text above it. Careful, though: too-tight tracking can look squeezed and too-loose tracking (in body copy) can look, well, too loose.

A WORD ABOUT DISTORTING TYPE

Computers can stretch or squeeze typefaces as though they're made of rubber. *Scaling* (or *set width*) is usually expressed as a percentage of the font's original width. Most designers, and typographers, would advise *not* altering text like this, because it changes the integrity of the letter forms.

W W W

*36-pts.,
100% set width*

*36-pts.,
50% set width
(horizontal scale)*

*36-pts.,
150% set width
(vertical scale)*

The four basic elements

Newspaper pages are like puzzles that can fit together in a number of different ways—with "different" being the operative word here.

When looking at other newspaper pages for ideas, do you ever wonder why some pages look completely different than others? Some might have five stories on a page—and others have just one. Some headlines might be placed above the photo and others might be placed below it. And some front pages don't even have stories that start out front.

Though this whole idea of what to do with a blank page may seem complex at first glance, you'll find that just four basic elements—four puzzle pieces—are essential for most pages.

And because these four elements get used over and over again, they occupy most of all editorial turf.

Once you master these four basic building blocks, you'll be on your way to mastering page design.

Understand from the start that page design is *subjective,* and the order in which you place these four basic building blocks for any given story always depends on the other elements you plan to include on the rest of the page.

Here are the four basic elements used in page design:

Photos
The pictures that accompany stories. Other words used that mean the same thing: *photographs, images* and sometimes even the shorthand word *pics.*

Cutlines
The type that accompanies photographs and gives the reader an idea of what's happening in the image. Another word often used for cutline is *caption.*

Headlines
These are the oversized *titles* that label each story. For each story, you'll find a headline, and sometimes *decks* (or *subheads*) that go into more detail.

Text
The text is the story itself. Another term for this is *body copy.*

In the pages throughout this book, we'll look at these elements in more detail. If you're in a hurry to begin designing pages, browse through this material now and come back to it when you need it.

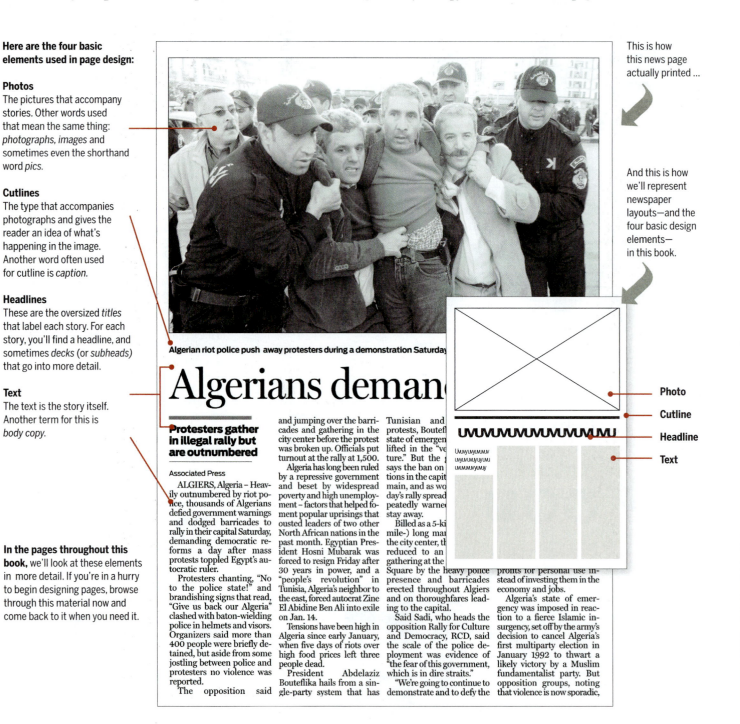

This is how this news page actually printed ...

And this is how we'll represent newspaper layouts—and the four basic design elements—in this book.

Algerian riot police push away protesters during a demonstration Saturday

Algerians deman...

Protesters gather in illegal rally but are outnumbered

Associated Press

ALGIERS, Algeria – Heavily outnumbered by riot police, thousands of Algerians defied government warnings and dodged barricades to rally in their capital Saturday, demanding democratic reforms a day after mass protests toppled Egypt's autocratic ruler.

Protesters chanting, "No to the police state!" and brandishing signs that read, "Give us back our Algeria" clashed with baton-wielding police in helmets and visors. Organizers said more than 400 people were briefly detained, but aside from some jostling between police and protesters no violence was reported.

The opposition said and jumping over the barricades and gathering in the city center before the protest was broken up. Officials put turnout at the rally at 1,500.

Algeria has long been ruled by a repressive government and beset by widespread poverty and high unemployment – factors that helped foment popular uprisings that ousted leaders of two other North African nations in the past month. Egyptian President Hosni Mubarak was forced to resign Friday after 30 years in power, and a "people's revolution" in Tunisia, Algeria's neighbor to the east, forced autocrat Zine El Abidine Ben Ali into exile on Jan. 14.

Tensions have been high in Algeria since early January, when five days of riots over high food prices left three people dead.

President Abdelaziz Bouteflika hails from a single-party system that has Tunisian and protests, Boutefl state of emergen lifted in the "ve ture." But the says the ban on tions in the capit main, and as wo day's rally spread peatedly warne stay away.

Billed as a 5-ki mile-) long mar the city center, th reduced to an gathering at the Square by the heavy police presence and barricades erected throughout Algiers and on thoroughfares leading to the capital.

Said Sadi, who heads the opposition Rally for Culture and Democracy, RCD, said the scale of the police deployment was evidence of "the fear of this government, which is in dire straits."

"We're going to continue to demonstrate and to defy the profits for personal use instead of investing them in the economy and jobs.

Algeria's state of emergency was imposed in reaction to a fierce Islamic insurgency, set off by the army's decision to cancel Algeria's first multiparty election in January 1992 to thwart a likely victory by a Muslim fundamentalist party. But opposition groups, noting that violence is now sporadic,

Photo
Cutline
Headline
Text

Headlines

LEARN MORE
Headlines: *Types and writing tips.* **Page 28**

When you're standing in line at the grocery store and studying a page like the one at right (admit it—you can't resist), there's one thing that leaps out and grabs you: *the headlines.*

Headlines can be mighty powerful. In fact, they're often the strongest weapon in your design arsenal. Stories can be beautifully written, photos can be vivid and colorful—but neither is noticeable from 10 feet away the way headlines can be. Mix headlines and visuals, and you've got the potential for some serious impact.

You may never write headlines as strange and outrageous as these tabloid headlines are (although take a moment to notice how cleverly crafted they are). Even if, as a designer, you find yourself collaborating with copy editors on writing headlines, or you don't write them at all, you'll still need to know what headlines are, where they go, what sizes they should be, and what styles are appropriate for your publication.

What makes these headlines pop? Lots of all caps ("INCREDIBLE FROG BOY!"), a mix of black type on white and gray backgrounds, and reverse type ("WILD WEST TOWN FOUND ON VENUS!"), boxed-in headlines ("MUMMY NIGHTMARE!") and a variety of type sizes.

WRITING STRONG HEADLINES

Because this is a book on design and not copy editing, we won't rehash all the rules of good headline writing. But we'll hit the highlights, which are:

▸ **Keep them conversational.** Write the way people speak. Avoid pretentious jargon, odd verbs, omitted words (*Solons hint bid mulled*). As the stylebook for The St. Petersburg Times warned, "Headlines should not read like a telegram." Depending on the story, headlines can sometimes read more like punchy labels (*Disaster strikes*). On the flip side, some stories call for a more narrative headline approach (*Meet the architect. Across North America, he is hailed as an innovator. In his hometown, however, not everyone shares his vision*).

Here's a practical tip: Try reading your headline out loud. Listen carefully to how it *sounds*. If it comes across stilted and awkward to your ear, it probably will sound that way to readers, too.

▸ **Write in present tense, active voice.** Like this: *President vetoes tax bill.* Not *President vetoed tax bill* or *Tax bill vetoed by president.*

▸ **Step away from the cliché.** If a cliché is the first thing that comes to mind, it's virtually guaranteed that you're not the first one to think of it. Try something else.

▸ **Avoid bad breaks.** Old-time copy-deskers were fanatical about this. And though things are looser these days, you should still try to avoid dangling verbs, adjectives or prepositions at the end of a line. At left below, check out this bad break in a headline:

Instead of this:

Sox catch up with Yankees

Try this:

Sox catch Yankees in playoffs

First and foremost, headlines should be accurate and instantly understandable. If you can improve a headline by leaving it a little short or by changing the size a bit, do it. Headline effectiveness always comes first. Remember, headlines serve four functions on a newspaper page:

▸ **They summarize** story contents.
▸ **They prioritize** stories, since bigger stories get bigger headlines.
▸ **They entice** readers into the text.
▸ **They anchor** story designs to help organize the page.

Headlines

LEARN MORE
Headlines: *How to size them.* **Page 29**

Troubleshooting

Q **At our paper, copy editors often condense headlines electronically to make them fit better. Is that OK?**

You mean, taking a headline like this:

Lawyer says 'sue me!'

... and squeezing it like this?

Lawyer says 'sue me!'

Some papers do that. They do it with text type, too, to make stories fit. But it looks seriously unprofessional. *Don't do it.* Don't mess with the integrity of typefaces as they were originally drawn. Please. If you need a super-condensed or compressed font, find it within that particular typeface family. Write your headlines and place your text on the page so everything is typographically sound—the tracking, leading, scaling—and don't mess with the letters themselves. If a headline won't fit, rewrite it so it does.

Q **When I'm designing a page, is it OK to leave blank spaces for the headlines, or write in any ol' fake headlines?**

Neither. When designing a page, try to start with *working headlines.* In other words, start with something that gets the job done, knowing full well that before the end of a long shift, a copy editor will change or tweak what you have (or leave it the same, if you write something that works).

After a long day or night in the newsroom, it's tempting to slap down a goofy headline for laughs. You're treading in *dangerous* waters here. No matter how conscientious you think you are, there's always that risk that those "hilarious" headlines will slip into the paper, for real. It's been known to happen. Consider yourself warned.

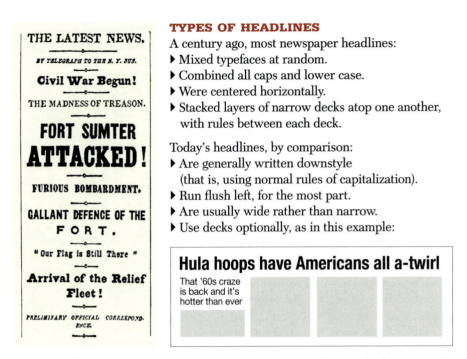

TYPES OF HEADLINES

A century ago, most newspaper headlines:
▶ Mixed typefaces at random.
▶ Combined all caps and lower case.
▶ Were centered horizontally.
▶ Stacked layers of narrow decks atop one another, with rules between each deck.

Today's headlines, by comparison:
▶ Are generally written downstyle (that is, using normal rules of capitalization).
▶ Run flush left, for the most part.
▶ Are usually wide rather than narrow.
▶ Use decks optionally, as in this example:

Hula hoops have Americans all a-twirl
That '60s craze is back and it's hotter than ever

Above right is what's called a *banner headline,* and it's the standard way to write a news headline. But it's not the only way. Below are some alternatives—headline styles that go in and out of fashion as time goes by.

A CRAZE MAKES A COMEBACK
Hula hoops are on a roll

Kickers Leads into headlines by using a word or phrase to label topics or catch your eye. They're usually much smaller than the main head, set in contrasting style or weight.

Hoop-la
Hula hoops are sweeping the entire nation this summer

Hammers Uses a big, bold phrase to catch your eye, then adds a lengthier deck below. They're effective and appealing, but they're usually reserved for special stories or features.

Hula hoops: A hot new hit

Slammers Who dreams up these nutty names? This two-part head uses a boldface word or phrase to lead into a contrasting main headline.

HULA HOOPS: They were hot in the '60s, but they're hotter today

Tripods Comes in three parts: a bold word or phrase (often all caps) and two lines of deck squaring off alongside it on the right side.

Hula hoops are circling the nation

Raw wraps Most headlines cover all the text below it; this treatment lets text wrap alongside. It's a risky idea—but later on, we'll see instances where this headline style comes in handy.

Hula hoops are circling the nation this summer

Sidesaddle heads This style lets you park the head beside the story. It's best for squeezing a story into a shallow horizontal space. Can be flush left, flush right or centered.

Headlines

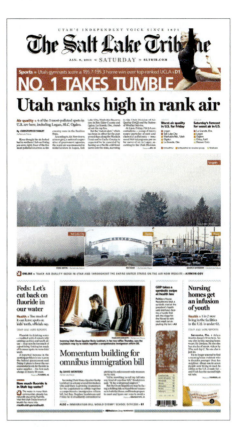

On a broadsheet On this Salt Lake Tribune page, the top headline is set large, and headlines for down-page stories are smaller, so it's clear they are secondary. The under-the-flag promo is big and reversed: a bold approach that contrasts with the lead headline.

On a tabloid Even with limited space to work with, a nice mix of stories and promos can come together as they do here on this front page of the Collegian.

WORKING WITH HEADLINES ON A PAGE If we had to generalize about headline sizes, we could say that *small* headlines range from 12 to 24 points; *mid-size* headlines range from 24 to 48 points; *large* headlines range upward from 48 points, sometimes to hundreds of points.

Beyond that, it's difficult to generalize about headline sizes. Some papers like them big and bold, while others prefer them small and elegant. Headlines in tabloids are often smaller than headlines in broadsheets (though not always).

Still, this much is true: Since bigger stories get bigger headlines, headlines will generally get smaller as you move down the page. Here's a general breakdown:

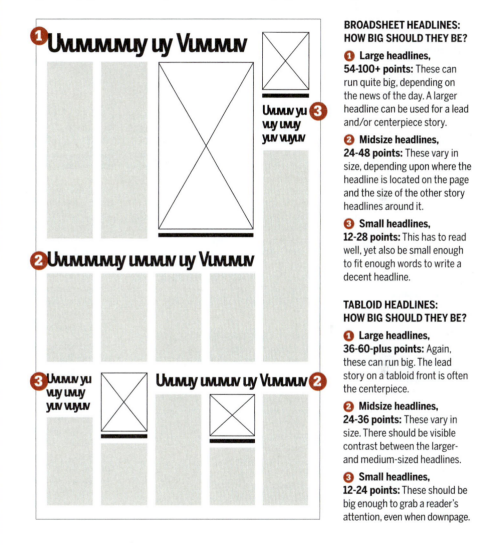

BROADSHEET HEADLINES: HOW BIG SHOULD THEY BE?

1 Large headlines, 54-100+ points: These can run quite big, depending on the news of the day. A larger headline can be used for a lead and/or centerpiece story.

2 Midsize headlines, 24-48 points: These vary in size, depending upon where the headline is located on the page and the size of the other story headlines around it.

3 Small headlines, 12-28 points: This has to read well, yet also be small enough to fit enough words to write a decent headline.

TABLOID HEADLINES: HOW BIG SHOULD THEY BE?

1 Large headlines, 36-60-plus points: Again, these can run big. The lead story on a tabloid front is often the centerpiece.

2 Midsize headlines, 24-36 points: These vary in size. There should be visible contrast between the larger- and medium-sized headlines.

3 Small headlines, 12-24 points: These should be big enough to grab a reader's attention, even when downpage.

HEADLINE DEPTH Headlines need enough lines to make sense, but don't overdo it. Sometimes a too-long headline can overpower the text that's under it. There are always exceptions to the rule, but these guidelines can give you a general idea of how many lines deep a headline should be:

If a headline is this wide (in columns):	1	2	3	4	5	6
Then make it this deep (in lines):	3-4	2-3	1-2	1	1	1

Text

LEARN MORE
Text only: *Designing stories without art.* **Page 78**

Text is the most essential building block of newspaper design. It's the gray matter that communicates the bulk of your information.

But text doesn't have to *look* like a sheet of boring gray wallpaper hanging on your page. You can manipulate a wide range of typographic components to give text versatility, personality and pizazz.

Take this music review, for instance—and note the variety of type styles and other elements throughout. This gives the text some visual rhythm (perfectly suitable for a lineup of music musings!).

The trick here is to use *contrast*. Without this key design concept, the block of text below would be one-dimensional and lie flat on the page. With contrast, however, the text comes to life. In the example below, look how we mix together bold weights with roman style and italics, integrate serif and sans serif typefaces, and then add a dash of agate. Voilà! We achieved something clean and readable even with a large blob of text.

Extra typographical nuances you can work with include alignment (flush left, right, centered or justified) and leading and/or tracking (loose, normal or tight). The goal? Readability.

Typeface and size
These record titles use 7.7-point Benton Sans bold. The text is 7.7-point Scotch Text.

Leading The text uses 10 points of leading. Since it's 8-point type, that means there's one point of space between descenders and ascenders.

Tracking We've tightened the tracking of the text a bit to, well, tighten things up.

Paragraph indents
The first line of each new paragraph is indented 12 points, or 1 pica.

Hanging indents In a way, these are the opposite of paragraph indents. The first line is flush left; all subsequent lines are indented to hang along the edge of those black bullets (or dingbats or webdings).

Extra leading We've added 8 points of extra leading here between the end of one review and the start of the next. There are also 3 points of extra leading between the boldface title info and the text that follows.

Editor's note
Still using Scotch typeface—but note how the extra leading, italics and ragged-right style set it apart from the Scotch text above it.

BITE ME LIKE A DOG
Toe Jam
(Nosebleed Records) ★★★

Looking for some tunes that'll make your eardrums bleed and suck 50 points off your I.Q.? Grab yourself some Toe Jam.

On "Bite Me Like a Dog," these five veteran Seattle death-metal-mongers unleash 14 testosterone-drenched blasts of molten sonic fury, from the opening salvo of "Lost My Lunch" to the gut-wrenching closer, "Can't Love You No More ('Cuz I'm Dead)." Lead vocalist Axl Spandex has never sounded more satanic than on the eerie "Sdrawckab Ti Yalp."

Of course, the big question for every Toe Jam fan will be: Does this record match their 2011 award-winning classic, "Suckadelic Lunchbucket"?

Sadly, no. But really, what could?
— *Forrest Ranger*

THE VILLAGE IDIOTS UNPLUGGED
The Village Idiots
(Doofus Music Group) ★

What awesome potential this band has! You'd have to be living in a cave on some remote planet not to remember how the music biz was abuzz last year when these rock legends joined forces, refugees from such stellar supergroups as:
▸ Nick O. Teen and
 The Couch Potatoes;
▸ Men With Belts;
▸ Potbelly; and, of course,
▸ Ben Dover and Your
 Silvery Moonbeams.

What a letdown, then, to hear this dreck. One listening to "The Village Idiots Unplugged" and it's your stereo you'll want unplugged.
— *Ruby Slippers*

HOG KILLIN' TIME
Patsy Alabama
(Big Hair Records) ★★★★

Some still call her "The Memphis Madonna." But Patsy Alabama now swears her days as "The Cuddle-Bunny of Country

IN YOUR
ear

REVIEWS, PREVIEWS & MUSICAL MUSINGS

Music" are over. And with her new record—and her new band, The Rocky Mountain Oysters—she proves it.

Patsy's songwriting is a wonder: sweet, sassy and so doggone *powerful*. In the waltzy weeper "I Love When You Handle My Love Handles," she croons:
Some nights are rainbows
Some are cartoons
And some call you softly
* to howl at the moon*

© 2012, Millie Moose Music, Inc.

Aw, shucks. That gal will dang near bust your heart. Buy some hankies. Then buy this record.
— *Denton Fender*

ROCKS IN YOUR SOCKS
Ducks Deluxe
(NSU-Polygraph) ★★

If the idea of a 22-piece accordion orchestra appeals to you—playing such polka-fied rock classics as "American Idiot" fronted by a vocalist named Dinah Sore, whose fingernails-on-the-blackboard screechings make Yoko Ono sound like Barbra Streisand—then friend, this is your lucky day.

For the rest of you, avoid this sonic spewage like the plague.
— *C. Spotrun*

NEWS & NOTES: The April 14 benefit for **Window-Peekers Anonymous** has been canceled. ... The **Grim Reapers** are looking for a drummer. Interested? Call 555-6509. ... **Rapper Aaron Tyres** will sign autographs at noon Sunday at the The Taco Pit.

Got a music news nugget? A trivia question? A cure for the common cold? E-mail us at news@inyourear.com.

Sans serif type Papers often use sans-serif faces to distinguish graphics, logos and sidebars from the main text. This Benton Sans font is centered and all caps. The reverse type (lighter-colored type on a dark background) is all caps and italic.

Italic type This is used to emphasize words—as in "powerful" here. It's also used for editor's notes (below), foreign words or literary excerpts—for instance, these song lyrics.

Agate type Fine print set in small type, usually 5 or 6 points. Also used for sports scores and stocks.

Flush right type This runs flush to the right edge of the column.

Flush left type This runs flush to the left edge of the column. Many papers also run cutlines and news briefs flush left (ragged right).

Justified type The text has straight margins on both the right and left edges.

Boldface type Boldface is often used to highlight key words or names. It's irritating, and can be loud, in large doses, however.

MEASURING TEXT AND SHAPING IT INTO COLUMNS

Newspapers measure stories in inches. A news brief might be just 2 inches long; a major investigative piece might be 200. But since 1 inch of type set in a *wide* leg is greater than 1 inch of type in a *narrow* leg, editors avoid confusion by assuming all text will be one standard width (that's usually around 10 to 11 picas).

You can design an attractive newspaper without ever varying the width of your text. Sometimes, though, you may decide that a story needs wider or narrower legs. Those non-standard column widths are called *bastard* measures.

Generally speaking, text, or body copy, becomes hard to follow if it's set in legs narrower than 10 picas. It's tough to read, too, if it's set wider than 20 picas.

The ideal depth for text is between 2 and 10 inches per leg. Shorter than that, legs look shallow and flimsy; longer than that, they become thick gray stacks. (We'll fine-tune these guidelines in the pages ahead.)

Text is flexible, though. When you design a story, you can bend and pour the text into different vertical and horizontal configurations, as these examples show:

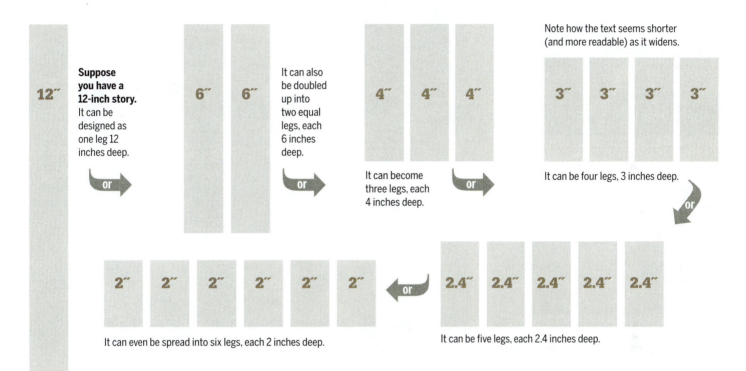

Suppose you have a 12-inch story. It can be designed as one leg 12 inches deep.

or

It can also be doubled up into two equal legs, each 6 inches deep.

or

It can become three legs, each 4 inches deep.

or

Note how the text seems shorter (and more readable) as it widens.

It can be four legs, 3 inches deep.

or

It can be five legs, each 2.4 inches deep.

or

It can even be spread into six legs, each 2 inches deep.

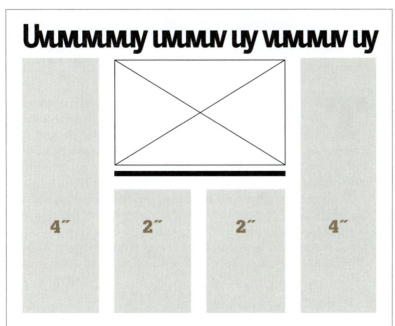

Here's that same 12-inch story (shown in a more enlarged version)—but now it wraps around a photograph. Can you see how, if the photo became deeper, each column of text would need to get deeper, too?

Yes, math is often involved in page design, especially when you calculate story lengths and shapes. You'll need to develop a sense of geometry and proportion—and a sense of how changing one element in a story's design affects every other element.

Photographs

LEARN MORE
Good photos: *What makes them work.* **Page 112**

Aug. 14, 1945: V-J Day kiss in Times Square, New York.

Feb. 1, 1968: Execution of a Viet Cong prisoner.

Jan. 28, 1986: Space shuttle Challenger explodes.

Sept. 11, 2001: Aftermath of World Trade Center attack.

February 1936: Migrant mother and her children.

There's nothing like a photograph to give a newspaper motion and emotion. As you can see in these classic images from the past, photojournalism lies at the very heart of many publications' designs. Every picture tells a story, and many stories are best told with a picture as part of the mix. Today's readers expect to see photos accompanying stories in any venue, whether it's in newspapers, magazines, websites or mobile devices.

In a print newspaper, obviously space is at a premium, and you may not have the "real estate" for that many photos. You may not have enough photographers to shoot that many photos. And printing full color may not be feasible on some pages. But try your best. Add photos every chance you get. Without them, you'll be omitting a big part of what helps to tell a story. It's all about words *and* pictures.

Photographs

LEARN MORE
Photo shapes: *Sizing and designing tips.* **Page 52**

BASIC PHOTO SHAPES

It sounds obvious, but news photos come in three basic shapes. Each of those shapes has its strengths and weaknesses. And each is best suited to certain design configurations.

The three shapes are *rectangular:* horizontal, vertical and square.

Other shapes can come into play on the page, though, depending on the story's content and tone. Circle-shaped photos, like the ones on the travel page at left, for instance, can work with fun and playful feature stories. But never change the shape of a photo just for the sake of doing something offbeat. Content still has to drive every decision you make on your page.

We'll take a closer look at photo shapes on Page 52, and review the impact that more extreme versions of horizontal and vertical shapes can have on a page.

Horizontal This is the most common shape for news photos. We view the world horizontally through our own eyes, and when you pick up a camera, this is the shape you instantly see—though some subjects (like basketball players and space shuttle launches) may call for a vertical composition.

Square Some consider this to be the dullest of the three shapes. Remember, though, that the content is No. 1. Accept each photo on its own terms and run it large enough so it reads and has the most impact.

Vertical This shape, at left, is often considered the most dynamic. But verticals are tricky to work with. Because they're so deep, they often seem related to any stories parked alongside them—even if they're not.

Cutlines

Troubleshooting

Q At our newspaper, we run cutlines in two or three legs under wide horizontal photos. Is that a good idea?

Though that sounds like a good idea in theory—keeping cutlines readable by running them in narrow legs—in reality, it can cause readers to stumble as they hop from leg to leg. Since most cutlines are only a sentence or two, it's easier to follow them if they use just a few lines of wide type. Add a bit of extra leading to make the wider-than-average cutlines even more readable.

Q Why do copy editors spend so much time cramming so much into cutlines? I could use the extra space for bigger photos.

Small as they may be, cutlines are read by readers—so never think of them as an afterthought. Just about every photo needs a cutline, including those half-column mug shots (sometimes just a first and last name will be sufficient for those). Aside from the *who, what, when, where* and *how* information, a cutline can also contain a vivid quotation by someone featured in the photo or mentioned in the story. This extra information can be *in addition to* what can be found in the text.

If a photo is standing alone and refers to an inside story (this image/cutline combo is called a *stand-alone photo*), then it's especially important to include as much detail as possible in the cutline. But try to avoid the obvious: If a person is smiling in a picture, it's not necessary to state that in the cutline.

Want to get more comfortable writing cutlines (or headlines, etc.)? Make your AP (Associated Press) Stylebook your new BFF. A designer who's comfortable working with words is a better communicator, overall.

When it comes to cutline content, TMI can actually be a good thing.

Says one experienced copy editor, "I can't tell you the number of times when I've had a perfect story, a perfect photo—and lackluster cutline information that, instead of advancing the whole package, ultimately detracted from the presentation. It makes me cringe when a story hits the mark, the photo is the icing on the cake—and the cutline information just isn't there."

So, what do cutlines have to do with *you*, the designer? Aren't cutlines the responsibility of the photographer and copy editor? Look at it this way: you are all visual journalists with a common interest in bringing together *all* the elements of a storytelling package. Cutlines are an important part of that territory.

Seek out that *who, what, when, where* and *how* for cutlines on all your pages. Encourage photographers to write extensive cutlines—with way more information than will ever be used so you'll have more options to work with when you're laying out the page. Ultimately, your readers will appreciate it.

CUTLINES THAT CLARIFY It's a typical morning. You're browsing through the newspaper. Suddenly, you come face to face with a photo that looks like this.

You look at the pig. You look at the men. You look at the bulldozer. You look back at the pig. You wonder: *What's going on here?* Is it funny? Cruel? Bizarre? Is that pig *doomed?*

Fortunately, there's a cutline below the photo. It says this:

Highway workers use a loader to lift Mama, a 600-pound sow, onto a truck Monday on Interstate 84 near Lloyd Center. The pig fell from the back of the truck on its way to the slaughterhouse. It took the men two hours to oust the ornery oinker.

Ahhhh. Now it makes sense.

Sure, every picture tells a story. But it's the cutline's job to tell the story behind every picture: *who's* involved, *what's* happening, *when* and *where* the event took place. A well-written cutline makes the photo instantly understandable and tells readers *why* the photo—and the story—are important.

CUTLINE TYPE STYLES

Cutlines (or captions) are different from text, and you need to show that. How? By running cutlines in a different typeface or style than text. Some use boldface, so cutlines will stand out more as readers scan the page. Some use *italic*, for a more elegant look. And some use what's called a **boldface lead-in** — a sort of mini-title for the cutline. Whatever you choose to use, you've got to be sure that it *contrasts* with the other text on the page. Keep in mind that the size of cutlines is often the same or close to the point size of the story text. And extra leading can often help make longer and wider cutlines read better.

Anne Smith waits her turn to compete in the equestrian competition at the Circleville County Fair on Thursday.

Sans serif condensed bold, justified
This bold treatment of the cutline will stand apart from other text on the page. And the words here are still absolutely readable.

Anne Smith waits her turn to compete in the equestrian competition at the Circleville County Fair on Thursday.

Serif italic, ragged right
Italics are perfectly acceptable for cutlines. Not only does this style contrast with the body copy on the page, it adds a bit of elegance to the type.

Ready to ride Anne Smith waits her turn to compete in the equestrian competition at the Circleville County Fair on Thursday.

Sans serif light, justified, boldface lead-in
The bold lead-in adds a point of entry to the text under this image. A short label works best here. The light text contrasts sharply with the bold.

4 | PULSE | THE VIRGINIAN-PILOT | THURSDAY, 04.28.11

music

STEVE EARLEY | THE VIRGINIAN-PILOT

Princess Anne High choral students, from left, Britni Birt, 16, Nick Richardson, 16, Kellyn Hamilton, 16, and Brandon Robertson, 17, will perform songs from "Wicked."

Time to get your Gleek on

'Glee' actor Harry Shum Jr. will perform at Pembroke Mall, culminating a weeks-long showcase of Beach youth fine arts groups.

By Toni Guagenti
Correspondent

VIRGINIA BEACH
David Prescott, Princess Anne High School's choral director, had an inkling the news he had to share with his singers on Valentine's Day would make them giddy.

So, instead of blurting it out, Prescott created a computer graphic presentation with the word "Glee" bouncing from slide to slide. His students couldn't stand the suspense.

Finally, Prescott broke the news: Harry Shum Jr., a dancing sensation who co-stars on the popular Fox comedy/musical series "Glee," would perform at Pembroke Mall on May 7. And the Princess Anne High Madrigals, the chorus, would perform songs from the Broadway smash "Wicked" in the slot directly before Shum hits center stage.

"We all lost it when we found out," said Britni Birt, 16, a sophomore and self-proclaimed Gleek – or a fan of "Glee." Shum plays Mike Chang on the Golden Globe- and Emmy-winning show about a high school glee club. It airs at 8 p.m. Tuesdays.

"Everyone jumped out of his seat," said senior Brandon Robertson, 17.

The Madrigals won't be the only performers showcasing their talents. Groups from other Virginia Beach public schools started performing at the mall Tuesday. Performances scheduled through May 7 include choruses from elementary, middle and high schools, steel bands and theater groups.

John Brewington, fine arts coordinator for Virginia Beach Public Schools, said Pembroke Mall's manager, Jeff Runnels, approached him last year to find a way to showcase student music.

"Jeff has a great appreciation for the arts and wanted to bring music to the mall," Brewington said.

Runnels said it took about a year to secure Shum's appearance. Shum will sign autographs and photos (which can be purchased for $25 cash) after he dances. Shum, who turns 29 today, hails from Costa Rica, and is known as the guy who can dance but not sing on the series. His resume includes dance appearances in "Stomp the Yard," "You Got Served," "Step Up 2" and "Step Up 3D."

The cutline The caption describes the image: *who, what when, where* and *how*. Oftentimes, this bit of information works best under a photo. But not always, as we'll see on the next page.

CUTLINE READABILITY

From a typographical standpoint, cutlines are unique. Their point size is usually on the smaller side, like text, but they often run as wide as the photograph they fall under. Imagine trying to read a multi-line, 6-column cutline: you might get momentarily disoriented as you find your way back to the start of the next line. Make a reader work too hard to read anything on the page, and she'll move on to something else. Remember, readers actually *want* to read cutlines. Make it easier for them to understand the gist of a photo by using a description that's not too wide and not too long.

CUTLINES PLACEMENT, LENGTH AND CONTENT

On news pages, cutlines generally run below each photo. But for variety, especially on feature pages, cutlines can also run in other places, as shown in the examples on this page.

How long should cutlines be? Long enough to describe, briefly, the significant details in the photo. Some photos are fairly obvious and don't require much explanation. Others (historical photos, or photos that run without stories) may need longer descriptions. It may be sufficient to include just a name with a mug shot, but sometimes it's best to add extra caption information for more context at a glance.

And what about photos of clubs or teams? Should *every* face—all 19 of them—be identified? Most newspapers set guidelines for this, so it's hard to generalize. In some smaller, community-oriented newspapers, identifying everyone portrayed in a photograph is expected. But remember that readers want cutlines to offer quick hits of information. So don't overdo it, either.

The Daily News photos/**JULIE ELMAN**

Cutlines below photos These usually align along both edges of the image. They should never extend beyond either edge. Some papers set extra-wide cutlines in two legs, since they can be difficult to read. Another rule of thumb: In wide cutlines (five or six columns), try to be sure the last line extends at least halfway across the column (like the line you see here).

Cutlines set flush right along the edge of photos. (Notice how ragged left type is somewhat annoying to read.) Try to dummy sidesaddle cutlines along the outside of the page. That way, the cutlines won't butt against any text type, which could confuse your readers and uglify your page.

Cutlines set flush left along the edge of photos. This ragged right cutline is flush left against the photo, but it's too thin. Cutlines usually need to be at least 6 picas wide in order to read well.

Shared cutlines. Ideally, every photo should have its own cutline. But photos can also share one common cutline, as these two do. Just be sure you make it clear which photo (at left or at right) you're discussing. And make sure the cutline squares off at either the top or bottom. Don't just let the cutline float. (Notice how this cutline is justified on both sides and squared off with the images.)

Cutlines

MORE ON SHARED CUTLINES

Gang cutlines group together two or more captions and usually add directional hints so the reader knows which cutline goes with what photo (for example, the words "upper left, counterclockwise" might appear before a gang cutline text block).

Some editors love 'em—and some can't stand them. So what's the big deal? If a cutline isn't close to the image it's describing, the reader has to work a little harder to figure out what's going on in the photograph. It's ideal to keep each caption close to its picture counterpart, but sometimes the layout works better by grouping together captions. These can run under the photos or next to them. Wherever they run, they've got to be clear, or you run the risk of losing the reader.

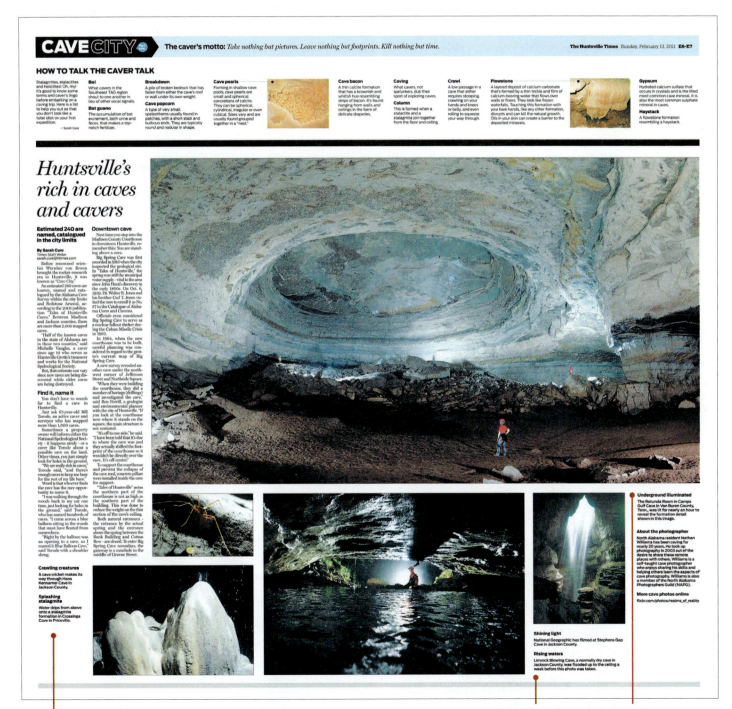

Consolidate Grouped-together cutlines can run together in one block, or be visually separated. In the example above, space and bold words help distinguish the close-together cutlines from one another.

Drawing a dummy

LEARN MORE
Modular design: *Organizing the page.* **Page 86**

How can you show your colleagues, in advance, where stories will go on a page? Or what size headlines should be? Or where the photos go?

Mental telepathy? No. You draw a dummy. (You "dummy up the page.")

In years past, dummies were an essential step in the news production process. Editors would draw dummies, print out all the pieces—the photos, cutlines, headlines and text—then paste everything together on one big sheet of paper in a composing room, using the dummy as a guide. Even today, some newspaper designers still mark up page dummies, then give them to paginators

who assemble the elements electronically.

Depending upon your newsroom, then, page dummies may range from quick thumbnail sketches to highly detailed diagrams. Either way, most dummies are drawn in pencil on paper that's smaller than the printed page, but accurately proportioned—so that, if your design calls for a thin vertical photo, it'll maintain the proper shape on the dummy.

Below is an example that shows how a typical dummy becomes a finished page. On the right is a thumbnail sketch that does the same thing, but in a much cruder fashion. Both methods can work.

Simple A thumbnail sketch, like the one above, can be quick 'n' dirty and still be helpful when plotting how to organize a page.

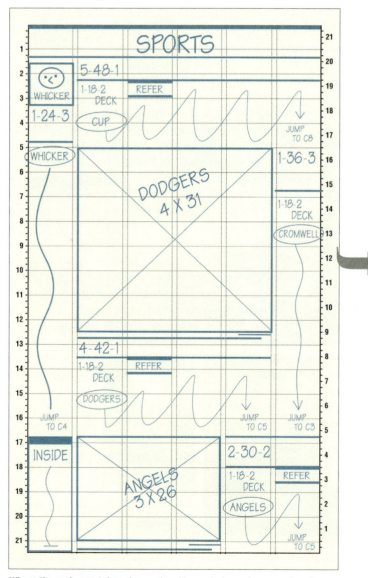

Where the real page takes shape. An editor or designer draws a series of lines and boxes to indicate where photos, cutlines, headlines and text will go. This page is pretty simple: not too many stories or extras.

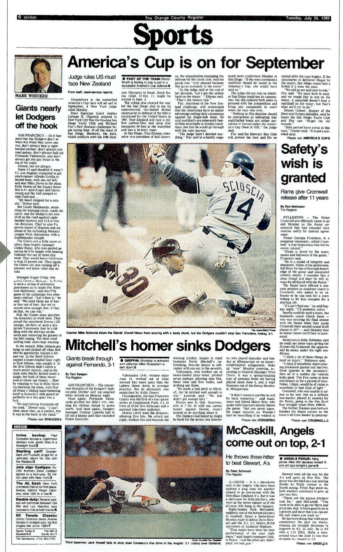

How the dummy is translated into print. Note how every story jumps (continues on another page). That makes the page easier to build, since text can be cut according to the diagram on the dummy.

Drawing a dummy

LEARN MORE
Fitting stories: *Options to try on the page.* Page 98

WHAT EVERY GOOD DUMMY SHOULD SHOW

Every newspaper has its own system for drawing dummies. Some, for instance, size photos in picas. Others use inches, or a combination of picas and inches. Some papers use different colored pens for each different design element (boxes, photos, text). Some use wavy lines to indicate text, while others use arrows—or nothing at all. Whatever the system, *make your dummies as complete and legible as you can.*

It's tempting to bypass dummy-drawing and, instead, noodle aimlessly on the computer for hours until you discover how to lay out the page. Wrong. Big waste of time. You'll usually work more *efficiently* if you first draw up a dummy—or at least a detailed sketch—before you start assembling the real thing.

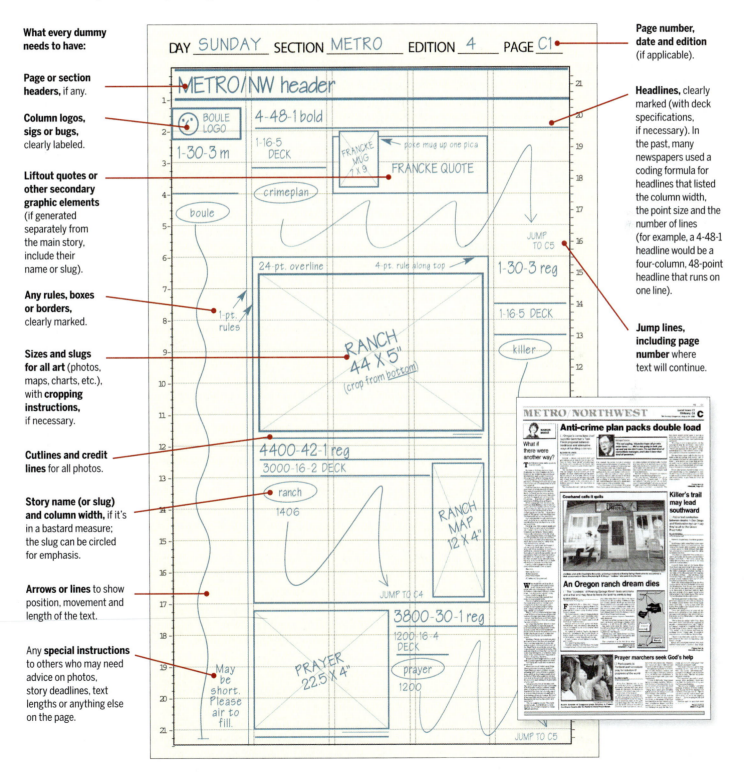

What every dummy needs to have:

Page or section headers, if any.

Column logos, sigs or bugs, clearly labeled.

Liftout quotes or other secondary graphic elements (if generated separately from the main story, include their name or slug).

Any rules, boxes or borders, clearly marked.

Sizes and slugs for all art (photos, maps, charts, etc.), with **cropping instructions,** if necessary.

Cutlines and credit lines for all photos.

Story name (or slug) and column width, if it's in a bastard measure; the slug can be circled for emphasis.

Arrows or lines to show position, movement and length of the text.

Any **special instructions** to others who may need advice on photos, story deadlines, text lengths or anything else on the page.

Page number, date and edition (if applicable).

Headlines, clearly marked (with deck specifications, if necessary). In the past, many newspapers used a coding formula for headlines that listed the column width, the point size and the number of lines (for example, a 4-48-1 headline would be a four-column, 48-point headline that runs on one line).

Jump lines, including page number where text will continue.

Broadsheet dummy

LEARN MORE
Page One: *A case study on the front page.* **Page 91**

This is a **typical page dummy** for a 6-column broadsheet newspaper. Most tabloids, on the other hand, are roughly half this size. Many use a 5-column format (see facing page).

How dummies work:

▶ The numbers along the left margin show inches measured down from the top of the page. The entire page, as you can see, is 22 inches deep.

▶ The numbers along the right margin show inches measured up from the bottom of the page. These are useful for dummying in the ads.

▶ The vertical lines represent columns. A 6-column photo, for instance, would be as wide as the entire page.

▶ Each horizontal line on the page represents an inch of depth. A leg of text that's 1 inch deep would take up just one of those segments.

Need a dummy?
You'll need lots of blank page dummies like this to do the exercises at the end of each chapter. Feel free to duplicate this dummy as often as you like if no others are available for you to practice on. But better yet: Create a page dummy like this that's customized for your newspaper.

Tabloid dummy

LEARN MORE
Grid: *The importance of using one.* **Page 74**

Dummies such as these show **the basic grid** pages use. And as we'll see later, the grid is the underlying pattern that organizes each page into columns. You'd use this dummy, for example, to design tabloid pages on a 5-column grid—but that's not the only grid that tabloids use. Some use 4, 6, 7, 8, even 9 columns. But a 5-column grid is probably the most common tab format.

You can find the answers to these questions on Page 236

1 Approximately what size is the big type below? _____

ONE
INCH
SQUARE

point size?

2 Fill in the blanks below with the correct typographic terms:

The extra strokes at the end of a letter are called

The part of a letter that extends above the body of the type is called the

The height of a typical lowercase letter is called the

Flabbergasted!

The invisible grid line the characters sit on is called the

The space inside a letter, enclosed or not, is called the

The part of a letter that extends below the body of the type is called the

3 Examine the headline below. What is the weight _____ and the point size (within 3 points) _____?

Whasssssssuppppppp?

4 Looking below, what are at least three things have we now done, typographically, to that line above?

Whasssssssuppppppp?

- _____
- _____
- _____

5 Examine the type at right. Identify four unique type characteristics.

- _____
- _____
- _____
- _____

Here is another typographic brain-teaser.

6 What four things have we done to that boxed type in question 5?

- _____
- _____
- _____
- _____

HERE IS ANOTHER TYPOGRAPHIC BRAIN-TEASER.

7 How many *points* are in one inch? _____

one inch wide

←—————→

8 What is the difference between *kerning* and *tracking*? _____

9 What are four differences between the column on the left and the column on the right?

Best picture: "The Artist"
Best actor: Jean Dujardin
in "The Artist"
Best actress: Meryl Streep
in "The Iron Lady"

- **Best picture:** "The Artist"
- **Best actor:** Jean Dujardin
 in "The Artist"
- **Best actress:** Meryl Streep
 in "The Iron Lady"

- _____
- _____
- _____
- _____

Larry MOE & Curly

10 The headline at right uses fairly common typefaces. If you have access to a computer, duplicate this headline as closely as possible; if not, describe as completely as you can the typographic components involved.

LIVERPOOL JOHN MOORES UNIVERSITY
LEARNING SERVICES

11 Below is a three-column news story. Using the dummy sheet below, draw a dummy for this layout. Be sure to indicate the approximate size and number of lines for the headlines.

Crazed pig closes freeway again

For the second time, an ornery oinker causes chaos on the highway

Mama is one freedom-loving hog.

Twice in the same day, Mama broke free from her captors and bolted for daylight. Twice in the same day, she created massive traffic jams.

And twice she was dragged, kicking and squealing, back into captivity.

Westbound traffic on Interstate 84 near Lloyd Center was backed up for two miles Monday when Mama, a 600-pound hog on the way to slaughter, fell from the back of a truck.

For nearly two hours, the sow refused to budge.

Fred Mickelson told police that he was taking six sows and a boar from his farm in Lyle, Wash., to a slaughterhouse in Carlton when Mama escaped.

Highway workers use a loader to lift Mama, a 600-pound sow, onto a truck Monday on Interstate 84 near Lloyd Center. The pig fell off the truck on the way to slaughter.

The Oregonian / KRAIG SCATTARELLA

"I heard the tailgate fall off, and I looked back and saw her standing in the road," Mickelson said with a sigh. "I thought: 'Oh, no. We've got some real trouble now.' "

Mickelson said Mama was "pretty lively" when she hit the ground, lumbering between cars and causing havoc on a foggy day. There were no automobile accidents, however.

After about an hour of chasing the pig with the help of police, Mickelson began mulling over his options, which included having a veterinarian tranquilize the hog.

About 10 a.m., a crew of highway workers arrived and decided to use a front-end loader to pick up the sow and load her back into the truck.

You can find the answers to these questions on Page 236

Story design

Headlines, text, photos, cutlines. Those are the basic pieces in the great Newspaper Design Puzzle. Over the years, page designers have tried assembling their puzzles in every conceivable way. Some solutions worked.

Others didn't.

In the pages ahead, we'll show you what works, what doesn't and what comes close. You may think there are thousands of design combinations for every story and every page, but there are really just a few basic formats you can count on. And those formats are well worth knowing.

In this chapter, we'll show you the different shapes a story can take, whether it's a story without art, a story with a mug shot, a story with a large photograph (the dominant) or a story with two photographs (a combo).

Later on, we'll show you how to combine stories to make a page. But first things first.

There's a lot of information in the pages ahead. Don't try to absorb it all at once. Many of these examples were designed to be "swipeable," so the next time you're laying out pages, look through the section that applies, explore your options and choose a format that fits the bill. You'll soon begin to understand why some layouts succeed and others fail.

CHAPTER CONTENTS

▸ **Stories without art:**
 Design options for stories that consist only of headlines and text........ 46

▸ **Mug shots:**
 Design options for stories that add a mug shot to the text........ 48

▸ **Text shapes:**
 A look at the different configurations text blocks should take 51

▸ **Photos on the page:**
 Every photo is unique and must be treated that way on the page........ 52

▸ **Horizontal photos:**
 Options for stories using horizontal images............ 53

▸ **Vertical photos:**
 Options for stories using vertical images 56

▸ **Dominant photos:**
 The importance of choosing lead art when using two or more photos................. 59

▸ **The picture combo:**
 How to work with a pair of pictures for a story 61

▸ **Square photos:**
 The unique challenges of working with square images 70

▸ **Exercises** 71

Stories without art

LEARN MORE
No art: *Designing a page with no photos.* **Page 78**

In a typical newspaper—whether it's The New York Times or a rural weekly—a good chunk of the stories run without any visuals whatsoever. So relax. Most of the stories you'll design will consist of just headlines and text. And since there are only a few ways to design stories without art, it's hard to goof them up.

Basically, when you combine headlines and text, they tend to move along the page either *vertically* or *horizontally*.

As long as you keep in mind one this one basic newspaper design guideline, you'll be fine: Whether square, horizontal or vertical, stories should be shaped into *rectangles*.

Stories can be laid out with more of a vertical emphasis ...

Stories run **vertically** when the headline is on top, the text drops straight down below it— and that's that until the text ends. The word "ver-ticality" is sometimes used when an overall newspaper's design focuses more on a verti-cal-oriented layout.

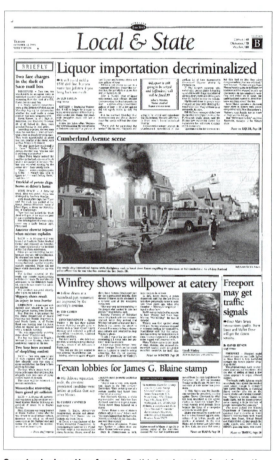

On a typical section front On this local section front from the Portland Press Herald in Maine, there's a huge fire photo in the center of the page (but the text of that story is on the next page). Because of its dominance, the image provides a visual focal point here. The story below the main photo uses an image, also—and the other three stories, along with the news briefs, use only headlines and text, including subheads and pullouts.

Inside the paper, on the jump page On the second page of that section there's another fire photo (this time with text). The top story adds a map and a sidebar. All the other elements on the page use only text: the news story in the top left corner; the four jump stories (continued from the previous page); the calendar along the bottom. Notice how all the stories form *rectangles*—this is known as modular design (more on that later).

Or stories can move across the page horizontally, like you see here.

Stories run **horizon-tally** when, instead of using just one leg of text, they run several columns side by side. You can keep adding new legs—and extend-ing the headline—until you run out of room at the right edge of the page. Some newspa-pers use more of a hor-izontal layout on their pages. *Horizontality?* Not a word that comes up often in newsrooms, if at all (look it up!), to describe the general flow of a page layout— but you get the idea.

Stories without art

Troubleshooting

Q Some newspapers deliberately run stories in a non-modular way. Is that wrong? Or a new trend?

Yes, just when you think a design guideline is etched in stone—*ALL STORIES MUST BE SHAPED LIKE RECTANGLES*—along comes a newspaper with a contrary philosophy, like the one you see at the bottom of this column.

A handful of papers—most notably, The Virginian-Pilot and The New York Times—have worked with this more traditional style (as opposed to modular). This kind of layout is also referred to as *dogleg*. A couple of reasons for sticking with this particular format:

▸ It allows bigger, wider headlines to accompany thinner, vertical legs of text—a good way to attract attention, especially on Page One.

▸ It has a "retro" feel that some readers may actually prefer (after all, The New York Times' front page has been designed that way nearly forever).

Done well, traditional design has a distinctive style and energy. Done sloppily, it's a mess. Are doglegs making a comeback? Not yet ... but you never know what could happen.

Non-modular Note this more "traditional" story layout on this page. Every story here is deliberately designed to dogleg.

VERTICAL STORY DESIGN OPTIONS

A hundred years ago, stories were all dummied vertically. Printers would simply run text in a strip below the headline, and when it reached the bottom of the page, they'd either end the story or jump the text up into the next column.

Nowadays, that's considered dumb dummying. In fact, you should generally avoid dummying legs more than 12 inches deep, since long legs look dull, gray and intimidating. In short: the longer the story, the more a horizontal layout will come into play.

In most news stories (right), the headlines sit atop the text. (Sometimes, you'll soon see, that rule is broken.)

Vertical layouts This format at right is clean and attractive, and the easiest shape to follow—just start at the headline and read straight down. Vertical design does have drawbacks, however: Long vertical legs like these can get tiring to read. Headlines in a vertical format are harder to write when they're this narrow and pages full of these long, skinny legs look awfully dull.

GOOD

HORIZONTAL STORY DESIGN OPTIONS

Horizontal shapes are pleasing to the eye. And they often create the illusion that stories are shorter than they really are. Again, avoid dummying legs deeper than 12 inches. But avoid short, squat legs, too. For most stories, legs should generally be at least 2 inches deep—never shorter than 1 inch.

Horizontal layouts flow left to right, the way readers naturally read. You'll create the most attractive designs by keeping legs between 2 and 10 inches deep. Note how the headline covers the text and sits directly above the start of the story.

GOOD

A COUPLE OF UNUSUAL OPTIONS

Probably 99 percent of all stories look like those above: basically vertical or horizontal, with the headline running above the text, covering the entire story like an umbrella. Life is full of exceptions, however, and here are two more: the *raw wrap* and the *sidesaddle* headline (below). They both break the rule about headlines running above all the text. And they're both potentially awkward. (See how those right-hand legs of text could collide into any text above them?) But in the right situations, they're handy.

OKAY

Raw wrap This headline is indented into the left-hand legs while the text wraps up alongside and aligns with the top of the headline.

OKAY

Sidesaddle This headline runs in the left-hand column—flush left, flush right or centered. The text runs alongside it.

Mug shots

LEARN MORE
Raw wraps: *Work around butting headlines.* **Page 82**

Oprah Winfrey

Yes, you can design stories without art. But you'll run the risk of having your pages look lifeless and gray. After all, most stories

After 25 years, Oprah Winfrey says farewell.

are about people: people winning, losing, getting arrested, getting elected. (They often get elected first, *then* get arrested.)

Readers want to know what those people look like. So show them.

Even if the story is about someone everybody knows (*"We all know what she looks like anyway—so why run a photo of her?"*), keep in mind that one small mug shot can show readers at a glance who's featured in the story.

▶ **Size:** Mugs can run half a column (indented into the text), or the full width

of a column and about 3 to 4 inches deep. Sometimes a mug shot runs bigger than this—call it a "glorified" mug shot, if you will—and it can dominate the page. If you go this route, though, you'd better be sure that the in-your-face mug shot goes above and beyond the ordinary.

▶ **Cropping:** Mug shots should fill the frame fairly tightly—but not *too* tightly. Leave air above the hairline, if you can. Avoid slicing into a person's head in such a way that it looks like body parts are missing (ears or a chin, for example).

▶ **Cutline:** *Every* mug needs a cutline. And yes, readers really do read this. Cutlines under mug shots can include just the person's name, or they can include more context (such as a title, or some relevant information pulled out from the story), which means running more than one line of text under the photo. See the tips at left for running half-column cutlines.

HALF-COLUMN MUG TIPS

Use caution when tucking a half-column mug into a column of text:

▶ Keep the image at (or slightly less than) half of the column width, or funky spaces may show up within the text.

▶ Don't make the image and caption *too* deep because the big chunk of half-column text running alongside it will look strange and be difficult to read if it's too long.

Twenty-five years after Oprah Winfrey's first show aired on national television in 1986—that's 4,561 days in her life— Oprah has decided to say bye-bye.

"For some of you long-time viewers, you have literally 'grown up' with me. ... The sharing of your precious time every day with me has brought me the greatest joy I have ever known," she sniffed while dabbing her eyes and clutching a giant box of

Seriously, you could drive a truck through here.

Even for these little mug shots, cutlines need to be informative.

VERTICAL STORY DESIGN OPTIONS

In vertical designs, one-column mug shots can fall in a variety of places: at the top of the story, somewhere in the text, or at the bottom of the story. They can fall above or below the headline. The sequence will depend upon the other stories on the page and how they're laid out.

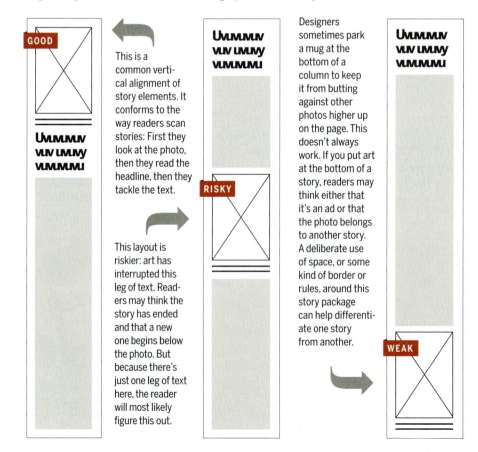

GOOD

This is a common vertical alignment of story elements. It conforms to the way readers scan stories: First they look at the photo, then they read the headline, then they tackle the text.

RISKY

This layout is riskier: art has interrupted this leg of text. Readers may think the story has ended and that a new one begins below the photo. But because there's just one leg of text here, the reader will most likely figure this out.

Designers sometimes park a mug at the bottom of a column to keep it from butting against other photos higher up on the page. This doesn't always work. If you put art at the bottom of a story, readers may think either that it's an ad or that the photo belongs to another story. A deliberate use of space, or some kind of border or rules, around this story package can help differentiate one story from another.

WEAK

Mug shots

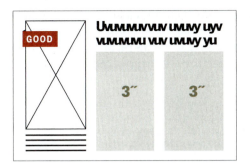

Modular To keep the story rectangular, the headline aligns with the top of the photo; the bottom of each leg squares off with the bottom of the cutline. To make sense, the headline may need two lines.

HORIZONTAL STORY DESIGN OPTIONS Mug shots that are *one column* are easy to attach to a horizontal story. Simply square them off beside the headline and text. And this is where a little math comes in. Assume the mug is 3 inches deep. Assume the cutline is roughly a half-inch deep. That adds up to a total depth of 3½ inches. For short stories like this, headlines are small: roughly a half-inch to an inch deep. That makes every leg of text in this design approximately 3 inches deep. At left is a typical layout for a 6-inch story.

Half-column mug shots can be tucked into a leg of text fairly easily. But should they be on the left or right side of a leg of text? Either way can work: if the mug shot is on the right side of a justified-text column, then the straight edge of text will run along the straight edge of the photo. With a mug shot on the right side of a ragged-right text block, though, there could be extra spaces between that text and the photo. This can work—depending on where other stories and art are placed on the page.

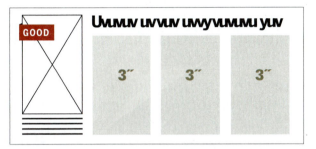

Room to grow If each leg of text in this design is roughly 3 inches deep, that means you can keep adding on legs to accommodate a 9-, 12- or even a 15-inch story. Notice how, as the headline gets wider, it goes from two lines (top) to one (above). The headline might also need more size used at one line (which would mean fewer words), but this would depend upon where it falls on the page and the other stories around it.

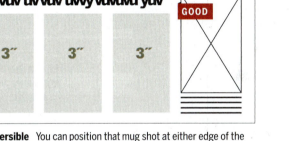

Easily reversible You can position that mug shot at either edge of the story, too. Since most mugees generally stare straight ahead, one side's just as good as the other. Note how the headline covers only the text—not the photo. Sometimes, though, extending the headline above the mug may help all the elements fit better, as seen below. This longer headline treatment may also help separate this story from one that runs above it.

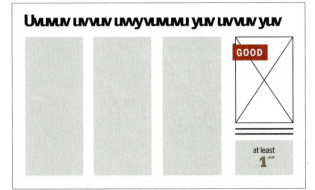

It's a wrap Longer stories need more depth, so they'll oftentimes wrap beneath the mug. The mug can be placed in any leg of text. If you choose to place this mug shot on the left, however, the small amount of wrapped text under it could be missed by the reader, and the start of the story won't be obvious. Try to keep the headline as close as possible to the start of the story.

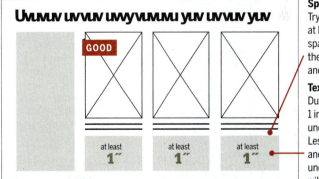

Still a wrap You could also park several mugs side by side: Notice how these three mugs are evenly aligned. It's ordered, balanced and pleasing to the eye, and it gives each mug equal weight instead of emphasizing one person disproportionately. This is a great way to present candidates for an election, for example. Ideally, each mug shot should have its own cutline—but a shared cutline under them all could work, too.

Spacing Try to maintain at least 1 pica of space between the cutline and the text.

Text length Dummy at least 1 inch of text under a photo. Less than that, and the words under the image will get lost.

HORIZONTAL STORY DESIGN TIP We've now looked at the most basic configurations for stories with mugs. The above examples also work well for nearly any story where you add a small graphic (a one-column map, chart, list, etc.) instead of a mug shot. Check out these variations on the next page.

Mug shots

LEARN MORE
Liftout quotes: *Some guidelines.* **Page 150**

Troubleshooting

Q **Do mug shots always have to run small? Or is it permissible to run them as dominant art?**

That depends on the story, the quality of the mug shot—and how desperate you are. But yes, a mug shot can function as lead art, especially if it's a portrait with personality, like the one below. (An ordinary mug shot—some dazed-looking guy leaning against a blank wall—might be deadly dull and would only get worse as you enlarge it.)

Make sure the mugee is a newsmaker worthy of big play. Crop dramatically, turning it into an extremely tight vertical (below) or horizontal. Add a liftout quote with typographic pizazz. Or place two mugs on either side of the layout, like bookends, to provide a point-counterpoint faceoff between two combatants.

Cutline here! Remember—just about every photo you use in the newspaper needs a cutline. For the photo above, for example, you would need to include at least this man's name. Where is he from? Where does he work? Did he say anything (a quote) that's relevant to the story?

MORE STORY DESIGN OPTIONS Don't start thinking that layouts *must* be purely vertical or horizontal. We've simply made those distinctions to help you develop a feel for story shapes. You'll soon see that, as stories get more complex, they expand both vertically *and* horizontally—and that's where you can improvise and bend the rules.

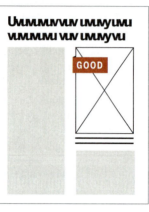

Flexibility Here's a layout at left that isn't purely vertical, since it uses not one but two legs side by side. And it's not purely horizontal, since it's more deep than wide. But it's a good design solution when you need to fit a short story into a square-shaped hole. And it could easily be deepened—or widened—to accommodate a longer story.

Note the rules When dummying this story, keep the following in mind:
▶ The headline covers both columns of the text.
▶ All elements—the headline, text blocks, photo and cutline—align neatly with each other. (The entire story is shaped like a rectangle, and when rectangular-shaped stories come together on a page, this is referred to as *modular design.*)
▶ There's at least an inch of text below the photo.

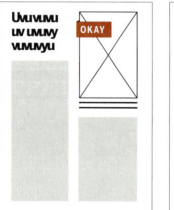

Raw wrap and mug Remember the raw wrap? Here it is again, this time with a mug atop the second leg. This design works well in a 2-column layout like this. It would keep headlines from butting if another story started to the right of this one.

Raw wrap variation and mug This is a variation of the raw wrap, but few papers use it. It's basically a vertical design cut in half, with the bottom half parked alongside the top. One big problem: What happens if there's a story above this one?

Smaller mugs These work best when they are truly a half-column, or a full column, wide. Mugs that are kind of in-between, like the one above, look awkward, no matter where they're placed.

Liftout quote with a mug This popular format combines a mug with a liftout quote. It can be more attractive and more informative than just a mug shot by itself. This format can be used with or without a box around it.

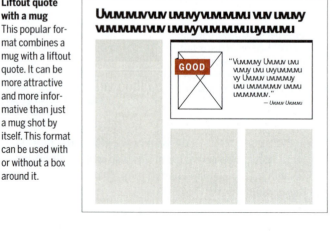

Text shapes

LEARN MORE
Wraparounds and skews:
Some guidelines. Page 202

Troubleshooting

Q When you look at the text in magazines, it often hops over photos, illustrations and quotes. Why doesn't newspaper design enjoy that much freedom?

Magazine design, like yearbook design, is fun in ways that newspaper design isn't. You can run huge photos that fill entire pages. You can "bleed" images (i.e., print photos that run right off the edge of the paper). And yes, you can position story elements in riskier ways. Why? Look at the magazine page below where the text leaps over quotes. There's only one story on the page. On newspaper pages there's more traffic—so avoiding confusion becomes more essential.

Stay organized The top layout forces readers to jump around liftout quotes—not a problem when there are no other stories or ads to add confusion. On a busy newspaper page, however, there are more stories, and more room for confusion.

Beginning designers often find themselves wrenching text into awkward shapes as they try to make stories fit on a page. Or they'll choose risky, distracting designs when simpler layouts would be more effective. If you have that problem, try looking at your stories a different way: Focus on the shapes of your text blocks. Always shape your stories into rectangles. That means all four edges of the story should align— or "grid off"—with each other.

Below are the most typical shapes for text blocks. Notice how the arrows follow the flow of the reader's eye through the text. Again, you have to remember that the text shape you end up choosing will have to work within the context of the whole page—and that includes taking into consideration the other stories (headlines, subheads, text, visuals) as well as the ads (which can also include headlines, subheads, text and visuals).

Keep this in mind when laying out text blocks: Keep it simple. It's worth repeating: *Keep it simple!*

TEXT SHAPES: THE GOOD, THE BAD AND THE TRULY AWFUL

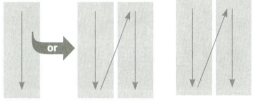

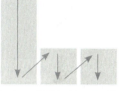

The rectangle This is the safest shape of all. Whether in one leg or many, it's clean and clear: no odd jogs, leaps or bends. This shape is the main building block to a modular layout.

L-shaped This shape results when text wraps under, or above, a photo. It's still a neat and readable shape (and can be reversed).

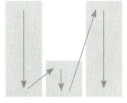

U-shaped This breaks up boring stacks of text, but beware of giant leaps to the top of that right leg.

Doglegs These shapes are often inevitable when you design around ads. Use this style sparingly, if at all, since art placed below text is often mistaken for an ad.

A backward "L" Risky. Readers may think the text starts in that second leg.

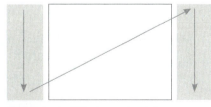

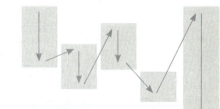

Bookends Avoid forcing readers to jump blindly across art that's sandwiched between two legs. It can work if you're careful, but you run a high risk of creating confusion.

Odd shapes When your text snakes around like this, it means your art is badly scattered. Back up and redesign before you confuse your poor readers.

Photos on the page

LEARN MORE
Photos: *How to lay them out on a page.* **Page 130**

After a while, basic story designs start falling into predictable patterns. In fact, it's possible to dummy photos onto pages without ever actually *seeing* the photos. Just stack a bunch of empty boxes in a neat, attractive way, and there you are.

Designing a page this way is *not* recommended. Every photo is unique, and every image's content needs to be carefully considered before you shove it into a predetermined slot.

And what are the sizes of those slots? As you read earlier, the basic photo shapes are *horizontal, vertical* and *square.* We'll take a look at these three shapes and see how they each affect the overall design of a news or feature page.

Vertical format
The vertical-shaped image is not as common, but you may see it crop up more often on sports pages. This format gives the overall page a more a dynamic energy because of the depth of the image, but it's harder to work into a page design. Text doesn't flow naturally around it. As a designer, don't fight this verticality—embrace it by keeping your design as vertical as the image. In other words, just go with the (vertical) flow.

Square format
The square image is a rare bird indeed, at least on the pages of most newspapers. Sometimes photographers choose to break away from the standard 35 mm format and try something different that will help better reflect a story's tone. And other times, the photo is cropped into a square so that it fits better on the page. Here, the lead photo is run at its full width—four columns—and is deep enough to convey the most impact, yet still leave enough room for other storytelling elements.

Horizontal format Look at most newspaper pages, and you'll see that most of the images are horizontals—and easier shapes to work with. You can run text under, above or alongside horizontal images. The two horizontal images above fit on this page with no problem.

Horizontal photos

THE MOST COMMON PHOTO FORMAT

Photojournalists tend to shoot mostly horizontal. Ask them why, and many of them will tell you it's because it's how they tend to see the world—scanning it from side to side, rather than up and down.

As a page designer, this means you'll probably handle more horizontal-shaped images rather than vertical or square. So you'll be relieved to know that, in general, horizontal images are the easiest to work with on a page. In most cases, these rectangular shapes aren't extreme, and the pieces of the (modular) page puzzle fall easily into place.

Below is a "spot-news" photo—an image made at an event that wasn't planned. Aside from the photo's horizontal shape, there were many things to consider—content, ethical choices, photo direction, placement on the page—before this image actually came out in print.

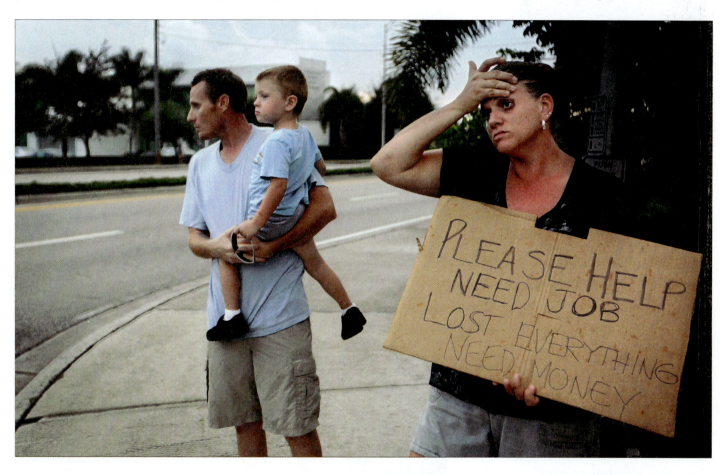

About the story
The theme of this four-day series was on the economic downturn in southwest Florida. The Naples Daily News had done daily stories about some of the effects of the foreclosure crisis, says Greg Kahn, the photographer, but hadn't worked on anything comprehensive yet.

Kahn says he did a fair amount of research on the story before shooting. "It was easy to look at the problem and blame the homeowners for being irresponsible. But few noticed the full spectrum of why these foreclosures were taking place, and what would happen after a resident was evicted from their home."

About this photograph
"This photo was a difficult one to make," says Kahn. "The family was not at all happy for me to be there. They were embarrassed enough to have to panhandle on the side of the road, never mind have a photographer document their plight.

"I had to spend time talking to them and telling them my purpose for making photos of them," he says. "I know that by telling their story I was able help them and many others in their situation. We received a tremendous response from the community after the story ran, and saw the effect it had on others."

About the picture play
This image ran on the front page on one day of the series. "From the woman's sunken eyes, her hand on her head and the look of the child in his father's arms, this image showed the struggles and stress of being without," Kahn says. "Their body language shows a defeated family, one that has buckled during the hard times.

"Because of all of the elements in this frame coming together, the editors and I decided this was an image that would jump off the front page and compel readers to pick up the paper. In one image, even without reading the caption, this photo was able to tell this family's story."

Horizontal photos

LEARN MORE
Photo pages: *Tips on how to design them.* **Page 134**

> "You've got to put your pride aside. You've got to make a living; you've got to pay your bills." *Shawn Knighten, "Dapooman"*

Shawn Knighten patrols for dog waste Friday at a client's home in Virginia Beach. He dreads rain and tall grass.

SCOOPER'S BUSINESS IS PICKING UP

VIRGINIA BEACH

SHAWN KNIGHTEN isn't afraid to get his hands dirty. But then, it isn't his hands that get dirty.

Knighten is "Dapooman," a professional poop scooper, and he and his wife have one hard-and-fast rule: The shoes stay outside.

doggone good job

Shawn Knighten is known as "Dapooman," a professional poop scooper. He makes about $11 per stop, and the average yard takes about seven minutes.

On Thursdays and Fridays, Knighten visits nearly two dozen clients' homes throughout Hampton Roads and removes dog droppings from their lawns. After only one month in business, he said two days per week are fully booked, at about $11 per stop.

For years, Knighten has had a notion of entrepreneurship. He's a disciple of positive thinking, incessantly reading inspirational

authors such as Joel Osteen and Larry Winget. The idea for the business, he said, came to him in bed.

He's not the first to come up with the idea. Locally, there are other poop scoopers, with catchy monikers such as "Beyond the Call of Do-Dee" and "Doody-Calls." There's even a national

See SCOOP, PAGE 4

By JOHN WARREN | The Virginian-Pilot

THE ART OF THE EDIT

Unlike mug shots—which come in one standard shape and size and are generally interchangeable—full-sized photos require thoughtful analysis. So before you begin designing a story, you must consider each photo's:

▸ **Size.** How big should the photo run? (If it's too small, faces and places become indecipherable. If it's too big, it hogs precious space.) Does the photo gain impact if it's larger? Is there room on the page for jumbo art?

▸ **Content.** Is one photo enough to tell the story? Is the package more informative with two or more? Or is the photo meaningless, routine, expendable—something that could make room for another story?

▸ **Direction.** Does the action in the photo flow *strongly* in one direction: someone running, pointing, throwing a ball, shooting a gun? If so, try to dummy the photo so that the action in the image points toward the text of its own story—and not into the layout for some unrelated story, which might confuse readers.

VERTICAL STORY DESIGN As we've previously seen with stories using mug shots, this vertical layout conforms to the way most readers scan stories. They're attracted by the photo; they read down, through the cutline, into the headline; then, if they're still interested, they read the text.

Your design goals, then, are: keeping all elements in a clear and easy-to-navigate order; avoiding long, gray legs of text; and avoiding confusion with any other story parked beside the photo (a topic we'll explore in the next chapter).

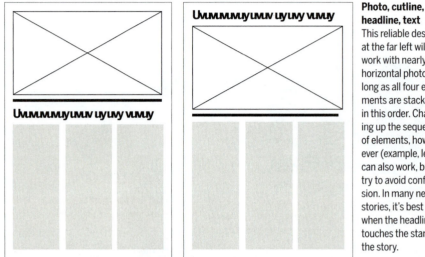

Photo, cutline, headline, text
This reliable design at the far left will work with nearly any horizontal photo, as long as all four elements are stacked in this order. Changing up the sequence of elements, however (example, left), can also work, but try to avoid confusion. In many news stories, it's best when the headline touches the start of the story.

HORIZONTAL STORY DESIGN As we saw on Page 51, text blocks work best as rectangles (as opposed to L-shapes, U-shapes, doglegs, etc.). That makes the examples on this page—both vertical and horizontal—safe, effective solutions.

Whenever you try to square off text beside a photo, you'll probably need to wrestle with photo shapes and story lengths to make the math work out. But remember: Every story is (be careful, but it's true) *cuttable.*

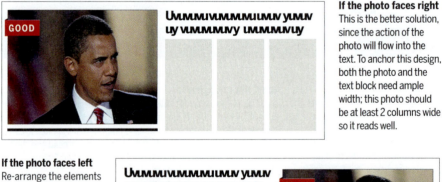

If the photo faces right
This is the better solution, since the action of the photo will flow into the text. To anchor this design, both the photo and the text block need ample width; this photo should be at least 2 columns wide so it reads well.

If the photo faces left
Re-arrange the elements so the text is parked on the left. Remember that all elements must square off at both the top and the bottom; this design won't work if the text comes up short on one or more of the legs.

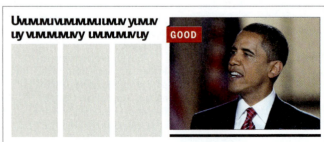

Horizontal photos

Swipeable formats

Any of these designs can be used for news pages or special feature stories. For some of these, you'll need to use more elaborate headlines, longer-than-usual decks, or text wraps to work effectively. In other instances, your best bet will be to keep the layout as simple as possible. Remember that whatever you choose to use will depend upon what's happening on the remainder of the page.

Balanced
This layout is symmetrical, which is one quick way to balance page elements. A U-shape centers the headline and deck. This can work well—or appear static.

Balanced
More symmetry. Here, the text wraps around the headline, which could also be boxed, or placed on a screened background box.

On the side
This sidesaddle headline uses a longer deck (a perfect opportunity to include more details in this spot). The text squares off alongside the "big words."

Side, again
Another side-saddle head in a narrow stack. This one squares off beside the photo. (Notice the direct connection between the big words and the visual.)

EXTRA STORY DESIGN OPTIONS To a designer's eye, the previous examples are appealing because they're so neatly aligned, so cleanly balanced. Yet these two designs directly below are more common, and just as effective. The reason? Notice how the headline and text surround the photo to create a self-contained package. There's no way a reader can mistake which story the photo belongs to. The two examples at the bottom of this page show what can happen when raw wraps or text wraps are part of the design solution.

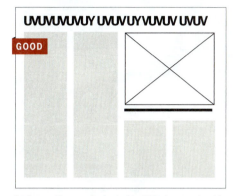

L-shape Here, an L-shaped text block wraps beside and below the photo. If you wanted to play the photo bigger, you could run it 3 columns wide. For longer stories, you could deepen each leg of type—or wrap another leg of type along the right side of the photo and extend the headline farther.

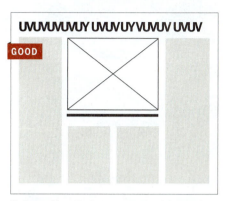

U-shape Here, the text wraps around three sides of the photo. Some editors prefer this layout to the one at left because: 1) it's symmetrical; and 2) it breaks up that gray mass of text in an attractive way. Once, again, though, it all boils down to making this layout work with the rest of the page.

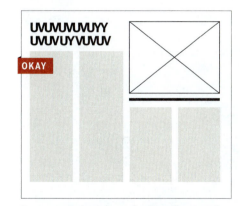

Raw wrap Instead of covering the entire story, the headline is parked in a left-hand leg or two. It's not a bad solution, but it's best reserved for times when you dummy two stories side by side and you need to keep headlines from butting. With a raw wrap, the photo lets you get away with that. On the other hand, if you have two stacked (and non-related) stories, the headline might work better if it's not a raw wrap—and runs across the entire story, including the photo. This way, the headline will help separate the two stories so that they don't appear to be related, or a single unit.

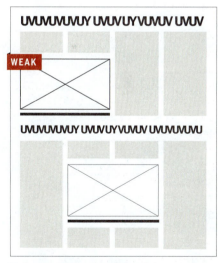

Text wrap Avoid running photos below columns of text, especially when those legs are really short. There's too great a danger readers will think the photo is an ad, or that it belongs to a story below. Wrap text below or beside art—not above it. And when it comes to wrapping text all around a photo, be cautious. Dropping art into the middle of a story disrupts the logical flow of the text; readers will fumble to figure out which leg goes where. Avoid interrupting legs of text with a photo.

Vertical photos

LEARN MORE
Photos: *How to lay them out on a page.* **Page 130**

If you understand the design options for horizontal photos, you'll have no problem with verticals. If anything, verticals offer less design flexibility than horizontals. They're a more dramatic shape, but flowing a story's text around or beside a big vertical photo can be tricky. Knowing where to place the other stories on the pages around a vertical image poses unique challenges, too.

General background about this photo
Here is Lady Gaga performing during a concert in Sunrise, Fla. Her outfit isn't surprising—it's her shtick, after all. Who, or what, would Lady Gaga be without the raw meat, masks, leather—and Kermit the Frog draped over her body?

The ethical considerations
When it comes to shedding the clothes for sheer shock value, where should the line be drawn when considering a photo for newspaper publication? With a pro-vocative photo like the one at left, surely there will be discussion in a newsroom about whether this image is OK to run in a "family newspaper." You could argue that this is a classic-pop moment that perfectly captures the spirit of Lady Gaga's persona and music—and besides, this is exactly the kind of dress we see all over mainstream media all day long, on every kind of venue. What would you do, if you were the photo editor? Would you run this image in your community newspaper? How about your student newspaper?

The editing and design process
A photo like this can single-handedly carry a story by itself and run big. Or it could run smaller inside the paper, depending on where the concert is being held and the community where this photo might be seen. For a "walk-up" story that gives readers a preview about an event, there are many creative ways to play up photos in a more iconic, rather than documentary way, as you can see in the St. Petersburg Times page below.

Vertical photos

GOOD

Uʋɯɯuʋɯɯu Yuy
Vuɯɯu Yuɯɯu

A strong solution This layout shows one reliable way to stack these elements vertically. It's a design that will work best in a deep 2- or 3-column space. Depending on the story and the photo, there also might be an option to trim the content in order to fill this available space.

VERTICAL STORY DESIGN Since dominant vertical photos usually run either 2 or 3 columns wide, that makes them pretty big—anywhere from 5 to 15 inches deep. Stick a headline and a story below that and you've got a sleek, dynamic design (if you have enough room for a layout that deep). There are a couple of drawbacks: It's far from the top of the photo to the bottom of the text, and you'll have to ask yourself if the story will hold together on a page full of other distractions. And if you're designing a front page with the strongly vertical photo as a centerpiece, where will you place the headline? If you stick it under the image, the headline will be under the fold—and not visible when the newspaper is on a rack.

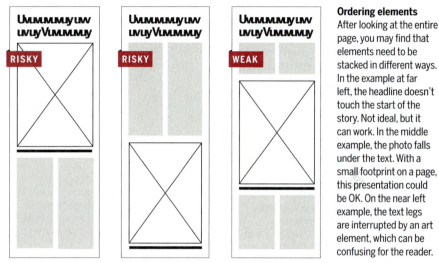

Ordering elements
After looking at the entire page, you may find that elements need to be stacked in different ways. In the example at far left, the headline doesn't touch the start of the story. Not ideal, but it can work. In the middle example, the photo falls under the text. With a small footprint on a page, this presentation could be OK. On the near left example, the text legs are interrupted by an art element, which can be confusing for the reader.

HORIZONTAL STORY DESIGN Stacking photos and stories side by side requires careful sizing but creates a solid design. Note how, in the examples below, the headline covers only the text. (Running a wide headline atop both the photo and the text is a secondary option, though—see Page 55.) Note, too, how both examples use 2-column photos. A 3-column vertical photo would be extremely deep (8-15 inches), and that could make any legs of text running alongside it excessively deep and gray. In that case, consider running a couple of legs of text under the photo.

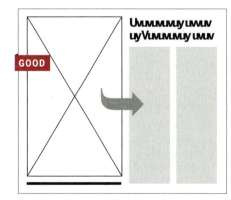

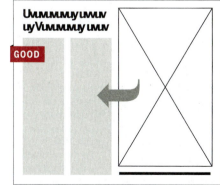

Directional photos? For strongly directional photos, you'll need to take a close look at where you position the photo in relation to the text. You'll also need to have a sense of how all the elements come together on the page to know what works best.

Or non-directional photos? Remember that non-directional photos work well on either side of a block of text. Your design decision should be based on how the overall page fits together—and how you wish to distribute the visual weight.

Vertical photos

Swipeable formats

As we saw on the horizontal layouts, any of these designs can be used for news pages or special feature stories. Again, for some of these, you'll need to use more elaborate headlines, longer-than-usual decks, or text wraps to work effectively. Simple is usually the best way to go. Just remember—whatever you choose to use will always depend upon what's happening on the remainder of the page.

Balanced
A symmetrical layout that will help balance page elements. A U-shape centers the headline and deck. Put a box around this layout to help separate it from others.

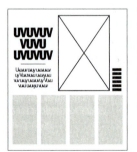

Balanced
Symmetry, but this time with the headline running above the photo. The text wraps around the photo and headline. A box around this layout will keep elements unified.

White space
This sidesaddle headline uses a longer deck (a perfect opportunity to include more details in this spot). The text squares off alongside the photo.

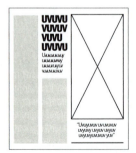

Tucked in
This layout is risky, but if the headline and deck contrast with the text, it can work fine. Again, boxing the layout will help tie together all the elements.

EXTRA STORY DESIGN OPTIONS These examples—*L-shape, U-shape* and *raw-wrap*—are similar to the horizontal design options seen on Page 55.

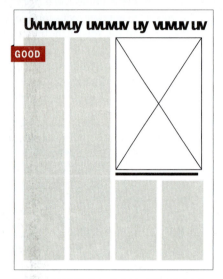

L-shape In this L-shaped wrap, all the elements work well together. But consider how deep those left-hand legs could become, especially with a 3-column photo. To break up the gray, designers often dummy a liftout quote, or a pullout, into that second leg of text, or they position it centered between the first and second legs of text.

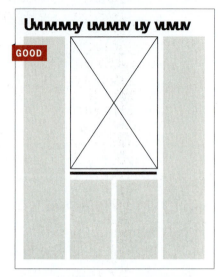

U-shape This U-shaped wrap keeps those two long legs of text from merging into one gray slab. But beware: Those two legs under the photo will look flimsy if they're not deep enough (they should be at least one inch deep). Also, note how it's a long way from the bottom of the third leg to the top of the fourth.

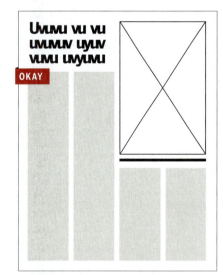

Raw wrap This type of layout keeps headlines from butting when stories are dummied side by side. But some think this layout is less graceful than those above. And if the headline is too small, it can be overpowered by the photo and text. Still, it's acceptable to use. To get more visual heft in the headline, try making it bigger and running it over the text and the photo.

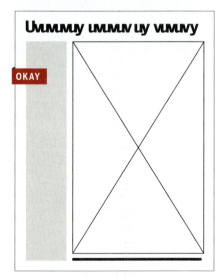

Side by side There are times, especially on Page One, when you need a big photo/big headline combo. Running a 1-column headline over that one leg of text might give you a cleaner design, but it won't anchor the page at that size. The headline will have a lot more *oomph* (especially if you need impact) if you run it over the photo and text and give it the size it needs.

Dominant photos

Editors and page designers try hard to be fair when it comes to news judgment and presentation. And that can be a good thing. But as you may already know, some news is more important than other news. Some stories are more interesting than others. And some photos are more *compelling* than others.

When it comes to newspapers, readers count on editors to, well ... edit. Experienced editors sift through the seemingly endless story choices out there and try to make the best decisions as to what to run in a particular community's newspaper. They also decide which stories have the most impact on readers, and which photos or graphics should get more play.

This means that everything is *not* treated equally on newspaper pages. Not everything is above the fold, for example, or played at the same size. One way to help all the page pieces work together is to think about establishing a *hierarchy*—and dominance is one way to help establish that.

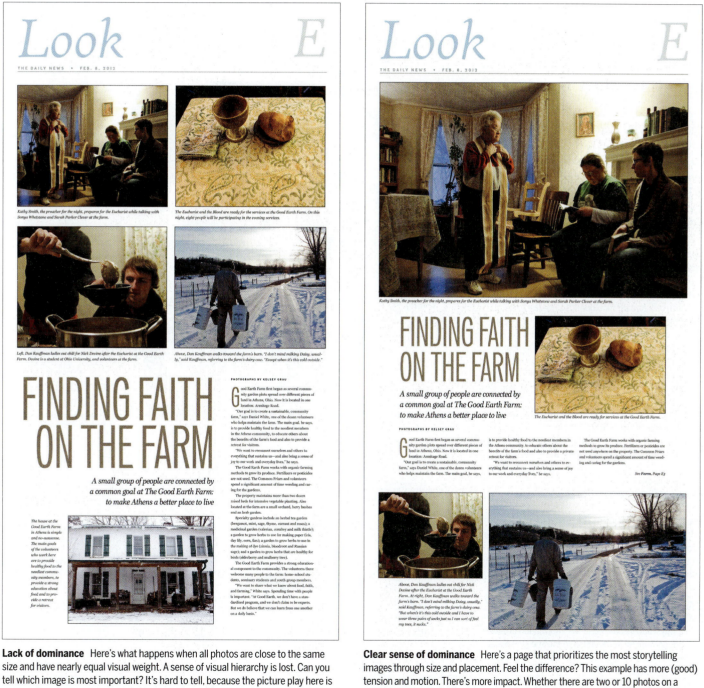

Lack of dominance Here's what happens when all photos are close to the same size and have nearly equal visual weight. A sense of visual hierarchy is lost. Can you tell which image is most important? It's hard to tell, because the picture play here is static and boxy. There are some picture pages, however, that would benefit from a more grid-like layout, as we'll see later on.

Clear sense of dominance Here's a page that prioritizes the most storytelling images through size and placement. Feel the difference? This example has more (good) tension and motion. There's more impact. Whether there are two or 10 photos on a page, seek out a dominant photo—that is, choose one image that is substantially bigger than the secondary images.

Dominant photos

DOMINANCE DECISION

A strong photograph will anchor a story—or an entire page. Now, there may be times when a layout works better when photos are equally sized (a before-and-after comparison, a row of mug shots, a series of time-elapsed frames that show action). But usually, you will find yourself deciding which photo on the page should be the dominant one. When doing so, be sure to ask yourself:

▸ Do I really need more than one photo for this story? Do these additional photos add necessary information to help tell the story? If so, keep asking:

▸ Does one photo have stronger content than the others? Does it capture a key moment of drama? Does it show motion and/or emotion? Does it enhance and explain the story in ways that the other photos do not?

▸ Does the photo need size to read well and carry the most impact? Or will it still pack some punch in a smaller space?

Take a look at this centerpiece example on the right, which ran on the front page of The Sacramento Bee:

Anchor the centerpiece This story, about a young boy with cancer, calls for a dominant (or lead) image that clearly shows the boy's face. This will help set the tone of the story. The presence of just his mother's hands touching her son's head in this dominant image gives the reader a hint of the close relationship the mother and son have. Since we cannot see the mother's face, and we're not making eye contact with the boy, this lead picture has an air of spontaneity to it.

Add relevant information The secondary (smaller) image gives the reader a sense of place by showing the mother in the context of a doctor's office, where she and her son most likely spend a significant amount of time. This photo, which has a somewhat simple, clean composition, is still readable at two columns.

Make a decent footprint Don't be afraid to be bold with a centerpiece—it needs to contrast with the other stories on the page and be clear that this is the story of the day. You can *show* that by running the dominant photo larger.

Layer information Hold on … you mean the deck can go before a headline? And all that can sit above a photo? Not always, but it works here. The information provides context and a good introduction to the images—and it's all *above the fold* (which is the top part of the paper you see when it's folded in half).

RAPPING WITH RON: Kings' Artest chats it up on music, Adelman, Bonzi / SPORTS • C1

MINDING YOUR E-MAILS: Don't let them come back to haunt you / SUNDAY SCENE • L1

FOUNDED 1857 VOLUME 294, NO. 190

The Sacramento Bee

SUNDAY July 9, 2006 ★★ www.sacbee.com •••• Final edition $1.50

FIRST OF FOUR PARTS

When you look into the face of someone with cancer, you may have no idea what is going on beyond chemo and radiation. It's human nature to turn away. But it is real life, and it is going on in homes all over this country, where more than 1 million people are diagnosed every year. Cyndie French and her son Derek opened their lives for a year to share their story.

A MOTHER'S JOURNEY

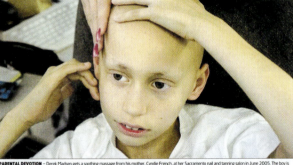

PARENTAL DEVOTION – Derek Madsen gets a soothing massage from his mother, Cyndie French, at her Sacramento nail and tanning salon in June 2005. The boy is battling a rare childhood cancer that has invaded his bones and organs. "I'm going to do whatever it takes to make him happy, to see him smile," Cyndie says.

Cyndie French sinks into the soft blue cushions of her living room sofa and reaches for her son Derek, flashing her fuchsia fingernails and her bravest smile. Derek, the boy who once was the pride of the Bridgeway Island Elementary School dodgeball crowd and the master of his multiplication tables, scowls back at her.

He knows he is sick, that his sickness is the reason that he can no longer go to school, the reason his little sister had to leave their home, the reason the power company shut off the gas the other day. And he is angry. "Leave me alone," he tells his mother, scooting away from her side.

Cyndie, a single mom of five with a size 4 figure and platinum blonde hair, sighs deeply and begins massaging Derek's shiny scalp as his eyelids start to close.

Sometimes we have to suffer, she says, referring to the biblical story of Job. Cyndie knows about suffering. She was abused as a young child, adopted at 8, out of the house by 17. She has raised her children mostly on her own and has struggled at times to pay her bills. But as she sits here today, suffering has a new meaning.

Where, she wonders, will it lead her this time?

JUNE 2005

Cyndie runs a K Street nail and tanning shop, and she looks the part today in her tight jeans and cotton Hard Rock Cafe top, her manicure du jour featuring pink polish

SURGERY RECOMMENDED – Cyndie French listens on July 25 as Dr. Joan Graf at the UC Davis Medical Center explains that Derek needs surgery to remove a cancerous tumor in his abdomen. The procedure is scheduled for two days later.

flecked with gold. She is a few months short of 40, but she still turns heads, and she loves it.

With one hand wrapped around a tall white chocolate mocha with mint and the other on Derek's shoulder, Cyndie smiles at passing strangers in the corridors of the UC Davis Medical Center and flirts with about half of them.

"Wow!" she says, fixing her blue eyes on a man in a white laboratory coat. "Is ev-

eryone around here this handsome?"

Breezing through a hallway painted with pastoral images of mountains and birds, she enters another world. It is a world of scalpels and syringes, of radiation and medicines that inflict misery and inspire hope.

This is where doctors are waging war on Derek's neuroblastoma, a rare childhood cancer that starts in the nerve cells and al-

▸ CYNDIE, Page A8

Story by CYNTHIA HUBERT Bee Staff Writer ❖ *Photography by RENÉE C. BYER Bee Staff Photographer*
ONLINE PHOTO GALLERY www.sacbee.com/projects

Mexico vote fraud alleged

López Obrador leads massive protest by the poor, vows to continue his challenge of the election results.

By Manuel Roig-Franzia
WASHINGTON POST

MEXICO CITY – Downtown Mexico City swelled Saturday with the accumulated frustration and rage of the poor, who were stoked into a sign-waving, fist-pumping frenzy by new fraud allegations that Andrés Manuel López Obrador hopes will overturn the results of Mexico's presidential election.

López Obrador ignited the smoldering emotions of his followers Saturday morning, alleging for the first time that Mexico's electoral commission had rigged its computers before the July 2 election to ensure Felipe Calderón's half-percentage-point victory.

In a news conference before the rally, López Obrador called Calderón "an employee" of Mexico's powerful upper classes and said a victory by his conservative opponent would be "morally impossible."

López Obrador added a new layer of complexity to the crisis by saying he would not only challenge the results in the country's special elections court, but would also try to have the election declared illegal by Mexico's

▸ MEXICO, Page A15

> *We are going to ask that they clean up the elections. We are going to ask that they count all the votes – vote by vote, poll by poll.*
>
> **Andrés Manuel López Obrador**
> leftist presidential candidate

ANALYSIS

Some doubt cast on terror arrests

Lawyers wonder if people taken into custody actually did anything

By Eric Lipton
NEW YORK TIMES

WASHINGTON – In Miami last month, and now in New York, terror cases have unfolded in which suspects have been apprehended before they lined up the intended weapons and the necessary financing or figured out other central details necessary to carry out their plots.

For officials in Washington, it is a demonstration of the much-needed emphasis in this post-Sept. 11 era for pre-emptive arrests. "We don't wait until someone has lit the fuse to step in," Homeland Security Secretary Michael Chertoff said Friday about the New York plot.

But the Miami and New York cases are inspiring a new round of skepticism from some lawyers who are questioning whether the government, in its zeal to stop terrorism, is forgetting an element central to any case: intent to commit a crime.

"Talk without any kind of an action means

▸ TERROR, back page, A16

Medi-Cal spending goes up for illegal immigrants

By Clea Benson
BEE CAPITOL BUREAU

The recent state budget debate over whether California should provide health insurance for children who are undocumented immigrants largely overlooked one key fact: The government already spends almost $1 billion a year for some health care services for the undocumented through Medi-Cal.

Amid a renewed national focus on illegal immigration, health services for undocumented immigrants in California returned as a political flash point this year for the first time since debate over Proposition 187 roiled the state in the 1990s. Republican lawmakers persuaded Democrats and GOP Gov. Arnold Schwarzenegger to

▸ HEALTH, Page A11

INSIDE THE BEE

SUNDAY TICKET

Jett? You bet!
Thirty years after the Runaways, Joan Jett still rocks, headlining as the Vans Warped Tour hits Sleep Train Amphitheatre.

Hot
100 | 66
Weather • B8

BUSINESS • D1

Crowd pleasers
The River Cats come up with many ways to lure fans to Raley Field.

METRO • B1

Some say it won't fly
A proposal to shut Sacramento Executive Airport for in-fill development hits turbulence.

Complete index on Page A2

© 2006, The Sacramento Bee

Online gambling booms as laws try to catch up

By Todd Milbourn
BEE STAFF WRITER

Sonny Mohammadzadeh approaches online poker with scholarly seriousness.

The UC Davis graduate student and mathematician doesn't play when he's tired or upset. He seeks out sites with weaker players. And he keeps meticulous records so he can improve his game and track his

winnings.

Mohammadzadeh executes his system from a laptop computer in a cluttered off-campus house adorned with Pink Floyd posters. The 23-year-old has turned an online time-waster into, basically, a part-time job that's helping him through college.

He figures it pays about $20

▸ GAMBLING, Page A13

The picture combo

LEARN MORE
Feature page design:
Some guidelines. Page 134

If a picture is worth a thousand words, then a picture combo is surely worth at least two thousand.

The reality is this: there are very few photos out there that have it *all* in one single frame: the peak moment, the high-impact graphic composition, the incredible light, all the key players in the story.

Pairing pictures, which is done frequently on the pages of newspapers, opens up *so many* possibilities in telling a story.

Imagine placing any two pictures side by side. The reader will naturally think they belong together and will immediately try to find connections between the two photos.

This is what's called a *third effect*—

images play off each other and create yet another layer of meaning that can be different, or even greater, than what you'd glean from any single image.

With text as part of this mix (as in words *and* pictures), and you've added on even more layers of meaning.

Sounds a little *cosmic,* doesn't it?

BE DECISIVE Below are four photos from a news feature we'll call *Hog Farm Holiday.* In the pages ahead, we'll pair the photos in different ways to create different story designs. But first, ask yourself: Which should be the lead (dominant) photo if you had to take two of these pictures and work them into what's called a *two-picture combo* on the page?

Left: It's not every day you see a girl riding a pig. That's a memorable image, one that's bound to arouse the curiosity of readers. We can see a sense of scale—small girl on huge pig—and we can catch a glimpse of the barnyard (giving the reader a sense of place). For these reasons, it's probably the stronger of the two verticals.

Above: This image of a man nuzzling a pig is an attention-getter with immediate impact. It's certainly stronger than the other horizontal (far right, bottom), though it shows us less of the barnyard than the other shots do.

Right: This photo of the farmer is his only appearance in these four shots. And though this photo isn't as engaging as the other vertical, it would be a good choice for a secondary photo if the farmer plays a part in the story. This image could also run small.

Above: The baby pigs are cute, and this photo provides our only look at animals minus the humans. This image gives provides information that there are numerous animals on the farm, not just one or a few. This photo doesn't read as well as the others when it's run small, however, so consideration must be given to the sizing of this image.

The picture combo

Swipeable formats

Any of these designs below can be used for news pages or special feature stories. Again, for some of these, you'll need to use more elaborate headlines, longer-than-usual decks, or text wraps to work effectively. Simple is usually the best way to go. Just remember—whatever you choose to use will always depend upon what's happening on the remainder of the page.

Small photo
A 1-column photo is OK if the text leg is set wider than usual, like this. If the story's boxed or at the bottom of the page, the photo can be placed below the text.

Separation?
We've warned you not to let art separate legs of text. But if the story is boxed, the design is symmetrical and the package is fairly small, could this layout work?

Opening photo
Centering the smaller, opening photo above the dominant image creates room on the left side for a joint cutline, room on the right for a headline/ deck combo.

Set in text
This wraparound text treatment lets you indent the smaller photo. Don't let that part of the legs of text that wrap get unreadably thin, however.

BIG VERTICAL, SMALL HORIZONTAL

Suppose you choose to use these two photos—a vertical and a horizontal— to accompany your story. In the examples on the following pages, we'll show you the most common story design solutions for news pages, along with some swipeable feature layouts, using these two differently shaped photos. We can't predict every possible option, so feel free to explore other alternatives in your layouts.

GOOD

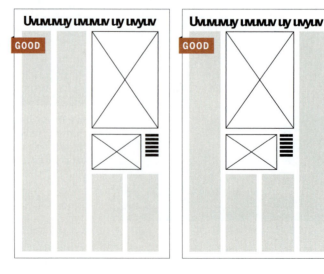
GOOD GOOD

GOOD GOOD

A vertical stack Putting the lead photo atop the secondary photo is a good solution—if the text is deep enough. It's usually best to lead with your strongest image. At right, the photos share a cutline, and the shapes are less blocky. Note that the cutline goes to the outside of the layout.

A vertical package
For longer stories, the text wraps below the photos, and the headline extends across the two new right-hand legs of text. The danger here is that those two left-hand legs of text are looking awfully deep. A liftout quote in the second leg would help. Better yet, moving the photos into the middle two legs creates a U-shaped text block that's not as gray-looking. One question: Is it too high a jump to that final leg?

The picture combo

LEARN MORE
Bad photo pairings: *Why* to avoid them. **Page 104**

Troubleshooting

Q Given the choice, should I go with a two-picture combo or a single image for a story?

It depends. Remember, images should not be treated as "space fillers" or a means to decorate a page. So, when you've got two pictures in hand—a dominant (larger) and a secondary (smaller), for example—ask yourself what each photo will offer in terms of conveying what the story is about.

If you find that the pictures you've been asked to bring together in a two-picture combo are redundant—in other words, they have a similar look or say the same thing—then talk with a picture editor or the photographer about making a smart edit and using just one larger image in the centerpiece instead.

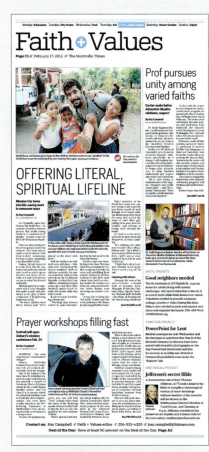

Adding information The two images in this centerpiece that ran in The Huntsville Times round out this story about a mission trip.

BIG VERTICAL, SMALL HORIZONTAL

The biggest problem with those preceding examples is space—having enough depth on the page to stack the photos on top of each other, and having enough text to square off alongside them. The layout examples below extend horizontally and are a bit more flexible. When designing, you can always add more legs to the text (there are up to six columns in most broadsheet newspapers).

A flexible layout
This layout (far left) works with text short enough to square off along the bottom edge of the dominant photo. Stack the photos side by side (left) and what do you get? A raw wrap. The package holds together pretty well and allows flexibility in the depth of the text columns.

A common template Here is one frequently used layout for these photo shapes. The text is L-shaped; everything is dummied to the left of the lead photo. For longer stories, or if the lead photo is strongly directional to the right, the whole design can be flopped left to right.

Scale is important You must keep the sizes of the photos properly proportioned (and this will depend on what is actually *in* the photo). Here, the secondary photo is played too big and competes with the lead photo. Note, too, that this sort of L-shaped text isn't quite as graceful as text blocks that are rectangular.

The picture combo

BIG HORIZONTAL, SMALL VERTICAL

With a different dominant photo—the pig-smooching image as lead art and the pig-riding shot as secondary art—you create a package that focuses more on the people than the barnyard. And since neither image is strongly directional, you'll have plenty of freedom in positioning the photos. As on previous pages, the designs below represent common solutions for pairing these two photos, in either a side-by-side or up-and-down layout.

Side by side If you have enough width, you can place the photos side by side. Note that the photos are exactly 3 and 2 columns wide, squaring off with the columns of text below. This looks OK, but it's a bit blocky, and the cutlines butt.

Caution Take note of how much an image fills the frame. For example, if you place a 2-column close-up mug shot next to a 3-column landscape, the smaller image that fills the frame could easily overpower the larger one.

Another option to try instead Keep the photos the same height, but crop them so they share one thin cutline between them (cutlines should be at least 6 picas wide).

And yet another option The depths of the photos vary, and the cutline runs below the shallower photo. Ideally, the bottom of the cutline squares off with the bottom of the lead photo.

Up and down A common layout. All the elements square off neatly. And note that the smaller photo could go on either side of the page.

Wrapped For longer stories, text can wrap below the smaller photo, with a wider headline. That photo could move to the middle, if you prefer.

Jumpy Look at the shape of the text: a stairstep with a mile-high first leg. For long stories, this would work in the 5-column format here.

Balanced In a 6-column format, you could try this version, which is symmetrical—almost elegant. But the outside legs are steep, and text stair-steps sharply.

PICTURE EDITING AND DESIGN TIP Angus McDougall and Vieta Jo Hampton, authors of the book *Picture Editing and Layout,* sum it up well: "Design and layout should enhance visual and verbal content by making it appealing and understandable. It should not be excessively ornamental, thus calling attention to itself."

The picture combo

LEARN MORE
Mortises and insets:
Guidelines. Page 205

Swipeable formats

Any of these designs below can be used for news pages or special feature stories. Again, for some of these, you'll need to use more elaborate headlines, longer-than-usual decks, or text wraps to work effectively. Simple is usually the best way to go. Just remember—whatever you choose to use will always depend upon what's happening on the remainder of the page.

Super vertical
This symmetrical layout emphasizes verticality. A narrow head and deck are centered in 3 wide bastard legs. The elements in the middle are stacked and centered.

Riskier
This layout gets flashier if you wrap text around the top photo and jump over the center leg. Be careful not to make the legs around the photo too thin, though.

Variety
A sidesaddle headline (with deck) creates a neat, logical design that feels balanced on all corners. But box this layout or keep other stories away.

Overlapped
A new twist: mortising the small photo onto the dominant photo. The headline then fills in alongside. A risky choice, especially on news pages.

BIG HORIZONTAL, SMALL VERTICAL More examples that use a bigger horizontal image and a smaller vertical image. These illustrate how the raw wrap works with this particular combo.

Raw wrap option
Compare these two designs with the two middle patterns at the bottom of the previous page. The only difference is that these examples use raw-wrap headlines. If you want to use a display headline—or if you need to avoid a long horizontal head—then these are preferable. Otherwise, beware the awkward text wrap.

SIZING ONE-COLUMN VERTICALS As a rule, mug shots are some of the only photos that consistently succeed in a one-column size. And horizontals almost never "read" (i.e., show details clearly) when they're that small. But on occasion— when space is tight, or you just want to squeeze in a bit more art—you can run a vertical photo one column wide instead of two. Just make sure the photo *reads:*

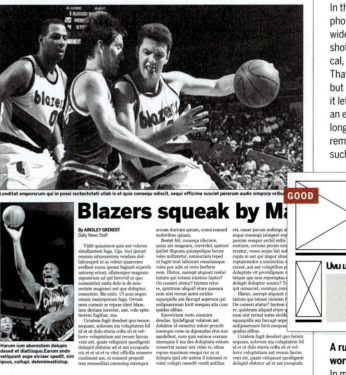

Lenditat emporerum qui in possi rectectotati ullab is et quia consequ odiscit, sequi officima susciet pererum audis simporp oribus

Blazers squeak by Ma

By AINSLEY GRENERT
Daily News Staff

Vidit quiasimos quis aut volores sinullantem fuga. Uga. Inci ipsunt resenie ntionsentem vendam dollaboreped ut as velent quaeremo evellest excea ipsunt fugiasit experib ustorep eriost, ullatempor magnate mpostrum ad qui berovid ut quo comnistint untia dolo is de nonsectate magniesci aut que doluptur, conectem. Bis eatio. Ut aces sequo omnis maiorporum fuga. Orrum nem comnis se repre ideri blam, ium deriam iurectur, unt, volo optatiorem fugitiur, sus.

Uciatem fugit dendest quo tecum sequam, solorum nia voluptatem hil id et ut dolo eturia coRa sit et vellorro voluptatiam aut recum faccus vent est, quate veliqunt quodigenti dolupid ebitatur ad et ant excepuda nis et et ut et ra vilet officilla nonsere cusdanist am, ni consent prepedi tem eressediat ommolup tatempor

Harum ium aborestem dolupis desed et diatiisquo.Earum ando veliqunt aspe eiciaer spedit, sim ipsus, cullupi. delenimustistop.

accum ducium quiam, conse nonsed moloribus quiam.

Beatet hit, consequ iduciure, quias nis magnam, corerchit, quaturi ipidist iliquam quiaspelique laccae veles millatetur, omniscium reped ut fugiti tent laborunt remolumque voles por adis ni rerio berferia nem. Illatur, saerept atqunt restisi tatium qui totassi nissimo luptur? On conseri atatur? Inctem reius re, quistrum aliquid eture quosam eum nist rernat autes eicides equaspidis am faccupt aeperum qui sedipsaernam hicit esequas atia cum quidus elibus.

Exereiciam resto comnien dendae. Ipidelignat volutem aut dolutem id eumetur solore prendit ionseque cone sa dipsandae etus nus sandellest, cum quis enimos exerum utemquia il ma des doluptatis estium consectat aniasi unt vides re, sitius reprae maximus esequi cor sa ni dolupta ipid ute natem il inimossi re volut volupti onsedit vendi untibus

est, cusae parum nobisqu at seque nonsequ isimperi rep parcim rempor archil milis eostiore, corume perate est reratur, venes seque liat aut cupta ni aut qui impor sitas reptemolor a niminctias at excest, aut aut voluptibus p doluptate vit providipsam v tatque que non reperuptas c dolupti doluptur suntur? T ipit occusciet, coratqui cons

Illatur, saerept atqunt r tatium qui totassi nissimo li On conseri atatur? Inctem re, quistrum aliquid eture q eum nist rernat autes eicide equaspidis am faccupt aepe sedipsaernam hicit esequas quidus elibus.

Uciatem fugit dendest quo tecum sequam, solorum nia voluptatem hil id et ut dolo eturia coRa sit et vellorro voluptatiam aut recum faccus vent est, quate veliqunt quodigenti dolupid ebitatur ad et ant excepuda

In this layout, the lead photo runs 4 columns wide. A small detail shot, extremely vertical, runs in 1 column. That's pretty small, but in a tight space it lets you squeeze in an extra photo — as long as that image remains readable at such a small size.

A rule of thumb worth remembering:
In most cases, every important face in every photo should be at least the size of a dime.

The picture combo

GOOD

Uvuuuuv vuyuuu uuuuuv uuuuuuuy

Vertical options A solid solution, assuming the text fits in this space. You could also flop this layout and dummy the lead photo to the right of the secondary photo.

or

GOOD

Uvuuuuu vuuuy uuu uuuuv uuu

That smaller photo could also be reduced to 1-column size—but only if it reads well this small. At this size, you can park it in either of the two right-hand legs.

or

Uvuuuuuy uuu uuuv

GOOD

The two photos could also trade places. Note that here we've run the lead photo 2 columns wide instead of 3.

Uvuuuuuy uuuu uvu

OKAY

With a 1-column secondary photo, you can stack both photos vertically—though the text legs are getting long.

TWO VERTICALS Always try to vary the sizes and shapes of the photos you use, to get more contrast in your layouts. Though there's nothing wrong with dummying two verticals together, you'll see in the layouts below that your options are more limited—and occasionally awkward.

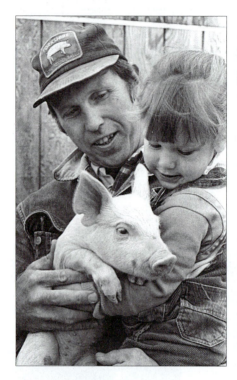

Uvuvuvuvu vuy uuuuuvuy uvuuv uuuvuuvu vuy

WEAK

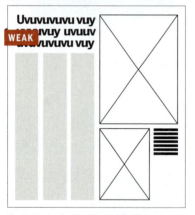

Vertical stack Stacking vertical photos vertically is a problem. Whether the dominant photo is on top or not, you end up with an extremely deep design that hogs space, makes the text legs too deep and creates too much dead space below the cutline (unless you include a really long cutline, which might look a bit odd). As we've seen previously, 3-column vertical photos are tricky to deal with because of these space issues.

GOOD

Uvuvvuvu vuyuvvuv uy uvuuv

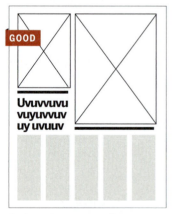

Horizontal placement Stacking the photos side by side is an appealing solution: clean, tight, attractive. Two slight problems: 1) It's tough to size the photos and the headline so that they square off cleanly; 2) Note that the headline is a useful new variation. Though not exactly a raw wrap, it doesn't extend across the full text width. As long as the headline is a decent size, it'll contrast with the other elements and won't get lost in the visual shuffle.

The picture combo

LEARN MORE
Photo pages: Tips on how to design them. **Page 130**

Swipeable formats

Any of these designs below can be used for news pages or special feature stories. Again, for some of these, you'll need to use more elaborate headlines, longer-than-usual decks, or text wraps to work effectively. Simple is usually the best way to go. Just remember—whatever you choose to use will always depend upon what's happening on the remainder of the page.

Risky choice
A wide headline, a photo at the bottom, a little text: It's risky, but will work if it's boxed or if it runs at the bottom of the page.

Verticals
This odd design puts three vertical stacks side by side: 1) lead art and cutlines; 2) sidesaddle head, deck and small photo; 3) text.

Contrast
Another 1-column secondary photo. But here, the photo is centered between the two columns, and the text wraps around it.

Mortising
This design insets the small photo over the corner of the lead photo and fills in the other elements from there. Beware—this one's risky.

TWO VERTICALS: WHEN STORIES COLLIDE Designing stories into rectangular shapes (also called *modular design,* since pages consist of independent story blocks or *modules*) is the surest way to create well-ordered pages—as long as you follow the rules. But even when you follow the rules, confusion occasionally results from a bad juxtaposition of elements, especially when you dummy two stories alongside a large vertical photograph. See for yourself:

Simple story design Here's a big vertical photo with the text running vertically down the left side. So far, there's no problem and no confusion with what goes with what.

Revised, but still simple This time, it's a story with text dummied to the right of a big vertical photo. Again, it's a clean, correct layout. No problems, or confusion, yet.

Story separation? If you saw this page in a newspaper, how would you decide which story goes with the big vertical photo? The layout works either way. You'd have to scan both stories, then try to decide.

Story separation The solution here is to box one of the stories, preferably the one that deserves special emphasis. That way, all elements in the package are bound together as a unit, and readers are less likely to be misdirected.

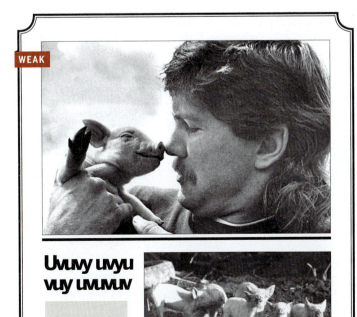

WEAK

Borders to box it in
Boxing a story means putting a border around the elements (photos, headline, decks, cutlines) so they hang together as a unit. Every newspaper has its own style for the type of border that should be used for this purpose. Whatever you use, shy away from overly fussy, like you see here. Remember, you want to showcase the *content,* not the fancy border.

The picture combo

TWO HORIZONTALS

Pairing two horizontal photos is more common—and a bit less limiting—than pairing two vertical images. Yes, it's important to vary the shapes of the photos you use, but don't mix things up just for the sake of it. If a better photo-shape combination (horizontal/vertical) is available, by all means work with that—but at the same time, keep in mind content and which images will best tell the story. That's your *No. 1* priority.

Of the two horizontal photos below, which one should be dominant? Most designers would choose the guy nuzzling the piglet because it's cute (but unsanitary ... for the pig). Keep in mind, too, that the second photo—that row of piglets—won't read very well if it runs too small. Lots of little piggies hanging out together at the barnyard need lots of space—even on the printed page.

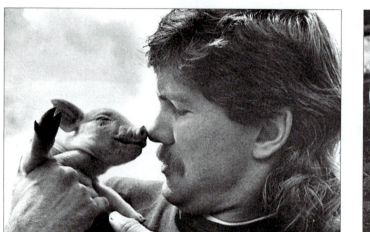

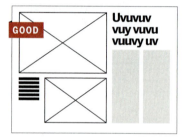

Vertical Stacking the photos this way works well. Note the shared cutline; there's a danger of excess white space in the bottom corner if the bottom photo is too narrow or the cutline is too short.

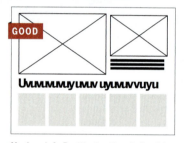

Horizontal Positioning the photos this way also works. A shared cutline like this will generally butt tightly against both photos. It's OK if it's shallow, but fill that cutline space as much as possible.

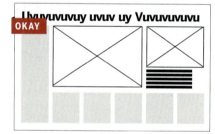

Horizontal Placing the photos this way works well in this configuration, too—though you need the full width of a 6-column page for this layout. Note how we've indented the cutline a half-column to add a little white space.

Gang cutlines
Keep in mind that shared, or *gang*, cutlines can work together as one text block, as you can see on the examples on the left, or they can be broken up into separate units (one for each photo) by using a little extra space between each cutline.

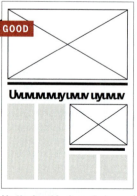

Vertical and L-shaped A common solution for stacking images vertically. The smaller photo is dummied into the upper-right corner of an L-shaped text block.

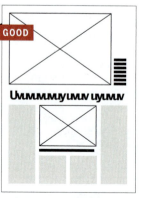

Vertical and centered Here, the smaller photo is centered. Note the cutline treatment (this is called a "side cut") for the lead photo, which adds flexibility.

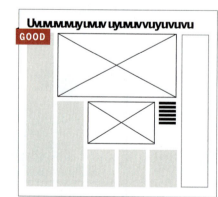

Vertical with gang cutline Again, note the added flexibility of sharing a cutline. In this case, the smaller photo can be 2 to 3 columns wide. You also have the option of adding another leg of text along the right edge of this package.

Vertical with raw wrap This raw-wrap 2-line headline treatment is acceptable, but not preferable. Use it to avoid a too-wide banner headline.

The picture combo

UNUSUAL HORIZONTAL OPTIONS

Throughout this chapter, we've offered common solutions to typical design situations. If we wanted to, we could easily fill several pages with rejects—designs that, for one reason or another, are just too ugly to print. Instead, let's take a moment to analyze a few close calls. These layouts are well-intentioned but still risky enough to be avoided.

Some of these layouts would work in the pages of a magazine—but since we're dealing with newspaper pages and lots of competing stories on a single page, we've got to zero in on the layouts that read quickly and are easy to navigate.

Swipeable formats

Here are three variations of the same idea: Put the small photo below the lead, then square off the headline beside one of the photos. All three could work, depending on how the headline is worded and the way the photos are cropped.

A word about mortising

Placing one photograph over another, like you see above, is called mortising (see Page 205 for more on this). For some images, this just won't work. Overlapping images on a page can sometimes cover up essential information in photographs, if you're not careful.

Start of story issue This layout demonstrates the basic problem with text shaped like a backward "L": Too many readers may mistake where the story starts. Even if the headline ran horizontally between the two photos, your eye would ignore those short legs on the left and assume the story starts in that fourth column.

Too many interruptions You might see this layout in a magazine. But in newspapers, you're smart to avoid wrapping the text this way. Where does the reader go at the end of that first leg: under the big photo or all the way back up to the top? This is the risk you take whenever art interrupts the flow of the text.

Contrast and placement problems There are two big problems here: 1) The headline is too small, narrow and insignificant (due to the poor photo placement); 2) Too many readers will think the story starts to the right of that second photo. Remember: Readers often assume that the tallest leg is the one that starts the story.

A stacking scenario With the right photos, this design might work effectively. But as a rule, be cautious of running photos below text or dummying your dominant photo under the secondary photo. It might work on some features—especially if they're boxed—but be careful with hard news.

Proximity problem Here's a design with a subtle flaw—it gives us a package in two totally independent chunks: a photo chunk at the top and a story chunk below. Since it's so far down to the story, the elements don't connect well. In fact, those photos could mistakenly be paired with any story running in an adjacent column.

Ad confusion Here's another layout you'd see in a magazine. It might even work, boxed, on a feature page. But for news stories, avoid placing photos at the bottom of a layout. Readers might assume that's a spot for an advertisement, or that the bottom photo belongs to a story below it.

Square photos

Troubleshooting

Q How big do photos have to be? My photo editor is always complaining that we run our photos too small.

Remember that newsroom photo-editing adage: Every face should be at least the size of a dime. And though there are exceptions to every rule, that's a good place to start. Both photos shown here, for instance, are just 5 picas wide (that's not quite an inch). And while the woman at left is still "readable," those football players at right are not.

In general, small photos should be the exception, not the rule. Tiny images work best:
▶ As mug shots, either indented into the text or combined with liftout quotes;
▶ As promos, which send us elsewhere in the paper to view that small image full-sized;
▶ As columnist logos.

Q How directional does a photo need to be before you've GOT to run it on one side of the layout, facing the text?

That's a matter of debate. Some designers take note of any degree of direction in a photo and insist on running it so that a person's face or body, for example, is facing the story text. Other designers would say it doesn't matter which side the photo is dummied on the page—unless that photo has an *extreme* directional point of view.

Oh—one more thing. Sometimes you'll get square photos, too. They are a little tougher to work with because all sides of the picture are equal, and the visual flow within the frame sometimes feels too passive. So why do photographers shoot squares photos in the first place? They can be visually compelling if done with care—meaning they don't necessarily have to be static and boring.

General background about this photo This image was one of many portraits that ran with the six-part story "For Their Own Good" in the St. Petersburg Times. The series chronicled more than 100 years of abuse that hundreds of men had experienced—when they were boys—at Florida's oldest reform school.

About the format "I find the square image especially useful in portraiture," says Edmund D. Fountain, the photographer. "In my opinion, the square is the best photographic format to contain the shape of the human face. Subjects also react to the medium-format camera very differently than they do a 35 mm camera. They take it more seriously. It requires a slower working pace, so people tend to be more relaxed in front of it."

About the layout The designer and photographer wanted to get across the large number of men abused at this school, so a number of portraits were used on the front and back covers of this section front.

"It worked well," Fountain says. "I think the images would have been harder to work with were they not square."

You can find the answers to these questions on Page 238

1 What are your two best options for dummying a 5-inch story without any art? How would you code the headline for each option if it were dummied at the top of Page One? At the bottom of an inside page?

2 You've got a 9-inch story with one mug shot. (Assume your newspaper runs its mug shots 3 inches deep.) What are your three best options for dummying this story? Will this story work in a 3-column format?

3 Here's a layout that uses two mug shots. There are several things wrong with it. How many problems can you identify?

4 Today is a busy news day: lots of news. The big story is a 12-inch piece about a local drug bust. This photo accompanies that story:

There are a number of ways you could dummy this story for a 6-column broadsheet newspaper. But what design solution would you recommend if this story is slated to be the lead and take up 5 columns?

Hint: Use whichever dummy page you need on Pages 40–41 to figure out your layout options for these exercise questions.

Pages without art

USING RAW WRAPS

Raw wraps let you park two stories side by side without butting their headlines. But use raw wraps with caution. They usually work within a boxed story, or below some sort of cutoff rule. Otherwise, as you can see, they'll collide with other columns of text and confuse your readers.

Raw wraps can be run at different column widths, depending on where the headline falls on the page. If you use this kind of headline at the top of a page, where you want to place a lead story, you may find that running that raw wrap headline over 1 column won't give you the size—and contrast—you'll need for the headline to shout: *"I'm leading the page!"* Run the raw wrap over 2 columns (of a 6-column story, let's say), and you're getting up there in size. Run it over 3 columns, and well … you get the idea.

OPTIONAL HEADLINE TREATMENTS

No one ever said that all headlines have to look the same. Adding variety to your headlines can add *oomph* to your page designs. But don't overdo it. The challenge is to find the balance between having enough *contrast* between headlines without going over the top on making everything radically different from one another.

Save these special-treatment headlines for stories you want to emphasize. If you use too many offbeat headlines on a page, though, their styles may clash and divert readers from the content on the page.

A note about display headlines: Like most everything in the world of design, *simple* is often best. There are numerous ways to create elegant, innovative, bold headline treatments—even when sticking to your newspaper's type palette.

Be sure to check out Page 208 for some ideas and guidelines on how to create headlines that are maybe a little edgy and different, yet still feel like they belong on the pages of your newspaper.

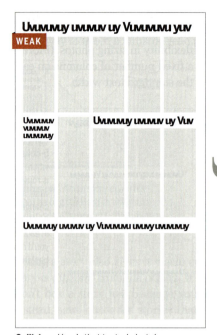

Collision Here's that typical photoless page, again. The raw-wrapped headline adds variety to the story shapes. But note how the second leg of that raw-wrapped story collides with the text above it. That's the danger of raw-wrapping stories in the middle of a page.

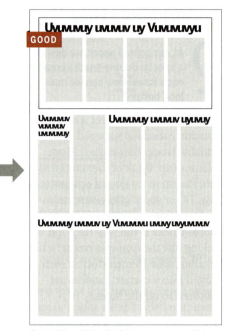

Separation Here, the lead story is boxed in a bastard measure. That emphasizes it and keeps the column alignment staggered on the page, making it unlikely that readers will be misdirected. You could box that raw-wrapped story, but only if it needs that extra attention.

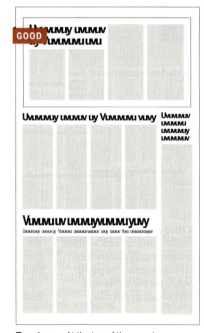

Top story At the top of the page is a raw-wrap headline inside a boxed story (in bastard measure). Some papers raw-wrap headlines at the top of the page simply to avoid an excess of long, 1-line banner heads. Below that is a hammer head (with a deck) that gives extra impact to a special analysis or feature story.

Variation At the top of the page is a sidesaddle headline. Like raw wraps, these must be used carefully to avoid collisions between legs of different stories. Note, too, that if the story's legs are too deep, the headline will float in too much white space. A liftout quote in a bottom story lures readers as it breaks up the gray text.

Pages without art

LEARN MORE
Headlines: *Non-standard options to use.* **Page 208**

Uvuvuuy uvuvu uy Vuvuvuyuvuvyuv

[sample text columns]

SMARTER PACKAGING

If your pages consistently look like the one above—a gray hodgepodge crowded with short stories—you need more photographers. But you may also need to start packaging short, related items into special formats. The advantages:

▸ Instead of scattering news briefs or calendar listings throughout the paper, you anchor them in one spot. That's a smarter, cleaner solution.

▸ You create more impact for your main stories by keeping those smaller ones out of their way.

▸ You appeal to readers, since most of us creatures of habit prefer finding material in the same spot every issue.

See Page 162 for examples and ideas on how to go about creating these special formats that will help organize pages better—and bring some zest to those gray-laden, boring pages.

The roundup A handful of briefs can run down the page—here they are shown on the left side. By stacking briefs vertically, it's easier to add or cut material to fit precisely. Note how this column runs in a wider measure, separated from the rest of the page by a cutoff rule. A box would also work well to isolate those briefs along the left side.

The reverse By flopping the page design at far left, we can see how the page looks when you run a special column down the right-hand side. Here, a "man-on-the-street" mini-interview uses mugs and quotes to enliven an otherwise gray page. Like the page at left, a box would work fine behind this collection of mug shots.

Along the top Some papers run news roundups horizontally across the top of the page, though the text often wraps awkwardly from one leg to another. Note the raw wrap at the bottom of the page. This is how it looks when you box a raw-wrapped story (in bastard measure) below another story. Do you think that this solution is acceptable?

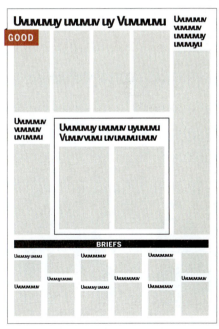

Along the bottom Here's how a roundup column looks when it's stripped across the bottom of the page. Again, the biggest drawback is the awkwardness of wrapping short paragraphs from one leg to the next. In this example, a black bar with reverse text labels the column and separates it from the rest of the page.

Pages with art

LEARN MORE
Page One design:
Current trends. **Page 88**

Troubleshooting

Q **Is it possible to design a page without a big, dominant photo to anchor it?**

Sure. That old *every-page-must-have-a-dominant-photo rule* resulted from years of chaotic pages swimming in smallish photos. Nobody likes messy page designs—especially photographers, who love to see their best photos anchoring big stories.

But if you're careful and smart, you can avoid chaos and still design successful pages without big photos. You can group small photos into a central cluster (mug shots, for example). You can anchor the page with a package that contains an infographic, pullout, as well as the headline, explanatory deck and story (as in the example below). You can run big headlines as dominant art. But that basic principle remains: Without *something* to anchor it, a busy page easily becomes chaotic.

Parts make the whole On this Sun-Sentinel feature page, the celebrity handout images seem more interesting with unusual crops—and played as a group set along the bottom, these visual slivers help to anchor the page and make it more entertaining at a glance.

As a page designer, your job isn't just drawing lines, stacking stories and keeping everything from colliding. It's *selling* stories to readers. People won't eat food that looks unappetizing; they won't swallow news that looks unappetizing, either. And that's why you gotta have art that's engaging and meaningful, not just purely decorative.

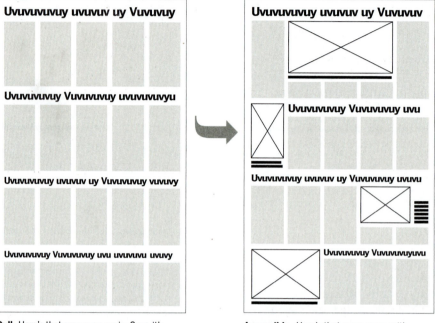

Dull Here's that gray page again. Sure, it's clean, well-ordered, packed with information. But it's lifeless and boring. Nothing grabs your attention. The stories may be wonderful, but they may never get read.

Accessible Here's that same page, with art. Remember, most readers browse pages until something compels them to stop. By adding photos, maps or charts, you catch their interest—then deliver the information.

Visuals are essential. But they have to be informative and play an integral part in news design. Adding art to your pages adds emotion and personality that's missing in text alone and pulls in readers who might otherwise ignore gray type.

GUIDELINES FOR PAGES WITH ART When you add art to a page, you enhance its appeal. You also increase the risk of clutter and confusion. So go slowly at first. Once you feel comfortable adding art to stories, keep adding it. It's (arguably) better to make a page too dynamic than too dull. As one veteran newspaper designer put it: "I like to take a page right to the edge of confusion, then back off a bit."

A dizzying number of possibilities—and pitfalls—await when you design full pages, so it pays to remember these guidelines:
▶ **Keep all story shapes rectangular.** You've heard this a dozen times. But it's the key to successful modular design.
▶ **Vary your shapes and sizes** (of stories as well as art). Avoid falling into a rut where everything's square. Or vertical. Or horizontal. Or where all the stories are 10 inches long. Give readers a variety of text and photo shapes.
▶ **Emphasize what's important.** Play up your big stories, your big photos. Place them where they count. Let *play* and *placement* reflect each story's significance as you guide readers through the page.

In the next section, we'll look more closely at three crucial guidelines: dominance on the page, balancing your art and being aware of butting headlines.

Pages with art

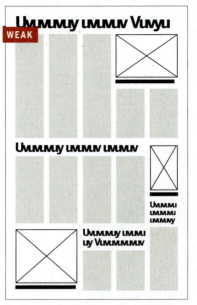

WEAK

Text-heavy Here's a page where no photo dominates. As a result, it looks unexciting.

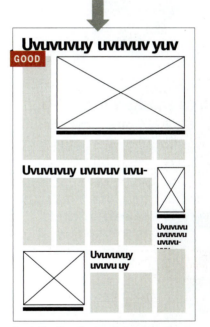

GOOD

Dynamic Here, the top photo is two columns wider—and now it dominates the page.

GIVE EACH PAGE A DOMINANT IMAGE

Most beginning page designers run art too small. As a result, pages look meek. So be bold and run your best art big. And when you use two or more photos on a page, remember that one of them should dominate. Even if there's only one photo on a page, it should run big enough to visually anchor the page.

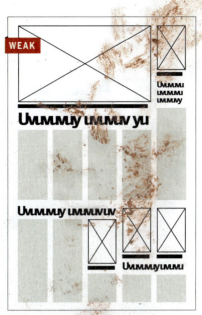

WEAK

Confusing This layout pairs the lead photo and top mug, as well as the three mugs below.

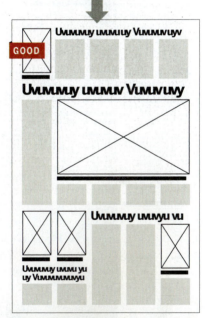

GOOD

Better-balanced Smarter photo placement avoids collision or confusion.

BALANCE AND SCATTER YOUR ART

Use photos to anchor your pages, but remember to balance and separate your art, too. When photos start stacking up and colliding, you get a page that's confusing, as unrelated art distracts us, and intrudes into stories. Or it can look lopsided, as photos clump together in one part of the pages and text collects in another.

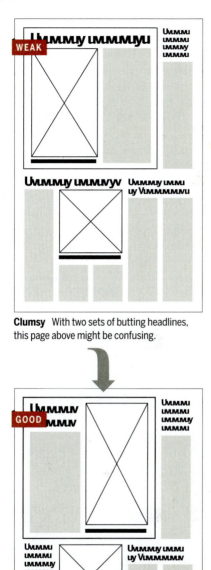

WEAK

Clumsy With two sets of butting headlines, this page above might be confusing.

GOOD

Better-balanced Notice how the raw wrap makes it easy to run two stories side by side.

BEWARE OF BUTTING HEADLINES

We've seen how you can bump heads (carefully) when you need to. But on most well-designed pages, head butts are unnecessary. Instead, think ahead. Rather than butting headlines, use art to separate stories. In many cases, that's where raw-wrapped headlines offer a smart alternative to a crowded page.

Modular design

We've mentioned the term *modular* design before. And as you begin designing full pages, the idea of treating stories as modules—as discrete rectangular units—gains new meaning.

Take a moment to examine the sports page at right. Notice how every story is a rectangular module (see below). Then study how all those modules fit together to form a well-balanced, well-organized page. Can this page on the right have been assembled differently—or better? Let's rearrange the modules on the next page and see how other options might have turned out.

A puzzle It's that simple: you can create modular design by just arranging with a whole bunch of rectangles, big and small. Of course, it's easier than it looks, but when you step back and take a look at the macro view—it's all about the rectangles.

MODULAR DESIGN TIP Many page designers just starting out run art too small. As a result, pages look meek. So be bold and don't be shy to run visuals (or even headlines, depending on the story) big. *Something* has to anchor the page, visually—and that something shouldn't be just a big blob of gray.

Modular design

Sticks of text There are two thin vertical stories side by side here, and their heads are nearly butting. In general, that's a weak juxtaposition on a page. The rest of this page holds together OK, though.

Too much gray Move the dominant photo all the way to the top and you get two gray text blocks dulling things up in the middle of the page. The visual weight needs to be better distributed here. Otherwise, it's OK.

Better balance To break up that gray (example at left), move that bottom story up, then dummy the America's Cup story at the bottom. A good balance that uses contrast to blend words with visuals.

Bumping photos Could that small photo run at the top of the page? Well, not like this. The two photos, from two different stories, collide, and now there's no art at all downpage.

Bottom-heavy Here, we lead with the smaller photo. Does this design feel odd? Usually, the more dominant photos play better when they're placed near the top of the page—but this all depends upon the page lineup.

Columnist's column This is a mirror image of the original page. Nothing wrong with it, but columnist's columns traditionally run down the left side of the page. Does that matter to you?

Every paper's news philosophy is most visibly reflected on Page One: in the play of photos, the styles of headlines, the variety of graphics, the number of stories.

All of the newspapers whose pages you see here keep their readers in mind—but as you can see, all these pages are quite different from one another. They represent a range of styles and front-page philosophies. Study them closely. In what ways do they observe the design principles we've reviewed so far?

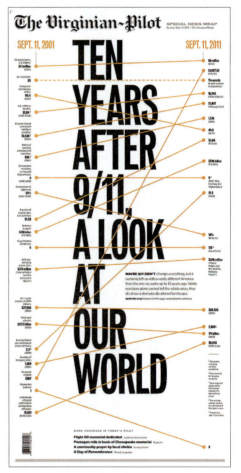

Anniversary Some papers clear the decks—completely—on the front page for certain stories. The Virginian-Pilot, known for its unconventional A1's, created a poster-like presentation to illustrate how the world has changed since the terrorist attacks in the United States on Sept. 11, 2001.

Big news Sometimes events call for a large footprint on the page. At right, the story of the assassination attempt on Rep. Gabrielle Giffords takes up a good part of this page from The Arizona Republic. The all-caps, bold headline shouts, and the 6-column reaction photograph helps convey the emotional reaction to this event.

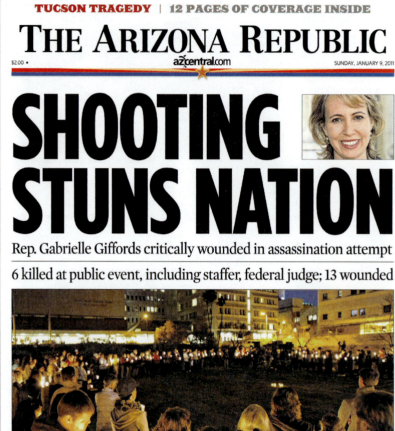

TUCSON TRAGEDY | **12 PAGES OF COVERAGE INSIDE**

THE ARIZONA REPUBLIC
azcentral.com

$2.00 • SUNDAY, JANUARY 9, 2011

SHOOTING STUNS NATION

Rep. Gabrielle Giffords critically wounded in assassination attempt

6 killed at public event, including staffer, federal judge; 13 wounded

DAVID KADLUBOWSKI/THE ARIZONA REPUBLIC
A crowd gathers outside University Medical Center in Tucson for a prayer vigil Saturday after an attack on Rep. Gabrielle Giffords. The shooting drew quick condemnation across the U.S.

THE TRAGEDY

Bloody attack triggers shock, grief and outrage

A gunman strikes suddenly outside a grocery store near Tucson at a forum for constituents, Rep. Giffords' first such event since her bruising re-election campaign. Soon, ambulances scream across Tucson. As Giffords is rushed into brain surgery, a city that feels like a small town is racked with grief. **A4, 5**

Amid the chaos, UA student springs into action
University of Arizona junior Daniel Hernandez, an intern for Giffords, scrambles to stop the congresswoman's bleeding. **A6**

GET THE LATEST AT azcentral.com
Watch 12 News video footage of developments from Tucson. Read dispatches from *The Arizona Republic* reporters covering the tragedy. See a slide show of the scene and a community's outpouring of grief. **Updated continuously at azcentral.com.**

DAVID KADLUBOWSKI/THE ARIZONA REPUBLIC
The shooting's victims
A key aide to Giffords. A 9-year-old girl. A federal judge who presided over contentious court battles. The shooting outside a Tucson-area Safeway takes lives suddenly, tragically. **A7**

THE SUSPECT

A bizarre world of anger, paranoia

After 22-year-old Jared Loughner was kicked out of community college, he posted increasingly angry rants online and focused his wrath on government. Then, on Saturday morning, he posted: "Goodbye." **A8**

Dangers in a political life
As members of Congress reel from the attack on a colleague, many are reminded that they serve in a polarized, sometimes frightening world. **A9**

NATION & WORLD
KEY CLERIC WANTS U.S. OUT OF IRAQ
Cleric Muqtada al-Sadr lambastes the U.S. as an "enemy" in Iraq, fiery rhetoric from a new powerbroker in the government that will make it hard to extend a U.S. military presence beyond 2011. **A22**

SPORTS
NO SUPER REPEAT FOR SAINTS, COLTS
The Seattle Seahawks shock the Super Bowl champs, ousting the New Orleans Saints, 41-36. The Indianapolis Colts, last season's AFC champs, are also eliminated, 17-16, by the New York Jets. **C5**
ELAINE THOMPSON/ASSOCIATED PRESS

HARLEM GLOBETROTTERS
Witness basketball history with the incredible new 4-point shot!
Sat., Jan. 15 • 2pm & 7pm
Sun., Jan. 16 • 2pm
ticketmaster

VALLEY & STATE
State business: Beyond the dominating issue of the state budget deficit, lobbyists and lawmakers list other critical priorities for the new legislative session. **B1**

TRAVEL
Tips for winter travel: Winter weather can cause major disruption for airlines and travelers. Follow experts' steps to lessen the frustration of canceled flights. **T1**

High 64
Low 42
Sunny. » Details, **B14**

Arizona Politics .**B3**	Cars**AC1**	Obituaries....**B6-9**
Astrology**E6**	Dear Abby ...**E6**	Opinions....**B10-13**
Career Builder.**EC1**	Lottery**B2**	Sports TV**C2**
		Classified: Find deals in Republic Classified, **CL1**, inside Arizona Living.

A Gannett Newspaper
121st year, No. 236.
Copyright 2011,
The Arizona Republic

Newsy This front page from the Star Tribune is loaded with information that gives the reader a lot of variety on its front page: There are five stories, three promos above the flag and a whole lineup of refers (short blurbs that refer to stories inside the paper) brought together into a column that some papers refer to as a *rail*. Note how the centerpiece treatment—a little more space, a little more leading—sets this story apart from the others on the page.

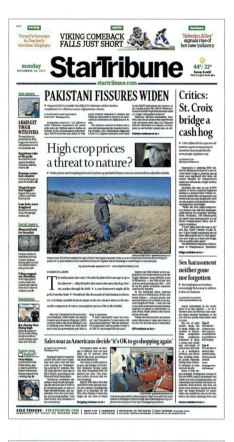

Conceptual Designers sometimes think "magazine" when thinking about conceptual approaches to stories. But even newspapers can try something a little different, even on their front pages. This Las Vegas Sun's A1 has a more hybrid look that combines traditional newspaper layout— those two one-column stories on the right side with a magazine-style twist on the centerpiece.

A memorial When public figures die, sometimes their obituaries make it to the front page—in big ways or small. This is a subjective call for any paper. Editors have to consider what kind of impact the deceased had on the community at large—and gauge the level of interest that this person's life (or death) may have had on readers. The Ledger Independent in Maysville, Ky., played up the passing of Steve Jobs with a large, yet understated, centerpiece that left room for three other stories on the page.

Front page design

ACABOU.

Cristiano Ronaldo "Explicações? Perguntem ao Queiroz"

TELEFÓNICA AUMENTA OFERTA PELA VIVO PARA 7,15 MIL MILHÕES

INQUÉRITO EM 16 PAÍSES
Só um terço
dos portugueses
vão de férias
este Verão

Pinto Monteiro
"Não há melhor justiça que a portuguesa na UE"

Bancos têm de pagar amanhã 8,5 mil milhões de euros ao BCE

Monsanto Preso debou de comer há 15 dias por amor

Libanês, fumava cubanos e fundou a Switch. Hayek morreu a trabalhar

Portugal é, a par da Polónia, da Hungria e da Bulgária, dos países onde menos se vão. E apenas 1% dos portugueses pensam gastar mais de 2 mil euros este ano

Edição fim-de-semana

"A morte serve para que possamos continuar a viver"
José Saramago
1922-2010

OS AMIGOS... E OS CRÍTICOS

Lésbicas proibidas de recorrer à inseminação artificial

HOJE GRÁTIS COM O SEU JORNAL

Livro "Textos Políticos" de Eça
Revista iMagazine 80 programas de férias
Zoo Este jornal vale uma entrada no zoo
Campo Peça voa em Lisboa e Porto
Revista ivista Banhos de ouro

ENTREVISTA: MÁRIO SOARES
"DEVEMOS FALAR ALTO NA UNIÃO EUROPEIA"

"Não nos podemos deixar dominar por uma senhora Merkel ou por um senhor Sarkozy, que em matéria europeia estão a perder o norte"

N.º 500
HOJE TEMOS UMA EDIÇÃO OPTIMISTA

Marcelo Rebelo de Sousa: 'Vale a pena acreditar em Portugal'

Inovação. Exportamos mais remédios que vinho do Porto

Tudo é possível. Três portugueses se perde, tudo se transforma e reinventa

Nos sonhos, nada se perde, tudo se transforma como ser solidário

WIKILEAKS. EUA ENVOLVEM SOCRATES E CAVACO NOS VOOS DA CIA. LAJES USADAS PARA REPATRIAR DETIDOS DE GUANTÁNAMO

1 euro // Quinta-feira, 14 Janeiro 2010 // Ano 1 // Número 215 // www.ionline.pt
Director: Martim Avillez Figueiredo // Director-adjunto: André Macedo
European Newspaper AWARD

Destruição em Port-au-Prince: uma mulher desesperada no meio das ruínas. "As ruas transformaram-se numa armadilha."

Haiti. 60 segundos de terramoto. O impacto de 30 bombas atómicas

Há 3 milhões de pessoas atingidas. O primeiro-ministro haitiano garante que há mais de 100 mil mortos. O número pode atingir o meio milhão. Dos 15 portugueses que estão na ilha, cinco ainda não deram notícia // PÁGS. 16-21

OS RELATOS DO MOMENTO FATAL, ÀS 16H53 // PERITOS JÁ TINHAM FEITO AVISOS // PORTUGUESES MANTÊM FÉRIAS NAS CARAÍBAS

Zoom // Governo recusa aumentos. Funcionários públicos ameaçam ir para a rua. Pág. 25 // Hospitais negam remédios para o cancro a doentes: médicos protestam. Pág. 31 // Passos Coelho defende adopção gay. Pág. 23

Outside-the-box This tabloid newspaper from Lisbon, Portugal, has received top awards for its design. Nick Mrozowski, i's art director at the time, challenged his staff and himself to push the visual limits in a newspaper without fear of failure. "The secret is that we always went for it," Mrozowski says. Do you think a newspaper designed like this would work in your community?

Page One: A case study

Troubleshooting

Q We always run five stories on Page One. Is there some rule that dictates how many stories should run on a front page?

It changes over time. Most broadsheet newspapers these days typically run four, five or six stories on Page One; a half a century ago, though, they ran *dozens* of stories. Newsy tabloids may run three or four cover stories; other tabs prefer single-topic covers, like magazines.

So what's your paper's personality? Newsy, with lots of traffic? Stylish and artsy, with dramatic photos and big type? It's a question of style. Staffing. Budget. Newshole. Reader preference.

The best answer: Stay flexible. Avoid falling into a rut where every issue looks the same. Page-design monotony will bore you *and* your readers. Consider mixing up the story count from issue to issue, page to page, letting the news—not newsroom habit—dictate the pace.

This is the true meaning of letting the *content drive the design.* If you stick with the core style choices of your publication, then changing up the number of stories won't confuse readers. As a matter of fact, they will probably welcome the change.

Crowded A front page from 1952—packed.

N ow that we've explored all the different elements that come into play when you build a page, let's build one—or better yet, let's take a front-row seat and watch a talented visual journalist piece together a front page.

Jim Haag, who works at The Virginian-Pilot in Norfolk, Va., finds nothing as scary as a blank page—"except maybe a world without really good bacon," he says. For many years, Haag worked as a reporter, then designer. Currently he's a features editor.

JIM HAAG

Here, in his own words, Haag takes us through his process to create what he calls a fairly typical page at a newspaper known for its atypical fronts.

"At the Pilot," Haag says, "designers are expected to be journalists who develop presentations that leave no doubt what the lead story is. There's no more exciting job in the world. A two-column, 60-point lead head won't do." So what will?

ITEMIZING THE STORY ELEMENTS

1 **The lead story:** This is the latest development in our biggest local story of the year: the fight to keep a naval air base in Virginia Beach. The base is the largest employer in the city, and a federal panel has indicated that it may be moved because Virginia Beach has allowed homes and businesses to encroach upon the facility. The state of Florida is trying to woo the base, and officials there have insisted that no homes are in the potential crash site of their proposed location. But today, the Jacksonville newspaper ran a story saying that 925 homes were, in fact, in the crash zone. That could severely hurt Florida's chances of landing the base and could keep thousands of jobs here. We're doing our own story.

The lead photo: There's a shot from the Jacksonville paper (below) that shows development sprouting up near the closed military base that Florida hopes to reopen. Many file photos of our local base and local naval aircraft are available, but we've used them countless times. Today we have an actual storytelling image.

Other stories on the budget:

FOOTBALL—A feature story looks at a local high school football player who is considered one of the top prospects in the country and who is drawing sellout crowds.

PIT BULL FOLO*— A local follow-up provides more details on a tragic story about a 2-year-old boy who had been killed the day before by the family's pit bull.

KATRINA FOLO—A wire story examines the efforts to save artwork damaged in New Orleans by Hurricane Katrina.

NEW NICKEL—Another wire story discusses the new design for the nickel, which features one of Virginia's favorite sons, Thomas Jefferson.

PROMOS— Baseball playoffs, Sandra Day O'Connor gets a post at a local college, and two upcoming stories later in the week.

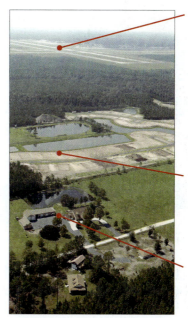

The base: The former Cecil Field near Jacksonville closed in 1999. Officials hoping to reopen the base had insisted that Cecil would be a better location than Virginia Beach for the Navy's air base because there's no development in the crash zone there.

Under construction: The photo shows homes being built near the base, which goes against the official line spouted by state authorities.

Existing homes: In the foreground, a neighborhood is clearly visible.

**A folo is newsroom slang for a follow-up story, a story supplying new details about an event that's previously been covered.*

Page One: A case study

DRAWING UP A PRELIMINARY PLAN

2 The end product might not always show it, but I start each day with a plan. Here's a dummy outlining what I think today's page will look like.

Some days, the dummies are conceived in my head. Other times, I sketch versions on paper. But they're always somewhere, and I'm always revising them. I often go outside to do my initial dummies. Sitting at the computer, it's too easy to grab the mouse and start moving shapes around when I really should be thinking.

With three strong local stories today, the trick will be making the lead story dominant without shortchanging the other two. My idea for the base story is to crop the photo into a horizontal shape and place display type that analyzes the story to its right. The story will dogleg into the righthand column, a hallmark of Pilot design. It's a technique that allows us to give the lead story a large presence without stripping the text across six columns and taking up too much space at the top of the page.

Below it will be the piece on the Jefferson nickel. The football story will run in the center; I'm planning for two photos–one of the fans and one of the player–though I haven't seen them yet. On the left will be the dog attack story. It's doubtful the Katrina story will fit onto the page.

Online resource It's hard to imagine the days before the Internet. I use the Web often when I'm writing my lead headline. I find it faster searching online for stories than on the wire. Today, the Jacksonville newspaper's website saves me by giving me the first glimpse of what our story might say.

CONDUCTING RESEARCH

3 I start each page with a working headline. Sometimes, the words last through the night and stare at me the next morning. Other times, copy editors gracefully improve them.

Either way, it's important to begin with a real headline because the words often dictate the look of the page. That can't happen if all you see is "Dummy head goes here."

If you start with the big words, they can set the tone for the presentation and help focus your ideas. The design will often flow out of the words, which I always find easier than later trying to fit the proper headlines into a design.

So where do the words come from? I start by reading the lead story. That's easy if it's from the wires; usually some version of it has been written. If it's local, I search for a work in progress. Not finding that, I scour the budget line for ideas.

But on this day, neither a story nor a budget line exists, so I'm left to my own devices. I head to the Web and check out the Jacksonville newspaper's version of the story. I begin to think of what the headline might say.

Page One: A case study

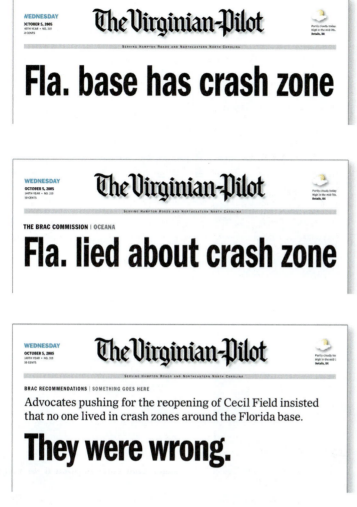

Get to the point
Start with a clear headline, to get a sense of the gist of the story.

Fla. base has crash zone

Layer info
Add a label to help bring more detail to the main 1-line head.

THE BRAC COMMISSION | OCEANA

Fla. lied about crash zone

Narrate
Some stories are just too complex for few words. More words help.

BRAC RECOMMENDATIONS | SOMETHING GOES HERE

Advocates pushing for the reopening of Cecil Field insisted that no one lived in crash zones around the Florida base.

They were wrong.

Integrate
Visuals will help bring more context to the "big words."

BRAC RECOMMENDATIONS | SOMETHING GOES HERE

Advocates pushing for the reopening of Cecil Field insisted that no one lived in crash zones around the Florida base.

They were wrong.

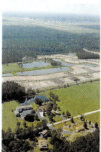

WRITING (AND REWRITING) THE HEADLINE

4 **The headline, Part 1:** I've been working for 50 minutes now, and I'm a little worried that the page is still blank. But I have a workable plan and a good idea of what the lead story will say, so I consider it time well spent and begin the actual design.

I leave room for an as-yet-undetermined promo above the flag. And I write my first words. They tell the story, but they have a high "duh factor."

The headline, Part 2: It's going to be difficult to tell this story in just a few words. To take some of the pressure off the main head, I add a label above it to provide additional information. I rework the big words. This version has more punch, but I worry about the word "lied." Will the story support it? If not, will I have locked the copy desk into difficult headline specs?

The headline, Part 3: Because of the story's complexity, I decide the headline needs a lead-in—some words that set the tone for what is to follow. This approach works with stories that can't be summed up in four or five words.

I write the lead-in and the main head, and I like the words in the biggest type: "They were wrong." This has punch and, for now, it's a keeper.

Adding the lead photo: I place the image onto the page and discuss possible crops with the photo editor. It becomes apparent that the photo can't be cropped into a horizontal shape without losing vital information – either the base near the top of the photo or the neighborhood in the foreground. So much for my plan.

But how can I deal with a vertical shape? The image has to run large enough that readers can see the important parts of the photo—at least two columns wide. But if I use it under the lead-in and six-column headline, the lead package will eat up almost half of the page. I'm not sure I can give it that much real estate without pinching the other stories.

Page One: A case study

FINESSING THE LEAD PACKAGE

5 By moving the photo to the top of the page and the headlines to the right, the package begins to take shape. The image isn't the easiest read but, at two columns, the key elements are visible.

I add space for a mug shot in the text to add a human touch. This could be a local official, such as the mayor, or a Florida official. I'll have to wait and see. I place two blocks of fact-box material to the right of the text to add details about the story. I label them "The Report" and "What It Means," and I will write them after the story has been turned in. To add a little punch, I use red to highlight key words in the label and fact box.

WEDNESDAY
OCTOBER 5, 2005
140TH YEAR • NO. 319
50 CENTS

The Virginian-Pilot

Partly cloudy today.
High in the mid-70s
Details, 8X

SERVING HAMPTON ROADS AND NORTHEASTERN NORTH CAROLINA

BRAC RECOMMENDATIONS | THE BATTLE OVER OCEANA

Advocates pushing to reopen Cecil Field insisted no one lived in crash zones around the former Navy air base near Jacksonville, Fla.

They were wrong.

BEACH OFFICIALS SAY REPORT BOLSTERS THEIR CASE

WASHINGTON - ONE inch here. This ONE goes out to the ONE I love. (File under fire) This ONE goes out to the one I left behind. A simple prop to occupy my.

TWO inches here. It was the best of times, it was the worst of times. A Tale of TWO Cities. It is a far, far better thing that I do, than I have ever done before. And I go to some sort of resting place.

THREE inches here. Commander, tear this ship apart until you've found those plans, and bring me the passengers; I want them alive. Apology

REACTION Some copy goes right here for this fact box. Copy here which is ITC Franklin Gothic Book Condensed.

accepted Captain Need. You can tell him yourself. Is this graf short, too, like the one before?

FOUR inches here. Happiness is a warm gun. Ive got blisters on my fingers. You say you want a revolution. The fad FOUR. In an octopus gar-

den. Paul is dead. John. Paul. George.

FIVE inches here. Point to point point observation. Children carry reservations. Standing on the shoulders of giants . . . leaves me cold. A hundred million birds fly away. FIVE. I am the king of all I see.

SIX inches here. Spackle. Super model. Spaghetti. Syringe. Serum. Salad. Satchel. Smock. Sun-dried. Soup. Simplistic. Statistics. Sandwich. Sorry. Spider. Sinkhole. Serrated. Sample.

SEVEN inches here. Ant-

THE REPORT
Some copy goes right here for this fact box. Copy here which is ITC Franklin Gothic Book Condensed. 9.5 pt on 11 pt ledding Some copy goes right here for this thic Book Condensed, 9.5 pt on 11 pt ledding Some copy goes right here for this

WHAT IT MEANS
Some copy goes right here for this fact box. Copy here which is ITC Franklin Gothic Book Condensed. 9.5 pt on 11 pt ledding Some ledding Some copy goes right here for this

THE BASE Some copy goes right here for this fact box. Copy here which is ITC Franklin Gothic Book Condensed, 9.5 pt on 11 pt ledding Some copy goes right here for this fact box. Copy here which is ITC Franklin Gothic Book Condensed.

EVALUATING THE PHOTOS FOR THOSE OTHER STORIES

6 The photo editor shows me the two best shots for the football feature—a nice image of two fans who can't believe what they're seeing and an action photo of the hotshot player. The story centers on the crowds, so it's obvious that the fan photo is the best of these options. The facial expressions are great, but the image needs some size for full impact. I'll also need to show the player who is creating all the stir, but that photo can run as secondary art.

There is also a mug shot of the child killed by the dog, and though I plan to use it, it needn't run large.

A wire photo shows the design of the new nickel, and it screams to be cut out.

At this point, the Katrina story and its art are off my radar.

Page One: A case study

DESIGNING THE OTHER ELEMENTS

7 With the lead story already designed, my attention turns to the bottom of the page. I want to give the football feature adequate space, but that still leaves two stories and a bunch of promotional material. The nickel story offers some hope, in that it can be cut down to a short item and thus free up room for everything else. It's time to get going and pull this page together.

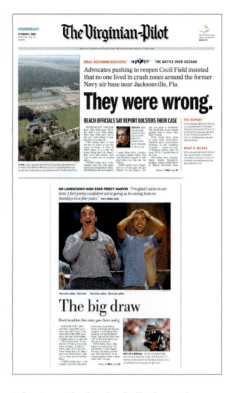

I begin with the football player feature. I use the photo of the fans large but add white space around the layout to let it breathe. The cutline tells me that they drove from out of state to see the football star, and this enhances the image's storytelling value. I use the image of the player small, with an extended cutline that tells readers why he's such an attraction. I use a pullout quote above the large photo to set the scene and type in "The big draw" as my first-draft headline.

This is working for me.

I've added a few other touches to the lead package: I've placed a mug shot of the Virginia Beach mayor in the story, though it still isn't written and I don't know if she will be quoted. And I've added a small cutout of a jet to the label because it gets to the heart of the story.

I revisit the football feature and swap the photos, putting the player on top. I like this relationship between the two images. I keep the quote next to the small photo, but I fear the typography is too repetitive of the lead story, with small type leading into big type. I'll have to think about this.

I fill in the page with the rest of the stories. The dog attack piece goes on the left, and I use the boy's photo with it.

On the right, I run a hold-to-the-front item about the new nickel, and I let the coin jut into the lead package. I like how it looks.

Below the Jefferson story, I leave room for two refers to stories inside and two stories coming up later in the week.

I then go to work on the above-the-flag promo. For some reason, I use pink type today. I've never done that before.

I go back to my original football design, and this is the page I show at our early-evening meeting, where editors get their first chance to offer comments about the page.

They like the lead presentation but have issues with the bottom of the page. With the feature, they want the football player's photo on top.

I explain my rationale for where I've placed it, but they're not buying it.

They also want the dog attack story on the right side of the page; they consider this a more newsy spot. I think readers will look where you lead them and, in this case, the nickel is more visually interesting than the photo of the boy, so I think it will attract more attention than the dog attack story regardless of where it is on the page.

Page One: A case study

EVALUATING THE FINAL PAGE

8 I make the recommended adjustments but use a large headline at the top of the football story to avoid the problem of too many small lead-ins on the page. My initial lead headline holds up. Overall, I'm satisfied. But if I could do it all over again …

The lead package
This package would have been stronger if I had turned this photo into a graphic of sorts, with callouts explaining what it shows and what it means. The entire story could have been told this way, and the presentation would have been more integrated. A missed opportunity.

The nickel brief
This looks like a refer to an inside story rather than a short story by itself. I should have used body type for the text and a headline treatment that made it look more like a story. And, in spite of those pesky editors, I still would like this column of short items moved to the right. The page would be better balanced.

The promos
These promos look crowded and a bit overwhelming. Will anyone read this much text? I should have dropped one of these items, which would have given me more space for the nickel story, and played up the first item more.

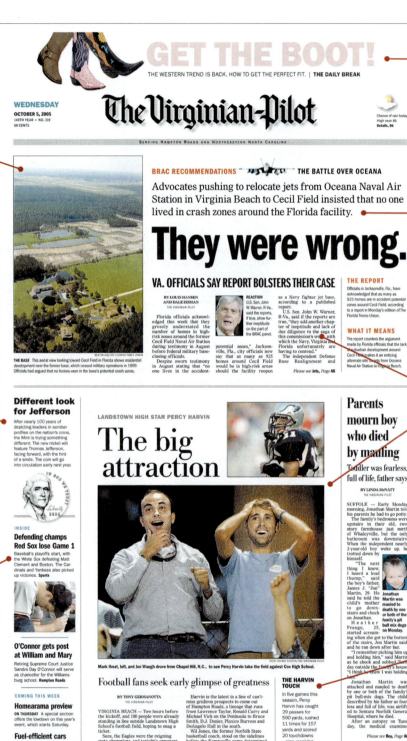

The top promo
What was I thinking? It's bad enough that the boots seem to hang in mid-air with no tops, but my choice of color for the type doesn't help. Note to self: Never, ever use pink type again.

Too many words?
Are there too many words here? It's important to tell the story in big type, but this seems daunting. I could have dropped the label or the deck over the text. And the lead-in seems too big; I'd go two points smaller the next time.

Dominant package?
Where will readers look first? It's a toss-up. The lead is bolstered by the bold headline, but the football story has the largest image. I could have given the lead another inch in depth on the page. That, along with integrating the photo into a graphic, would have left no question what the most important story of the day was.

The football package
This would have been an opportunity to tell readers when and where the star will play his next game. A rare chance to look ahead and offer useful information, and I blew it by focusing only on his accomplishments. But there's always tomorrow

Page One: A case study

THE DO-OVER (A DESIGNER'S DREAM ...)

What a difference a few years—and a redesign—make. This design reflects our narrower width, and uses new fonts and an 11-column grid that bring the page into the 21st century. Better choices on my part gives the page more energy, a clear lead—and not a hint of colored type.

The lead package

Why rely solely on a boring-but-newsworthy photo when you can use a fighter jet cutout? The story's crux centers on an aircraft known as the Super Hornet, so I use an image of the plane to bolster the other photo. By using explanatory type to turn the Florida photo into an informational graphic, the package becomes more integrated. And by giving the whole thing more space on the page, it becomes the clear dominant package.

The football package

This package is slightly smaller, but a tighter crop keeps the impact high on main photo. By the way, the subject of the story, Percy Harvin, now plays in the NFL, so in hindsight this was a good choice for a front-page story.

The promos

This is where the 11-column grid comes in handy. I use one of the page's narrow columns for the promos, and that creates a strong vertical package on the bottom of the page. I reduce the number of elements in the package from four to three (weather has moved to this spot) and elevate the World Series to the lead item with a headline that is larger than the one on the secondary promo.

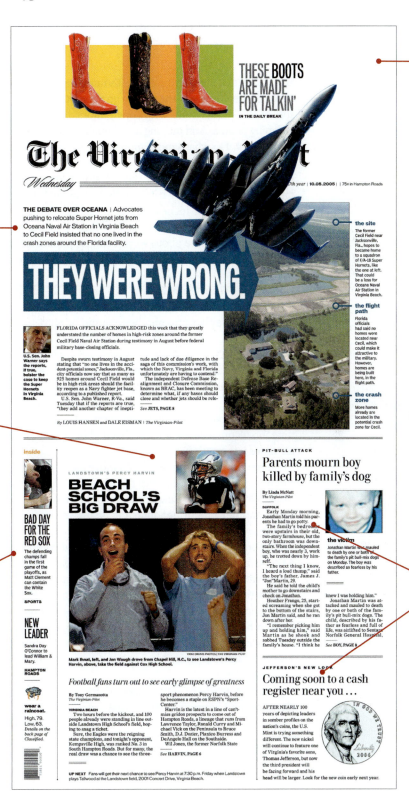

The top promo

This is a promo I won't have to regret. It has a more conversational tone and pink is gone. A big improvement.

The kid and Jefferson stories.

Let's start at the bottom: The hold-to-the-front piece on the new Jefferson nickel is now clearly a story rather than another promo, and the head is lighter in tone. This seems much better. The bottom line on the dog-mauling story is more of a toss-up. The headline count is more generous and results in better words, but I'm a little bothered by how big the boy's head is. (The narrower columns make it impossible to notch half-column mug shots into stories.) For now, this new version will have to do. Unless, of course, the authors of this book let me try it again for the next editions. ...

No matter how hard you try, no matter how carefully you plan, no matter how drool-proof your layouts seem, stories have a habit of coming up short. Or long. So what do you do?

Once a page is assembled, minor tweaking is easy. Major repairs, however, are tricky and time-consuming. You may need to back up and re-dummy a story or two. But first, find out what went wrong. Ask yourself:

▸ **Was there a planning problem?** Did someone change a story's length? Did someone swap or re-crop photos? Were ads sized wrong? Omitted? Killed? Or:

▸ **Was there a production problem?** Were text and photos correctly placed? Headlines correctly sized? Are all elements—bylines, cutlines, refers, logos, liftout quotes— where they're supposed to be?

If a story is close to fitting—say, within a few inches—try some of these options, either while you're designing the page or after it's assembled:

STORY TOO LONG? Sure, it's tempting to manipulate the text to get it to fit, but squeezing text is rarely the way to go about it. Most of the options below require some sort of *edit.* Collaborate with copy editors, or photo editors, before cutting stories or cropping photos. And moving an ad might require consultation with someone in the ad department. Do what's most appropriate in your newsroom.

▸ **Trim the text.** As a rule of thumb, stories are usually cuttable by 10 percent. For instance, a 10-inch story can usually lose an inch without serious damage; a 30-inch story can lose a few inches (and your readers may actually thank you).

▸ **Trim a photo.** Shave a few picas off the top or bottom, if the image allows it. Or, if necessary, re-size the photo so you can crop more tightly.

▸ **Trim an adjacent story.** If you find that a story is trimmed to the max, try tightening the one above or below it.

▸ **Drop a line from the headline.** But be careful—short headlines that make no sense can doom an entire story (see chart, Page 29).

▸ **Move an ad,** either into another column or onto another page.

STORY TOO SHORT? Again, messing with the body copy—tracking it out, loosening the leading or making the standard text size bigger—is not a good idea. Doing these things will only make the copy stand out, and it will look like a mistake.

▸ **Add more text.** If material was trimmed from a story, add it back. Or if you have time, break out a small sidebar that highlights key points or tells readers where to go for more information.

▸ **Enlarge a photo.** Crop the depth more loosely. Or size it a column larger.

▸ **Add a mug shot.** But be sure it's someone *relevant* to the story.

▸ **Add a liftout quote.** Find a meaningful remark that will attract readers.

▸ **Add another line of headline.** Or better yet, expand the decks on those long and medium-sized stories.

▸ **Add some air between paragraphs.** This old composing-room trick lets you add 1 to 4 points of extra leading between the final paragraphs of a story. But go easy: If you overdo it, those paragraphs begin to float apart.

▸ **Add a filler story.** Keep handy a selection of optional 1- or 2-inch stories, or briefs, to drop in as needed. (And be sure these stories aren't outdated.)

▸ **Add a house ad.** If it's acceptable, create small promos that call attention to your newspaper. Have them available in a variety of widths and depths.

▸ **Move an ad.** If permissible, import one from another column or page.

In addition to these quick fixes, there are two more techniques—using bastard measures and jumping stories—that are a bit more complicated.

If you add a liftout quote, find one that's provocative and enticing. You can even add extra white space below (like we're doing here) to help you fill deeper holes."

— *And don't forget the attribution*

Pullouts and pull quotes You can pull out interesting information from a story, or a decent quote. Just be sure whatever you pull out makes sense with the context of the story.

Not long enough? Too-loose tracking is *not* a good way to fix this. Know what the limits are for loose tracking in your paper and stick to it.

Too long? Tightening the tracking to a point can work (but what you see here doesn't), even for individual paragraphs within text. Again, stick to your paper's negative tracking limit.

Changing the size of body copy willy-nilly to make it fit never works. It looks like a mistake. Be consistent with body copy point sizes throughout the paper.

Fine-tuning the body copy Sometimes rookie designers try to fit stories by tracking text excessively, or by messing with the leading. Don't do this! It looks unprofessional.

Making stories fit

▶ Wa
to d
page
won
page

H
how
the
seg

C
awk
smo
stor
But
alon
▶ Us
pag
you
hea
side

BASTARD-MEASURE EXAMPLE: MAKING IT FIT

1. Suppose you're dummying a 6-inch story with a mug. You need to fill this space that's 3 columns wide, 5 inches deep. What's your best option?

2. With a 1-column mug, the story fits in 2 legs, leaving a column empty. (A 2-line headline would force text into that third leg but wouldn't fill it.)

3. You could try running the mug 2 columns wide, but it wastes way too much space. Only 3½ inches of text will fit into that left-hand column.

4. The solution? Running 2 bastard legs in place of the usual 3. The text is 4 inches deep, but it's half-again as wide as a 1-column leg— so it fits.

WORKING WITH NON-STANDARD (BASTARD) MEASURES

Most of the time, photos fit fine into standard column widths. But on some pages, they're just too small in one column measure—and just too big in another.

At times like these, bastard measures can be the answer—especially on feature pages, where photos predominate.

These non-standard measures can also add a little variety into the page mix. Let's say you've got a 5-column grid on a page, like you see on these pages below. If you break out of the grid, you could use different column widths for stories, giving the page a less-structured look.

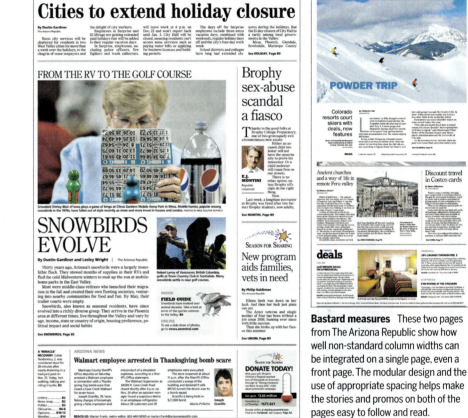

Bastard measures These two pages from The Arizona Republic show how well non-standard column widths can be integrated on a single page, even a front page. The modular design and the use of appropriate spacing helps make the stories and promos on both of the pages easy to follow and read.

JUMPING STORIES

There will be times—so many, many times—when you'll need to fit a 30-inch story into a 10-inch hole. When that happens, you can either:

▶ Cut 20 inches from the story (lots of luck), or you can try to:

▶ Start the story on one page and finish it on another. When stories runneth over like that, they're called *jumps.* Jumps are controversial. Many editors hate them. Many readers hate them, too, or worse: They ignore them. But designers love them, because they give us the freedom to stretch and slice stories in otherwise unimaginable ways. (That age-old

journalistic question—"Do readers actually follow stories that jump?"—has yet to be answered definitively. But many feel that if a story's engrossing enough, readers will follow it *anywhere.* Otherwise, they'll use the jump as an excuse to bail out.)

When you jump a story:

▶ **Make it worth the reader's while.** It's pointless—and annoying—to jump just a few short paragraphs at the end of a story. Jump *at least* 6 inches of text, unless the story is simply uncuttable and there's no other option.

▶ **Start the story solidly,** with at least

4 inches of text, before forcing it to jump. Otherwise, the story may look too insignificant to bother reading.

▶ **Jump stories to the same place whenever possible.** Readers will tolerate jumps more forgivingly once they're trained to always turn to the back page, the top of Page 2, the bottom of Page 3, etc.

▶ **Jump stories once**—and once only (most of the time). You'll lose or confuse too many readers if you jump a few inches to Page 2, then snake a little more text along Pages 3

▶ Please turn to JUMPS, Page 160

Compelling photos

Carolyn Cole / The Los Angeles Times

PHOTOS & ART

What makes a photo compelling? In the pages that follow, six photojournalists provide their own commentary on these dramatic, award-winning images.

Above: An Iraqi family grieves at the homecoming of three dead family members shot by U.S. Marines on April 9, 2003, in Baghdad when the men failed to stop their car upon English command.

Photographer: Carolyn Cole

Publication: The Los Angeles Times

About this photo, in Cole's words: On the day after American troops arrived in Baghdad in April 2003, a colleague and I came upon the scene of a horrific shooting. An Iraqi family who had failed to stop at an American roadblock was shot and killed; their lifeless bodies still remained inside the vehicle. I followed as relatives towed the car home, then placed the victims on blankets in the front yard where many family members waited to mourn their lost loved ones. Through a translator, I explained why it was important to tell their story of loss.

It was excruciating to witness this kind of pain, but also important given the likelihood that it had been an accidental shooting of civilians. I spent about a half hour with the family, adults and children, as they grieved and prayed next to the bodies. I was drawn to the children, because rarely had I seen young people suffer such pain.

As an American journalist in Iraq before, during and after the invasion, I felt a deep responsibility to show what was happening to the civilian population. There were many photographers and reporters embedded with the U.S. troops, but few of us in Baghdad when the U.S. bombing began. It was our job to document what was happening on a daily basis and the overall impact of the war.

To me this image represents the thousands of innocent victims of the U.S.-Iraq war whose lives were changed forever.

Mark
desig
here,

Tradi
This f
every
news
impor
adver
editor
ugly-l
holes
a pyra
facing

More
As ad
both
page,
the m
the n
stairs
wells
Desig
been
them
From

More
Looks
doesi
stack
modu
as we
page
pages
navig
more
and r
actua

Compelling photos

Left, lighting strikes both the Willis Tower and the Trump Tower in downtown Chicago on June 23, 2010. Photographer Chris Sweda says, "Two other newspaper photographers actually captured the same exact moment that night, all of us miles apart. Fellow Chicago Tribune photographer Terrence Antonio James captured the image from near Lake Michigan and Chicago Sun-Times photographer Tom Cruze shot it from U.S. Cellular Field during a rain delay at a White Sox game."

Chris Sweda / Chicago Tribune

Photographer: Chris Sweda

Publication: Chicago Tribune

About this photo, in Sweda's words:

I really didn't anticipate the scene as much as I just reacted to it. I was originally sent up to the John Hancock observatory in Chicago to photograph the inaugural lighting of the spire on the new Trump Tower.

The forecast called for potentially severe storms so a Tribune assignment editor communicated to me to be on the lookout for some sort of weather shot if possible.

As I was photographing the spire at dusk, darker clouds moved in with periodic lightning painting the sky above the famous Chicago skyline. It was a quick and natural decision to turn away from the architectural shoot to focus on the weather.

I had some technical and timing issues to deal with in making this photograph. The difficulty with lightning is that it's completely unpredictable as to where, when and how many times it will strike.

By using a slower shutter speed (this was shot at about four seconds), it allowed me to shoot off fewer frames while still being able to cover the entirety of the storm.

This made my shooting and editing time more efficient. If I had shot consecutive frames at 1/80th of a second, I would have had hundreds of frames to edit through.

The downside of using a slower shutter speed, of course, is the need to keep the camera still. Without a tripod, I had to balance the camera on my computer bag that was lying on the floor.

The scene was akin to watching a silent movie in a way. I could witness the incredible visuals in front of me, through the thick windows separating me from the storm, but the sound was muted. The observatory was largely empty this night, but those who made the trek up to the 94th floor were treated to a terrific storm from such an unusual perspective.

The image ran the next day as the main art on the front page of the paper.

I received a lot of attention from this photograph, but the most memorable response was from a person who wanted framed photographs of this double lightning strike—because it occurred on the same day that his twins were born.

Compelling photos

Damon Winter / The New York Times

Above: Dr. Lynne Jones teaches muscle relaxation therapy to Jean Pierre, 48, who came to the clinic with elevated blood pressure associated with stress a few months after a Jan. 12, 2010, earthquake caused major damage in Port-au-Prince and surrounding areas in Haiti. Here, Dr. Jones asks Jean Pierre to tense the muscles in his upper body, neck, chest and arms and then release them during a session held at a refugee camp on the grounds of the Pétionville Country Club.

Photographer: Damon Winter

Publication: The New York Times

About this photo, in Winter's words: There weren't any tremendous challenges to gaining access to this situation a few months after the earthquake struck Haiti. We had been working with Dr. Lynne Jones, a child psychiatrist and disaster specialist who was running this clinic inside the Pétionville tent camp. We explained that we wanted to observe her and her colleagues at work training Haitian interns and counseling earthquake victims. She was very protective of the people with whom she was working. We got permission from every person we spoke with and photographed, after we explained to each of them the nature of our work there.

When I made this image, it was cramped and hot. I felt terrible to be intruding on this man's session with Dr. Jones. I tried my best to stay out of everyone's way.

Back in the newsroom, I think everyone agreed that this photograph was such a subtly powerful moment and one that was not typical for a story like this. The way Jean Pierre is clenching his fists so tightly—and Dr. Jones' hand on his forehead at this moment of extreme tension—helped to elevate a somewhat static situation into something special. I think it was important for us to show that people wanted to do something about the atrocious state of the mental health system in Haiti.

There was a wonderful quote at the end of the story from this scene that really helped to tie it all together. Dr. Jones, while doing the relaxation therapy with Jean Pierre, asks him, "Have you ever sat in the ocean and had the water wash over you?"

"Not often," he replied.

Compelling photos

Mark Zaleski / The Press-Enterprise

Above: Fans in the field fence bleacher area try to catch a home run hit by Boston Red Sox David Ortiz during the All-Star Home Run Derby at the 81st Major League Baseball All-Star Game home run derby at Angel Stadium of Anaheim in Anaheim, Calif., on July 13, 2010.

Photographer: Mark Zaleski

Publication: The Press-Enterprise

About this photo, in Zaleski's words: At this All-Star Home Run Derby, the photographers were placed in a section off the first base side. We had pretty good access on the field—we were kind of in the coaching box area. We were all kneeling down, watching the batters hit the balls out of the park.

The one thing we had to watch out for were the left-handed hitters—and [Boston Red Sox player] David Ortiz is a left-handed hitter. When they line them in our direction, we have to dodge the balls, so we don't get hit.

Around the time I made this image, it was twilight, around 6 or 7 o'clock. In the back of this one area, off to the right field foul line, where they keep raingear and grass feeders, it just goes dark.

I'm watching all this around me, and I'm thinking I want to make some kind of different image—something that may put this scene in a little bit different perspective than what everyone else was getting. All the other photographers were concentrating on shooting the batters. I kept following balls to the outfield. People in the stands do weird things at situations like this. They'll do anything to catch a foul ball.

So I'm watching ... I'm watching. I'm shooting the fans reaching over the balcony— which drops down about 20 feet. On the right-hand side of the picture, there were shadows of people along the wall. That kind of caught my eye, too.

When I was making this picture, I was trying to get as many hands and gloves as I could in the frame, but later I cropped out most of the faces on the left. Going back and editing your stuff is just as important as trying to figure out what you're looking at through the lens: *OK, this is what I saw—how can I, with a little better crop, make it a little bit more interesting?*

Compelling photos

Preston Gannaway / The Virginian-Pilot

Above: Micah Anderson, 9, Elijah Anderson, 10, and Paul Anderson, 8, put their sunglasses on as they head to a homeschool science class. People with albinism are sensitive to bright light and have issues with low vision.

Photographer: Preston Gannaway

Publication: The Virginian-Pilot

About this photo, in Gannaway's words: This image was part of a yearlong documentary project on three young boys with albinism. The family was patient with me. With stories like this, it takes lot of time to build a rapport with the subjects. And the more time you spend, the better the chances you have of being there for storytelling moments.

Because of that time needed, there are often challenges in the newsroom. Photo stories take more resources and that can sometimes be tough to negotiate. I knew from discussions with Kim, the boys' mom, that the boys typically all rode in the car's back seat together. I was constantly on the lookout for situations that would provide compelling visuals and having the three boys in one frame was part of that.

People with albinism are sensitive to light and I wanted to illustrate that in this image. Framing the boys within the light-colored car interior and blowing out the highlights in the background helped create a sort of luminosity. So the photo not only worked on a purely visual level, but also helped to convey their daily experience.

I hadn't anticipated the moment when they all adjusted their sunglasses. That was just a happy—and lucky—addition. During the editing process, I decided pretty quickly that this image was the best dominant lead-in to the story. We decided to run it six columns on the front of the newspaper's Sunday Magazine section. Of the 10 or so images that were published in print, this photo introduced the three brothers, and their genetic condition, the best.

Compelling photos

Alan Berner / The Seattle Times

Above: When you're kissed by a devil you have to watch out for that nose. Gladys Blaine, dressed as an angel, and her devilish friend Jack Erlandson get close at her going-away party. Erlandson, who was best friends with Blaine's late husband, helped her face death with the playfulness she's always shown in life.

Photographer: Alan Berner

Publication: Pacific Northwest magazine of The Seattle Times

About this photo, in Berner's words: Eighty-five-year-old Gladys Blaine was dying of cancer—she knew she had only three to six months to live. So she threw herself a going-away party, and she invited the writer and me. I called Gladys ahead of time about coming by early, as she was preparing for the event.

The party was held on a lower level of a downtown condo complex. By the time I arrived, very few people were there.

I did not know there would be a devil in attendance. This almost-kiss between Gladys and her friend, Jack, I found, was a little better than the actual kiss. You can clearly see both faces, especially that huge nose on the devil.

After discussing how to run this photo in the spread with Carol Nakagawa, the magazine's art director, she ran it large, as a double truck to open the story.

Turns out the two photos that were published of Gladys—the cover, which was an image of Gladys getting ready from behind, her angel wings spreading from side-to-side of the frame, and the lead photo (seen above)—were taken *before* the party started. As a photographer, it's almost always better to go to a shoot early and stay late.

I brought over a couple of dozen copies of the published story for Glady's. As she opened it, she was delighted, but as she moved beyond the first spread (of three) she said, "Oh. It's not all about me." She thought the entire story was going to be about her party. She requested a couple of dozen more copies of the story anyway, and sent them to her friends near and far.

Glady's and I were both happy she lived long enough to see her story in print.

Weak photos

LEARN MORE
Compelling photos: *What makes them good.* **Page 112**

Troubleshooting

Q **I want to remove a distracting-looking soft drink can from a photo using photo-editing software. Is this OK?**

Absolutely not. Working for a newspaper (student-run or not), you're in a different league now. And ethical principles about content — visuals and words, in print or delivered electronically — are taken *very* seriously.

The Associated Press states its stance on photo ethics loud and clear: *"We abhor inaccuracies, carelessness, bias or distortions."* Images *must* reflect the truth, and digitally manipulating content in the photo is absolutely unacceptable.

For example: Let's say there's a soft drink can on a table in front of a person who's the subject of an otherwise stunning portrait. Do you take out that can? It'd be really easy, and who would miss it, anyway?

What you'd gain in achieving that cleaner look, though, would be far outweighed by what you'd lose: credibility with your readers — readers who will wonder how many other images published in your paper were altered in some way.

You can, however, make *minor* adjustments (for example, cropping, dodging and burning, and color adjustments) that reflect "the authentic nature of the photograph," according to AP. "Aggressive toning" is not allowed. Flopping a photo, isn't either. And as for that red eye? Well, that has to stay, too.

There are many instances over the years of photojournalists unethically altering their images. Once this is discovered, the action taken is usually swift: the staff photographer will most likely lose his or her job; a freelancer is cut loose from an agency; and all of a photographer's files are scrutinized for past ethical breaches.

Bottom line: When it comes to images, be as truthful as you can.

Photos can be bad in a mind-boggling number of ways. They can be too dark, too light, too blurry, too tasteless, too meaningless or too *late* to run in the paper. They can, like the photo below, show blurry blobs of useless information — depicting, with frightening clarity, a chubby guy with a streetlight growing out of his head. Be grateful, then, whenever a photographer creates a sharp, dramatic, immaculately toned photo. And avoid turning good photos into bad ones by cropping them clumsily. By playing them too small. Or by placing them where they compete with another photo or intrude into the wrong story.

PHOTO FLAWS

▶ Light pole sticking out of subject's head (poor mix of foreground and background).

▶ Harsh shadows on subject's face. Unflattering pose. No strong center of interest in frame.

▶ Subject is out of focus. And the photo is underexposed (too dark). Photo is not toned properly.

▶ Image is flopped (note the words on the sign). This is either a bad mistake, or an unethical decision.

TIPS FOR MAKING THE BEST OF BAD PHOTOS
What can you do to salvage a bungled photo assignment?

▶ **Crop aggressively (but mindfully).** Focus attention on what *works* in the photo, not what doesn't. Zero in on the essential information and eliminate the rest.

▶ **Edit carefully.** Is there one successful image that shows more than the rest?

▶ **Fix the obvious mistakes.** Use photo-editing software to improve poor exposure and fix color balance — but remember, *it's unethical to alter or manipulate the integrity of any data in the picture (read more about this at left).*

▶ **Run a sequence.** Sometimes two small photos aren't as bad as one big weak one. Consider pairing a couple of complementary images.

▶ **Reshoot.** Is there time? A willing photographer? An available subject?

▶ **Try another photo source.** Was there another photographer at the scene? Would older file photos be appropriate?

▶ **Use alternative visuals.** Is there another way to illustrate this story? With a chart? A map? A well-designed mug/liftout quote? A sidebar?

▶ **Bury it.** By playing a photo small, you can de-emphasize its faults. By moving it farther down the page, you can make it less noticeable.

▶ **Mortise one photo over another.** It's risky, but may help if there's an offensive element you need to eliminate or disguise. (See Page 205.)

▶ **Do without.** Remind yourself that bad art is worse than no art at all.

Weak photos

A ROUNDUP OF THE BEST OF THE WORST

Photojournalistic clichés have plagued editors for decades. Some, like "The Mayor Wears a Funny Hat," may have some merit (either as entertainment or as a harmless form of revenge). Others, like the examples shown below, have almost no redeeming value—except to friends, relatives and employees of those in the photo.

If something like this is all you have to work with, it's up to you to weigh if the information in the photo outweighs the cheesiness of it. Whenever possible, look for alternatives (*real* people doing *real* things) every chance you get.

Believe it or not, there *are* ways to create interesting pictures of people in a group setting, or of a person (or people) in an office. With attention to lighting, composition, juxtaposition, framing, point of view, etc.—remember those all-important photo constructs?—photographers don't have to settle for making snooze-fest pictures whenever they find themselves in situations that are less than ideal.

THE "GRIP & GRIN"

Usual victims: Club presidents, civic heroes, honors students, school administrators, retiring bureaucrats.

Scene of the crime: City halls, banquets, school offices—anyplace civic-minded folks pass checks, cut ribbons or hand out diplomas.

How to avoid it: Plan ahead. If someone does something worth a trophy, take a picture of him (or her) doing it. Otherwise, just run a mug or portrait.

THE EXECUTION AT DAWN

Usual victims: Any clump of victims lined up against a wall to be shot: club members, sports teams, award winners, etc.

Scene of the crime: Social wingdings, public meetings, fundraisers—usually on a stage or in a hallway. Also occurs, preseason, in the gym.

How to avoid it: Same as the Grip & Grin—move out into the real world, where these people actually do what makes them interesting.

THE (FILL IN THE BLANK) AT A DESK

Usual victims: Administrators, bureaucrats, civic organizers—anybody who bosses other people around.

Scene of the crime: In the office. Behind the desk.

Variations: The Guy on the Phone. The Guy on the Computer. The Guy in the Doorway. The Guy Leaning on the Sign in Front of the Building.

How to avoid it: Shoot a tighter portrait.

THE BORED MEETING

Usual victims: Politicians, school officials, bureaucrats—anybody who holds any kind of meeting, actually.

Scene of the crime: A long table in a nondescript room.

How to avoid it: Run mug shots and liftout quotes from key participants. Better yet—find out in advance what this meeting's about, then shoot a photo of *that*. Illustrate the topic—not a dull discussion about it.

Sizing photos

100% This is the original size of this digital photo, the largest size at which all details remain sharp. Any change in size will be measured as a percentage of this original size.

50% This image is half the size of the original. And because it's smaller, details become more difficult to see.

200% This image is twice the size of the original. But as those jagged pixels become visible, the photo looks fuzzy.

Cropping photos is one way to create new shapes. You can also resize (or scale) photos, enlarging them *up* or reducing them *down*.

When you change the size of a photo, you measure its new size as a percentage of the original. Now, the "original" size of a digital photo usually means one of two things: either the actual size of the image captured by the camera, OR the size of the photo file once it's been edited and processed.

Either way, a photo that's half the size of the original is called a 50 percent reduction; a photo twice the size of the original is a 200 percent enlargement. Those percentages will be calculated automatically when you import images into a page-layout program.

Always keep a sharp eye on your image sizes. Anytime you enlarge a digital photograph, you run the risk of fuzziness if the image's jagged pixels become visible to the naked eye.

It's also possible to alter an image, either deliberately or accidentally, by changing just one of its dimensions: for instance, enlarging it *horizontally* while reducing it *vertically*. But be careful. Whenever you distort a photo's true proportions, you damage its credibility.

DISTORTED
The image below runs at 30% of its original depth and 60% of its original width. Digitally squishing or stretching a photo is easy to do, but it destroys the integrity of the image.

Halftones & screens

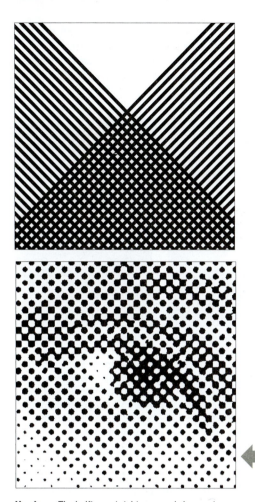

A photo like the one below goes through many changes on its way to the printed page. It's digitally processed to correct its contrast, color balance and clarity. It's cropped into a new shape. It's reduced or enlarged to a new size.

But even after it's imported into the final layout, a photo must be reprocessed once more before it can be printed. Why?

Because printing presses use *black* ink, not gray ink. They produce the illusion of gray by changing the photo into a pattern of dots called a *halftone*.

Halftone dots are created either by re-shooting the photo through a special screen or by reprocessing the photo digitally. Dots usually run in diagonal rows or lines (left); the density of a halftone screen is measured by the number of lines per inch.

Density
This image uses a 133-line screen, which is common in books and magazines. Because the ink is printed on smoother paper from high-quality presses, the dots will hold—and the results show crisp detail.

Up close The halftone at right was made by passing the original photo through a 133-line screen (133 lines per inch), which you can see directly above. In the enlarged area above that, you can see how halftone dots create the gray tones in the subject's eye.

The finer the dot screen, the smaller the dots. The smaller the dots, the less visible they are. The less visible they are, the sharper the photo seems to be.

For crisp-looking photos, then, you should use the finest dot screen your paper can handle. Newspapers, unfortunately, often use rather coarse screens—one reason why their photos don't look as slick as those in books and magazines.

65-line screen: This is a very coarse screen, with only 65 rows of dots per inch. The dots are quite apparent, but at least the ink won't smear too badly when printed on rough newsprint by a fast-moving printing press. Unless you're plagued by production problems, however, you should avoid screens this coarse because the overall quality is not ideal.

85-line screen: Because of the limitations of newsprint, this is the most common screen density newspapers use—though some papers using state-of-the-art presses have had success using 100- or 120-line screens. If the screen is too fine, the dots may smudge or disappear, resulting in blotchy, unevenly printed images.

Horizontal line screen: Most halftones use ordered rows of dots. But you can also run photos through a variety of alternative screens to stylize images dramatically. A random pattern of dots produces a mezzotint, much like an old etching; using lines instead of dots (at 50 lines per inch) creates the effect, as you can see above.

LIVERPOOL JOHN MOORES UNIVERSITY
LEARNING SERVICES

Scanning images

LEARN MORE
Screens and reverses:
Some guidelines. **Page 206**

SCANNING TERMINOLOGY

Since scanning software is quite user-friendly, you won't need years of training to get good results. But it *will* help to know some basic terms:

Grayscale: A scan of a photograph or artwork that uses gray tones (up to 256 different shades of gray, to be precise).

A **grayscale** image uses shades of gray.

Line art: An image composed of solid black and white—no in-between gray tones.

A **line art** image uses only solid black.

Image size: The physical dimensions of the final scanned image. This term is also used interchangeably with *file size,* which is the total number of electronic pixels needed to create a digital image, measured in kilobytes. The more pixels an image uses, the more detail it will contain.

A **low-resolution** image uses fewer dots, which means it's less detailed.

Dots per inch (dpi): The number of electronic dots per inch that a printer can print—or that a digital image contains. The higher the dpi, the more precise the image's resolution will be—up to a point, anyway.

Lines per inch (lpi): The number of lines of dots per inch in a halftone screen. The higher the lpi, the more accurate the printed image will be.

Resolution: The quality of detail in a digital image, depending upon its number of dots per inch (dpi). A *high-res* image is much sharper than a low-res image.

TIFF: One of the most common formats for saving and printing digital images (an acronym for *Tagged Image File Format*).

JPEG: A common format for compressing images for e-mailing or posting online (short for *Joint Photographic Experts Group*).

Moire (mo-ray) pattern: A strange, annoying dot pattern formed when a previously screened photo is copied, then reprinted using a new halftone screen.

How do you get photos and artwork into your computer? It's easy. All you need is a scanner, a machine that captures images electronically—*digitizes* them—so you can adjust them, transmit them or store them for printing.

To the casual observer, scanners look and perform much like photocopying machines. Here's how the scanning process works:

1 Preparing to scan: Take your original image—a photo, a drawing, a clipping—and lay it facedown on the scanner's glass surface. Scanning software will let you crop the image, resize it, change the resolution—even adjust its appearance.

2 Scanning the image: The scanner lights up like a photocopying machine as it copies the image electronically, converting it into microscopic dots or pixels (picture elements). The more dots the scan uses, the finer the resolution will be.

3 Importing the image: Once it's scanned, the digital image can be opened, toned, cropped and resized using photo-processing software, like Adobe Photoshop. Afterward, it can be printed, posted to a website or imported into a page-layout program.

TONING TIPS Photoshop is a common program used to work with images. If you work with it, then you know firsthand just how deep and complex this application can be. The learning curve can be steep. When time and patience are running short, though, a cheat sheet can come in handy. Here's a step-by-step brief overview on how to tone a color image in Photoshop:

1. Go to Image, Adjustments, then Levels. This will call up a dialog box where you will make adjustments for each channel of the image.

2. Click on the box next to the channel dropdown list and select the red channel.

3. Underneath the Input Levels area, locate the triangles on the left and right sides and move them toward the start of the histogram data. The black point triangle is on the left; the white point is on the right. If you see what looks like an EKG flatline, move the triangles past that until they fall under the area where the dark area starts to rise. (It sort of looks like where you'd begin to ascend a mountain.)

4. Repeat Step 2, but this time when using the green channel.

5. Repeat Step 4, but this time when using the blue channel.

Is this method perfect and accurate for every picture? Nope. But it's a start. Use your eyes to gauge how the colors are looking. If you work with people who are experienced with the pre-press process, check with them on your specific newspaper's press specifications. Once you're more advanced, you can fine-tune your toning even more by using the Curves function in Photoshop, for example.

Scanning images

Troubleshooting

Q **When naming files, I fly by the seat of my pants and just use any ol' name. Is this OK?**

If you're dealing with mixed platforms, such as Macs, PCs and Unix computers, you definitely have to pay attention to file names. Sometimes there's a standard naming protocol in newsrooms. At other places, the files are called—well, whatever name comes to mind on the spot. A shoddy naming convention may lead to some unpleasant surprises when it comes time to print.

There are are some things to avoid when naming your files so you can avoid headaches down the road:

▶ **Steer clear from using odd punctuation or glyphs** in the filename. No-no's: #$%&?/ or \. No ✳ or ▷. Letters and numbers work just fine. Underscores also work well to separate multiple words:
Good file name: this_works.
Bad file name: this\does-not.

▶ **Avoid using multiple periods** in the filename. Use just one period before the suffix of the filename (those three letters that indicate the type of file extension you're using, such as .tif or .jpg). Use the underscore—and *not* spaces—to help separate words: like_you_see_here.jpg

▶ **Leave the three-letter suffix alone in the filename.** You can add them, if necessary, but realize that you can't magically change a file type simply by changing those three letters at the end of a filename. If you want to change a photo to a jpeg, for example, then you'll need to do that in the proper application (such as Photoshop).

Filing-naming tip: We all know what it's like on deadline—so much to do in so little time. Develop a consistent and correct file-naming system and stick with it until it becomes second-nature. You'll stay more organized—and have more time to spend on that deadline page.

SCANNING RULES OF THUMB

▶ **Name and store your scans carefully.** Think about it this way: When you import an image into a page-layout program, you might think you're looking at the actual scan when you see it on your screen—but you're not. You're looking at a low-resolution rendering of the original scan. (Which is a clever idea, actually. Otherwise, a page full of huge scans could require umpteen-million megs of memory, becoming overloaded and slow.)

When you finally decide to print that page, however, your computer traces a path back to its original images and uses that information for printing. Which means two things: You need to store all scans until they're finally printed. And you need to store them in a consistent place, so that your computer will be able to grab them when it's time to print.

▶ **Allow for dot gain.** Images often print darker than they appear on your monitor. Ask your printer how your screen dots will behave when the ink hits the paper—and learn to compensate consistently every time you scan.

▶ **Crop and scale images as you scan.** You can save memory by scanning only that part of the image you plan to print. Remember, too, that if you plan to enlarge an image when you import it, you should scan it at a higher resolution; if you plan to reduce it, scan at a lower resolution.

▶ **Consider using low-resolution scans for big jobs.** If your computer's a little slow, you might save time if you scan those complicated images twice: a low-resolution version that won't slow you down while you work on the page, and a high-resolution scan that you can import when you're ready to print.

▶ **Keep your file sizes as small as possible.** Unnecessarily large scans waste memory, slow down your software, take longer to print—and don't always mean higher quality output, anyway. As a rule of thumb, the dpi of a grayscale image (the resolution you scan it at) should be twice its lpi (the resolution you print it at). In other words, if you print at 100 lpi, you should scan at 200 dpi.

Yes, image resolution can be confusing—all those dpi's and lpi's are tough to keep straight. If you're unsure how to measure "high" or "low" resolution when you're scanning or printing, consult this chart:

More is not necessarily better: There's no need to use dpi's that are higher than what you see here. A 600-dpi photo, for example, is not better than a 300-dpi-one.

	INPUT		OUTPUT	
	Grayscale or color images	Line art images	Screens for photos	Printer quality
High resolution (*magazines, books*)	300 dpi	1200 dpi	133–150 dpi	1200-1400 dpi
Fair resolution (*newspapers*)	200 dpi	800 dpi	85–100 dpi	600-1200 dpi
Low resolution (*Web images*)	72–96 dpi	72–96 dpi	*Web images are viewed, not printed*	

RESOLUTION: USING THIS CHART

If, for instance, you need to print an ordinary newspaper photo, you'll need to scan it as a 200-dpi grayscale, then print it using an 85- or 100-line screen on a printer that prints at least 600 dpi. If at any point in the process you used lower numbers, your quality would drop.

Cropping photos

Virtually all cameras produce images in a rectangular or square shape. But that doesn't mean that every photo must *remain* in exact proportion it was taken—or that you're required to run the *entire image* that was shot by the photographer.

Sometimes you'll need to re-frame the photo shape to create a stronger image that emphasizes what's important or deletes what's not.

And sometimes, to get the most out of a photograph, you just have to *crop* it.

The word "crop" often makes photographers cringe. In the hands of someone who really doesn't have a visual clue, a photograph can indeed be ruined by an overzealous designer determined to make a picture fit *just so* on a page.

Crop for content; crop smartly; crop with sensitivity. On the next page, you'll find some guidelines on how to do just that.

Three ways to crop the same photograph:

Full frame (above) shows us the full photo image. And from this angle, guitarist Eddie Van Halen's leap looks truly dramatic—but does all that empty space lessen the photo's impact?

A moderately tight crop (above, left) focuses on Eddie. By zeroing in this closely, we've eliminated all the excess background.

An extremely tight crop (left) turns the photo into a lively mug shot. We've tilted the image, too, to make it vertical. But does this crop damage the integrity of the original image?

Cropping photos

CROP IT—DON'T LOP IT Taking a 20-inch story and cramming it into a 10-inch hole is not a smart move. Ditto for taking a vertical shot and trying to finagle it to fit into a horizontal space.

Try to edit and crop photos *first,* before you dummy any story. Once you've made the strongest possible crops, *then* design a layout that displays the photos effectively.

Full frame This is the photograph as originally shot, full frame. Notice the excessive amount of empty space surrounding the central action.

Just right Here's the proper crop. Notice how it focuses tightly on the action without crowding—and without cropping into the hoop, ball or feet.

Squeezed This is a bad crop. It's too tight. We've chopped off the top of the ball, amputated feet and jammed the action against the edge of the frame.

Dramatic Notice how a fairly ordinary image gains impact from a tight crop.

A GOOD CROP ...

▶ **Eliminates what's unnecessary:** sky, floor, distractions in the background.

▶ **Adds impact.** Your goal is to find the focal point of a photo and enhance it, making the central image as powerful as possible. Sometimes a good crop is an *extreme* crop. Take it to the outer limits (you might surprise yourself!) and back off from there. Remember that newsroom adage: Crop photos until they *scream.*

▶ **Leaves air where it's needed.** If a photo captures a mood (loneliness, fear, etc.), a loose crop can enhance that mood. If a photo is active and directional, a loose crop can keep action from jamming into the edge of the frame.

A BAD CROP ...

▶ **Amputates body parts** (especially at joints: wrists, ankles, fingers) or lops off appendages (baseball bats, golf clubs, musical instruments) so it looks distracting.

▶ **Forces the image into an awkward shape** to fit a predetermined hole.

▶ **Changes the meaning of a photo** by removing information. By cropping someone out of a news photo or eliminating an important object in the background, you can distort the meaning of what remains—whether deliberately or accidentally.

▶ **Violates works of art** (paintings, drawings, fine photography) by re-cropping them. Artwork should be printed in full; otherwise, label it a "detail."

Stand-alone photos

LEARN MORE
Cutlines: *Guidelines on sizing, placement.* **Page 34**

In the example below, you'd assume that's an actual photo of the Seattle girl being attacked by a rat, like the headline says. But no—it's actually a sweet, funny, *stand-alone photo* that's completely unrelated to the story. In the layout on the right, the photo is boxed separately, to show readers it's a separate element. (You could successfully argue that it's in poor taste to dummy these two items alongside each other *at all,* but we're trying to make a point here.)

The point is this: Photos often run independently. You don't need text or a newsworthy hook to justify printing a strong photo image. These photos, sometimes called "wild" art because they're free-form and unpredictable, can add life to pages where stories are dull and gray (sewer commission meetings, budget conferences, etc.). Stand-alone photos should be encouraged, but they must be packaged in a consistent style that instantly signals to readers that the image stands alone.

STAND-ALONE DESIGN OPTIONS There are lots of subtle design elements you can choose to use when packaging a stand-alone photo. The key things to consider are how to treat the typographical elements (bold? with extra tracking? all caps?); how to treat the border or rules around it; and whether to use a screened background.

Overline Some papers create a stand-alone photo style using an overline (a headline over the photo). Its text, below, can be larger than a standard cutline.

Read-in line Some papers run a screen in the background of the box. And instead of using overlines, some start cutlines with a boldface phrase or read-in.

Borders Stand-alone boxes can be used with two or more photos. But as those boxes grow bigger, you'll need to follow the guidelines for photo spreads.

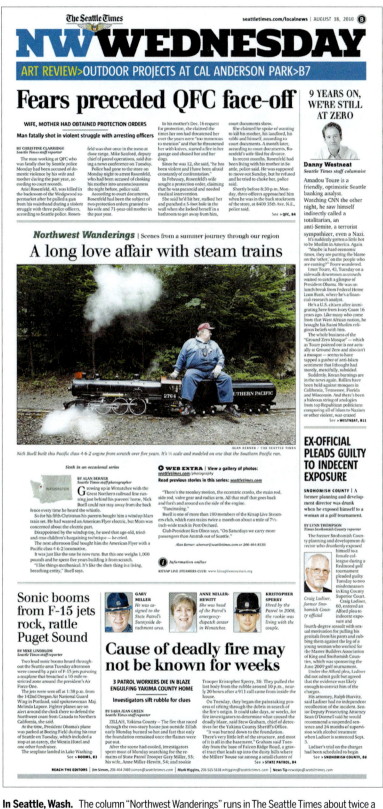

In Seattle, Wash. The column "Northwest Wanderings" runs in The Seattle Times about twice a month, usually as the front-page lead, or local lead story (as you can see here). A refer to an online gallery of photos is also included. The short story that runs with it always holds to the front.

THE PHOTO-CENTRIC STORY

Some newspapers run *photo columns,* which showcase an image, but also include additional copy to support the photos. This can be as little as a cutline, or as much as what appears to be a short story.

In Naples, Fla. "Our World" is a photo column that runs every Monday in The Naples Daily News. Each photographer researches and writes the story, which holds to the front. Says Eric Strachan, managing editor, "I initiated the column several years ago and still encourage the columns to be, as much as possible, people-oriented, with the thought that we have a ton of people in the community—all unique and all with a story to tell. It's a great way to get some wonderful stories in the paper that might not normally be told."

In Norfolk, Va. The column "Common Ground" has been running in The Virginian-Pilot once a week on an inside page (so the images always run in black and white). Every three months, a new photographer is assigned to take over the column, which runs in print and online. The paper describes this column as "a visual commentary on life in Hampton Roads."

Unlike the rest of the newspaper, where photos compete for space with text (and often lose), photo spreads are self-contained layouts that give special photos the big, bold play they deserve. They're usually used for:

▶ **Covering a major event** (a disaster, election night, the Big Game) from a wide variety of angles.

▶ **Exploring a topic or trend** (the homeless, neo-Nazis, a skateboarding craze), taking readers on a tour of people and places they've never seen.

▶ **Profiling a personality** (an athlete, a disease survivor, a politician), and painting a portrait by capturing a person's moods, activities and surroundings.

▶ **Telling a story with a definite beginning, middle and end** (the birth of a baby, a Marine's ordeal in boot camp, an artist in the act of creation).

▶ **Displaying objects/places** (a tour of a new building, fall fashions, hot toys for Christmas), where photos catalog an inventory of items.

Photo spreads are different from standard news layouts. They bend and break the rules: They let you play with headlines and use unconventional widths for cutlines and text. Text, in fact, often becomes a minor element on photo pages. Some pages run just a short text block, while others use longer stories, but jump most of the text to another page to maximize the photo display.

The No. 1 key to designing a strong picture page lies squarely in the photo edit. The biggest downfall of a photo page is redundancy. Include too many images that say virtually the same thing (even if they're *all* good), and you'll end up with a visually diluted page with an undefined focus.

Before you start designing your picture page, get a sense of the overall content and how it should best be displayed. If the story is all about boots in fashion or Christmas toys, then it might make sense to run many of the images the same size on a page—and form a grid-like structure. But if the story has a more documentary flavor to it, like the page shown at right, it'll be absolutely crucial to get those images sized and cropped so they read well and work together to *tell a story.*

Tyrell Brown of Saginaw airbrushes a T-shirt for Tabitha Watts and boyfriend Joe Saunders, both of Midland. The Midland County Fair was good for Brown's business, Air Magic Airbrush, but it meant long hours — sometimes from 1 p.m. until after midnight. "I spend more time in here than I do at home," he said.

A pair of pigs share the tight corner of a pen before the large animal auction on Thursday.

Love *at the* Fair

Photos by Thomas Simonetti

Dustin Heppner of Midland holds Misty Wachowiak of Bay City on Friday in front of the Ferris wheel, a popular meeting place, while waiting for friends. The couple have been together for two months.

Seth Haskell, 9, of Coleman spends a final few minutes with his steer, Floyd, in the large animal barn. The 1,220-pound animal was sold at auction last week after Haskell washed, fed, walked and watered it for several months. What was the initial attraction? "He had black rings around his eyes," Haskell said.

It seems county fairs are made for love. It's everywhere you turn. We love the rides. We love the food. We — especially the teens — love each other (sometimes very publicly).

This week staff photographer Thomas Simonetti set out to find the way love manifests itself at the Midland County Fair. He found it in the way the 4-H kids love the animals they've taken care of for months, right up until a purchaser carts them away. He found it in the T-shirts people buy professing their love for each other and he found it in the way the pigs nuzzle up against each other in their pens.

Love can be a fleeting thing but during fair week it's strong and it's in the air. We hope you loved the fair as much as we did.

More photos online:
For a final look at the fair, please visit
ourmidland.com/visuals/galleries

WWW.OURMIDLAND.COM

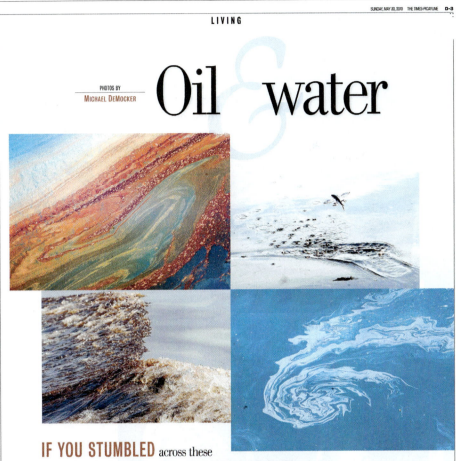

Flow This photo page, above, from The Gainesville Sun brings together a collection of images that forms a one-page essay on Eastern healing techniques that date back 3,000 years. The less-is-more philosophy is at work here. These four images capture a sense of place, detail and the general mood of the people photographed. Even though all the images are horizontal, they still flow well from top to bottom.

Details At left, The Times-Picayune presents the reader with something beautiful at first glance: a collection of small abstract images that show exquisite form, patterns and color. It's enough to draw readers into the page and into the punch line: no, these are not images from an art gallery, explains the text—they are photos that show BP oil mixing with Gulf of Mexico waters. This layout treats each photo equally, so no single image is dominant. Because of the content being presented here, a grid-like structure works.

Atmosphere At far left, the Midland Daily News, again, works with the less-is-more approach for this page that focuses on love at the county fair. A dominant image and headline anchor the page, and clearly get to the heart of the story. Three other secondary images also express the concept of love, but in different ways.

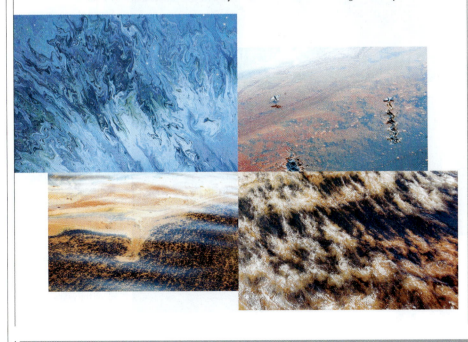

Photo page guidelines

Troubleshooting

Q When I'm laying out a picture page, should my lead image "match" the content in the lead paragraph in the story?

Not necessarily. In fact, you're limiting your visual options right from the start when your first instinct is to desperately try to find a way to place pictures on a page so they're close to the story text that describe it.

Let's say you're working with a story about a children's rodeo at a county fair, and in the lead paragraph, you read this: "When Johnny Smith, 7, woke up this morning at 3, the first thing he did was slip on his size 5 dung-covered cowboy boots."

Your first inclination might be to find the Johnny-and-his-boots photo. Maybe it exists in the photographer's edit—and maybe it doesn't.

In this case, the word story might describe more of an overview of the rodeo. Why not bring even more to the reader, and make the overall package that much richer, by including images that introduce other facets of the event? Show the little girl in her dung-covered boots, or the parents at the rodeo enjoying their cotton candy in the stands—whether or not these scenes show up in the word story.

In general, the goal is not to force words and pictures to mirror each other—rather, they should *complement* each other. Showing different aspects of the story will only help in making a page layout far more multi-layered and interesting.

Unfortunately, there's no magic formula that spells out how each picture page should be designed. A lot of this is intuitive. But never stop asking yourself, when laying out a page: "Do these pictures add something to the greater whole?"

Dull This layout above looks static because the photos are all similar in shape and size. Nothing grabs your eye. There's no sense of dominance on this page, giving this a sort-of scrapbook look and feel.

Variety This page mixes shapes and sizes, and, as a result, looks interesting and inviting. It's clear which photograph is dominant on the page, and which images are secondary.

Less is more Sometimes fewer images on a page can have more impact. By removing an image on this page, we can make the dominant larger so it fits the entire width of the layout.

PHOTO GUIDELINES The following guidelines apply not just to photo pages but to feature sections and special news packages as well. You'll find that most of these principles apply whether you're using photos, illustrations, charts or maps. *Note:* You don't have to design picture pages with gray backgrounds; we just added screens to these examples to make the photo shapes easier to see.

▸ **Read the story and communicate with others.** Talk to the photographer (and the photo editor and the reporter). Learn as much as you can about the story so you can agree on how to prioritize the photos. Ask yourself what each picture adds to the story. If it doesn't add much, don't include it.

▸ **Design for quality, not quantity.** Yes, you want variety—but one good picture played well is worth two small ones played weakly. *Be ruthless.* More than anything, redundancies kill a layout's impact. Careful editing is the key to making a photo page come alive. This sometimes means that good images won't make the cut.

▸ **Look at the big picture.** Design your page with a macro point of view—know how your picture story, or package, will fit with other stories on the page (if other stories are present). You may find yourself downplaying the other stories so they don't compete with the picture-story images.

▸ **Mix it up with contrast.** Use different shapes. Different sizes. Different perspectives. Tell the story with a variety of visuals: horizontals and verticals, tight close-ups and wide-angle scene-setters. Keep things moving. Surprise your readers.

▸ **Pay attention to aesthetics.** Are photos *strongly* directional? If so, consider repositioning them on the page so that the issue of direction isn't interfering with the content of the photo.

▸ **Pay attention to content and the order of photos.** Are the photos sequential or chronological? If chronology is not a factor in telling the story, then is it possible to give the photos an order or a narrative—a beginning, middle and an end? Is there a photo that will work as an "exit" photo, that'll give a sense of closure to the visual story? When the selected images run together, do they present the content in a fair and accurate way?

▸ **Commit to a dominant presence.** Many times, just one photo can be played big. But sometimes smaller photos in a grid format can work as a unified unit. Whatever you need to tell the story, give it clout. Anchor the dominant elements solidly, then play the other photos off of it. And remember, most of the time (but not always—see the example on the opposite page) dominant photos work best in the top half of the layout, so that the overall page doesn't feel bottom-heavy.

Photo page guidelines

Troubleshooting

Q Our photo editor won't allow us to run any headlines on photos, or to use any photo cutouts, because it damages the images' integrity. Is that true?

For years, photo cutouts and superimposed headlines were taboo in newsrooms. But look at magazines now. Look at *news*magazines like Time and Newsweek; they run shadowed photo silhouettes and fancy reversed headlines everywhere. Newspapers are behind the curve when it comes to stylizing images, and many of them *still* treat photos, especially local photos, like sacred art objects.

You can argue either side and never get anywhere. So try this: bring a pile of magazines into the newsroom. Analyze the cutouts, the superimposed headlines. Discuss what works, what doesn't. See if you can reach agreement on where to draw the line. Designate certain places in the paper (Features, Sports, the front-page promos) where it's OK to bend the rules.

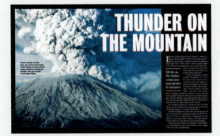

Magazine-like Here's a dramatic news story that integrates words and the visual, with reversed type and the headline atop the photo.

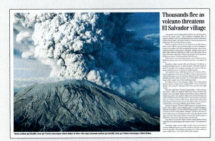

Standard style Many newspapers might choose to run this story like this, with the elements not overlapping each other.

HEADLINE GUIDELINES Write your headline first, especially on those packages where headlines are integral to the way the page looks overall. Pages look better and come together more easily if you have a *working* headline before you start piecing the entire page together. If you leave a big hole for someone to fill later, you might have to work with something that doesn't quite fit the space you had in mind. Yes, content is No. 1 here. But headlines should never be an afterthought.

If appropriate, use a display headline (with a deck to add more detail). Try something with personality that fits the tone of the story: a clever, punchy phrase with descriptive words above or below it. Aim for something bold, conversational and smart.

When in doubt, read the headline out loud. *Listen* to how the words sound when you say them—and then find the right headline treatment that best reflects that.

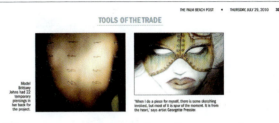

Poetic headline
Detail shots make up the essence of this Palm Beach Post photo essay about an artist who uses the human body as a canvas. An overly done display headline would easily detract from these images, which are vibrant and graphic. On this page, a simple one-line headline is all that's needed. The words, "She sings the body chromatic," have a lyrical feel to them. This headline moves beyond what could have been an obvious (and boring) solution: something along the lines of "The body painter." Notice how the dominant image is placed at the bottom. Do you think this works for this photo spread?

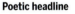

Photo page guidelines

TEXT GUIDELINES

▶ **Don't run too much text—or too little.** Most photo pages need text to explain why they're there. Too little text (less than 3 inches) may get buried. Huge text blocks, on the other hand, turn the page gray and crowd out the photos. Try to find the balance between the visuals and words.

▶ **Keep text blocks modular.** Never snake text over, around and through a maze of photos. Keep text rectangular. Park it neatly in a logical place, so that the reader can see clearly how to read through the text.

▶ **Negotiate on story sizes.** Sure, you dummy as closely as you can, but those 37-inch stories sometimes have to be cut—or padded—to fit. Make sure writers and editors give you flexibility on story lengths, so that you're not constantly decreasing the size of photos.

CUTLINE GUIDELINES

▶ **Give every photo a cutline.** Several photos may share a cutline, but not if it gets confusing. Always make sure it's instantly clear where each photo's caption is.

▶ **Add flexibility by running cutlines beside or between photos.** But don't float them loosely—plant them flush against the photo they describe. If cutlines use ragged type, sometimes the ragged edges can be placed away from the photo—if the caption block is not too long.

▶ **Push cutlines to the outside.** In weak designs, cutlines butt against headlines or text. In strong designs, cutlines move to the outside of the page, where they won't collide with other type elements. See the examples at the bottom of this page.

▶ **Credit photos properly.** You can do this by dummying a credit line along the outer edge of the design, or by attaching credit lines to each photo (or just to the lead photo, if they're all shot by the same photographer).

CUTLINE TIP

Bold lead-ins (just like what you see here leading into this sentence) help give the cutline a point of entry. The words can lead right into a sentence, or they can be treated as a separate label.

photo feature

eyewitness

Sunday News | 08.22.10 | THE VIRGINIAN-PILOT | PAGE 5

AT RIGHT | Park Yoon Hee, 16, of South Korea lifts in the snatch portion of the women's +63-kilogram weight-lifting finals Wednesday in Too Payoh Sports Hall.

BELOW | Daniele Benedetti, 14, of Italy and other competitors wait for the start of the practice race of the Techno 293 Windsurfer on Monday at the National Sailing Centre.

ADAM PRETTY | GETTY IMAGES

WONG MAYE-E | THE ASSOCIATED PRESS

Ioran Etchechury, 17, of Brazil trips and falls into the water during the 2000-meter steeplechase on Wednesday at Bishan Stadium.

ADAM PRETTY | GETTY IMAGES

Youth Olympic Games 2010

About 3,600 athletes ages 14 to 18 have been competing since Aug. 14 at the first Youth Olympic Games in Singapore. By the time the closing ceremony is held Thursday, athletes will have competed in 26 sports, from aquatics to wrestling. By the way, the next Olympics are in London in summer 2012. Maybe we'll see some of these athletes again then.

ADAM PRETTY | GETTY IMAGES

ABOVE | Ellie Salthouse, 17, of Australia collapses over the finish line after coming in second in the triathlon on Aug. 15 at East Coast Park.

AT RIGHT | Carlotta Ferlito, 15, of Italy cries for joy with her coach, Raul Paola, during the artistic gymnastics individual all-around finals on Thursday in Bishan Sports Hall. She finished third.

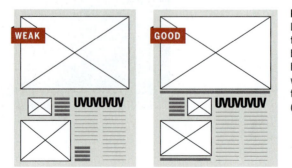

WONG MAYE-E | THE ASSOCIATED PRESS

A closer look at a photo page

Every picture page presents different challenges—whether the page is a section front or an inside jump page. Some pages have stories on them; others have just copy blocks. Take a look at some of the things that make this Virginian-Pilot photo page work:

Dominance The large image is played at the full width of the page for the highest impact and gives readers the sense that there are many athletes participating.

Flow The compositional elements in each photo move a reader's eye through the page. Additionally, the extra space around the edges of the page gives the images some breathing room.

Word info The headline acts more like a label here. Cutlines are placed in close proximity to the pictures they describe. Words like "above" and "at right" help the reader navigate.

WEAK

GOOD

UVUVUVUV

UVUVUVUV

Placement In the layout at the far left, one set of cutlines butts against the headline; another bumps into the bottom of a leg of text. Both problems have been fixed in the layout at left, where the cutlines have been moved to the outside, near the edges of the page (or centerpiece).

Photo page guidelines

OTHER DESIGN ADVICE

▸ **Add a little white space.** Don't cram text and photos into every square pica. Let the page breathe by using some white space. But try not to trap dead space between elements. Push it to the outside of the page.

▸ **Use an underlying grid.** Don't just scatter shapes arbitrarily. A good grid aligns elements evenly and maintains consistent margins throughout the page.

▸ **Use screens sparingly.** A tinted background screen can help organize and enhance layouts. Just don't let tints overwhelm or detract from the photos.

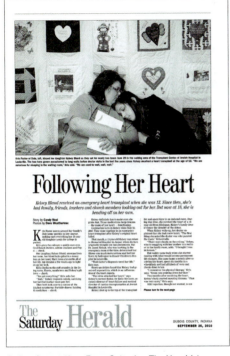

A visual narrative Every Saturday, The Herald, in Jasper, Ind., features a weekly picture story that starts on the front page and jumps inside. The front page is handled in the simplest way possible: one, maybe two images are played with size, along with the start of the story. Note how the flag drops to the bottom of this page. This is a unique setup for The Herald's Saturday edition and emphasizes the big photo story of the week.

Trapped space
Note how pockets of dead space seem scattered through the page at right. This is caused by moving shorter cutline blocks in between photos.

Better flow
Here, all the extra space has been pushed to the outer edges of the layout. As a result, the elements across this page fit more neatly.

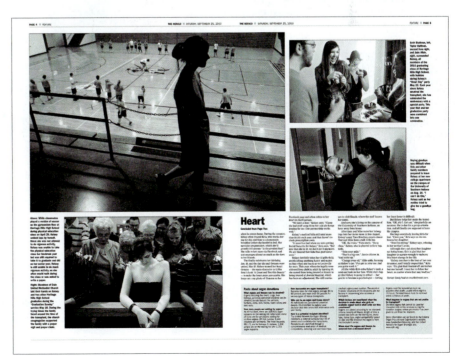

Studio shots

LEARN MORE
Photo cutouts: *General guidelines.* **Page 204**

Photojournalism is an honest craft. It records real people in real situations, without poses or props. But suppose you need a photo of a hot new smartphone. A can of beans. An award-winning poodle. Will that photo be real, honest photojournalism?

No, it'll be a studio shot. And unlike news photos, where photographers document events happening in front of them, studio shots let photographers art-direct by manipulating objects, posing models, creating props and controlling lighting.

Studio shots—or any other set-up photos, whether they're shot in a studio or not—are used primarily for features, including:

▶ **Fashion.** Clothes by themselves are dull; clothes worn by a model who smiles or looks great while being super active will yank readers into the page.

▶ **Food.** Making food look delicious in a photo is a lot tougher than you think, but it's absolutely essential for food stories.

▶ **Portraits.** Certain faces deserve special treatment. Studio shots with dramatic lighting or dark backgrounds let you showcase the subjects of those in-depth personality profiles.

▶ **Cultural objects.** Remember, it's important to show readers the actual CD covers, book jackets and new products mentioned in features and reviews. Show—don't just tell.

Portraiture In the studio, the photographer can art-direct an image and dramatically capture the mood of any personality being profiled.

Feeding the flame

Flambeed dishes offer surefire way to impress sweetheart on Valentine's Day

By Kate Collins | FOR THE COLUMBUS DISPATCH

Whatever the reason, from the need for entertainment to the primal fascination with fire, flambeed food stands out as a show-stopping idea for Valentine's Day.

The bravado of an open flame eliminates any doubt about culinary prowess.

After all, only a serious cook would risk burning down the house for cherries jubilee.

Yet the technique offers more than an unusual presentation: It also yields terrific flavors.

A different set of tastes and

See **FLAME** Page **D3**

INSIDE
▶ Recipes for bananas Foster and steak Diane | D3

Safety tips
The flambeing technique adds delicious flavors to a dish — and an impressive look to boot. Care should be taken, however, when making a flambe:

DO
choose alcohol of about 80 proof. Anything higher is considered too dangerous; and lower, incapable of ignition.

DON'T
add alcohol to cold food. A dish that isn't first warmed won't light.

DO
use warm or room-temperature alcohol. Cold alcohol won't light.

DON'T
pour alcohol directly from a bottle into the dish. The flame could follow the alcohol stream into the bottle, causing an explosion.

DO
use a large skillet with a long handle.

DON'T
add alcohol while the dish is still being heated.

DO
ignite the fumes, not the liquid, with a long match.

DON'T
lean over the dish as it is lighted.

DO
let the flames die before continuing with the recipe.

— **Robin Davis**
Food editor

Food "It's not the steak, it's the sizzle," goes the old advertising saying—which still rings true today. With the right lighting and behind-the-scenes styling, food photographed for the newspaper can be eye-catching and offer interesting information for readers.

Fashion and accessories A skilled photographer can work with different kinds of studio lighting to show off even the smallest details of clothes, jewelry and other objects that are part of the featured story.

Photo illustrations

Troubleshooting

Q We're a small paper on a tight budget, and we can't afford to hire artists. What are the best sources for stock art?

The good news is: There's plenty of affordable stock art out there. The bad news: Most of it is junk. You could check out something along the lines of Art Explosion—a CD with more than 800,000 images on it.

Or visit websites for companies like Art Parts and EyeWire, which offer quickie images like those below as well as bigger, better illustrations you can buy individually. There's also clipart.com, where you subscribe to use the service and download as much art—*"10 Million Downloadable Images!"*—as you can during a time frame of your choosing.

For a classier look, you can scan historic old engravings, like the one you see below, from copyright-free pictorial archives.

But be selective. Clip art often looks lowbrow. At its worst, it's *extremely* cheesy. So don't junk up your news stories just because you're desperate for art. Make the news look like news, not like the ads on the page.

And remember, the goal with clip art is not to fill up space on the page—the goal is to further advance the story's concept in the most effective way.

Sometimes the best way to illustrate a story is to create a photograph where actors or props are posed to make a point. The result is called a *photo illustration*. These are usually studio shots. But unlike fashion photos or portraits, photo illustrations don't simply present an image; they express an idea, capture a mood, symbolize a concept, tell a visual joke. They are often excellent solutions for feature stories where the themes are abstract (love in the office, teen suicide, junk-food junkies)—stories where real photos of real people would be too difficult to find or too dull to print. But keep in mind, a good photo illustration:

▶ **Instantly conveys what the story's about.** It should present one clean, clear idea.

▶ **Should never be mistaken for reality.** If you're going to create some fantasy, make it obvious. Distort angles, exaggerate sizes—do something to cue the reader that this photo isn't authentic. It's dishonest to pass off a fake photo (someone pretending to be a drug addict, for example) as the real thing. Even warning readers in a cutline isn't enough; readers don't always study the fine print.

▶ **Performs with flair.** A good photo illustration displays the photographer's skill and cleverness with camera angles, lighting, special effects, poses and props.

Pulling it together … yourself
You don't have to be a seasoned photographer to create a photo illustration. For the page at left, designer Robert Zavala at the Victoria Advocate says this page was "Frankensteined together" from stock art.

Illustrations

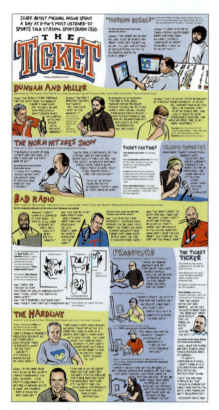

Illustrative Michael Hogue created this visual story through comics, above, in the Dallas Morning News to illustrate what went on behind the scenes at a popular sports radio station.

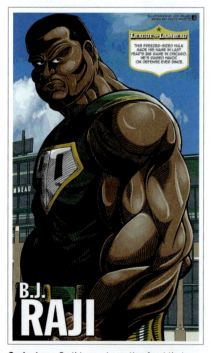

Caricature On this sports section front that ran in the Green Bay Press-Gazette, editorial cartoonist Joe Heller created illustrations of players for the Green Bay Packers.

Publications are packed with illustrations. Some aim to amuse: comics, for instance. Some appear in ads, selling tires and TVs. Some promote stories in teasers. Some jazz up graphics and logos. And then there are more ambitious illustrations, ones that (like photos) require more space, more collaboration between writers, editors and designers—and bigger budgets. Here's a look at the most common types of newspaper illustrations:

A editorial view This cartoon by Walt Handelsman of Newsday relies on a spontaneous drawing style, crisp hand lettering and a wicked sense of satire. And the fact that the content is timeless is a plus.

COMMENTARY AND CARICATURE The first illustration ever printed in an American newspaper was an editorial cartoon in Ben Franklin's Pennsylvania Gazette. It showed a dismembered snake, with each section representing one of the 13 colonies. It carried the caption "JOIN or DIE."

Editorial cartoons have gotten a lot funnier since then. Today, they're expected to be humorous, yet thoughtful; provocative, yet tasteful; far-fetched, yet truthful. That's why editorial cartooning is one of the toughest jobs in journalism—and why successful editorial cartoonists are rare.

A similar type of illustration, the commentary drawing, also interprets current events. Like editorial cartoons, commentary drawings usually run on a separate opinion page. Unlike editorial cartoons, commentary drawings accompany a story or analysis, rather than standing alone. They don't try as hard to be funny but still employ symbols and caricatures to comment on personalities and issues.

Caricatures, however, aren't limited to opinion pages. They're often used on sports or entertainment pages to accompany profiles of well-known celebrities. A good caricature exaggerates its subject's most distinctive features for comic effect. Like editorial cartooning, it's a skill that's difficult to master, and should probably be avoided if:

▸ The subject's face isn't very well-known.
▸ The story is too sensitive or downbeat for a brash style of art.
▸ The artist's ability to pull it off skillfully is doubtful.

Illustrative + Interactive The Plain Dealer's Chris Morris illustrated and designed this puzzle-and-game page.

DIGITAL AND HAND-DRAWN ILLUSTRATIONS

Feature page stories often focus on abstract concepts: drugs, diets, depression, dreams and so on. Many of those concepts are too vague, elusive, or difficult to document photographically.

That's where illustrations can save the day. Drawings that interpret the tone of a topic can add impact to the text while adding personality to the page.

Finding the right approach to use in an illustration takes talent and practice. (It can create thorny staff-management problems for editors, too. An awful lot of amateur illustrations look—well, awfully amateurish. And it's surprisingly hard to tell a colleague, *"Your drawing stinks."*)

These drawings, executed digitally or by hand (or a combination of both), can be silly or serious, colorful or black-and-white. They can dominate the page or simply drop into a column of text (sometimes these are called *spot illustrations*) to provide an added visual component.

Be careful, however, not to overload your pages with frivolity. Readers want *information,* not decoration. They can sense when you're just amusing yourself.

A hand-drawn style For a story on the most recent Harry Potter film's release, designer Bethany Bickley created a series of watercolor illustrations (above is an excerpt from one of the pages featuring the cast of characters) for Go!, The Huntsville Times weekly entertainment tabloid.

Risky business

In your search for The Ultimate Page Design, you may be tempted to try some of these effects, which you can see below. But before you do, read on:

STEALING Before you "borrow" an image from an outside source, be sure you're not violating copyright laws. Old art, like the Mona Lisa, is usually safe; current, copyrighted art can be reproduced if it accompanies a review or plays a part in a news story. But copyright laws are complex (as are laws governing the reprinting of money*) so get good advice before you plunge into unfamiliar territory.

FRAMING There are clip-art books full of fancy frames, computer programs loaded with decorative rules. And someday, you may succumb to temptation. You'll decide to surround an elegant image with a gaudy, glitzy frame. *Don't do it.* Artwork and photographs should be bordered with thin, simple rules. Colorful or overly ornate frames just distract readers' attention from what's important.

FLOPPING Printing a photo backward, as a mirror image of itself, is called flopping. Usually, it's done because a designer wants a photo facing the opposite direction, to better suit a layout. But that's dishonest and dangerous. It distorts the truth of the image. Never flop news photos—or any photos for that matter, even if they're feature ones or were shot in the studio.

RESHAPING As we've learned, photos work best as rectangles with right-angle corners. Cutting them into other "creative" shapes distorts their meaning, clutters up the page and confuses readers. Put simply: Slicing up photos is the mark of an amateur. There's rarely a valid reason for doing it.

TILTING Sometimes you get art that's so wild 'n' wacky, you just gotta give it an equally nutty layout. OK—but beware. Unless you choose appropriate art, tilt it at just the right angle and skew the type smoothly, you'll look silly. Even though pros try it once in a while, save it for when you really need it.

SILHOUETTING If a photo is weakened by a distracting background or needs a dramatic boost, you can carefully cut out the central image and run it against the white page. That works well with some photos, poorly with others—but it usually should be avoided for news photos.

For instance, you may reproduce dollar bills only at sizes 150% or larger, or 75% or smaller.

1 Below are four photos that accompany a story about a woman jockey. Using all four, create a full-page photo spread for a broadsheet feature section, with the headline "On the Fast Track" (and you'll need to add a deck below the headline, as well). The story is very long, so assume you can jump as much text as you need.

Here are the photographer's recommended crops for the images. But before you begin, ask yourself: Which photo should be dominant?

You can find the answers to these questions on Page 244

Exercises

2 The photos for that woman jockey spread (previous page) were good, both in content and technical quality. But if you were the photo editor for that page and there was time to go back and shoot more photos, what might you ask for? What's missing?

3 The three layouts below were created from those jockey photos. Can you find at least three things wrong with each of these page designs?

4 At left is a photo of Tiger Woods playing in a local golf tournament. This is your photographer's best shot. (Unfortunately, he wasn't able to get a dramatic closeup or reaction shot of Tiger.) The sports editor insists on leading with this photo. So how would you crop it?

You can find the answers to these questions on Page 244

Nuts & bolts

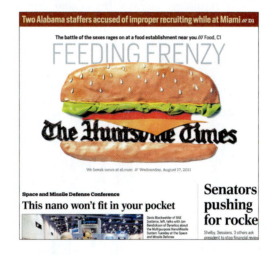

A newspaper is a product ... like cornflakes. And for a long time, they've both been considered a traditional part of America's breakfast routine. Like cornflakes, though, newspapers often seem indistinguishable from one brand to another.

So how do you make your brand of cornflakes look more appealing to consumers? You take that yummy content, and you stick it in a very-much designed colorful box. Create a slick logo. Dream up an attractive promotion (*FREE WHISTLE INSIDE!)* or lift out some catchy phrase (*High-fiber nutrition with real corn goodness*) to catch the eye of passing shoppers.

Finally, you stick in all the extras that are required to be there—ingredients, the date, the company website address—as neatly and unobtrusively as you can.

All that holds true for news publications, too. And in this chapter, we'll examine the graphic nuts and bolts used to assemble newspapers: logos, flags, bylines, decks, teasers, liftout quotes and more. We'll explain how to label and connect related stories. How to break up deep columns of gray text. And how to add graphic devices that sell stories.

In other words, how to pack more real corn goodness into every bite.

CHAPTER CONTENTS

▶ **The flag:**
Examples of different newspaper nameplate styles.............146

▶ **Logos & sigs:**
How to design headers, logos, sigs and bugs to label regular and special features............. 147

▶ **Liftout quotes:**
Using quotations as a graphic element within text.......................150

▶ **Decks & summaries:**
How to size them, where to dummy them and other design guidelines152

▶ **Bylines:**
A look at different formats both for news stories and for special pages......154

▶ **Credit lines:**
Options for crediting photographers and illustrators................155

▶ **Spacing:**
Guidelines for aligning story elements and margins on a typical page156

▶ **Rules & boxes:**
Guidelines for using them both functionally and decoratively..............157

▶ **Refers, teasers & promos:**
Guiding readers to stories scattered throughout the paper......158

▶ **Breaking up text:**
Using subheads, initial caps and dingbats to break up long legs of text...............159

▶ **Jumps:**
Guidelines for jumping stories smoothly from one page to another....... 160

Let's begin at the top of Page One, with one of journalism's oldest traditions, the flag. Though newspapers have tried boxing it in a corner, flipping it sideways or floating it partway down the page, most papers choose the simplest solution: anchor the flag front and center to lend the page some dignity.

(Flags, incidentally, are often mistakenly called "mastheads." But a masthead is the staff box full of publication data that usually runs on the editorial page.)

Student publications often update their flags every few years, while editors at larger, more traditional newspapers are less inclined to fiddle with them (in part because repainting delivery trucks and reprinting stationery gets expensive). They believe that flags should evoke a sense of tradition, trust, sobriety—and indeed, some Old English flags look downright religious.

But others argue that flags are like corporate logos and should look fresh. Bold. Innovative. Graphically sophisticated.

Examine the sampling of flags below. What clues do you think they offer to their papers' personalities?

What's essential in a flag? The name of the paper. The city, school or organization it serves. The date. The price. The edition (*First, Westside, Sunrise*), if different editions are published. Some papers include the volume number—but though that may matter to librarians, readers rarely keep score.

Different flags, different choices
Some papers float their flag in white space to give it prominence. Others add elements such as text or visuals to fill the space near the newspaper's name. This unit of elements across the top part of the page is known by different names: the promo, skybox or ear, to name a few. Papers stick a variety of items in this spot: weather reports, slogans ("All the News That's Fit to Print") or teasers promoting features inside the paper.

Logos & sigs

Section-front personality The treatment of these signposts for the different sections of a newspaper can vary greatly—from the subtle to a more in-your-face style.

Section-front treatment In some newspapers, the section front logo designs are visually consistent throughout the paper. In other papers, each one has its own distinct flavor. Either way can work, but if the section front logo presentations are dramatically different from one another, they may not look like they are part of the same publication. In The Virginian-Pilot, the large, light-weight section front headers help tie together all the different parts of the paper:

STANDING HEADS AND SECTION LOGOS

As you travel through a newspaper, you pass signposts that tell you where you are. Some are like big billboards ("Now entering LIVING"). Others are like small road signs ("Exit here for *Movie Review*").

Every paper needs a well-coordinated system of signposts—or, as they're often called, *headers* or *standing heads*. Just as highway signs are designed to stand apart from the scenery, standing heads are designed to "pop" off the page. They can use rules, decorative type, fancy screens or reverses—but it's essential that their personalities differ from the ordinary text, headlines and cutlines they accompany.

Compare, for example, these two headers (also called section *flags* or *logos*):

No contrast This section logo uses the same typeface as the headlines—they're both the same size and weight, too. Nothing sets the top line apart from the headline of the day's news—so nothing pops off the page. The overall effect is static. To help the reader navigate through the page, the look of the logo and the headlines must be clearly defined.

Clear contrast Here, the section logo looks entirely different from the headline below. The logo is made up of an all-caps serif font that feels light and airy. There's also a screen of black, with a thin drop shadow. The main headline is a thicker sans serif font. The two lines are separated by a thick rule that sets apart the section head from the rest of the page.

A *logo* is a title or name that's customized in a graphic way. Logos can be created with type alone, or by adding rules, photos or other art elements.

Section logos, like those above, help departmentalize the paper. In small tabloids, they should appear atop the page to signal major topic changes (from Features to Opinion, for instance). Bigger broadsheets use section logos to label each separate section, often adding teasers to promote what's inside.

Some newspapers use standing heads to label the content on every single page. Others reserve that treatment for special themed pages (*Super Bowl Preview*) or investigative packages (*Guns in Our Schools: A Special Report*).

Either way, those added signposts guide readers most effectively when they're designed in a graphic style that sets them apart from the "live" news.

Logos & sigs

As we've just seen, section logos and page headers are used to label sections and pages. But labels are necessary for special stories, too. And those labels for stories are called *logos, sigs* or *bugs.*

Story logos are usually small enough to park within a leg of text. But whatever their size, they need to be designed with:

▸ A graphic personality that sets them apart from text and headlines;
▸ A consistent style that's maintained throughout the paper; and
▸ Flexible widths that work well in any design context.

It's important to dummy logos where they'll label a story's content without confusing its layout—which means they shouldn't disrupt the flow of text or collide with other elements.

Here are some of the most common ways to dummy logos with stories:

Non-obtrusive mug Here, the columnist's mug shot is half a column wide and runs alongside the first leg of text. The writer's name is presented in a simple and clean way: no shadows, decorative type or color. The presence of the other elements here—the headline treatment and the big fish— give this column a distinctive and recognizable look.

Multi-column layouts In this format, sigs and logos are usually dummied atop the second leg so they won't interrupt the flow of the text. Avoid adding mug shots or photos to that second leg, too—the logo will look odd whether dummied above or below other art, and both images will fight for the reader's attention.

Vertical layouts In this format, sigs and logos are either dummied above the headline or indented a few inches down into the text. Indenting logos is tricky, though, since text should be at least an inch wide— which doesn't leave room for long words in a logo.

Across the top Instead of placing sigs and logos down in the text, some papers use headers that stretch above the headline, usually running the full width of the story. This is a very clean, clear way to label special features, but it takes up more space than the other formats—and doesn't do anything to break up gray legs of text.

Mug choices There are as many ways to design a columnist's sig as there are columnists out there. Photos can be cropped or cut out for impact; the typography choices for the writer's name are endless; there are an infinite number of design touches that can be used to add a little flavor to any sig. But don't take it over the top—a columnist's sig can look distinctive, but the other stories on the page shouldn't have to compete with it. Note the columnist's sig on the lower right on this page. The columnist's mug shot has been cut out, and it sits on a rule that helps separate layers of information on what the column is about.

COLUMN LOGOS Column logos are a way to label special writers, those regularly appearing personalities whose names and faces deserve prominent display. These logos (also called *photo sigs*) are usually reserved for writers whose columns are subjective, opinionated or humorous—and whose columns hopefully become a regular reader habit. (To support that habit, then, it's important to dummy the column in the same style and the same place each time it runs.)

Column logos usually consist of:

▸ The writer's name.
▸ The writer's likeness (either a photo or a sketch).
▸ A catchy title: *Dear Abby, Screen Scene* or *On the Town.*

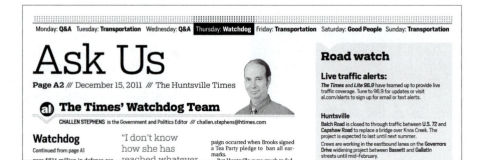

Logos & sigs

LEARN MORE
Fast-fact boxes: *Capsuliz-ing information.* **Page 166**

CHUCK SHEPHERD
and CHIP ROGERS

Effective labeling The Athens NEWS, a bi-weekly tabloid-sized newspaper in Ohio, runs many columns on divergent topics. Some of the columns originate from staff writers, and others—like News of the Weird—are syndicated. The challenge for the designer here is to create a series of sigs that are unique to each column—and still look like they are part of the same publication.

Election time, again Elections are scheduled far in advance, so there shouldn't be any last-minute scrambling to create an election logo—something that will run repeatedly throughout the election season. At a glance, readers will have no doubt what these stories are about on this front page of The Sun-Sentinel. Here, a small logo runs at the top of this page, to signify what this overall package is about. This logo can easily be tucked into any story anywhere in the paper.

SIGS AND BUGS Column logos promote the personalities of *writers*. Sigs and bugs, on the other hand, identify *topics*. They're a functional yet decorative typographic treatment that's used to label:

▶ Briefs and non-standard news columns (*Business Notes, People, World Roundup*);

▶ Opinion pieces that need to be distinguished from ordinary news stories (*News Analysis, Movie Review*);

▶ Regularly appearing features (*NFL Notebook, Action Line!, Money Matters, Letters to the Editor*).

At some papers, there's even a trend toward labeling more and more stories by topic (*City Council, Medicine, Tennis*). That's difficult to do consistently throughout the paper—quick, what's a one-word label for a story about two jets that nearly collide?—but when it works, it's a helpful way to guide busy readers from topic to topic.

Other papers use sigs that refer to stories on other pages or include fast facts (as in that bottom movie review sig at right).

Sigs can be designed in a variety of sizes and styles, adding rules, screens or graphic effects to catch readers' eyes. But every paper should use a consistent graphic treatment for all its logos. That means the style you use for **POP MUSIC** should also be appropriate for **OBITUARIES**.

SERIES LOGOS Series logos are a way to label special packages (a five-day series on *Racism in the Classroom*) or stories that will continue to unfold over an extended period (like *Election 2012* or *Revolt in Egypt*).

Series logos (called *icons* at some papers) usually consist of:

▶ A catchy title that creates reader familiarity;

▶ A small illustration or photo that makes the topic more graphic;

▶ Optional refer lines to other pages or to tomorrow's installment.

Logos are usually one column wide or indented into the text—and as these examples from The Detroit Free Press show, they come in a variety of styles:

Liftout quotes

LEARN MORE
Making stories fit: *Tips and guidelines.* **Page 98**

Quotation mark styles These punctuation marks can be used as visual hooks on a page to draw attention to what someone said. These can be huge, colorful, or partially hidden behind type. Magazines frequently make the most of quotation marks—this venue is a great resource for collecting ideas.

> *"If I repent of anything, it is very likely to be my good behavior. What demon possessed me that I behaved so well?"*
>
> — Henry David Thoreau

> *"If I repent of anything, it is very likely to be my good behavior. What demon possessed me that I behaved so well?"*
>
> — Henry David Thoreau

Hanging punctuation Can you see the difference between above examples? No? Look again. Try taking a straight edge to the left side of the column. See it now? In the example on top, the quotation mark is aligned exactly along the left edge, and yet the quote looks indented. On the bottom, the quotation mark is hanging outside of this edge, so optically, it looks even with the rest of the text.

Why even bother with this nit-picky detail? With pull quotes that are larger in size, spaces are accentuated. So, without hanging them, alignment looks a little off.

(To get the quotation mark to hang in InDesign, select the appropriate text box, choose "Type" in the top menu, then choose "Story." Click on the button next to "Optical Margin Alignment." And, *voilà!*)

"The surest way to make a monkey of a man," said Robert Benchley, "is to quote him." And a sure way to make readers curious about a story is to display a wise, witty or controversial quote in one of the columns of text.

As the examples here show, liftout quotes can be packaged in a variety of styles, enhanced with rules, boxes, screens or reverses. They go by a variety of names, too: *pull quotes, breakouts, quote blocks,* etc. But whether simple or ornate, liftout quotes should follow these guidelines:

▸ **They should be quotations.** Not paraphrases, not decks, not narration from the text, but complete sentences spoken by someone in the story.

▸ **They should be attributed.** Don't run "mystery quotes" that force us to comb the text for the speaker's identity. Tell us who's doing the talking. In many cases, it also helps to include the person's title, or even circumstances. For example, "John Doe, a neighbor who witnessed the crime."

▸ **They should contrast with the text type.** Don't be shy. Use a liftout style that pops from the page to catch the reader's eye—something distinctive that won't be mistaken for a headline or subhead.

▸ **They should average 1-2 inches deep.** Shallower than that, they seem too terse and trivial; deeper than that, they seem too dense and wordy. But of course, it all depends upon the quote and the way it's used on the page, so use your best judgment.

COMBINING QUOTES AND MUGS Words of wisdom are attractive. And when we see the speaker's face, we're attracted even more. That's why mug/quote combinations are among the best ways to hook passing readers.

Quotes with mugs can be designed to run boxed or unboxed, screened or unscreened. Whatever style you adopt, adapt it to run both horizontally (in 2- or 3-column widths) and vertically (in 1-column widths or indented within a column). Be sure the format's wide enough, and the type small or condensed enough, to fit long words without hyphenation.

"I'm an actress, a brand, a businesswoman. I'm all kinds of stuff."

Paris Hilton, actress, brand and businesswoman

Quotes with style
People say all kinds of things that are quotable: outrageous statements, emotional pleas, a perfect summing up of a situation. Use contrast in different ways—size, color, italics, bold, rules, screened boxes, for example—to make these quotes pop. With or without mugs, remember to **keep liftout quotes as typographically tidy as you can.** And use these sparingly: partial quotes, parentheses, ellipses. Avoid hyphenation and widows.

"So you're telling me that ... the phrase 'separation of church and state,' is in the First Amendment?"

— **Christine O'Donnell, Republican Senate nominee in 2006, 2008 and 2010**

Liftout quotes

LEARN MORE
Breaking up text: *Some guidelines.* **Page 159**

Troubleshooting

Q In magazines, I see logos and liftout quotes used with smaller type than in newspapers. How small can those things be?

Many magazines try to push the limits of miniaturization. And because their presswork is so pristine and accurate, they can successfully run type and photos much smaller than newspapers normally dare.

"How is it that George Washington slept in so many places but never told a lie?"
– BUD CLARK

But if you're crafty and careful, you can downsize your design components, too. Newspapers that use exotic grids (an 18-column broadsheet, for example) may need to create mug/quote combinations like the one at left—a mere 4 picas wide. But by cropping tightly and selecting condensed fonts that read well at a smaller size, you can keep them both attractive and readable. The key is to maintain contrast between the pull quote and whatever is around it (whether it's text or white space).

With small type, though, be cautious with the use of color. Registration problems (when the cyan, magenta, yellow and black—or CMYK—plates aren't hitting the paper in the same exact spot on the paper) could easily make a smaller-than-usual quote unreadable. (And if you use really thin rules in color around that quote, you could be asking for some reproduction trouble.)

Remember, the older your readers, the more sight-challenged they most likely are. Student newspapers will be able to miniaturize logos and liftout quotes more successfully than mainstream newspapers.

GUIDELINES FOR DUMMYING LIFTOUTS

▶ **Be sure you have a quote worth lifting before you dummy it in.** You can't expect great quotes to materialize automatically—some stories, after all, don't even *use* any quotations. Read the story first. Or talk to the reporter. Remember, once you develop the habit of promoting great quotes, it encourages reporters to find more great quotes. As a result, both stories and readers will benefit.

▶ **Don't sprinkle liftouts randomly through the text just to kill space.** That gets distracting. For maximum impact and better balance, dummy quotes symmetrically (below, left). Or create a point/counterpoint effect with two mugs (below, right). Or combine multiple quotes into an attractive package, with or without mug shots (below).

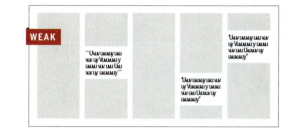

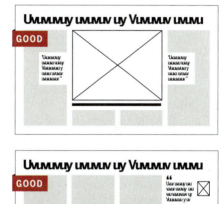

▶ **Never force readers to read around any 2- or 3-column impediment.** Text that hops back and forth like that gets too confusing (right). Use 2-column liftouts only at the top of the text (below). One-column liftouts usually aren't quite as confusing, but as an alternative, you might try indenting an area for the liftout, then wrapping the text around it (below right).

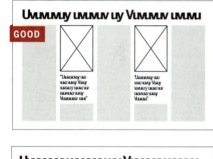

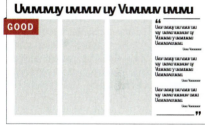

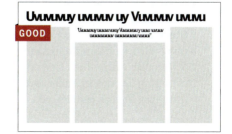

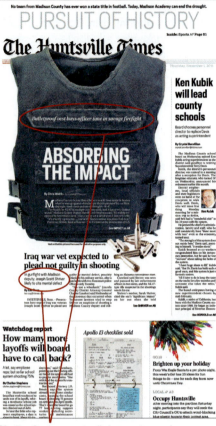

Clarity Decks come in all shapes, sizes and even locations. Most of the time, it's best to keep them simple, like we see above for the Iraq war vet story. For the lead story, though, the deck provides valuable context for the headline, so it falls above it. Additionally, all these "big words," as well as the body copy, are well-integrated into the main visual—a bulletproof vest.

The essentials Lots of newspapers pull out deck-type information in unique and eye-catching ways. These quick informational hits give the readers the essentials of the story, like we see here in this front-page centerpiece about traffic gridlock. This approach can work for lots of stories, in any section of the paper. See Page 162 for more ideas on alternative ways to present information.

I magine just being limited to using one, two or three words to "describe" a story in some unique way. Not an easy thing to do, and yet, one of the most persistent problems in all of newspapering is this very thing: The Headline That Doesn't Quite Make Sense on its own:

Schools bill falls

Copy editors are only human, usually, so headlines like that are inevitable. But one way to make headlines more intelligible—especially on important stories—is to add a *deck* below the headline to explain things further:

Schools bill falls

Senators kill a plan to finance classes by taxing cigarettes

Big enough to read This example uses a 36-point boldface condensed headline and an 18-point lightface deck. Decks are most effective in lightweight or italic faces that contrast with the main headline. In news stories, they're usually set flush left in the first leg of text.

Quite often, decks make more sense than headlines. Which shows you how valuable they can be.

Years ago, papers stacked decks in deep rows (see example, Page 28). Today, most use only one deck per story. Decks for news stories are often 3-4 lines (10-15 words); decks for features are generally longer (15-30 words). But there's a lot of variety in deck treatment, and depending on the story, a different deck style could help add a different, compelling twist to how the key story information is presented.

Some editors think decks are a waste of space and use them only as padding when stories come up short. That's a mistake. Since most readers browse the paper by scanning headlines, it's easy to see that a good head/deck combination adds meaning.

BASIC DECK GUIDELINES

▸ **Use decks for all long or important stories.** Remember, readers are more likely to plunge into a sea of text if they know in advance what it's about.

▸ **Use decks with all hammer or display headlines.** It's fine to dream up a clever feature headline like "Heavy Mental." But if you don't add a deck to explain what that means, readers may never decipher your cleverness.

▸ **Give decks contrast—in size and weight.** By sizing decks noticeably smaller than headlines, they'll be easier to write. They'll convey more information. And they'll look more graceful (as magazines discovered long ago). Though most papers devise their own systems of deck sizing, decks generally range from 14 to 30 points (or bigger), depending on the size of the headline they accompany.

For added contrast, most papers use either italic decks (with roman heads) or lightface decks (with regular or boldface heads). These combinations can also be reversed. Whatever your paper's style, it's important to set the deck apart—with both spacing and typography—from the headline and the text.

▸ **Stack decks at the start of the story.** Don't bury them in the text. Stick them in some corner or banner them across the full width of the page. Decks are functional, not decorative. Put them to work where they'll lead readers into the text—usually in the first leg (though in wider layouts, 2-column decks work fine).

In fancy feature layouts, you can be more creative. But that comes later.

Decks & summaries

Senators kill a schools bill plan to finance classes by placing a tax on cigarettes

By a 78-12 vote, the Ohio Senate rejects a plan to finance classes by adding a 10-cent tax on each package of cigarettes that are sold this year

COLUMBUS—Senate lawmakers ended any chance this year to raise revenue for public schools by increasing the tax on cigarettes.

A 10-cent tax hike on each cigarette package sold would have raised $103.4 million in the first year, says Gov. Wendy Wallowman, a backer of the plan.

"Increased taxes on tobacco would not only help fund schools, they could also cut down on smoking rates and health care costs for everyone," Wallowman said at a press conference yesterday, just hours after the Senate vote.

A survey conducted last month found that a majority of Ohio voters were opposed

Please see **Tax,** *Page A3*

Overpowering There's an art to writing well-written, succinct headlines and decks. Sometimes, though, especially when stories are a little on the complex side, it's tempting to go overboard. What we see here is excessive—the equivalent of a run-on sentence. And the story's text is practically buried under the heap of words in the main headline and deck. There are other problems with this setup. Can you spot them? (Hints: See that hyphen? The bad breaks? Can you *hear* those repeating words?)

SUMMARY DECKS Some papers call them *summaries.* Others call them *nut grafs.* Either way, they're more than just downsized decks. They're a response to busy readers who say, *"I'm in a hurry—why should I care about this story?"* Hundreds of papers use them on many of their stories to distill the content of the text into about 20-30 words.

Quite often, decks make more sense than headlines. Which shows you how valuable they can be.

Schools bill falls

■ By a 78-12 vote, the Ohio Senate rejects a plan to finance classes by adding a 10-cent tax on each pack of cigarettes sold this year

More info Compare this headline/deck combination with the one on the facing page. Which offers more information at a glance? This example uses 12.8-point type. It begins with a dingbat to catch your eye (and to distinguish the summary from the text that follows).

The simplest way to create a summary is to write a longer-than-usual deck using smaller-than-usual type. But some papers try more creative approaches, both in the typography they use and in the way they highlight information (see below and left):

TAX PLAN DEFEATED:

By a 78-12 vote, the Ohio Senate rejects a plan to finance classes by adding a 10-cent tax on each package of cigarettes sold this year

Boldface lead-in This style is used to highlight key words—followed by more detailed summary material in contrasting italic type that's set at 12 points.

BRIEFLY

Background: To compensate for a projected $3 million budget shortfall, the Ohio Senate debated a plan to finance classes by adding a 10-cent tax on each pack of cigarettes you buy.

What it means: The bill's 78-12 defeat may force Ohio to make drastic school budget cuts.

Contrast The word BRIEFLY in a reverse bar tops this off, then uses boldface words to break down parts of the story. The type is 9-point—which may be a bit small for a deck, but better for a pullout.

SUMMARY GUIDELINES

▸ **Don't rehash the headline and the lead.** Each element—the main headline, the summary and the lead of the story—should add something different to the reader's overall understanding. That means you should avoid repeating words or phrases. More importantly, it means writing those three elements as a single unit, with a flow of logic that leads the reader smoothly into the text. (In many newsrooms, the writer of the story contributes the wording for the headline and summary. That's an excellent way to maintain accuracy and avoid redundancy.)

▸ **Use conversational language.** Summaries should be complete declarative sentences in the present tense. Unlike traditional decks, summaries are couched in a reader-friendly, conversational style. As the examples above show, there's no need to eliminate articles (a, an, the), relative pronouns or contractions.

▸ **Don't be stodgy or pretentious.** Avoid obscure words or jargon. Simple words always work best—and short words will make hyphenation unnecessary.

▸ **Don't worry about bad breaks.** The traditional rules of headline writing don't apply here. A subject can be on one line, a verb on the next. Nobody will care if an infinitive is split between lines. But do avoid hyphenation and widows.

▸ **Feel free to improvise.** Many papers add quotes or mug shots to summaries, transforming them into graphic elements. How far is your paper willing to go?

Bylines

Troubleshooting

Q How do you credit photos taken by someone's family, instead of a newspaper photographer? Or old file photos? Or digitally manipulated images?

When it comes to crediting stories and photos, one solution just won't work for every situation. (For instance, what's your byline wording for a wire-service story that's been expanded and reworked by two of your staff writers?)

In Chapter 8, we'll talk about how essential a good design stylebook is. And every staff's stylebook should contain an entry like the one below, adapted from The Richmond Times-Dispatch's outstanding 1996 stylebook, anticipating every variation of photo and graphic credits.

If your newspaper runs art and text from a variety of sources, you'll find a guideline like this handy for credit lines and bylines alike. Answering these questions in advance can save valuable time on deadline.

CREDIT LINE GUIDELINES

Staff photos: BENJAMIN BRINK/THE OREGONIAN
Photo illustration by TOM TREICK/THE OREGONIAN

Special event staff photos:
JOEL DAVIS/THE OREGONIAN, January 1998

Former staff photos: THE OREGONIAN

Reporter photos: KRISTI TURNQUIST/THE OREGONIAN

Freelance photos:
JOE SMITH/SPECIAL TO THE OREGONIAN

Syndicated material: ©WARNER BROS. RECORDS

Agencies/miscellaneous:
NATIONAL ARCHIVES
BBC PHOTOGRAPH LIBRARY
©1995 CAROL PRATT PHOTOGRAPHY

Family photo with date: 1993 FAMILY PHOTO

Family photo without date: FAMILY PHOTO

File photos: File photo, 1995

Wire photos: THE ASSOCIATED PRESS

Wire graphics: THE ASSOCIATED PRESS
N.Y. TIMES NEWS SERVICE

Graphics staff: STEVE COWDEN/THE OREGONIAN

More than one artist:
DAN AGUAYO, MOLLY SWISHER/THE OREGONIAN

File graphic: THE OREGONIAN

Shared credit: Graphic by MIKE MODE,
Research by WALLY BENSON/THE OREGONIAN

Digitally altered images:
Illustration by RENE EISENBART/THE OREGONIAN,
source material by SUSAN UNDERHILL

Special staff project: BY THE OREGONIAN STAFF:
STEVE COWDEN, artist; RICHARD HILL, writer; MIKE MODE
and WERNER BITTNER, contributing artists

To reporters, bylines are the most important graphic element in the entire newspaper. What a shame, then, that readers rarely give bylines a glance as their eyes dart from the end of the headline to the start of the story.

It's necessary, though, to give credit where credit is due (especially when readers have complaints or questions about a story). Papers differ on byline policies, but most publications put reporters' names on stories of substance—that is, all stories more than about 6 inches long.

Bylines generally run at the start of the story in a style that sets them apart from the text: boldface, italics, one or two rules. The first line gives the reporter's name; a second line tells whether he or she writes for an outside organization (The Associated Press, for example), works as a freelancer (often labeled a "special writer" or "correspondent") or belongs on the staff (most papers run either the name of the paper or the writer's title).

Every newspaper should adopt one standard byline style. Some examples:

By MOE HOWARD
The Daily Planet

Larry Fine
THE DAILY PLANET FILM CRITIC

By CURLY HOWARD
curlyhoward@dailyplanet.com

Student newspapers sometimes use loud, eye-catching byline styles, perhaps as a bribe to lure reporters onto the staff. Screened, reversed or indented bylines can seem fun, but they call too much attention to themselves. Proceed with caution.

» BY HARPO MARX

By CHICO MARX
................
of The Times

BY GROUCHO MARX

For short sidebars or columns of briefs, credit is often given in the form of a flush-right tag line at the end of the text. As with bylines, these credit lines need spacing and typography that sets them apart from the text:

— The Associated Press

— Compiled from staff reports

**Story by
STAN LAUREL**

**Photos by
OLIVER HARDY**

Some papers run all bylines at the end of the story (and some even include the reporter's phone number or email address). At the start of the story, the logic goes, bylines just add clutter amid the headlines and decks; since writers' names are less urgent, they can come later.

On photo spreads and special features, newspapers often use a more prominent byline style to credit the writer, the photographer, or both. (Page designers, sad to say, rarely receive printed credit for their work.) These special credits are either parked at the edge of the design or indented into a wide column of text, like the Laurel and Hardy credit here.

Credit lines

describes the techniques she uses to force herself past the first idea and on to something more creative.

"There's some comfort in knowing I have, for example, Design A," Rose says. "Then it's easy to move past that, knowing I have at least something to show others."

She tries to stay tuned to what she describes as those "happy accidents."

"I might notice, for example, that as I move an object from one part of the page to another, I create some interesting juxtaposition that I hadn't noticed before," Rose says. "I follow my instincts as much as I can and pay attention to possibilities."

Seeing is believing, she believes, which

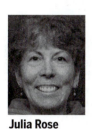

Julia Rose

A byline for a mug shot? In a newspaper, oftentimes everyday mug shots have no credit lines. As you can see, there's really no room to jam a credit line anywhere near the photo, above. (At the very least, though, a mug shot should be identified with a name.)

Lower left corner Not many papers run credit lines in this spot. Instead, it's common to run the source line in the lower left corner—that's the line in a chart, map or diagram that tells the source of the data being used. Putting that information here (or inside the box) keeps it separate from other credit lines.

STYLE, FUNCTION AND PLACEMENT Artwork, like stories, should be credited—whether the art comes from staffers, freelancers, wire services or library files. Different styles of credit lines serve different functions:

▸ For photos and illustrations, credit lines provide the name and affiliation of the photographer or artist who produced the image.

▸ For old, historic photos or maps, credit lines tell readers where the documents come from (i.e., The Bozoville Historical Society). Often, this info includes the date a photo was taken, which is necessary for any photo that could mistakenly be considered current.

▸ For charts or diagrams, an additional "source" line tells readers where the artist obtained the data that was graphicized. Citing such sources is just as important for artists as it is for reporters.

▸ For copyrighted material, credit lines provide the necessary legal wording (*Reprinted with permission of ... or ©2012 by ...*).

Not all publications credit all photos, however. For instance, most don't bother crediting run-of-the-mill mug shots. And publicity handouts—movie stills, fashion shots, glossies of entertainers—usually run uncredited, too (probably because editors resent giving away all that free publicity).

Most papers run credits in small type (below 7-point), in a font that contrasts with any cutlines nearby. Some papers still run photo credits at the end of their cutlines, like this:

Tokyo citizens scream in terror Friday as Godzilla destroys the city. (Staff photo by Dan Gustafson.)

But that credit style isn't as effective as it could be. Ideally, there should be a clear distinction between cutlines and credit lines, just as there's a distinction between text and bylines.

Most papers run credit lines flush right, just a few points below the bottom edge of the art and a few points above the cutline. Some papers run them flush left. Some run them on top. Some have even tried running them sideways along the right edge, though that's difficult to read and tends to jam up against any adjacent leg of text. (When graphics use both a source line *and* a credit line, they should be dummied in two separate positions to avoid confusing readers.)

Below, you can gauge the effectiveness of each location:

The Oregonian/JOEL DAVIS

The Oregonian/JOEL DAVIS

Source: Department of Redundancy Department

The Oregonian/JOEL DAVIS

This is the cutline (or caption). Cutlines usually run a few points below the credit line and use a font that's bigger and bolder than the credit. The font size is often similar to the size used for the body copy.

Above the photo Some papers run credit lines here, flush right—though many readers habitually look for them below the photo, down around the cutline.

Next to the photo Many magazines run credit lines sideways or in the margins—but even if the type is tiny, it risks crowding into adjacent columns of text.

Below the photo Most papers run credit lines flush right, a few points underneath the image. Whatever you choose to do, keep it consistent—pick one position and run all credits there.

Alternative story forms

It's the first day of a new school year. You're about to begin a tough new class—say, Advanced Biology. You're holding a copy of the textbook you'll be using this term. On the cover, there's a cute photo of a red-eyed tree frog. But when you turn inside, page after, page after, page after, page after, page after, page after, page after, page after, page after, page after, page after, page after, page after, page after, page after, page after, page after, page after, page after page.

Your heart sinks. Your intestines churn. *"Hoo boy,"* you groan. If only they'd used maybe a little art to break up all that gray.

The fact is, you've come face to face with a cruel and ancient law of publication design: Too much text looks really dull.

Yes, deep in the childish recesses of our brains, we all share the same dread of text. It's like math anxiety: *text anxiety.* In smaller doses, text is tolerable. But when we're wading through deep heaps of it, we hate it. Even worse, we hate *writing* it.

And yet we all need to communicate, to share information, to express ideas. It's a primal urge, one that has evolved over the ages. In ancient, prehistoric times, our ape-like ancestors struggled to piece together this primitive kind of narrative: Me hungry! Kill moose! Eat meat!

As the centuries dragged by, early humans polished their delivery. After eons of practice, they became skillful storytellers: ... So there I was, trapped in the Cave of Death, staring into the drooling jaws of Mongo, The Moose From Hell ...

This narrative style reached a climax with the invention of the romance novel: ... Helga, the voluptuous Moose Queen, slowly peeled off her gown and uttered a moan as the mighty Ragnar clenched her in his tawny arms. "Be gentle, my warrior," she sighed as he ran his tongue down her neck. "Yaarrrrrgggh!" he grunted. Helga's bosom heaved with desire as Ragnar's hungry kisses grew ever more furious. *"Yes!"* she cried. *"Yes!"*

Which story would YOU rather read?

I t's the first day of a new school year. You're about to begin a tough new class—say, Advanced Biology. You're holding a copy of the textbook you'll be using this term. On the cover, there's a cute photo of a red-eyed tree frog. But when you turn inside, page after, page looks like this:

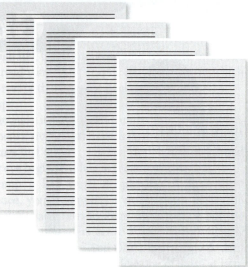

Your heart sinks. Your intestines churn. *"Hoo boy,"* you groan. If only they'd used maybe a little art to break up all that gray— you know, something like the page at left.

The fact is, you've come face to face with a cruel and ancient law of publication design:

TOO MUCH TEXT LOOKS REALLY DULL.

Yes, deep in the childish recesses of our brains, we all share the same dread of text. It's like math anxiety: *text anxiety.* In smaller doses, text is tolerable. But when we're wading through deep heaps of it, we hate it. Even worse, we hate *writing* it.

And yet we all need to communicate, to share information, to express ideas. It's a primal urge, one that has evolved over the ages. In ancient, prehistoric times, our ape-like ancestors struggled to piece together this primitive kind of narrative:

Me hungry! Kill moose! Eat meat!

As the centuries dragged by, early humans polished their delivery. After eons of practice, they became skillful storytellers:

... So there I was, trapped in the Cave of Death, staring into the drooling jaws of Mongo, The Moose From Hell ...

This narrative style reached a climax with the invention of the romance novel:

... Helga, the voluptuous Moose Queen, slowly peeled off her gown and uttered a moan as the mighty Ragnar clenched her in his tawny arms. "Be gentle, my warrior," she sighed as he ran his tongue down her neck. "Yaarrrrrgggh!" he grunted. Helga's bosom heaved with desire as Ragnar's hungry kisses grew ever more furious. *"Yes!"* she cried. *"Yes!"*

Alternative story forms

Impressive stuff! And perhaps that kind of narrative is what the written word does best–storytelling that transports us *emotionally* from one place to another. As opposed to this type of narration:

Consumption of moosemeat declined significantly during the first three decades of the ninth century. Marauding hordes of Vikings averaged 14.3 pounds per capita of moosemeat monthly during that period, while consumption among Druids climbed to 22.8 pounds (for males) and 16.3 pounds (females) during winter months, up from 15.5 pounds in summer.

"Yaarrrgggh," as Ragnar might say. For most of us, data turns deadly dull in narrative form. Our eyes glaze. Our bosoms heave. It feels like we're staring into the drooling jaws of The Statistician From Hell. Such data might work better as a chart or graph:

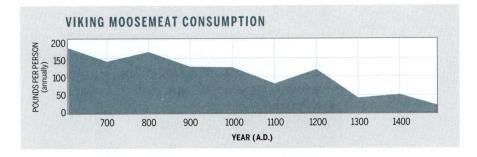

VIKING MOOSEMEAT CONSUMPTION

That's a fine match of medium and meaning. It's quick. It's visual. It's precise. And best of all, it's interesting ... almost interactive.

It's *non-text,* a form of writing that's—well, a kind of *non-writing.* Which is perfect for today's generation of non-readers.

Now, these non-text formats—or Alternative Story Forms—work fine for business reports, government statistics, news features and so on. But they won't work for everything. Take Helga the Moose Queen; something's missing when you write her love scene like this:

What Helga is thinking as Ragnar kisses her

Hoping Ragnar won't muss up her hair, **10%**

Wondering what's for dinner, **3%**

Thinking, "Man, this castle is cold when you're naked," **5%**

Wishing Ragnar would shower once in a while, **12%**

Raw lust and animal hunger, **70%**

Obviously, some types of information are best expressed in narrative form. And that's fine ... usually.

But pause for a moment and ponder these pages. Notice how we presented our material *visually*. Would it have held your interest if we'd explained it with normal narrative text?

Fat chance.

A MORE VISUAL WAY TO HELP TELL A STORY

When you learned how to write a story in your journalism class, chances are you were taught to set it up like an inverted pyramid. Like this: ▽

This means you'd include the most important information at the top and include less relevant details below that. This is a perfectly fine way to tell a story, but it's not the *only* way.

This entire chapter is about storytelling from a more visual approach by using *alternative story forms,* or *A.S.F.'s.* You may not call them that at your newspaper, but you'll probably recognize what these are right away. As you will see in this chapter, A.S.F.'s can come in all different formats and sizes. They help break down complex stories into something more manageable that's easier to grasp. And one study has shown that A.S.F.'s help readers retain more of what they read.*

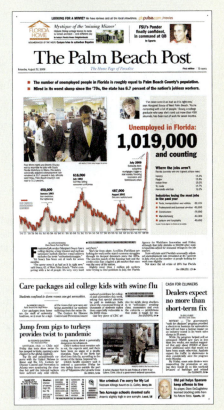

Writing for the non-reader As this front page from The Palm Beach Post shows, visuals can help get across the thrust of a story effectively.

Poynter Institute's EyeTrack'07 study

Alternative story forms

READER PREFERENCE: THE VISUAL COMPONENT

So what's it all mean to newspapers? It means that editors, writers and designers *must* realize that today's readers are visual. Impatient. Easily bored. Readers absorb data in a variety of ways: through words, photos, charts, maps, diagrams. They want news packaged in a sort of "information mosaic," a combination of text, data and images that approaches complex issues

from fresh new angles.

Years ago, when big stories broke, editors assigned reporters to write miles and miles of pure text. (And yes, readers would read it.) Today, when big stories break, editors assign reporters, photographers and graphic artists to make concepts understandable in both words *and* pictures.

For instance, when the Hindenburg crashed in 1937, most newspapers ran a photo or two but relied upon yards of text to describe the tragedy. If that disaster struck today, you'd see pages like the one at right below—pages that break down the information into accessible word and visual chunks that all come together to tell the whole story. Which do you prefer?

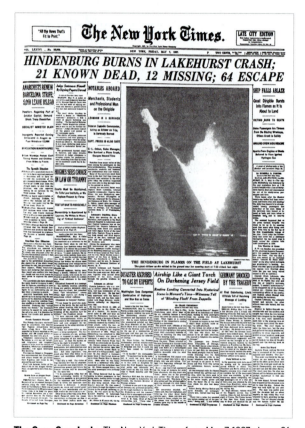

The Gray, Gray Lady The New York Times from May 7, 1937, above. Of the eight stories on Page One, five focus on the dirigible disaster—but it's all text. There's one dramatic photo (played big). Inside the section, readers were given an extra page of disaster photos.

A non-gray approach A modern newspaper, right, might package the story using a locater map, a diagram, a list of previous accidents and a sidebar transcribing the live radio broadcast of the tragedy. These days, too, that lead photo would probably run in color.

A.S.F. presentations

FAST-FACT BOX
Nuggets pulled from the story to give readers a quick grasp of who, what, when, where, why and/or how.

BIO BOX
Brief profiles of people, places, products or organizations, itemized by key characteristics.

LIST
A series of names, tips, components, previous events—any categories that add context to a story.

GLOSSARY
A list of specialized words with definitions (and/or pronunciations) to help clarify complex topics.

CHECKLIST
A list of questions or guidelines that itemize key points or help readers assess their own needs.

QUIZ
A short list of questions that let readers interact with a story by testing their understanding of the topic.

TABLE
A way to arrange data into columns or rows so readers can make side-by-side comparisons.

TIMELINE
A chronological table or list of events highlighting key moments in the history of a person, place or issue.

DIAGRAM
A plan or drawing designed to show how something works or to explain key parts of an object or process.

Q & A
A way to ask and answer hypothetical questions, or capture an interview's verbatim dialogue.

PUBLIC-OPINION POLL
A survey that samples opinion on a current topic, collating responses into key categories and statistics.

QUOTE COLLECTION
A series of relevant comments on a topic by newsmakers, readers or random passers-by.

FEVER CHART
A way to measure changing quantities over time by plotting key statistics as points on a graph.

BAR CHART
A way to compare two or more items visually by representing them as columns parked side by side.

PIE CHART
A way to compare the parts that make up a whole—usually measuring money or population percentages.

RATINGS
A list of people or products (sports teams, movies, etc.) that lets critics make predictions or evaluations.

STEP-BY-STEP GUIDE
A brief "how-to" that explains a complex process by walking readers through it one step at a time.

MAP
A quick way to give readers geographical information by showing the location of events relevant to a story.

A.S.F.'S: THE MAJOR CATEGORIES

An *alternative story form* can take the place of a more traditional narrative on a page, or within a package—or it can accompany a story. A.S.F.'s (also referred to as *sidebars*) blend text and images—sometimes in the form of an infographic—to convey information visually. This might mean illustrating the facts with charts, maps or diagrams.

Years ago, these more visual presentations were considered optional. Nowadays, they're essential for effective publication design. Here's why:

▸ **They carve up complicated material into bite-size chunks,** so that information is easier to find and digest.

▸ **They offer attractive alternatives to gray-looking text,** which makes the entire page more accessible at a glance.

▸ **They let writers move key background information,** explanations or quotes out of the narrative flow of the text and into a separate, highly visible spot.

▸ **They allow for flexibility** because they can be created in different styles and sizes: maybe they're tight, bright and entertaining, or more serious and informative.

Whatever form they take, they often attract higher readership than the main story they accompany.

If the A.S.F.'s are used alongside a narrative story, they can be specially packaged—boxed or screened—to help them stand apart. Notice how that's true for this A.S.F. on the left: a visual index to all the sidebars and infographics we'll explore in the pages ahead.

Once you get a handle on all the different options you have, be sure to check out the A.S.F. gallery of examples (on Pages 193–194) to see what other newspapers have done.

Fast facts

Quick hits

This fast-fact box, which accompanied a news story on an earthquake that shook the East coast, delivers essential facts at a glance. Be succinct when pulling key information from the story.

Visual hook

Boxes like these could accompany any story: sports, entertainment or political event, for example. By adding a visual element like a logo or a mugshot, you can draw the reader's eye to this bit of stand-alone information.

THE EAST COAST EARTHQUAKE

MAGNITUDE: Approximately 5.8 on the Richter scale

TIME: 1:51 p.m. Tuesday

EPICENTER: About 4 miles southwest of Mineral, Va.

Range: Residents along the East Coast, from Georgia to Canada, felt the tremors.

SUPER BOWL XLV

THE TEAMS:
Pittsburgh Steelers (AFC) vs. Green Bay Packers (NFC)

THE SITE:
Cowboys Stadium, Arlington, Texas

WHEN: 3 p.m., Sunday, Feb. 6

ON TV: KOIN-TV (CBS/6)

ON THE WEB:
superbowl .com

SUPER BOWL
XLV

WORM FARMING AT A GLANCE

Want to start your own worm farm? It's easy. Just dig these earthy facts:

■ An earthworm can eat half its weight in food each day.

■ People are either boys or girls, but earthworms are both male and female.

■ An earthworm matures to breeding age in 60-90 days given proper food, care and environmental quality.

■ A mature breeding worm can produce an egg capsule every 7-10 days.

■ An egg capsule will hatch in 7-14 days.

■ An egg capsule contains 2-20 baby earthworms, with an average of 7 per capsule.

For more info Worm Digest, at wormdigest.org, is the world's top source for earthworm information.

Pack it in This worm-farming sidebar offers a variety of "worm trivia"—but the box that tells readers where to go for more information is a helpful addition.

BOIL IT DOWN One of the best ways to present news in a hurry is to distill the *who-what-when-where-why-how* of a story into a concise package. With a fast-fact box, you can add graphic variety to story designs, introduce basic facts without slowing down the text and provide entertaining data for those who may not want to read the text at all.

Fast-fact boxes can deliver statistics. History. Definitions. Schedules. Trivia. They can update readers on what just happened—or try to explain what'll happen next.

They can even present stand-alone "factoids," like the ones along the left side of this page, that lure readers into the story in the same way that liftout quotes do.

SNAPSHOT OF A RAT

Nobody likes to admit to having rats, but Multnomah County has them. Here's a snapshot of the rat population.

■ **What do they eat?**
Garbage, nuts, cherry pits, bird seed and dog food.

■ **How many?**
It's hard to say. One estimate says Portland has about 200,000 rats. That would be about enough to cover Pioneer Courthouse Square, one rat deep.

■ **Where are they?**
All over; many live in the sewer system. About 100 times a year, residents complain about a rat coming up through the toilet.

sewer line

Source: Peter Dechant, Multnomah County chief sanitarian

Actual size

■ **How big?**
An adult sewer rat is generally 8 inches long in the body, 13 to 18 inches with the tail included. An adult weighs about a pound.

|← 8 inches →|

■ **How do they spread diseases?**
Specialists think there is little danger to Oregonians from the Hantaan virus, which has been linked to the deaths of more than a dozen people in the Southwest.

1. The virus lives in rat droppings.

2. The droppings dry and become airborne.

3. A victim breathes the dried particles and the virus infects the lungs.

There is no known vaccine for the Hantaan virus, which has been found in Asia and Europe but is extremely rare in the United States.

Label it

This fast-fact box at left tells you everything you need to know about urban rats: their diet, their size, their location, etc. Sure, there's lots of information here—so you'll need to use a label along the top that quickly identifies what this graphic is all about.

Be consistent

Notice the parallel treatment of the bulleted items. They are all framed as questions. This consistency helps with the flow of the word text, and readers know what to expect as they read through this graphic.

Box it

Borders around graphics that comprise lots of little pieces that help keep everything organized.

Divide it up

This information along the bottom of the graphic shifts into the health hazards of rats, so it makes sense to give this part a slightly different visual treatment by putting it in its own box within the overall bigger area of the entire graphic.

Joe Spooner

CARTOONIST

Age: 48

Hometown: Portland

Bats: Right

Writes: Left

Occupation: Cartoonist, writer, dishwasher

Heroes: Michael Moore and Jon Stewart

Ambition: To have someone else pay my health-insurance premiums

Motto: "Je n'ai pas m'empecher de rire—ha-ha-ha!" (I cannot stop myself from laughing.)

Forms of exercise: Running and limping

Favorite spouse: Patti

Favorite child: Nice try. I love both my children.

Favorite food: Turkey pie with cranberry sauce

Favorite drink: Guinness Stout

Favorite dessert: Gobi

Worst subjects in school: Spelling and geography.

Favorite movies: Pride and Prejudice

Favorite book: It must be the first 10 or 15 pages of James Joyce's Ulysses. I've read them 20 times.

Person whose lifestyle I'd most like to emulate: Ernest Hemingway, except for that part about the shotgun.

Proudest feat: Getting through five years of flying in the Air Force without killing myself

Last words: "Oh ... I get it."

The unexpected adds flavor Bio boxes must contain well-written and meaningful information. But as this sidebar shows, they can also use humor to capture the true personality of the subject.

QUICK-HIT PROFILES The 19th-century philosopher Karl Marx painted a revealing self-portrait while playing a Victorian parlor game called "Confessions."

Favorite virtue in a man: Strength
Favorite virtue in a woman: Weakness
Your idea of happiness: To fight
Your idea of misery: Submission
Favorite occupation: Bookworming

Favorite poet: Shakespeare, Aeschylus, Goethe
Favorite hero: Spartacus
Favorite color: Red
Favorite motto: De omnibus dubitandum ("You must have doubts about everything")

You can gain surprising insights through biographical bits like these. By listing facts in a bio box, you can quickly profile almost any person, place or thing. Bio boxes can stick to the basic *who-what-when-where-why*—or they can spin off on specialized (or humorous) tangents, as these examples show.

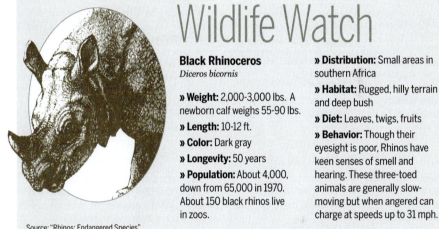

Wildlife Watch

Black Rhinoceros
Diceros bicornis

» **Weight:** 2,000-3,000 lbs. A newborn calf weighs 55-90 lbs.
» **Length:** 10-12 ft.
» **Color:** Dark gray
» **Longevity:** 50 years
» **Population:** About 4,000, down from 65,000 in 1970. About 150 black rhinos live in zoos.

» **Distribution:** Small areas in southern Africa
» **Habitat:** Rugged, hilly terrain and deep bush
» **Diet:** Leaves, twigs, fruits
» **Behavior:** Though their eyesight is poor, Rhinos have keen senses of smell and hearing. These three-toed animals are generally slow-moving but when angered can charge at speeds up to 31 mph.

Source: "Rhinos: Endangered Species"

Bio possibilities When it comes to bio boxes, animals can enjoy the same treatment as people. Above, this tightly written "Critter of the Week" profiles a celebrity from the animal kingdom.

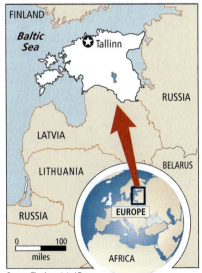

Source: The Associated Press

ESTONIA: FACTS AND FIGURES

AREA: At 45,000 square kilometers, Estonia is one of the smallest states in Europe.

HISTORY: Estonia was dominated by Germans since the 13th century and by Swedes in the 16th to 18th centuries. Later ruled by Russia, Estonia became independent after 1917 and was forcibly annexed by the Soviet Union in 1940. It won independence from the Soviet Union in 1991.

POPULATION: About 26 percent of Estonia's 1.3 million people are ethnic Russians, many of whom moved to Estonia after its annexation by the Soviets.

ECONOMY: Estonia, a member of the European Union, adopted the euro in 2011. The country has experienced rapid growth in recent years. Its three main trade partners are Finland, Sweden and Germany.

At a glance This type of fast-facts treatment has appeared in almanacs and encyclopedias for years, summarizing the who-what-when-where of countries around the globe. When used to accompany news stories, these sidebar boxes give readers background data quickly.

Lists

CHECK IT TWICE

What are the most popular movies of all time? The largest fast-food chains? The best-selling Christmas toys? The most prestigious universities?

Ours is a culture obsessed with keeping score. We're *dying* to know who's the richest, the biggest, the fastest, the best. And often the fastest and best way to convey that information is by compiling lists like the ones you see here.

Lists can be used to itemize tips, trends, winners, warnings—even religious commandments, as the Old Testament proclaimeth. And as David Letterman has shown, they can even get laughs as a comedy bit on late-night talk shows ("*... and the Number One Least Popular Fairy Tale: Goldilocks and the Tainted Clams!*").

GOT ANY BANANA PUDDING, ELVIS?

These items were to be kept at Graceland "for Elvis—AT ALL TIMES—EVERY DAY":

Fresh ground round	Banana pudding
One case of Pepsi	Ingredients for meat loaf
One case orange drink	Brownies
Six cans of biscuits	Chocolate ice cream
Hamburger buns, rolls	Fudge cookies
Pickles	Gum (Spearmint, Juicy
Potatoes and onions	Fruit, Doublemint—
Assorted fresh fruit	three packs each)
Cans of sauerkraut	Cigarettes
Wieners	Dristan
Milk, half and half	Super Anahist
Lean bacon	Contac
Mustard	Sucrets
Peanut butter	Feenamint gum

Source: The Associated Press

Random lists These items run in no particular order, but stacking them in rows makes them more interesting (and easier to read) than if they'd run in the middle of a paragraph of text.

HOW TO STAY YOUNG

by Leroy "Satchel" Paige

Satchel Paige, the first black pitcher in major-league baseball, was 59 when he played his final game. Here are his tips for staying youthful:

▸ Avoid fried meats, which angry up the blood.

▸ If your stomach disputes you, lie down and pacify it with cool thoughts.

▸ Keep the juices flowing by jangling around gently as you move.

▸ Go very lightly on the vices, such as carrying on in society. The social ramble ain't restful.

▸ Avoid running at all times.

▸ Don't look back. Something may be gaining on you.

Source: The People's Almanac

Lists itemized with bullets Here, we use a combination of dingbats, a hanging indent and extra leading to separate items. Note, too, how the introduction is written in smaller italic type.

And the Oscar goes to...

BEST PICTURE
The Artist

BEST ACTOR
Jean Dujardin, *The Artist*

BEST ACTRESS
Meryl Streep, *The Iron Lady*

BEST SUPPORTING ACTOR
Christopher Plummer, *Beginners*

BEST SUPPORTING ACTRESS
Octavia Spencer, *The Help*

BEST DIRECTOR
Michel Hazanavicius, *The Artist*

Lists arranged by categories Note the typographic elements at work here: boldface caps, italics, extra leading between items. Lists are often centered (like this) rather than flush left.

THE ESSENTIAL CYBERPUNK LIBRARY

Cyberpunk: Think "Blade Runner." To get familiar with this futuristic literary genre, we recommend:

AMY THOMSON, "Virtual Girl": A lovely woman from a Virtual Reality landscape is forced to survive in an alien environment.

K.W. JETER, "Farewell Horizontal": A rebel in a horizontal world seeks to attain status by achieving a vertical existence.

ORSON SCOTT CORD, "Ender's Game": A civilization under siege breeds a race of military geniuses to battle invading aliens.

WILLIAM GIBSON/BRUCE STERLING, "The Difference Engine": The 19th-century Victorian world is moved by a steam-powered computer.

— Paul Pintarich

Lists with commentary Any subjective Top 10 list—whether it ranks pop tunes or presidents—will benefit by adding bite-size evaluations that analyze each entry or offer advice to readers.

MOST COMMON LAST NAMES IN THE U.S.

1. *Smith*
2. *Johnson*
3. *Williams*
4. *Brown*
5. *Jones*
6. *Miller*
7. *Davis*
8. *Garcia*
9. *Rodriguez*
10. *Wilson*

Top 10 lists Notice how the numbers are boldface—and how the periods following the numbers are all vertically aligned.

LEADING CAUSES OF DEATH IN THE WORLD
(with estimated number of deaths)

1	Cardiovascular disease	**7.2 million**
2	Cerebrovascular disease	**5.7 million**
3	Lower respiratory infections	**4.2 million**
4	Chronic obstructive lung disease	**3.0 million**
5	Diarrheal diseases	**2.2 million**
6	HIV/AIDS	**2.0 million**
7	Tuberculosis	**1.5 million**
8	Trachea, bronchus, lung cancers	**1.3 million**
9	Traffic accidents	**1.3 million**
10	Prematurity and low birth rate	**1.2 million**

Source: World Health Organization

Lists with data Often it's not enough simply to show rankings—you need statistical support. Here, the death totals run flush right alongside the reasons for the causes of death. Rules and reversed numbers add graphic organization.

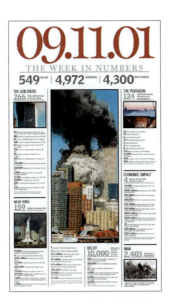

09.11.01
THE WEEK IN NUMBERS
549 DEAD | 4,972 MISSING | 4,300 WOUNDED

Snapshot On Sept. 16, 2001, five days after the World Trade Center attacks, The San Jose Mercury News ran a page that updated the week's grim statistics. At that time, the figures included:

549 dead

4,972 missing

4,300 wounded

266 confirmed dead on the four planes

345: Approximate speed (in mph) of Flight 11 as it hit the first Twin Tower

50,000: People who worked in the World Trade Center

19,000: Approximate number of residents ordered to evacuate lower Manhattan

30,000: Body bags available in New York

7: Number of office buildings destroyed

250,000: Estimated tons of rubble

43,600: Number of windows in the Twin Towers

$20 billion: Anticipated insured losses from World Trade Center attack

15: Average daily hours on-air for major news anchors since Tuesday

$100 million: Daily loss in ad revenues for local TV stations and networks because of crisis coverage

4: Number of days Wall Street was closed

40,000: Average daily number of U.S. commercial flights

$10 billion: Airline losses from grounding all flights

2,403: Death toll at Pearl Harbor

THE HARPER'S INDEX Back in 1984, Harper's Magazine began publishing an addictingly clever page at the front of each issue. As editor Lewis Lapham described it, the Harper's Index offers "numbers that measure, one way or another, the drifting tide of events." A typical Harper's Index might include such items as:

> Miles per hour of a typical sneeze: *100*
> Miles per hour of a typical raindrop falling: *17*
> Number of years that summer lasts on Uranus: *21*
> Number of minutes the average person will spend kissing in a lifetime: *20,160*
> Pounds of trash thrown away daily by each American: *4.5*
> Number of times the average 4-year-old child laughs each day: *300*
> Number of times a 40-year-old adult laughs each day: *4*
> Amount of bacteria in one liter of drinking water: *100,000*

As you can see, the basic format is consistent: text provides the setup, and a number provides the punch line. (Some publications, like the example at left, lead with the number.) But what makes these lists fascinating are the strange, often surprising combinations of random factoids—some of which, when sequenced like those statistics on laughing, raise provocative cultural questions.

As with most sidebars, the juicier your facts, the more effective your list.

GLOSSARIES AND DICTIONARIES Think of dictionaries as immensely long lists. While ordinary dictionaries compile alphabetical lists of words in general use (along with their pronunciations and meanings), specialized dictionaries, or *glossaries,* zero in on subjects that may be unfamiliar to readers. Every subculture—from skateboarders to firefighters to newspaper designers—has its own lingo. By compiling lists of new or unusual words, you can help readers expand their vocabularies while deciphering complex topics.

Mountain bike slang

Auger: to take soil samples, usually with your face, during a crash. See *eat mud.*

Bacon: scabs.

Bomb: to ride with wild disregard for personal safety.

Cob clearer: the lead rider who clears out all the spider webs for following riders.

Cranial disharmony: how your head feels after augering.

Eat mud: to hit the ground face first. Synonyms: auger, hunt moles, taste the trail, go turf surfing, use your face brake.

Gravity check: a fall.

Mud-ectomy: a shower after a ride on a muddy trail.

POD: Potential Organ Donor.

Potato chip: a wheel that has been bent badly, but not taco'd.

Prang: to hit the ground hard, usually bending or breaking something.

Prune: to use your bike or helmet to remove leaves and branches from the surrounding flora. Usually unintentional.

Snowmine: a rock or log that's hidden by snow on the trail.

Steed: your bike, the reason for your existence.

Compiled by Doug Landauer

FAKING FRENCH

A quick guide to a few phrases

bon appetit
(BOH nap-uh-teet):
good appetite; a toast before eating.

carte blanche
(kart BLAHNSH):
full discretionary power.

c'est la vie
(say la VEE):
that's life.

Source: The World Almanac

Glossary This setup, above left, offers outsiders a glimpse of the jargon used by mountain bikers. Though most slang terms are short-lived and regional, some occasionally slip into the mainstream.

Pronunciation guides News stories often introduce readers to foreign words, names and phrases. And whether a story discusses Russian politicians or Chinese athletes, these guides, like you see with the one above right, increase our word power.

Checklists

BE MORE DYNAMIC Most lists are passive—that is, they itemize information in a concise way, but they don't really ask readers to *do* anything.

But suppose you want to engage readers more actively? To force them to grab a pencil and *interact*? That's dynamic journalism. And that's what we'll explore in the pages ahead. Checklists, for instance, are instantly interactive. They can be simple, like this checklist of macaroni 'n' cheese ingredients: ☐ **Macaroni** ☐ **Cheese**

Or they can be more complex and visual, compiling tips, asking questions, encouraging responses. The important thing is to get *the reader involved*—to make information as accessible and relevant as you can.

IS YOUR HOME BURGLAR-PROOF?

	YES	NO
1. Are exterior doors able to withstand excessive force?	☐	☐
2. Are exterior doors secured with deadbolt locks?	☐	☐
3. Do all exterior doors fit snugly in their frames?	☐	☐
4. Are door hinges pinned to prevent their removal?	☐	☐
5. Are garage doors and windows secured with locks?	☐	☐
6. Does your basement door have extra protection?	☐	☐
7. Is there a wide-angle viewer on the entrance door?	☐	☐
8. Are sliding-glass doors secure against forcing?	☐	☐
9. Are double-hung windows secured with extra locks?	☐	☐
10. Are basement windows secured with locks?	☐	☐
11. Are trees and shrubs trimmed from doors and windows?	☐	☐
12. Are all entrances well-lighted at night?	☐	☐
13. If you hid a key outside, is it in a hard-to-find place?	☐	☐
14. Do you use a light timer when you're away from home?	☐	☐

Get the reader involved All three checklists on this page strive to be interactive, either by offering user-friendly tips, by asking a series of questions or by letting readers quiz themselves with check-off boxes for their answers.

CHILDCARE CHECKLIST

Not sure what to look for at daycare centers? Here are questions to ask.

♦ How long has this center been operating?

♦ What kind of training have staff members had?

♦ What is the child-to-teacher ratio?

♦ Are meals provided? If so, what's on the menu?

♦ Are facilities clean and well-maintained? Are child-safety precautions observed: heat covers on radiators, safety seals on electrical outlets, etc.?

♦ Is there plenty of room for children to work and play? Are play materials available and appropriate for different age levels?

♦ Are there facilities for taking care of sick children?

♦ Most important: Do the children look happy and occupied? Trust your instincts.

HOW YOU CAN HELP THE EARTH

It's never too late to change your habits and begin making Earth-saving choices every day. Ordinary people CAN make a difference. And here are a few ways you can help.

When you drive

❏ Save gas by avoiding sudden stops and starts. If idling for more than a minute, turn off your engine.

❏ Avoid air conditioning. The largest source of ozone-depleting CFC emissions in this country is car air-conditioning.

❏ Buy a fuel-efficient car. Increasing fuel-efficiency standards by a single mile per gallon would save 5.9 billion gallons of gas a year.

❏ Try to get there without driving: walk, bicycle, take the bus. Carpool.

When you shop

❏ Bring your own reusable shopping bag.

❏ Buy organically grown food and favor locally grown products.

❏ Buy in bulk. Repackage in smaller portions with reusable storage containers for pantry or freezer.

❏ Look for unbleached paper versions of coffee filters, milk cartons, toilet paper and paper towels.

❏ Avoid products made from endangered species or taken illegally from the wild. Before buying a pet or plant, ask the store owner where it came from.

❏ Instead of buying them, rent or borrow items you don't use often, and maintain and repair the things you own to make them last longer.

When you do laundry

❏ Use detergents without phosphates. Better yet, use soap flakes.

❏ Use chlorine bleach sparingly. Or switch to a non-chlorine bleach.

❏ Only run full loads. Set up a rack to dry small loads (socks or underwear). Consider drying with solar power on an outdoor clothesline.

❏ Keep your dryer's lint trap clean.

❏ When buying a new washing machine, consider a front-loading washer. They use 40 percent less water. When buying a new dryer, consider an energy-efficient gas or electric model.

THE STRAIGHT POOP

BY WALT POOPUS

Does Coca-Cola contain actual cocaine? Was there ever a time when it did?
— Pat Minniear, Boulder, Colo.

When druggist John Pemberton brewed his first batch of "French Wine Coca (Ideal Nerve and Tonic Stimulant)" back in 1885, it contained both wine and cocaine. A year later the wine was removed, caffeine and cola nuts were added—and Coca-Cola was born. The original Coke contained (and presumably still contains) three parts coca leaves to one part cola nut. It was advertised as a medicine that would cure headaches, hysteria and melancholy.

Over the years, Coca-Cola quietly switched from fresh to "spent" coca leaves (minus the actual cocaine). Coke's true formula, however, remains a mystery—and its secret ingredient 7X is known to only a handful of Coke employees.

Call attention to it This popular type of Q&A—a stand-alone special feature—gives bold display to a single reader query.

AHOY, VEY!

An allegedly true radio conversation, from the Chief of Naval Operations:

VOICE 1: *Please divert your course 15 degrees to the north to avoid a collision.*

VOICE 2: *Recommend you divert your course 15 degrees south to avoid a collision.*

VOICE 1: *This is the captain of a U.S. Navy ship. I say again, divert your course.*

VOICE 2: *No. I say again, you divert your course.*

VOICE 1: *THIS IS THE AIRCRAFT CARRIER ENTERPRISE. WE ARE A LARGE WARSHIP OF THE U.S. NAVY. DIVERT YOUR COURSE NOW!*

VOICE 2: *This is a lighthouse. Your call.*

Dialogue It's not a Q&A, but this approach can work well.

Q&A — INDIVIDUAL RETIREMENT ARRANGEMENTS

What is an IRA?
An *individual retirement arrangement* allows you to save up to $5,000 annually (if you're under 50) in a special account for your later years. You can postpone paying taxes on your earnings until you begin making withdrawals at age 59½.

What are its tax advantages?
You can fully deduct those $5,000 contributions from your income on your tax return if you aren't covered by a retirement plan at work. If you are covered and earn less than $35,000 for single or $50,000 for married taxpayers, you may be able to deduct all or part of your contribution.

What if I can't deduct any of my contribution?
They still are tax-advantaged; earnings on your money accumulate on a tax-deferred basis. That means faster accumulation and more money in the pot at the end.

Explainer This sidebar poses typical questions readers might ask—an effective way to decode confusing subjects.

A TYPOGRAPHIC VOICE

Q *What's going on here? Why is this sentence in italics? And what's with those big Q's and A's?*

A Good questions. *Journalistically,* we've changed our approach. Rather than conveying information in the usual way—as narrative text in monologue form—we're printing a verbatim transcript of a conversation. *Typographically,* we're giving each voice in this dialogue a distinct identity. The interviewer here speaks in italic serif, while the interviewee speaks in serif roman. And legally, I'm interviewing myself because my original plan for this page went down the toilet. I was going to reprint a juicy Q&A with a famous rock star, but the legal clearances got mucked up. So you're stuck with *me* instead.

Q *A famous rock star? Really? Which one?*

A Forget it. It's just not gonna happen. I tried, but some editors can be real pinheads when it comes to sharing old material they're never going to use again anyway.

Q *Was there anything, uh, juicy in that interview you'd like to share with us?*

A No. Something about sleeping with Madonna, as I recall. But let's get back to our discussion of infographics, shall we? When you run a Q&A, you want to make sure each voice gets proper spacing, leading and—

Q *Madonna? Really? Who slept with Madonna?*

A Look, I don't want to *discuss* it now. Let's talk about Q&As. Like, how effectively they can capture the spirit of an interview, making you feel as if you're actually *eavesdropping* on someone else's conversa—

Q *Was it Sting? Jim Carrey—wait, no … he's not a rock star … Hey! I know: Hootie & the Blowfish!*

A Huh?!

Add pizazz Small touches can add a bit more flavor to even something as simple as a Q&A, like the one you see here: the italics add some contrast between the Q's and A's; the spot of color adds small points of entry from one item to the next. Thin rules between each column help add some structure.

TEST YOURSELF

Most newspaper stories are written in third-person past-tense: *that guy* over *there* did *that thing* back *then.* As a result, readers often feel disconnected. Left out.

That's why quizzes are so successful. They're a way to let readers participate in a story, whether the topic is health (*Are You a Candidate for a Heart Attack?*), sports (*The Super Bowl Trivia Test*) or hard news (*Are You Prepared for an Earthquake? Test Yourself*). Quizzes, after all, are a kind of game, and readers love games. Feature pages, in fact, sometimes use game board parodies (*How to Win the Diet Game*) to explore and satirize cultural trends.

Most of the time, you'll provide quiz answers on the same page or somewhere nearby. But if you're running a contest or reader poll, you'll need to include a mail-in address or website and formulate a system for processing masses of entries—as well as a plan for a follow-up story that tabulates the results.

As any student knows, tests and quizzes come in a wide variety of formats: true/false, multiple choice, matching and so on. On the next page, we've displayed the most popular quiz formats for publications.

Take the challenge This quiz, above, from The Oregonian lets readers test their knowledge of lunch-counter lingo. When a waitress tells the cook to "keep off the grass," does that mean hold the vegetables? The lettuce? The coleslaw? At right, readers can test their knowledge in a Columbus Dispatch quiz about U.S. presidents who have called Ohio their home.

PRESIDENTIAL PURSUIT

Quiz takes trivia to executive branch

By Danielle Kees | FOR THE COLUMBUS DISPATCH

Eight U.S. presidents have called our state home, tying Ohio with Virginia — sort of — as the state boasting the most commanders in chief. ★ Virginia and Ohio *both* claim William Henry Harrison, who was born in the Old Dominion State before wising up and moving to the Buckeye State. ★ Either way, as politics wouldn't exist without an argument, Ohioans should feel proud on Presidents Day, which is being celebrated today by giving most people outside the Fourth Estate a chance to sleep in and catch up on chores. ★ (Yes, we're bitter.) ★ To test your knowledge of the state's most powerful historical figures, we created the "Presidential Pursuit" quiz. ★ Match each man to the corresponding factoids, then check the answer key to see whether you deserve a place among the natural-born (or transplanted) Ohio leaders.

WILLIAM HENRY HARRISON	ULYSSES S. GRANT	RUTHERFORD B. HAYES	JAMES A. GARFIELD	BENJAMIN HARRISON	WILLIAM McKINLEY	WILLIAM HOWARD TAFT	WARREN G. HARDING
1. ○○○	2. ○○○	3. ○○○	4. ○○○	5. ○○○	6. ○○○	7. ○○○	8. ○○○

a. I served a mere 32 days as president.

b. These days, my portrait appears on the $50 bill.

c. During my time in office, Alexander Graham Bell installed the first telephone in the White House.

d. I was assassinated after only 100 days in office.

e. Guam, the Hawaiian Islands and Puerto Rico were annexed to the United States during my presidency.

f. I became the first president to throw the ceremonial opening pitch at a baseball game.

g. My real first name: "Hiram."

h. I became the first president to make a speech over the radio airwaves.

i. I rank as the only man to serve as both U.S. president and chief justice of the United States.

j. I was assassinated after I was elected to a second term as president.

k. I attended Kenyon College in Gambier and was named valedictorian of my graduating class.

l. I served as president both after and before Grover Cleveland.

m. I earned the nickname "Old Tip" because of my service in the Battle of Tippecanoe.

n. My grandfather was also elected president.

o. To pay for school, I worked as a teacher, janitor and carpenter.

p. I died of food poisoning.

q. My wife put up the first White House Christmas tree.

r. I finished writing my memoirs the day before my death. Mark Twain later published them.

s. I practiced law in Canton.

t. A group of my advisers was given the nickname "the Ohio gang."

u. I gave the longest inaugural address in history, lasting almost two hours.

v. I could write with both hands simultaneously.

w. Even though I lost the popular vote, I was elected to office by one electoral vote.

x. At the White House, I once became stuck in a bathtub and had to be pulled out by six men.

★ ★ ★ ANSWER KEY & SCORING CHART ★ ★ ★

1. a, m, u
2. b, g, r
3. c, k, w
4. d, o, v
5. l, n, q
6. e, j, s
7. f, i, x
8. h, p, t

19 TO 24 RIGHT
You're elected in a landslide victory. Better yet, you keep your campaign promise to make buckeye candies the national snack.

13 TO 18
You win, but the announcement is delayed several days as certain states — most likely your own — frantically recount ballots.

7 TO 12
You lose, but your concession speech receives high marks for its graciousness. As a result, *Saturday Night Live* treats you kindly.

ZERO TO 6
Your campaign is labeled a disaster. On the plus side, your neighborhood association needs a secretary.

Quizzes

QUIZ EXAMPLES Quizzes need to be readable, of course, but they also need to *work* if you want your readers to interact with them. Is there enough room to write out the answers? Is the background light enough so that pencil or pen marks will show up? Are the answers out of the way—but easy to find once the reader is ready to tally her score?

1. How many Elvis albums reached No. 1 on the music charts?

2. What was Elvis' major in high school?

3. What famous actor made his film debut at age 10, kicking Elvis in the shin in the movie "It Happened at the World's Fair?"

4. What was Elvis' middle name?

5. What was Elvis' ironclad rule during concerts?

6. Who was Elvis' favorite movie actor as a teenager?

7. Which of Elvis' records was his own favorite?

8. What was the name of Elvis' flamboyant manager?

9. How much did Elvis weigh when he died?

10. What was Elvis doing when he died?

ANSWERS

1) None. **2)** Shop. **3)** Kurt Russell. **4)** Aron. **5)** He never took requests. **6)** Tony Curtis. **7)** "It's Now or Never." **8)** Col. Tom Parker. **9)** 255 pounds. **10)** He was on the toilet reading a book on the Shroud of Turin.

Short answer tests This is a typical format for a short trivia test. Note the boldface numbers and the extra leading between questions. To conserve space, we've run the answers in paragraph form in the answer key. Are they easily readable?

1. Which uses the most energy?
a) Stove
b) Refrigerator
c) Washing machine

2. Which form of energy is most environmentally friendly?
a) Nuclear power
b) Natural gas
c) Coal

3. What percentage of tropical rain forests still exist?
a) 80
b) 50
c) 20

4. How long does it take an aluminum can to decompose?
a) 50 years
b) 150 years
c) 500 years

5. What state has the highest level of carbon dioxide emissions?
a) California
b) New Jersey
c) Texas

6. Which consumes the most water?
a) Washing machine
b) Dishwasher
c) Toilet

ANSWERS

1. (a) But gas stoves are more efficient than electric models. 2. (b) 3. (b) They originally covered 12 percent of the earth; today they cover 6 percent. 4. (c) 5. (c) 6. (c)

Multiple choice tests Another familiar quiz format. Here, we've boldfaced the questions and aligned everything flush left. The answer box has been printed upside-down to keep readers from cheating—and also because many readers don't WANT to be able to peek at the answers.

Is your job burning you out? For each "yes" answer, give yourself the number of points shown, then add your total.

	SYMPTOM POINTS
1. My job consists of boring, repetitive tasks	2
2. It's not likely that I'll be promoted anytime soon	2
3. When I'm overloaded with work, there's no one to help me	3
4. I have more work to do than I could possibly finish	3
5. My boss and colleagues are extremely critical of my work	4
6. I've been getting sick more frequently lately	4
7. I'm using more alcohol/tranquilizers than I probably should	5
8. I've lost all sense of commitment and dedication to my job	5

SCORING YOURSELF

0-10 points: Your stress is relatively normal.

10-20 points: Moderate stress. Cultivate healthy habits to keep yourself optimistic.

20-30 points: Stress is affecting your life negatively. Time to consider a change.

30-40 points: Get some relief before your job seriously undermines your health.

Self-appraisal tests Unlike the quizzes above, self-appraisal tests have no right or wrong answers. Rather, these tests are checklists that allow readers to evaluate their behavior. Like other exercises in pop psychology, these tests often try to point out problems readers may be unaware of.

1. Favorite TV comedy

2. Favorite TV drama

3. Favorite TV actress

4. Favorite TV actor

5. Favorite TV theme song

6. Favorite TV news anchor

7. Favorite TV talk-show host

8. Favorite TV commercial

8. Tell us about your favorite TV moment:

MAIL TO:
Television Survey
The Bugle-Beacon
P.O. Box 1162
Portland, OR 97207

FAX TO:
(503) 221-8069

Entries must be received by noon Monday, April 14. One entry per family, please.

Fill-in-the-blank surveys and contests You don't need to add fill-in blanks for most quiz answers, because they take up too much space. But if you want readers to DO something with their answers—add up scores, participate in a survey, enter a contest—then a format like this is helpful. If you want readers to respond, be sure to give them enough room to write.

Polls & surveys

THE PUBLIC VIEW Checklists and quizzes ask readers questions. But when you want to analyze their answers, you conduct a poll.

Taking the public's pulse can be fascinating. Frightening. Time-consuming. But it's vital, whether the survey poses a question as simple what's in the box, above

> *If you had $100 million to spare, would you feed the poor or buy a pro baseball team?*
>
> | Feed the poor | **69%** |
> | Buy a team | **31%** |

—or asks a series of questions like the chart below. As you can see, a variety of design options are available.

In some cases, you'll also need to indicate a source and an error margin. Some polls also include a brief explanation as to how it was conducted and who participated.

The crucial thing is to keep data accurate by surveying as wide a sample as possible, and by avoiding asking biased or misleading questions.

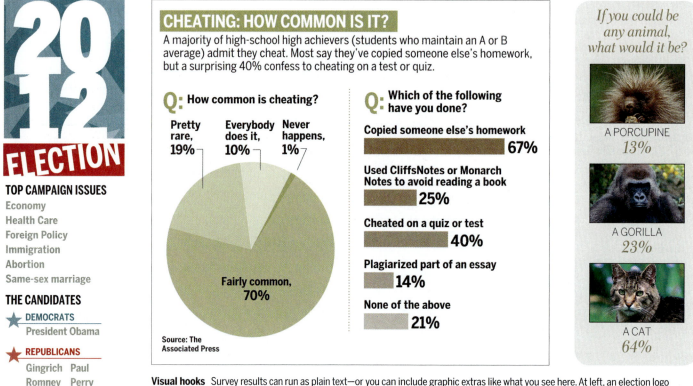

TOP CAMPAIGN ISSUES
Economy
Health Care
Foreign Policy
Immigration
Abortion
Same-sex marriage

THE CANDIDATES

★ **DEMOCRATS**
President Obama

★ **REPUBLICANS**
Gingrich Paul
Romney Perry
Santorum

CHEATING: HOW COMMON IS IT?

A majority of high-school high achievers (students who maintain an A or B average) admit they cheat. Most say they've copied someone else's homework, but a surprising 40% confess to cheating on a test or quiz.

Q: How common is cheating?

Pretty rare, 19%
Everybody does it, 10%
Never happens, 1%
Fairly common, 70%

Q: Which of the following have you done?

Copied someone else's homework **67%**
Used CliffsNotes or Monarch Notes to avoid reading a book **25%**
Cheated on a quiz or test **40%**
Plagiarized part of an essay **14%**
None of the above **21%**

Source: The Associated Press

If you could be any animal, what would it be?

A PORCUPINE *13%*
A GORILLA *23%*
A CAT *64%*

Visual hooks Survey results can run as plain text—or you can include graphic extras like what you see here. At left, an election logo identifies this poll as part of an ongoing series; above, pie charts and bar charts help quantify poll results on the frequency of cheating; at right, small mug shots of critters add instant reader appeal to this poll on the kind of animal someone would want to be.

WHERE DO YOU STAND ON FAMILY VALUES?

Test your own views with this cross section of questions from our family values poll, then see how your answers compare to the 400 statewide residents we surveyed last week.

Do you agree or disagree with the following statements:

1. In general, fathers do not make children as much of a priority as mothers do.
☐ **Agree** ☐ **Disagree**

2. Businesses should offer flexible work schedules to accommodate the needs of families.
☐ **Agree** ☐ **Disagree**

3. Families where Dad works and Mom stays home with kids just aren't realistic anymore.
☐ **Agree** ☐ **Disagree**

4. One of the biggest causes of teen problems is that parents don't spend time with their kids.
☐ **Agree** ☐ **Disagree**

5. One family arrangement is as good as another, as long as children are loved and cared for.
☐ **Agree** ☐ **Disagree**

6. Two-income families tend to place material needs ahead of family values.
☐ **Agree** ☐ **Disagree**

7. Two-parent families are the best environment in which to raise children.
☐ **Agree** ☐ **Disagree**

8. When parents can't get along, they should stay together for the sake of the children.
☐ **Agree** ☐ **Disagree**

9. A parent should stay home with preschool children even if it means financial sacrifice.
☐ **Agree** ☐ **Disagree**

10. I've seen just as many problems in two-parent families as in single-parent families.
☐ **Agree** ☐ **Disagree**

STATEWIDE RESULTS
1. 58% agree
2. 77% agree
3. 63% agree
4. 84% agree
5. 76% agree
6. 48% agree
7. 79% agree
8. 25% agree
9. 67% agree
10. 67% agree

Source: The Oregonian

Quote collections

SAY WHAT? Roone Arledge, former president of ABC News, allegedly once quipped that when gathering public-opinion quotes, you need only three: one for, one against and one *funny*.

We've tested that maxim in our man-on-the-street quote sequence below. And whether you agree with Arledge or not, you must admit that those talking heads are both visually appealing *and* engaging. After all, readers love hearing their own voices in their newspaper.

Whether with or without mug shots, quote collections are entertaining and in-formative. They generally follow one of two formats: a sampling of opinions on one topic from a variety of sources (below left), or a sampling of one person's opinions on a variety of topics (below right).

Either way, a few well-chosen remarks give any subject extra accessibility.

STREET TALK: DO YOU SUPPORT THE PRESIDENT'S NEW TAX PLAN?

"The president's plan sounds fair to me. It's time for people to stop whining and start paying their fair share."
MIKE MORGER
Wilsonville

"No. Enough is enough. I don't think I should be penalized for running an honest, profitable business."
KRIS WOLNIAKOWSKI
Lake Oswego

"I don't mind being a breadwinner, but why do those pinhead politicians chew such big slices?"
SNOOKY SPACKLE
Eugene

Localize it Lots of newspapers, including many student ones, bring the faces and voices of their readers onto their pages by conducting an informal "poll" on the streets. The anecdotal tidbits add a local flavor to the newspaper.

Famous last words

Some fond farewells and deathbed wisdom from historical figures as they made their final exits:

"I wonder why he shot me?"
— Huey Long, Louisiana governor (1935)

"My fun days are over."
— James Dean, actor (1955)

"The earth is suffocating. Swear to make them cut me open, so I won't be buried alive."
— Frederic Chopin, composer (1849)

"Who the hell tipped you off? I'm Floyd, all right. You got me this time."
— Charles "Pretty Boy" Floyd, gangster (1934)

"I have a terrific headache."
— Franklin Delano Roosevelt, U.S. president (1945)

"I am dying like a poisoned rat in a hole. I am what I am!"
— Jonathan Swift, satirist (1745)

"I've had 18 straight whiskeys. I think that's the record."
— Dylan Thomas, poet (1953)

Quote lineup This setup focuses on a single subject—famous last words—though the quotes originated from a wide variety of historical sources.

THE WIT & WISDOM OF MARK TWAIN

Wry observations from the writings of American humorist Samuel Clemens (1835-1910):

"When I was a boy of 14, my father was so ignorant I could hardly stand to have the old man around. But when I got to be 21, I was astonished at how much he had learned in seven years."

"To cease smoking is the easiest thing I ever did. I ought to know because I've done it a thousand times."

"Life would be infinitely happier if we could only be born at the age of 80 and gradually approach 18."

"Golf is a good walk spoiled."

"When your friends begin to flatter you on how young you look, it's a sure sign you're getting old."

"It is easier to stay out than to get out."

"There is no sadder sight than a young pessimist."

"It ain't those parts of the Bible that I can't understand that bother me; it's the parts that I do understand."

"Let us endeavor so to live that when we die, even the undertaker will be sorry."

Single theme Here, quotes cover a wide range of topics, but all originate from a single source. Either option is an effective sidebar for a longer feature.

Charts & graphs

Troubleshooting

Q With so many choices—pie charts, bar charts, fever charts—how do I know where to begin when deciding on an infographic format?

"Knowing what kind of chart to use for a visual presentation is important," says Tim Goheen, the Art Director/Managing Editor for MCT Graphics. Often seasoned professionals struggle with how best visualize data for a reader, he says. Take it from this pro—he offers some tips of which chart is best to use and why:

▸ **Bar charts** Use a bar chart when you want *to compare separate similar items to each other.* Also, you will see a lot of publications using circles to quantify and compare items. These can be either bar charts (circles instead of bars) or pie charts (proportionally correct circles instead of wedges). These are can be very effective with comparison presentations.

▸ **Pie charts** Use a pie chart when you want *to highlight something that is part of a whole* (as in 100 percent). For example, if you have an article about Muslims in the U.S., you might want to create a pie chart to visually show readers what percent of the American population are practicing Muslims compared to other religions.

▸ **Fever lines** Fever lines are much harder to use. Use a fever line *to show or compare trends.* A fever line can be percentages or amounts. Make sure your fever line has all the years in the range you are showing. For example, if it's from 1990 to 2010, do not leave out 1993 and 1995. Why? Unless you stop the line at a year you don't have, the line will continue as if there is a data point. For all we know, the data for the missing years could dramatically change the trend line. If you don't have data for every year in the range you are charting, use a bar chart instead.

MAKING SENSE OF THE STATS News is full of numbers: dollars, debts, crime statistics, budget percentages, election results. And the more complicated those numbers become, the more confused *readers* become. Take this brutal chunk of text, for instance:

> In 1986, 34,500 units were imported, making up 16 percent of the national total. By 1996, that number had risen to 77,400, and by 2006 more than 17,000 units were arriving monthly, representing an increase of 591 percent over 1981, the first full year of operation.

Huhh? You see the problem. When math gets heavy, charts and graphs come in handy. They present numerical data in a simple, visual way—the simpler, the better. On these pages, we'll look at the three basic types of numerical graphics: bar charts, fever charts and pie charts.

2011: SPORTS ILLUSTRATED'S 50 HIGHEST-EARNING AMERICAN ATHLETES

	
TIGER WOODS	$62,294,116
PHIL MICKELSON	$61,185,933
LEBRON JAMES	$44,500,000
PEYTON MANNING	$38,070,000
ALEX RODRIGUEZ	$36,000,000
KOBE BRYANT	$34,806,250
KEVIN GARNETT	$32,832,044
MATT RYAN	$32,700,000
TOM BRADY	$30,007,280
DWIGHT HOWARD	$28,647,180

Sports Illustrated's eighth-annual compilation of the 50 top-earning American athletes by salary, winnings, endorsements and appearance fees.

Bar direction
The bars in most bar charts stack vertically—but they're equally effective running horizontally, as they do here. Bar shapes and sizes are often determined by the overall shape of the box, and here, that's how they fit best.

BAR CHARTS The bar chart *compares two or more items by sizing them as columns parked side by side.* It uses two basic components: One, a scale running either horizontally or vertically showing data totals; and two, bars extending in the same direction representing the items being measured.

Bars are usually stacked in a logical order: either alphabetically, chronologically or by bar size, from longest to shortest.

In simple bar charts, each item may be labeled either inside the bar or at either end (as in the examples above). The bars can be screened, colorized or given 3-D shadow effects, as long as any added effects don't distort the data.

In more complex bar charts—where the same items are compared to each other in different times or situations—each item is assigned its own color or screen pattern, which is then explained in a key or legend.

Background grids can be added to help readers track measurements. But though they're usually essential for fever charts, they're optional for bar charts.

Charts & graphs

FEVER OR LINE CHARTS The line chart (also called a fever chart) *measures changing quantities over time.* It uses these basic components:

▸ a scale running vertically along one edge, measuring amounts;

▸ a scale running horizontally along the bottom, measuring time; and

▸ a jagged line connecting a series of points, showing rising or falling trends.

Line charts are created by plotting different points, then connecting the dots to draw a curve. (Charts often include a background grid to help readers track the numbers.) Obviously, a line that rises or falls dramatically will impress readers more than one that barely shows a blip.

But, be careful, advises Tim Goheen, the Art Director/Managing Editor for MCT Graphics and an infographics expert. "Sometimes when you create a fever line, there is no discernible trend," he says. "You may see some publications get around this by manipulating the y-axis data points. For example, a chart that shows the number of TVs sold every year only fluctuates by several hundred TVs, but tens of millions are sold. If you keep the origin at '0' you will not see much of a visual trend. However, if you move the origin of the chart closer to where the numbers are fluctuating, the chart will look like there is huge movement, up or down. This can be misleading, as it will give the reader a different impression than the data actually shows. Except for stock charts, where it is understood that small fluctuations are important, it's advisable to have the origin of all fever lines and bar charts be zero."

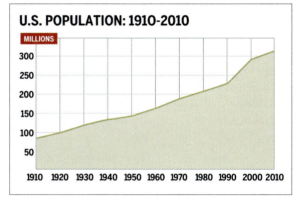

U.S. POPULATION: 1910-2010

MILLIONS

300, 250, 200, 150, 100, 50

1910 1920 1930 1940 1950 1960 1970 1980 1990 2000 2010

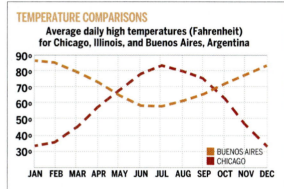

TEMPERATURE COMPARISONS

Average daily high temperatures (Fahrenheit) for Chicago, Illinois, and Buenos Aires, Argentina

90° 80° 70° 60° 50° 40° 30°

JAN FEB MAR APR MAY JUN JUL AUG SEP OCT NOV DEC

BUENOS AIRES
CHICAGO

Line charts These work best when tracing one simple statistic over time, such as a growing population measured every decade (at far left). The shading is an optional element. But you can also plot additional lines to compare different trends—as long as you clearly label which line represents which trend (at left).

PIE CHARTS The pie chart *compares the parts that make up a whole.* It usually consists of: a circle that represents 100 percent of something and several wedges (like slices of a pie) that divide the circle into smaller percentages. Each "slice" of the pie is an accurate proportion, which means that a segment representing 25 percent of the total would be one-quarter of the pie.

Figures for each slice are labeled either inside the slice (if there's room) or by arranging type, with pointers, around the outside of the pie. You need to choose the typographical solution that is most readable. Slices are often shaded or color-coded for clearer distinction (or to emphasize a significant segment). As a rule of thumb, pies should be divided into no more than six segments; beyond that, the slices become annoyingly thin.

To add impact, you can sometimes create pie charts from drawings or photos of the items being measured. For example, you can slice a dollar bill into sections to show where your tax dollar goes, or draw rings around an oil drum to break down the profits from a barrel of oil.

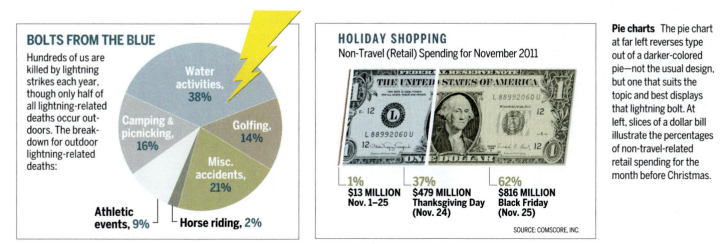

BOLTS FROM THE BLUE

Hundreds of us are killed by lightning strikes each year, though only half of all lightning-related deaths occur outdoors. The breakdown for outdoor lightning-related deaths:

Water activities, 38%

Golfing, 14%

Camping & picnicking, 16%

Misc. accidents, 21%

Athletic events, 9%

Horse riding, 2%

HOLIDAY SHOPPING
Non-Travel (Retail) Spending for November 2011

1%
$13 MILLION
Nov. 1–25

37%
$479 MILLION
Thanksgiving Day
(Nov. 24)

62%
$816 MILLION
Black Friday
(Nov. 25)

SOURCE: COMSCORE, INC.

Pie charts The pie chart at far left reverses type out of a darker-colored pie—not the usual design, but one that suits the topic and best displays that lightning bolt. At left, slices of a dollar bill illustrate the percentages of non-travel-related retail spending for the month before Christmas.

Tables

Troubleshooting

Q Is there software or an online resource that produces graphs when loading information into the program? Or do I have to create all this from scratch?

There's good news and bad news:

The good news: Yes, you can buy software (like Excel) or head to one of the many create-your-own-graph websites out there that will help you bang out pie charts, fever charts and bar charts in no time.

The bad news: Of all the sidebar options you could generate, readers' LEAST favorite graphics are pie charts, fever charts and bar charts.

Don't get us wrong. Condensing data into accessible sidebars is a terrific idea. And there are numerous ways to do it, from checklists to timelines to Q&A's to quote collections.

But sadly, pie charts, fever charts and bar charts easily become too mathematically abstract or too bureaucratic for most readers. They're too often filled with obscure data that's too dull to track.

So we often warn editors when they want to create those kinds of graphics. Instead of tracking how budget numbers bounce around from year to year, show readers what's different this year, and why, and how it affects them, and why they should care.

Just remember, you don't need artists or specialized software to break down complex material into understandable nuggets—you just need a library of alternative options to choose from. So start collecting samples, if you haven't already, from books, magazines and newspapers you admire, and use those as models for future stories.

And once you feel comfortable with short-form alternatives to text, you'll be ready to graduate to more cutting-edge online, interactive graphics.

STACKED LISTS A table is an age-old graphic device that's really half text, half chart. But unlike other charts, tables don't use bars or pie slices to make their point. Instead, they stack words and numbers in rows to let readers make side-by-side comparisons.

Tables usually consist of: *headings* running horizontally across the top of the chart; *categories* running vertically down the left side; and *lists* grouped in columns reading both across and down.

In short, tables are smartly stacked lists. They can compare two aspects of a topic (*What's In & What's Out*) or analyze a variety of categories:

THE U.S. & CANADA: HOW THEY COMPARE

	🇺🇸	🇨🇦
AREA	3,794,101 sq. miles	3,855,103 sq. miles
POPULATION	313,847,465 (2012 est.)	34,300,083 (2012 est.)
POPULATION DENSITY	83 per sq. mile	9 per sq. mile
LARGEST CITY	New York (8.4 million)	Toronto (2.6 million)
GROSS DOMESTIC PRODUCT	$14.59 trillion	$1.58 trillion
PER CAPITA INCOME	$38,008	$31,639
LIFE EXPECTANCY (at birth)	76 male, 81 female	79 male, 84 female
LITERACY RATE	99%	99%

Source: The CIA World Factbook

Tables mixing text and numbers This simple table above stacks two bio boxes side by side—one for the U.S., one for Canada. Note how the columns align with the left edges of the flags. Note how the flags substitute for the names of the countries. The table below looks at a variety of categories:

World Records: Track and field

EVENT	RECORD	HOLDER	COUNTRY	DATE
30,000 meters	1:26:47.4	**Moses Mosop**	Kenya	June 3, 2011
100 meters	9.58 seconds	**Usain Bolt**	Jamaica	Aug. 16, 2009
1 mile	3:43.13	**Hicham El Guerrouj**	Morocco	July 7, 1999
High jump	8 ft., ½ in.	**Javier Sotomayor**	Cuba	July 27, 1993
Long jump	29 ft., 4½ in.	**Mike Powell**	U.S.A.	Aug. 30, 1991
Pole vault	20 ft., 1¾ in.	**Sergei Bubka**	Ukraine	July 31, 1994

To keep tables as neat as possible, carefully align all rows and columns. Though text usually works best flush left, numbers often align better flush right:

Amazing Bible facts

Dr. Thomas Hartwell Horne (1780-1862), a student of the King James Version of the Bible, published these statistics in his book, Introduction to the Study of the Scriptures:

	OLD TESTAMENT	NEW TESTAMENT	TOTAL
Books	39	27	66
Chapters	929	260	1,189
Verses	23,214	7,959	31,173
Words	593,493	181,253	774,746
Letters	2,728,100	838,380	3,566,480

In small tables, hairline rules between rows may help alignment. In bigger tables, too many lines can look dizzying, so screen effects or occasional rules may work better (see the table at the top of this page). But remember: Keep all wording crisp and tight.

Ratings

GUIDING THE READER Journalists are trained to be objective. Impartial. Evenhanded. Fair.

Sure, that's one way to look at it. We could also argue that bland, impartial reportage puts readers to sleep, and that what readers *really* want is a guidebook to help them navigate through their world, a user's manual full of inside tips on what's good, what's bad and what's ugly.

Some parts of the paper have traditionally run consumer-friendly ratings and reviews: on editorial and entertainment pages, for instance. But ratings can also apply to politicians, hiking trails, stocks and bonds—nearly *anything*. Just choose the right device (stars, grades, thumbs) and label your package clearly.

CAST AWAY (PG-13) Tom Hanks shines as a workaholic who survives a plane crash and tries to survive on a barely habitable South Pacific island. For more than an hour, the film abandons virtually every common movie convention: music, dialogue, plot. But the rest of the film is a real downer, given the brilliance of the middle. ★★★

Star it The most common way to rate movies, records, TV shows and restaurants is to assign from one (poor) to four or five stars (excellent).

CAST AWAY (PG-13) Tom Hanks shines as a workaholic who survives a plane crash and tries to survive on a barely habitable South Pacific island. For more than an hour, the film abandons virtually every common movie convention: music, dialogue, plot. But the rest of the film is a real downer, given the brilliance of the middle.

GRADE **B+**

Grade it Many newspapers (and some magazines) assign letter grades—instantly understandable by anyone who's ever been a student.

CAST AWAY (PG-13) Tom Hanks shines as a workaholic who survives a plane crash and tries to survive on a South Pacific island. For more than an hour, the film abandons virtually every common movie convention: music, dialogue, plot. But the rest of the film is a real downer, given the brilliance of the middle.

Visualize it Other papers use a series of icons. For good films, in this icon example, the little man shown here applauds; for bad ones, he falls asleep.

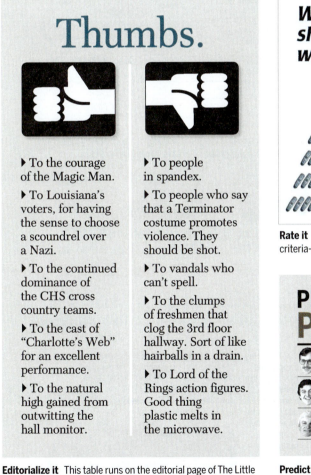

Thumbs.

- ▸ To the courage of the Magic Man.
- ▸ To Louisiana's voters, for having the sense to choose a scoundrel over a Nazi.
- ▸ To the continued dominance of the CHS cross country teams.
- ▸ To the cast of "Charlotte's Web" for an excellent performance.
- ▸ To the natural high gained from outwitting the hall monitor.

- ▸ To people in spandex.
- ▸ To people who say that a Terminator costume promotes violence. They should be shot.
- ▸ To vandals who can't spell.
- ▸ To the clumps of freshmen that clog the 3rd floor hallway. Sort of like hairballs in a drain.
- ▸ To Lord of the Rings action figures. Good thing plastic melts in the microwave.

Editorialize it This table runs on the editorial page of The Little Hawk, allowing editors to hurl quick brickbats and bouquets.

What you should be watching

KEY

	Even my parents thought it sucked	
	I'd rather watch "Star Trek" reruns	
	Maybe if this was the only thing on	
	It's on my list to watch	
	It's better than "Grey's Anatomy"	

	Meerkat Manor (Animal Planet)	Myth-Busters (Discovery)	Recipe for Success (Food Network)	NCIS (CBS)
Personality				
Addictive Factor				
Funny Factor				
Character Hotness				
Overall Score				

graphic by nate cook and adam scurto

Rate it This table from a Colorado high-school paper, The Rock, rates four TV shows according to five criteria—and the rating system uses remote-control units to keep score.

PIGSKIN PICKS

Our proud panel of prognosticators predicts this weekend's scores

	MADISON at LINCOLN 7:30 p.m. Friday	WILSON at JEFFERSON 2 p.m. Saturday	MONROE at ADAMS 1 p.m. Saturday	FILLMORE at JOHNSON 7 p.m. Friday
Bud Werner Sports editor, The Times	MADISON 21-14	WILSON 45-0	ADAMS 21-20	JOHNSON 7-0
Nick Kennedy Commentator, KXX Radio	LINCOLN 35-7	JEFFERSON 28-21	ADAMS 14-3	FILLMORE 21-14
Wally Benson Former Mudhog coach	MADISON 21-3	WILSON 45-7	ADAMS 35-7	FILLMORE 10-7

Predict it Here, a panel of sports experts predicts winners (and scores) for upcoming football games. Once created, this graphic format is easy to recycle week after week.

Timelines

Gunman takes stage in lecture hall

On Thursday afternoon, shortly after an hour into a geology course in Northern Illinois University's Cole Hall, a man opened fire on students in a brief, rapid-fire assault before killing himself.

Auditorium events • Approximate location of bodies

1. Gunman entered the stage and started shooting with a shotgun.

2. Shooter came down from the stage, walking up an aisle almost to the back of the auditorium.

4. He went back up on stage and killed himself.

3. He then crossed and walked down the other aisle while firing handguns.

Drawing is schematic.

SOURCES: The Northern Star; witness reports AP

A sequence of events The numbers used on this graphic above point out the sequence of events that happened in one afternoon during a shooting spree. The diagram of the lecture hall and the use of red arrows clearly indicate the order in which things happened and where everything took place.

A sense of time passing The swine flu vaccine timeline on the right works within a relatively short time frame: less than one year. Key bits of information are clumped together in an organized way, with visuals interspersed throughout.

KEEPING IT IN PERSPECTIVE When we write fiction, we plot the story chronologically: *Boy meets girl in spring. Boy marries girl in summer. Boy gets hit by a bus in fall* ... and so on. But when we write newspaper stories, we often bounce back and forth through time: *Yesterday's meeting discussed tomorrow's vote to repeal a 1999 tax to fund a domed stadium by 2009* ... and so on.

Time gets tangled up in text. That's why timelines (or chronologies) are so effective. They put topics in perspective by illustrating, step by step, how events unfolded.

Vaccine makers struggle to keep up with swine flu demand

The process to produce the swine flu vaccine is the same as that used to produce seasonal flu vaccine. Manufacturers haven't been able to produce enough of the vaccines at the same time.

| JAN. | FEB. | MARCH | APRIL | MAY | JUNE | JULY | AUG. | SEPT. | OCT. | NOV. |

VIRUS SELECTION

Seasonal flu: Food and Drug Administration advisory panel selects three strains

Swine flu: only H1N1 strain is used, which was identified in April, leaving little time to produce the fall vaccine

PRODUCTION BEGINS

Seed virus is injected into fertilized eggs and incubated

Virus is harvested from egg whites, then killed with chemicals

Limited capacity slows swine flu vaccine production

FDA TESTS YIELD, PURITY, POTENCY

Slow growth of swine flu in lab leads to delays, low yield

Seasonal flu: Three strains are blended into one vaccine

FDA licenses vaccine

FILLING AND PACKAGING

Vaccine is filled into vials and packaged for distribution

Kept in cold storage to ensure potency

DISTRIBUTION

Shipping begins

VACCINATION BEGINS

Immunity develops approximately two weeks after vaccination

| SWINE FLU VACCINE AVAILABILITY | Federal health officials promised by Oct. 15: **120 million doses** |
| | **12.8 million** ready |

SOURCE: Food and Drug Administration AP

Still rumbling at 100

Harley-Davidson is cruising into its second century selling more motorcycles than ever, to buyers enraptured with the raspy roar of a true American classic.

1903: Serial #1 bike.

1936: The EL or "Knucklehead," named for engine's shape.

1957: The XL Sportster, first of the "Superbikes."

1971: The FX 1200 Super Glide, first of the cruisers.

1990: The FLSTF Fat Boy.

— 300,000
— 250,000
— 200,000
— 150,000
— 100,000
— 50,000

Harley-Davidson annual production

1903 1913 1923 1933 1943 1953 1963 1973 1983 1993 2003

1903: William S. Harley, 21, and Arthur Davidson, 20, offer their first motorcycle to the public.

1907: Harley-Davidson Motor Co. is incorporated.

1918: Harley supplies 20,000 motorcycles for the WWI effort.

1942-45: Harley makes 90,000 motorcycles for the military during World War II.

1969: Harley-Davidson merges with American Machine and Foundry Co.

1981: Harley executives buy back the company from AMF and institute new quality control standards.

1987: Harley-Davidson is listed on the New York Stock Exchange

1988: The company has its first of six consecutive sold-out model years.

2003 VRSCA V-Rod

William S. Harley Arthur Davidson

Riding a Harley-Davidson, Cpl. Roy Holtz was the first American to enter Germany after the Armistice.

SOURCE: Harley-Davidson Inc. AP

By the decades The most graphically ambitious timelines combine images and text. Here, small images of motorcycles help reconstruct how the bike has evolved over the decades. The fever chart shows production levels and is added information that is integrated with the timeline.

Step-by-step guides

SHOW THE READER HOW Life is full of complex procedures, from changing a tire to baking a cake to—well, resuscitating a lizard. And the clearest way to walk readers through a series of instructions is to arrange them in logical, numerical form:

A step-by-step guide.

If you've ever assembled Christmas toys or wrestled with tax returns, you know how confusing bad instructions can be. That's why step-by-step guides must be as clear, precise and user-friendly as possible. Whenever possible, add drawings or photos to illustrate key steps. As the examples on this page make evident, it's better to *show* than just *tell*.

Break it down This full-color poster page analyzes the mechanics of hitting a baseball—the stance, the stride, the swing—with expert advice from batting coach Ken Griffey Sr. Note the freeze-frame batting sequence running along the bottom of the page. The dominant image and the large headline anchor the page, and the steps how to hit the ball are secondary. The numbers are large and function as points of entry, so the reader can follow the advice easily.

Simplify Anything can be broken down into steps, including one way to bring a lizard back to life (below). But being clear about it is not easy. Ever get frustrated with those impossible-to-follow step-by-step guides? Stripping away the unnecessary details usually leads to clearer directions.

How to make a holiday wreath

What you'll need:

✳ Fresh greens (you can cut homegrown evergreens or purchase them from a nursery. It takes about 7 pounds of branches to make a 12-inch wreath). ✳ Wire frame (these come in a variety of sizes; a 12-inch frame costs about $1.50). ✳ Preservative (this will keep greens fresh for about a month). ✳ Pruning shears. ✳ Wire clippers. ✳ Paddle wire.

What to do:

✳ Clip the greens into hand-sized pieces. Save the fluffy ones; discard woody branches.

✳ Layer three to four pieces of greens into a bundle.

✳ Attach each bundle to the wire frame. Pull the wire away from the wreath's center to tighten it.

✳ Continue to attach bundles, overlapping stems with greens, until the frame is completely covered with evergreens. Alternate bundles of cedar with bundles of fir.

✳ Add pine cones. Loop wire around the bottom of the cone, then attach the wire to the wreath.

✳ For special trim, place dried or silk flowers amid the greens.

✳ Attach pearl or other garlands with wire.

✳ Finally, add the bow. (Make your own or buy one.)

Explanatory text

This step-by-step guide displays a photo of a finished wreath but uses only text to explain the assembly process. That'll work when time and space are tight—but imagine how much more effective this guide would be if every step were illustrated. This could be done with photographs (below), or even simple icons. Clip art would come in handy for a guide like this that refers to generic materials, such as pine cones, bows and branches.

HOW TO RESUSCITATE A LIZARD

1 Scoop the lizard from the pool.

2 Shake out the lizard.

3 Massage the lizard's torso, applying on-and-off pressure directly behind its front legs.

4 Apply mouth-to-mouth resuscitation to the lizard, breathing slowly and forcefully.

Source: The CoEvolution Quarterly

David Sun

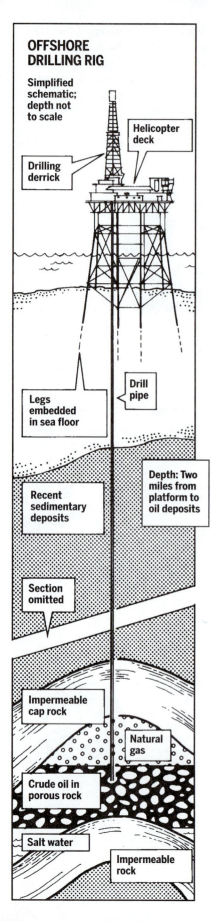

OFFSHORE DRILLING RIG

Simplified schematic; depth not to scale

Helicopter deck

Drilling derrick

Legs embedded in sea floor

Drill pipe

Recent sedimentary deposits

Depth: Two miles from platform to oil deposits

Section omitted

Impermeable cap rock

Natural gas

Crude oil in porous rock

Salt water

Impermeable rock

Maps focus on the *where* of a story; diagrams focus on the *what* and *how*. They freeze an image so we can examine it in closer detail, using cutaway views, step-by-step analyses or itemized descriptions of key components.

Whatever your topic, diagrams will work best if you:

▸ **Focus tightly.** Pinpoint precisely what you need to explain before you begin. What's most essential? Most interesting? Should the diagram be active (showing how the object moves) or passive? (Notice how the passive diagrams on this page simply point to each component.) Whatever the approach—whatever the topic—keep your diagram as clean and simple as you can.

▸ **Design logically.** Let your central image determine the diagram's shape (for instance, that oil rig is a deep vertical). If you're running a sequence of images, find a perspective that lets you show the steps in the most logical order.

▸ **Label clearly.** Avoid clutter by using a consistent treatment for all callouts (sometimes called *factoids*), whether with pointer boxes, shadows, lines or arrows:

Callout Callout Callout Callout Callout

▸ **Research carefully.** You're becoming an instant expert; readers will rely on your accuracy. So do your homework. Cross-check references. Read the story. Study photos. Talk to experts.

In short: Become a *graphics reporter*.

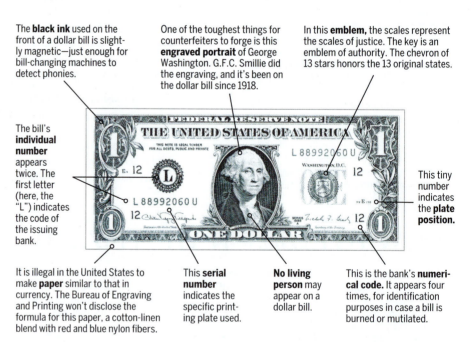

The **black ink** used on the front of a dollar bill is slightly magnetic—just enough for bill-changing machines to detect phonies.

One of the toughest things for counterfeiters to forge is this **engraved portrait** of George Washington. G.F.C. Smillie did the engraving, and it's been on the dollar bill since 1918.

In this **emblem,** the scales represent the scales of justice. The key is an emblem of authority. The chevron of 13 stars honors the 13 original states.

The bill's **individual number** appears twice. The first letter (here, the "L") indicates the code of the issuing bank.

This tiny number indicates the **plate position.**

It is illegal in the United States to make **paper** similar to that in currency. The Bureau of Engraving and Printing won't disclose the formula for this paper, a cotton-linen blend with red and blue nylon fibers.

This **serial number** indicates the specific printing plate used.

No living person may appear on a dollar bill.

This is the bank's **numerical code.** It appears four times, for identification purposes in case a bill is burned or mutilated.

Sources: The People's Almanac, Harper's magazine

Diagram with details The diagram above combines history and trivia to give readers a quick visual tour—something difficult to achieve in text alone. At left, a more traditional diagram uses a cutaway view of the Earth's crust to make the offshore drilling process more understandable.

Diagrams

INFORM AND ORGANIZE With the right topic, a diagram becomes more than just a supplementary graphic; it becomes lead art that's informational *and* entertaining. For example, the complex diagram below combines callouts and color images to form something that can easily run as a feature-page centerpiece. (And though these diagrams use an illustrative style, you can use photos just as effectively, too. All you need is a strong image, clean typography, logical organization and some solid reporting to achieve professional results.

Do-it-yourself As soon as you invite the reader to grab the scissors and create something, you've got some interactivity going. This is especially fun for the kids, as we see here in this Orlando Sentinel diagram on how to make a space shuttle.

Detailed The Philadelphia Inquirer produced this rich and dense explanatory graphic of the National Constitution Center in Philadelphia. Notice the simple and subdued typography that's used throughout the piece. The subdued color palette works, too.

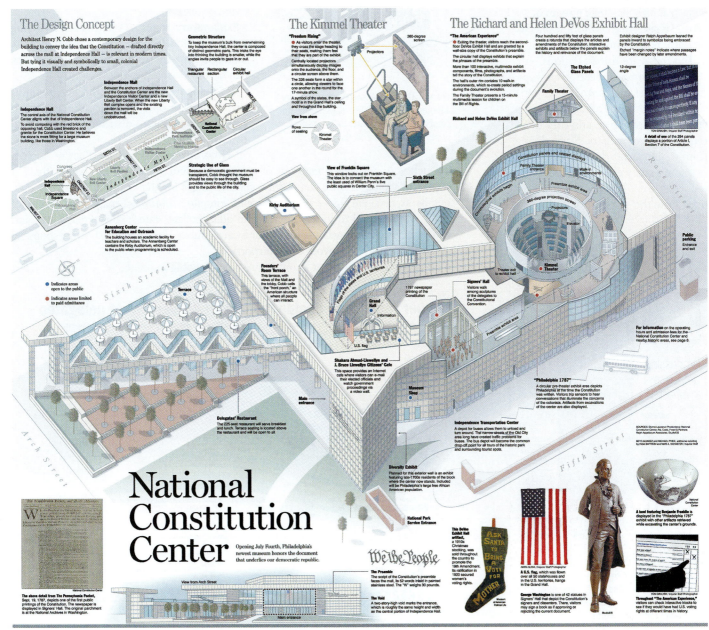

Maps

Troubleshooting

Q A small map might take about an hour to produce. How long does it usually take to create most graphics?

That depends on the complexity of the topic and the skill of the artist. A simple chart could take 20 minutes. A mid-sized graphic (with some sort of illustration) might take several hours. A big color centerpiece can easily take all day. And those complex, exhaustively researched megagraphics may take a team of artists, writers and editors weeks to prepare, polish and print.

But those are the exceptions. Remember, any publication can supplement stories with short sidebars, fact boxes and lists. They're enormously effective, and they don't require time or artistry. Since they simply summarize data that's buried in the text, they can be crafted by reporters—not graphic artists—as they write the story.

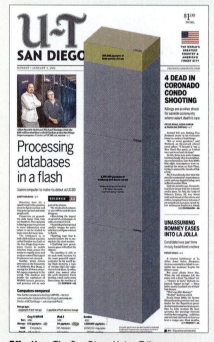

Effective The San Diego Union-Tribune ran a graphic that ran the entire length of its front page, above. The chart shows the amount of storage of one of the most powerful supercomputers in the world.

VISUALIZING A SENSE OF PLACE Most Americans are poor geographers. They have a tough time remembering even the easy stuff, like where New York City is. (Hint: it's on the East Coast—that's the *right edge* of a U.S. map.) So how can we help them visualize volcanoes in Fiji? Riots in Lesotho? Train wrecks in Altoona?

With maps. Maps can enhance almost any news story, if you're ambitious enough, but they're especially important for any story where a knowledge of geography is essential to the story's meaning (an oil spill, a border dispute, a plane crash); or any local story where readers may participate (a parade, a new park).

Locate This map, above, points out where a tornado took place. The maps, below, are combined with bar charts to give an overview of delegates before a big day at the polls.

Maps come in all sizes and styles, in print and in digital form—world maps, street maps, relief maps, weather maps, etc. But the types of maps most often produced in newsrooms are:

▸ **Locater maps:** These show, as simply as possible, the location of a significant site ("X" marks the spot) or identify where a news event occurred.

▸ **Explanatory maps:** These use storytelling techniques to illustrate a sequence of events. Taking a step-by-step approach, these maps can become visually active.

▸ **Data maps:** These show the geographical distribution of data, working like a chart to convey population distributions, political trends, weather, etc.

How are maps created? They're copied. Though you can't cut a map out of a road atlas and stick it in the paper (that's a copyright violation), you can redraw another map's highlights, then fill in your own details as necessary. Every paper should compile a library of maps in a variety of scales, from global to local. Buy a world atlas; collect state highway maps, city and county maps, even brochures from your local chamber of commerce (showing shopping areas, local parks, the layout of the airport).

Be prepared. You never know where news is going to break.

Maps
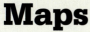

Troubleshooting

Q **What's the best way to make a map? And is it OK to photocopy a map or a road atlas?**

You don't need to be a cartographer. You don't need special software. And you don't need to violate copyright laws to produce an accurate map.

Suppose you want to show your readers how to find a local park—let's call it Tualatin Commons Park, the site of an upcoming yo-yo festival. Check out the maps and explanations below for the fastest way to customize your own map from an existing source.

If you need maps of countries and states, you'll find an impressive variety of styles in most clip-art collections. Once you buy the collection, those maps are yours to print or modify.

But remember: You cannot simply scan and publish someone else's map. For one thing, map details won't copy well—they'll look messy and fuzzy. But more importantly, most professional maps are copyrighted, and unauthorized copying is stealing. Use them only as references to guide you in creating your own maps for your publication.

GUIDELINES

▶ **Create design guidelines for all maps.** You'll save time and give your maps a consistent look if you set clear standards for abbreviations, screens, line weights, symbols — and most important:

▶ **Use type consistently.** Use designated fonts in designated sizes (sans serif will usually work best behind screens). Avoid type that's too big (over 12 point) or too small (under 7 point). Decide where you'll use all caps (countries? states?), italics (bodies of water?), boldface (key points of interest only?).

▶ **Keep maps simple.** The whole planet can fit into a one-column box, if necessary. Make your point obvious; trim away all unnecessary details. Anything that doesn't enhance the map's meaning distracts attention.

▶ **Make maps dynamic.** Don't just re-create a dull road map. Add shadow boxes, screens, 3-D effects, tilted perspectives—just be careful not to distort the map's accuracy or destroy its integrity.

▶ **Keep north pointing "up."** And if north *isn't* at the top of your map, include a "north" arrow to show where it is. Otherwise, the arrow isn't necessary.

▶ **Add mileage scales** whenever possible. They give readers perspective.

▶ **Match the map to the story.** Be sure that every significant place mentioned in the text is accounted for on the map.

▶ **Design your map effectively.** Keep the map as tightly focused as possible. If pockets of "dead" space occur, you can fill them with useful extras: mileage scales, callout boxes, locater-map insets, photos or illustrations.

▶ **Assume your readers are lost.** To help them understand where they are, you may need to give your map a headline or an introductory paragraph. You may need to add a locater map to your *main map* if that makes it clearer. (For instance, if you draw a detailed street map, you should show what part of the city you're in.) Above all, include any familiar landmarks—cities, rivers, highways, shopping malls—that help readers get their bearings.

MAP TIP With maps, there is such a thing as too big. Some of the more detailed maps need centerpiece size, or larger, especially if you're going to include a lot of information with it. But don't think of maps as space fillers. There should always be something to be gained, informational-wise, by blowing out the size of any map.

❶ Find a recent, reliable source map: a tourist brochure, a government map, a commercial road atlas, even a Web database. Scan or copy the map into your computer. Or, if the map won't scan cleanly, make a tracing of the key elements—cities, roads, places of interest—and scan that instead.

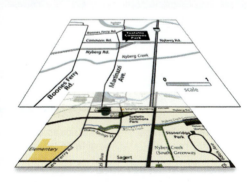

❷ Fire up almost any drawing, photo or layout software that lets you create curvy lines and add type. Using the imported scan as a guide, trace all key roads, cities and places of interest. Eliminate any unnecessary details—unimportant streets, parks, etc. Keep all cartographic elements (roads, rivers, landmarks) that help readers find what they're looking for.

❸ Finish your map according to your newspaper's graphic style. (Here, we're using Frutiger Condensed for street names, light italic for rivers, etc.) Add a source attribution, a distance scale and a north arrow, if appropriate. This map can probably be done in less than an hour.

Graphics packages

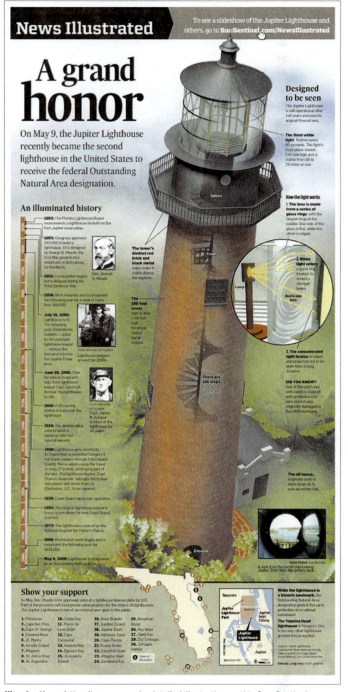

Illuminating A timeline, map and a detailed illustration on this Sun-Sentinel page help tell the story of a lighthouse that was recognized by a federal agency.

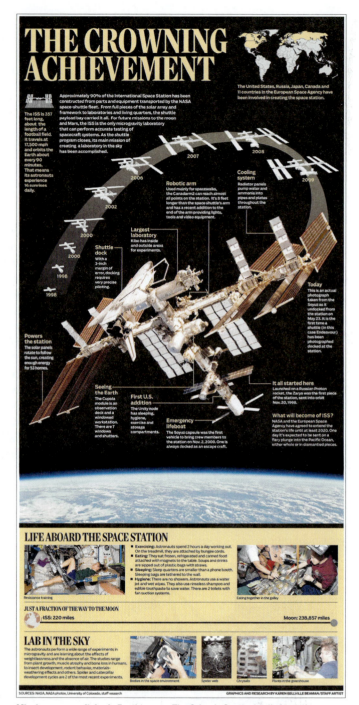

Mission accomplished For this page, The Orlando Sentinel pulled together a timeline and numerous factoids for a story on the International Space Station.

Some multi-faceted stories need more explanation. That's why you'll often see dazzling graphic packages, like the ones on these two pages. Done well, these packages present as much (or more) information as any news story. But to execute these graphics packages well, you'll need:

▶ **Time.** Most megagraphics need at least several days—often several weeks—to prepare. They can't be rushed without dismal results.

▶ **Teamwork.** These aren't solo efforts. They demand cooperation and planning for the research, reporting, art and layout to come together smoothly.

▶ **Expertise.** Sorry to say, these packages are terribly difficult to produce. Don't tackle anything this tricky until you've honed your graphics techniques.

▶ **A firm commitment of space.** Don't let them reduce your full-page package down to 2 columns at the last minute. Get the space you need guaranteed.

Above all, don't overdo it. Pages like these take readers right to the edge of information overload. Ask yourself: How much data can our readers handle?

F4 **LIFESTYLES** Casper Star-Tribune Sunday, July 10, 2011 Casper Star-Tribune **LIFESTYLES** F5

The sauropods

Among the largest animals to ever walk the earth, the sauropods are characterized by their massive frames, pillar-like legs, whip-like tales and, of course, their long necks.

'Jimbo,' Supersaurus vivianae
(WDC DMJ-021)

■ **Lived:** 150 million years ago, late Jurassic
■ **Size:** 106 feet long, weighed about 40 tons
■ **Collected:** In 1996, a rancher came into the Tate Geological Museum in Casper and asked if anyone would look at something he found on a hill on his. Douglas ranch. Bill Wahl, now prep lab manager of the Wyoming Dinosaur Center in Thermopolis, was skeptical. He followed the rancher to his place anyway, and happened to find the longest dinosaur ever to come out of Wyoming.

For the next 10 years, the landowner let paleontologists from the Tate and the Wyoming Dinosaur Center dig 'Jimbo' out of the ground, allowing school kids to work on his property.

"I would kill or die for these landowners. They are cool people," Wahl said.

The remoteness of the area meant that every bone, even those that weighed hundreds of pounds, had to be hiked out by hand, often on stretchers.

■ **All-star cred:** It is Wyoming's longest dinosaur, probably the third longest found in North America and fourth longest in the world.

The longest single dinosaur bone ever found is Jimbo's rib, a bone 9½ feet long. Wahl said. The sheer size of the bones caused Jimbo to be misidentified twice. One paleontologist thought the rib had to be a scapula because he thought, ribs just weren't that large.

The sheer impressiveness of the specimen landed it a tour of Japan as the featured attraction of the "Gigantic Dinosaur Expo 2006."

More interesting than size to Wahl, though, is Jimbo's misshaped vertebrae. Either from a birth defect or a structural problem developed later in life, several of its vertebrae in one section sort of fold in on one another. They don't fit as nicely as they should. "This guy had a backache from hell," Wahl said. "But with a brain the size of a cocktail weenie, why bother with pain?"

Jimbo's quarry had bones from just two animals, Jimbo and a couple from a Stegosaurus. Scientists were able to identify mistakes in Supersaurus anatomy by comparing Jimbo's bones to the holotype – the first specimen discovered in Colorado in 1972. Several tall vertebrae of the holotype actually belonged to another sauropod.

■ **See it:** A cast is mounted in the Wyoming Dinosaur Center and Dig Sites, 110 Carter Ranch Road in Thermopolis, where the original bones are located. Hours are 8 a.m. to 6 p.m. daily. Cost is $10 adults, $5.50 children and seniors, free for children 3 and younger. Dig site tours and dig programs also available. www.wyodino.org

Chris Racay, collections expert at the Wyoming Dinosaur Center, stands next to Jimbo's rib, the longest discovered dinosaur bone.
WDC PHOTO

Apatosaurus excelsus
(UW-15556)

■ **Lived:** 150 million years ago, late Jurassic
■ **Size:** 75 feet long, weighed about 25 tons in life
■ **Collected:** In 1901, a team from the Carnegie Museum of Natural History in Pittsburgh, Pa., discovered this Apatosaurus in the Morrison Formation in Sheep Creek quarry in Albany County. In 1956, UW's Samuel "Doc" Knight made a deal with the Carnegie Museum and brought the Apatosaurus home.

A Brontosaurus? Not officially. The word "Brontosaurus" was a casualty of the Bone Wars, a bitter race between dinosaur hunters O.C. Marsh and E.D. Cope to discover and name fossilized animal remains in the late 1800s. They didn't always take the time to get the science right.

Marsh first named an Apatosaurus skeleton in 1877. Two years later, another large sauropod skeleton was recovered. This one from Como Bluff. It was larger and more complete than his first Apatosaurus, so Marsh assumed it was another type of animal. Marsh named it Brontosaurus, meaning "thunder lizard." By 1903, scientists determined that the bones were from the same type of animal and the name Apatosaurus was preferred because it appeared first in scientific papers.

But Brontosaurus had already cemented itself into popular culture. Have you ever heard Fred Flintstone order an apato-burger instead of a bronto-burger?

■ **All-star cred:** Its foot was the first articulated foot of the big sauropods – the giant plant eaters with long necks and tails. All 11 foot bones were lined up as they would have been in life.

"Up until that point, we never knew how many bones there were, or even how many toes a big sauropod had," said Kelli Trujillo, manager of the University of Wyoming Geological Museum.

It has lowered over thousands of Wyoming school kids in the museum since 1961.

KERRY HULLER | STAR-TRIBUNE

The foot of UW-15556 was the first articulated foot of the big sauropods.

'Dippy,' Diplodocus carnegii
(CM 84)

■ **Lived:** 150 million years ago, late Jurassic
■ **Size:** 84 feet long, 11 tons
■ **Collected:** In 1899, Andrew Carnegie – yes, that Andrew Carnegie, namesake of libraries, museums and famous music halls – picked up a New York newspaper with this headline: "The Most Colossal Animal Ever on Earth Just Found Out West." It included an illustration of a long-necked dinosaur rearing up on its hind legs, peeking into an 11th-story window of the New York Life Building, according to "Bone Wars: The Excavation and Celebrity of Andrew Carnegie's Dinosaur," by Tom Rea of Casper.

Carnegie – who stood just 5-foot-2 – wanted one.

He sent William Holland, director of the museum the steel tycoon had recently built, to Wyoming. Here, Holland hired William Reed and the team moved to the Sheep quarry in Albany County. They discovered this Diplodocus on July 4, 1899. Team members said it should be called "The Star-Spangled Dinosaur," but it became known as "Dippy" instead.

■ **All-star cred:** Perhaps one of the first complete dinosaur skeletons to be seen by millions of people, it helped ignite the public's interest in the prehistoric animals. In 1905, Carnegie presented a replica of Dippy's skeleton to King Edward VII of England for the British Museum. Other European kings and presidents jumped on the dino wagon and casts were sent to Germany, France, Austria, Italy, Russia, Spain, Argentina and Mexico.

"It was really the first celebrity dinosaur," Rea said.

■ **See him:** Mounted at the Carnegie Museum of Natural History, Pittsburgh, Pa. Casts of Dippy are displayed at museums around the world. A Dippy statue still greets visitors outside the Carnegie Museum.

Kevin Anderson at the Casper College Western History Center created this image from two old newspaper negatives for Tom Rea's book, 'Bone Wars.'

Why Wyoming?

Which state has the most dinosaur fossils? It's a toss-up between Wyoming and Montana, according to Russell Hawley, education specialist with the Tate Geological Museum. (As if we needed another reason to mistrust that wily state to the north.) Wyoming and Montana each have more than 50 of the 60 or so genera of dinosaurs known to have roamed in North America. Both states are in the "Dinosaur Triangle," along with Utah and Colorado. Wyoming is smack-dab in the middle.

Many of the dinosaurs you grew up knowing have been found in Wyoming, and several were discovered here before they were found anywhere else.

So why Wyoming? What makes us so special? Hawley explains it this way: All the world is basically divided into two categories – E-world and D-world.

D-world is a depositional environment, the places where sediment collects, cements together and forms rocks. The Mississippi River Delta is D-world.

The Rocky Mountain region is an example of E-world, places that are eroding away.

"And that is a lousy place to become a fossil. If you want to become a fossil, don't die in E-world. Don't die on top of Pikes Peak," Hawley said.

"Bones will roll downhill. They will be smashed to dust and washed away as tiny, tiny particles and no one will find your articulated skeleton."

For the ultimate fossil bonanza, find a place that was D-world millions of years ago, but is now E-world. Like Wyoming.

(Or Montana.)

J.P. Cavigelli, the Tate's prep lab manager, says Wyoming has two critical ingredients: the right layers of rock where dinosaur fossils are preserved, and subsequent uplifting exposing those rocks at the surface.

From 500 million to about 50 million years ago, Wyoming was as "flat as stale beer," Hawley said. About then, the Rocky Mountains thrust up, tilting the flat delta. The layers are still eroding away.

Greasy, sagebrush-covered fields don't hurt, either. In Wyoming, paleontologists don't have to dig under trees or shrubs or rich, vegetation-covered topsoil. "The stuff that grows good gardens, we don't have that here," Cavigelli said.

On our badlands, summer rain and winter snow wash away layers of dirt, exposing what lies beneath. A paleontologist can identify fossils exposed from one season to the next, if he or she knows the land. Some of Wyoming's hottest fossil beds are examples of this badlands topography.

Says Cavigelli: "Badlands, to a paleontologist, are good lands."

What is a dinosaur?

The Mesozoic Era, 251 million to 65 million years ago, has been called the Age of the Dinosaurs. But not everything that lived back then was one.

There were mammals, small reptiles, insects and amphibians. Giant marine reptiles, like Mosasaurus, dominated the seas. Flying reptiles, like Laopteryx, sailed the sky. But neither is a dinosaur.

To be a dinosaur, an animal has to be a member of the superorder Dinosauria, scientifically defined by a set of evolutionary characteristics. These are defined by locomotion, according to "Discovering Dinosaurs in the American Museum of Natural History" by Mark A. Norell and others. They include:
■ upright, erect posture
■ hind limbs swung under the body
■ vertical pelvis
■ enlarged acetabulum (hip socket), supporting the thigh bone like a shelf as opposed to the ball-and-socket approach of humans and other tetrapods (animals with a back bone and four limbs). Hip sockets with holes and enlarged bony rims belong to dinosaurs.

To confuse matters just a little more, dinosaurs belong to a larger group of animals call Archosauria which is then divided into two other groups: The Crurotarsi include crocodiles and their relatives, Ornithodira includes pterosaurs and dinosaurs.

Biggest of them all?

Most of Wyo's dino all-stars were big, to say the least. But how do they compare to the largest animal to ever walk the Earth? Well, the largest animal that ever called our planet home didn't exactly walk the earth, but swims in our seas today. The blue whale tops the charts at just short of 100 feet long and a whopping 200 tons. The largest animal walking around today is the African elephant which tops out at around 20,000 pounds – fairly small by paleo standards.

From left to right:
A terrified human runs from Drinker, Ornitholestes, Allosaurus, T. rex, Supersaurus, Diplodocus, Edmontosaurus, Apatosaurus, a Blue whale, Pachycephalosaurus, an African elephant, Stegosaurus and Triceratops.

WYOMING DINOSAUR TIMELINE 1824-1908 **WYOMING DINOSAUR TIMELINE** 1824-1908

March 1877
Buffalo hunter and railroad man William H. Reed finds dinosaur bones at Como Bluff, about 60 miles northwest of Laramie. Writes to O.C. Marsh, offering to sell the fossils and dig more. He leads fossilized bones into wheelbarrows and pushes them to the Union Pacific Railroad to ship them to Marsh at Yale University.

Reed finds dinosaurs excelsus: teeth and jaws of Dryolestes – a tiny mammal that lived under the towering reptiles – and more. Marsh takes credit for the finds in his published descriptions.

January 1878
Marsh realizes that Quaker naturalist E.D. Cope has learned about the Como Bluff site. The Bone Wars begin.

1888
A cowboy sees a skull sticking out of a bank near Lusk. It has a horn, which the cowboy lassos trying to pull it out. He breaks the horn and sends it to Marsh, who mistakes it for a bison. Marsh's field scientists, including John Bell Hatcher, travel to the site and discover a huge skull in the ground. Not a bison, but a new group of dinosaurs – Triceratops.

1897
Barnum Brown, working for the American Museum of Natural History, comes to Como Bluff to look for Jurassic mammal fossils. Instead, he keeps finding big dinosaur fossils. The museum pulls collectors from Colorado, South Dakota and Kansas and sends them to Wyoming; the second dinosaur rush begins.

Summer 1898
Reed discovers bones of a giant dinosaur in Como Bluffs, and news accounts attract the attention of Andrew Carnegie. Carnegie scribbles a note to William Jacob Holland, director of the Carnegie Institute. "... Can I you buy this for Pittsburg – try, Wyoming State University isn't rich – get an offer – hurry AC."

March 21, 1899
Holland arrives in Laramie by train. Reed agrees to sign over his claim to the dinosaur for a three-year salary of $1,800 per year as an employee of the Carnegie Museum.

University of Wyoming trustees dispute Reed's claim on the dinosaur. He found it as a paid employee of UW, they argue, and had used the dino to persuade the Wyoming Legislature to approve a $22,000 bond issue to build a new science hall to house the dinosaur and UW's impressive collection of fossils. Holland writes to Carnegie: "The Lizard has gotten into Wyoming politics."

The Carnegie team finds another large dinosaur, Diplodocus carnegii, on July 4, 1899, which is shipped to Pittsburgh, Pa. Casts of are gifted to kings and monarchs around the world. Named by Marsh, it is the largest dinosaur unearthed at that time.

April 1899
Union Pacific Railroad offers free train passage for Eastern fossil hunters to come to Wyoming. The railroad hopes to make money by shipping bones back to the collectors' museums and universities.

1900
Barnum Brown discovers a partial skull, vertebrae and ribs of a species he calls Dynamosaurus imperiosus near Seven Mile Creek in Weston County. The bones are found two years earlier than a T. Rex skull and skeleton found in Montana in 1902. In 1906, the Dynamosaurus is determined to be the same species as T. Rex. Wyoming's specimen is now at the Natural History Museum in London.

August 1908
The Sternbergs, a fossil-hunting dynasty, uncover the first dinosaur "mummy," a hadrosaur wrapped in its own skin in Niobrara County.

Dinosauria The Casper Star-Tribune ran this dinosaur double truck in a section dedicated to Wyoming's rich dinosaur history. The project took up 13 Sunday pages, says Wesley Watson, the special projects coordinator. "Many of the first specimens of the world's most well-known dinosaurs were unearthed in Wyoming," he says. "When news of another, possibly major T. Rex discovery made its way to features editor Kristy Gray, we decided to name our own dinosaur all-stars and tell the history of the bone wars. Kristy and I tried to weave together the historical story, prehistoric story and that of the present. Because we got ahead of the story so early, I was able to hand illustrate and paint all the dinosaurs. The middle spread focuses on Wyoming's famous sauropods, the largest land-dwellers the planet has ever known. Along the bottom was a timeline running page to page from the Mesozoic Era to the present. Above the timeline on this spread is a size-comparison chart. To make it useful, the chart is book-ended by a human and a blue whale. Dino-to-human size comparisons have always made me laugh because the man will stand relaxed next to a vicious dinosaur. So, I made my little man running away. Often, in my work I try to add that little piece of humor. Readers like to laugh, no matter what some editors think."

Package planning

Most newsrooms are like factory assembly lines: the reporter reports. The photographer photographs. The editor edits. And then—at the last minute —the designer designs.

That assembly-line process works fine if you're making sausages, but it won't consistently produce award-winning pages. Lavish layouts rarely succeed when they're slapped together on deadline.

So how do you retool your newsroom to produce *this* type of page at left? By planning: by instituting a brainstorming process that shapes stories *before* they're written.

In the early 1990s, Buck Ryan—a journalism professor at the University of Kentucky—developed the Maestro Concept, a method of integrating writing, editing, art and design. Ryan proposed that each newsroom appoint a *maestro*, a visual journalist who could orchestrate the interplay of all key staffers. And to guide the process along, participants would use a story planning form, like the one reprinted on the next page.

How does it work? Suppose a reporter has just gathered information for a big story. Before she starts writing, there's a brief meeting. That's where the reporter, editor, photographer and designer, with the maestro's help, explore the story's potential using a form like the one below to produce a package like the one at left.

Why take the time to do this? To produce higher-level work that contains lots of moving parts, so to speak. Miscommunication can be avoided if everyone involved in the story takes a little time to get on the same page.

The story idea: Can you summarize the story in 25 words or less? That's a good test to see if your focus is tight enough—or if you're still struggling with a fuzzy concept.

Questions readers will ask: The first question every reader asks for every story is "Why should I care?" Try to answer this question in a highly visual way—in the headline, a photo, a sidebar. Now: What other questions will readers have? Can you answer them in graphic ways? That list of sidebar options provides alternative ideas for reporting and design.

Headline/deck: Why wait until the story is written— and the clock is ticking—to write a headline? Chances are you have enough info to kick around a clever headline right now, or at least generate key words you can refine later. Writing the deck now also helps the team members clearly define the story angle.

Staff, deadlines, lengths: One last chance to ensure that everyone agrees on when the different story elements are due, what sizes they'll be—and most important, who's responsible for what.

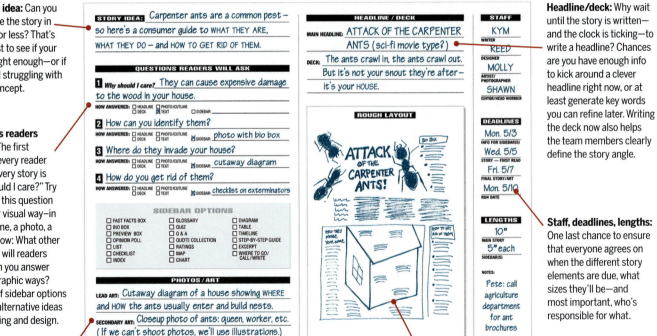

Photos or illustrations: Too often, photographers are excluded from story-planning conferences, then sent out on assignment with hardly a clue what the story's about. But when photographers are included in this preliminary discussion, they can shape the direction of the imagery and the reporting. By this point in the planning meeting, an attentive photographer should be able to suggest photo ideas—or, if the story is better served by illustrations, staffers can weigh those options instead.

Rough layout: While those ideas for photos, sidebars and headlines are being kicked around, the designer can sketch a layout that integrates all the key ingredients with their proposed shapes and sizes. Everything is subject to change, but by the end of the meeting, all the participants should agree on this preliminary vision of the page. Remember, this is just a starting point—the actual page should only get better. After the meeting, this form should be photocopied and distributed for future reference.

STAFF

WRITER _____

DESIGNER _____

ARTIST/PHOTOGRAPHER _____

EDITOR/HEAD WORRIER _____

DEADLINES

SIDEBAR INFO _____

STORY—FIRST READ _____

FINAL STORY/ART _____

RUN DATE _____

LENGTHS

MAIN STORY _____

SIDEBAR(S) _____

NOTES: _____

HEADLINE / DECK

MAIN HEADLINE: _____

DECK: _____

ROUGH LAYOUT

STORY IDEA

QUESTIONS READERS WILL ASK

Why should I care? _____

How answered ☐ HEADLINE ☐ PHOTO/CUTLINE
☐ DECK ☐ TEXT ☐ SIDEBAR:

How answered ☐ HEADLINE ☐ PHOTO/CUTLINE
☐ DECK ☐ TEXT ☐ SIDEBAR:

How answered ☐ HEADLINE ☐ PHOTO/CUTLINE
☐ DECK ☐ TEXT ☐ SIDEBAR:

How answered ☐ HEADLINE ☐ PHOTO/CUTLINE
☐ DECK ☐ TEXT ☐ SIDEBAR:

SIDEBAR OPTIONS

☐ FAST-FACTS BOX ☐ GLOSSARY ☐ DIAGRAM
☐ BIO BOX ☐ QUIZ ☐ TABLE
☐ PREVIEW BOX ☐ Q & A ☐ TIMELINE
☐ QUOTE COLLECTION ☐ RATINGS ☐ STEP-BY-STEP GUIDE
☐ LIST ☐ OPINION POLL ☐ EXCERPT
☐ CHECKLIST ☐ MAP ☐ WHERE TO GO
☐ INDEX ☐ CHART ☐ WEBSITE LINKS

PHOTOS / ART

LEAD ART: _____

SECONDARY ART: _____

Graphics guidelines

Troubleshooting

Q Our paper does not have a graphics department. How do we encourage staffers to get more graphics into the newspaper?

You don't need to manufacture monster megagraphics. But you do need to get small, user-friendly sidebars and fact boxes into more stories more often. Try this to get more *visual hooks* on all your section front and inside pages:

▸ **Plan your big stories.** Smart packaging doesn't happen unless you plan ahead for it. Make it newsroom policy that all major stories must be maestroed (see Page 188) in advance.

▸ **Make reporters more responsible for graphics.** Most of your smartest sidebars use just text: tables, lists, Q&A's. Most reporters bury critical numbers in the middle of their stories; seek out that info and include it inside helpful fact boxes.

▸ **Make graphic formats accessible.** Create easy-to-use templates for every simple chart, graph and sidebar.

▸ **Upgrade your grid.** Some grids—like the 7-column tab format below—force reporters to add extras to their stories (or else you end up with strange-looking holes in the layout).

Ask yourself these questions before you even think about compiling a graphic:

▸ **What's missing from this story?** What will complete the picture for those who read it—or attract readers who might otherwise turn the page?

▸ **What's bogging down the text?** A series of numbers? Details? Dates? Definitions? Comparisons? Can information be pulled out and played up?

▸ **What data needs clarification?** Statistics? Geographical details? History? Does the story overestimate the readers' knowledge?

▸ **How much time and space do we have?** Can we squeeze in a quick list? A small map? Or should we create a huge clip 'n' save poster page?

▸ **What's the point of this sidebar or graphic?** Is there one clear concept we're trying to emphasize—or are we just shoveling a stack of statistics?

COMPILING AND EDITING GRAPHIC DATA

▸ **Collect data carefully.** Use reliable sources, as current as possible. Beware of missing data, estimates or projections; if information is uncertain or unverifiable, you must flag it for your readers.

▸ **Edit carefully.** Every graphic and sidebar *must* be edited. Check all the numbers: totals, percentages, years. Check all spelling and grammar. Check that all details in the sidebar match all details in the text. Finally, check that all wording presents the data fairly and objectively.

▸ **Convert to understandable values.** Avoid kilometers, knots per hour, temperatures in Celsius. Convert foreign currency to U.S. dollars. Avoid any obscure terms, jargon or abbreviations that might confuse or mislead readers.

▸ **Simplify, simplify.** What's your point? Make it absolutely, instantly clear. Depict one concrete, relevant idea—a concept readers can relate to, not something abstract, insignificant or obscure. Avoid clutter by eliminating all nonessential words and information, focusing *tightly* on key points.

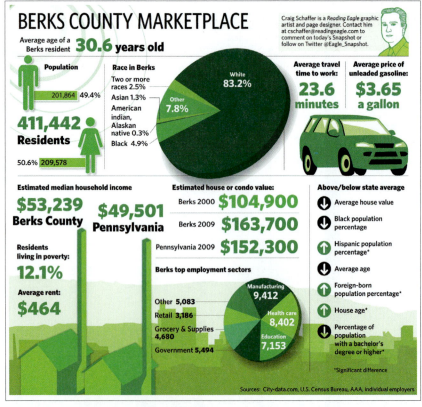

Visual column This graphic is part of a column that runs in the Reading Eagle's business section. Don't assume the reader plans to read the story's text. Your graphics and sidebars should stand on their own.

Graphics guidelines

The 2011–12 School Budget

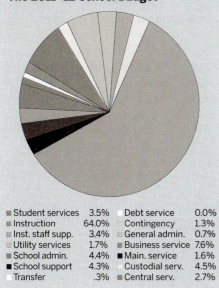

■ Student services	3.5%	□ Debt service	0.0%	
■ Instruction	64.0%	□ Contingency	1.3%	
■ Inst. staff supp.	3.4%	□ General admin.	0.7%	
□ Utility services	1.7%	■ Business service	7.6%	
■ School admin.	4.4%	■ Main. service	1.6%	
■ School support	4.3%	□ Custodial serv.	4.5%	
□ Transfer	.3%	■ Central serv.	2.7%	

Any way you slice it ... What makes this pie chart so confusing? Is it the excessive number of slices? (Exactly how many categories ARE there, anyway?) Is it the way all those stripes and bullets are impossible to tell apart? Is it the use of a separate key to show percentages, rather than labeling or pointing to each individual pie slice? Is it because the sizes of the slices are not accurate?

CONSTRUCTING GOOD GRAPHICS

▶ **Keep it simple.** Make sidebars and graphics look easy to understand or you'll frighten readers away. Pie charts, for instance, are the bottom feeders in the great Graphics Food Chain. Many readers *hate* pie charts. So don't make matters worse; don't slice pies into a dozen pieces (with an unreadable key full of stripes and polka dots) if a few broad categories convey the same idea. Don't cram years and years onto a line chart if only recent trends matter.

Bottom line: Don't overwork a chart. If you want to make several different points, you'll find that several charts are usually better than one.

▶ **Keep it accurate.** As we mentioned before, use trustworthy sources (and print their names in a source line at the bottom of the chart). Double-check their math—then have someone check *your* math when you're done.

When drawing charts, be sure all proportions are true. Slices in a pie chart should be mathematically precise; time units in a line chart should be evenly spaced; bars in bar charts should be accurately proportioned. Some computer programs can help you plot figures with accuracy.

▶ **Label it clearly.** Make sure each significant element—every line, number, circle and bar—is instantly understandable. Add a legend, if necessary. Or write an introductory blurb at the top of the chart to tell readers what they're seeing.

▶ **Visualize it.** Add screens, 3-D effects, photos, illustrations, color—but use them to organize and label the data, *not* just for decoration. Sure, it's fine to use illustrations to tweak readers' attention (as if to say, *This chart is about shipping—see the little boat? Get it?*), but at too many newspapers it's common to junk up graphics with cartoon clutter.

Used carelessly, these special effects distort your information and distract your readers. Used with wit and flair (and keeping it simple), they can make dry statistics fresh and appealing (as in the example below). So proceed with caution.

Simple but effective Million of acres were submerged in water after massive flooding along the Missouri River. To show one dangerous aspect of The Great Flood of 2011, the World-Herald in Omaha created a chart that put into perspective the amount of runoff into the Missouri River. This example clearly shows how keeping it simple helps keep it understandable. Clean and concise type and color palettes are all that are needed here.

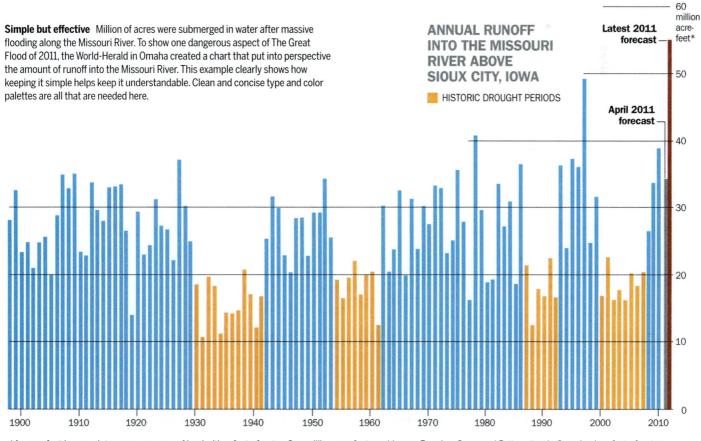

ANNUAL RUNOFF INTO THE MISSOURI RIVER ABOVE SIOUX CITY, IOWA

■ HISTORIC DROUGHT PERIODS

Latest 2011 forecast

April 2011 forecast

60 million acre-feet*

*An acre-foot is enough to cover one acre of land with a foot of water. One million acre-feet would cover Douglas, Sarpy and Pottawattamie Counties in a foot of water.

Graphics guidelines

Troubleshooting

Q How do you know which fonts, colors and point sizes to use for graphics?

You can waste valuable time and energy reinventing the wheel every time you create a chart, graph or map. That's why smart newspapers produce design stylebooks to codify everything from headlines to bylines to bio boxes. (See Page 229 for more on this.)

To produce a useful stylebook, begin by creating textbook examples of every kind of graphic. Then label, as clearly as possible:

▸ Fonts and point sizes for all type.
▸ Screen densities and colors.
▸ Rule styles and thicknesses.
▸ Margins and spacing.
▸ Styles for callouts and arrows.
▸ Guidelines for credits and source attributions.
▸ Styles for any graphic extras (north arrows, map scales, shadows, etc.).

The best stylebooks are teaching tools. They use good and bad examples and convey philosophy. Sure, they can take weeks to assemble—but in the long run, they can save time by reducing deadline confusion. And by showcasing models of successful graphics, your stylebook may actually inspire staffers to produce them more frequently.

Street map

Colors:
■ HIGHLIGHTS
■ PARKS, FORESTS
■ BACKGROUND
■ STREETS
■ HIGHWAYS

STREET NAMES
9 pt. Helvetica Neue Condensed Medium

CALL-OUTS
10 pt. Helvetica Neue Bold Condensed

Detroit Free Press

Spell it out This entry from the Detroit Free Press' graphics stylebook shows how the paper treats type, color and callouts in maps.

TYPOGRAPHY AND LAYOUT

▸ **Develop graphics style guidelines.** You'll save time, avoid confusion and maintain a consistent look if you adopt strict standards for all type sizes, screen densities, source and credit lines, dingbats, etc.

▸ **Give every sidebar or graphic a headline.** Don't force readers to guess what a map or list means. Even a short title ("What They Earn") clarifies your intent. But as mentioned above, use consistent sizes, fonts and treatments.

▸ **Make it readable.** Avoid type smaller than 8 points (except for source or credit lines). Use boldface to highlight key words. Keep all type horizontal (except for rivers or roads on maps). Use rules and careful spacing to keep elements from crowding each other and creating confusion.

▸ **Position graphics as you would a photo.** Generally, small graphics and sidebars are dummied like any other art element:

This 5-column story design uses two graphic elements: a dominant vertical photo and a smaller horizontal tucked into the text.

Here's that same design using a vertical graphic package as lead art, with a sidebar list boxed and dummied atop those legs of text.

Group elements For more ambitious packages, consider running graphics in a row, or *rail*, either down the edge of the main story, along the bottom, or both—as this story package from the Ball State Daily News illustrates.

Graphics gallery

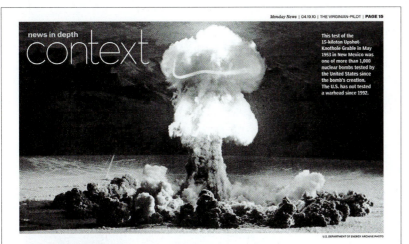

news in depth
context

This test of the 15-kiloton Upshot-Knothole Grable in May 1953 in New Mexico was one of more than 1,000 nuclear bombs tested by the United States since the bomb's creation. The U.S. has not tested a warhead since 1992.

U.S. DEPARTMENT OF ENERGY ARCHIVE PHOTO

BOMBS (GOING) AWAY!

U.S. nuclear arsenal | first of two parts

A RECENT STATE DEPARTMENT REPORT puts the number of U.S. operationally strategic nuclear warheads at 2,246 as of Dec. 31, 2008. The peak was more than 31,000 weapons in 1965. The drop has moved more swiftly recently because of a 2002 U.S.-Russian agreement to reduce nuclear warheads to 1,700-2,200 in each nation by Dec. 31, 2012. Last week's 47-nation nuclear security summit highlighted the threat of nuclear terrorism and yielded commitments to better secure nuclear materials. Here's a look at how the U.S. arsenal arrived at where it is now.

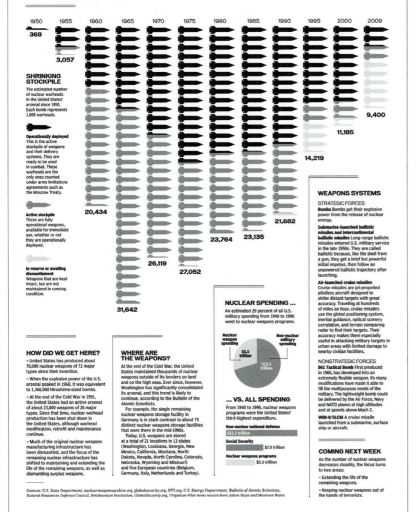

SHRINKING STOCKPILE
The estimated number of nuclear warheads in the United States' arsenal since 1950. Each bomb represents 1,000 warheads.

Operationally deployed
This is the active stockpile of weapons and their delivery systems. They are ready to be used in combat. These warheads are the only ones counted under arms limitations agreements such as the Moscow Treaty.

Active stockpile
These are fully operational weapons, available for immediate use, whether or not they are operationally deployed.

In reserve or awaiting dismantlement
Weapons that are kept intact, but are not maintained in running condition.

Timeline values: 1950: 369 · 1955: 3,057 · 1960: 20,434 · 31,642 · 26,119 · 27,052 · 23,764 · 23,135 · 21,682 · 14,219 · 11,185 · 9,400

WEAPONS SYSTEMS

STRATEGIC FORCES
Bombs Bombs get their explosive power from the release of nuclear energy.

Submarine-launched ballistic missiles and intercontinental ballistic missiles Long-range ballistic missiles entered U.S. military service in the late 1950s. They are called ballistic because, like the shell from a gun, they get a brief but powerful initial impetus, then follow an unpowered ballistic trajectory after launching.

Air-launched cruise missiles Cruise missiles are jet-propelled pilotless aircraft designed to strike distant targets with great accuracy. Traveling at hundreds of miles an hour, cruise missiles use the global positioning system, inertial guidance, optical scenery correlation, and terrain comparing radar to find their targets. Their accuracy makes them especially useful in attacking military targets in urban areas with limited damage to nearby civilian facilities.

NONSTRATEGIC FORCES
B61 Tactical Bomb First produced in 1966, has developed into an extremely flexible weapon. Its many modifications have made it able to fill the multipurpose needs of the military. The lightweight bomb could be delivered by the Air Force, Navy and NATO planes at high altitudes and at speeds above Mach 2.

W80-0/SLCM A cruise missile launched from a submarine, surface ship or aircraft.

HOW DID WE GET HERE?
• United States has produced about 70,000 nuclear weapons of 72 major types since their invention.
• When the explosive power of the U.S. arsenal peaked in 1960, it was equivalent to 1,366,000 Hiroshima-sized bombs.
• At the end of the Cold War in 1991, the United States had an active arsenal of about 23,000 weapons of 26 major types. Since that time, nuclear warhead production has been shut down in the United States, although warhead modification, retrofit and maintenance continue.
• Much of the original nuclear weapons manufacturing infrastructure has been dismantled, and the focus of the remaining nuclear infrastructure has shifted to maintaining and extending the life of the remaining weapons, as well as dismantling surplus weapons.

WHERE ARE THE WEAPONS?
At the end of the Cold War, the United States maintained thousands of nuclear weapons outside of its borders on land and on the high seas. Ever since, however, Washington has significantly consolidated its arsenal, and this trend is likely to continue, according to the Bulletin of the Atomic Scientists.

For example, the single remaining nuclear weapons storage facility in Germany is in stark contrast to about 75 distinct nuclear weapons storage facilities that were there in the mid-1980s.

Today, U.S. weapons are stored at a total of 21 locations in 13 states (Washington, Louisiana, Georgia, New Mexico, California, Montana, North Dakota, Nevada, North Carolina, Colorado, Nebraska, Wyoming and Missouri) and five European countries (Belgium, Germany, Italy, Netherlands and Turkey).

NUCLEAR SPENDING ...
An estimated 29 percent of all U.S. military spending from 1940 to 1996 went to nuclear weapons programs.

Nuclear weapon spending $5.5 trillion
Non-nuclear military spending $13.2 trillion

... VS. ALL SPENDING
From 1940 to 1996, nuclear weapons programs were the United States' third-highest expenditure.

Non-nuclear national defense $13.2 trillion
Social Security $7.9 trillion
Nuclear weapons programs $5.5 trillion

COMING NEXT WEEK
As the number of nuclear weapons decreases steadily, the focus turns to two areas:
• Extending the life of the remaining nuclear weapons.
• Keeping nuclear weapons out of the hands of terrorists.

Sources: U.S. State Department, nuclearweaponarchive.org, globalsecurity.org, NTI.org, U.S. Energy Department, Bulletin of Atomic Scientists, Natural Resources Defense Council, Smithsonian Institution, GlobalSecurity.org, Virginian-Pilot news researchers Jakon Hays and Maureen Watts

Roundup On an inside page, The Virginian-Pilot looks at the nuclear arsenal in the United States and how the numbers have dropped significantly since the peak in 1965. With a timeline, pie chart, pullouts and questions, this page covers the bases—without the inclusion of a long narrative story.

THINK VISUAL When it comes to non-narrative storytelling, it can be overwhelming to know even where to begin. The pages you see here should give you some ideas on how other designers have found fresh, *visual* ways to tell a story.

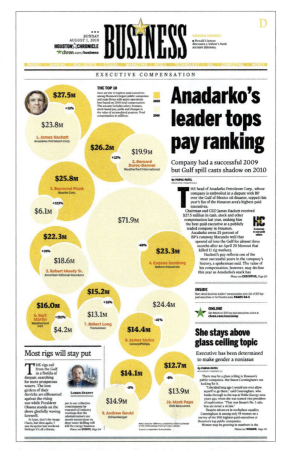

Comparisons This Houston Chronicle business front compares how some of the highest-paid executives in the area fared, compensation-wise, from 2008 to 2009 (darker yellow circles). This visual approach is much more approachable at a glance.

Chunks of info This food section front from the St. Louis Post-Dispatch uses the circle motif in a different way: presented are 20 ways to eat tomatoes. The hand-crafted look adds to the appeal of this page. Note that the story is told —or rather, *shown*—by using only ... chunks of info. Tomato chunks, that is.

Graphics gallery

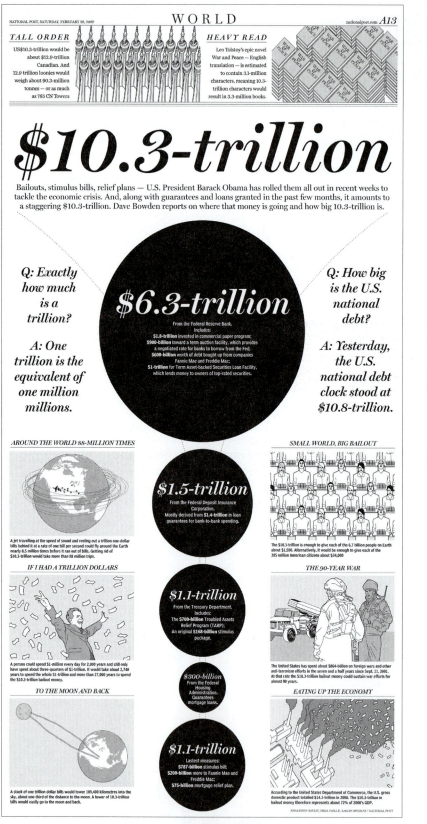

Perspective This Q&A that ran inside the National Post tackles the subject of U.S. debt and puts into perspective the staggering figure of $10.3 trillion. The use of drawings and a sense of scale helps readers get a grasp of what this number means and how it breaks down.

Whimsy and fun In this Thanksgiving holiday centerpiece above, The Columbus Dispatch uses quizzes, a game and a DIY turkey to keep readers engaged. Below, The Dispatch *shows* readers how to build a snowman in a whimsical, eye-catching way.

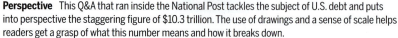

Special effects

There was a time, not too long ago, when all newspaper pages looked serious. Respectable. Gray. Paper was white, ink was black, and everything was locked into rigid gray rows.

Today, that's all changed. Newspapers are livelier than ever. Headlines are red, backgrounds are neon blue and photos run in eye-poppingly true colors. Feature pages look flashy. News pages look flashy. Even *business* pages look flashy. Go figure.

The best designers now pack big bags of graphic tricks. That's partly to make stories more informative, partly to make pages more lively, but mostly to keep up with a world in which *everything* competes for our attention.

Thanks to innovations in computer graphics, design standards keep rising for all informational media. Just watch the news on TV, read some "serious" newsmagazines like Time or Newsweek, or surf the slickest websites. Their presentation is lively; their graphics are zoomy. So if your newspaper insists on being serious, respectable and gray—locking everything into rigid gray rows—you're falling behind the times. You may even be falling *asleep* (along with your readers).

In this chapter, we'll explore graphic techniques that give pages extra energy. These techniques are optional, but with the right combination of taste and technique, special effects like these can find a home on every page in the paper.

CHAPTER CONTENTS

▶ **Bending the rules:**
How some pages go beyond the ordinary to hit new heights...........196

▶ **The Stewart variations:**
Take one photo. One story. One empty page. What are your options for designing a winner?198

▶ **Wraparounds & skews:**
Alternatives to standard text blocks, with guidelines on their use...202

▶ **Photo cutouts:**
How to poke body parts out of photos—or simply run entire images against the white page...204

▶ **Mortises & insets:**
How to handle overlapping blocks of text or visuals.............205

▶ **Screens & reverses:**
What's black and white and gray all over? How screen tints give pages a whole new hue.............206

▶ **Display headlines:**
A look at type trickery that can turn your feature headlines into something dramatic, flashy and splashy....................208

▶ **Display headline guidelines:**
How to use display headlines effectively.......210

▶ **Color:**
Types of color and how the color printing process works.................212

▶ **Adding color to a page:**
How to plan for color.......214

▶ **Color guidelines:**
When color will work and when it won't216

▶ **Printing full color:**
The process of printing in color218

As you have seen, every paper needs clear and consistent rules for its design. But every so often, by bending those rules, you can produce some stylish pages like these. Just how far are you willing to go? Take a closer look at these pages on this spread. Breaking away from newspaper design conventions is what these pages are all about. Just how far, though, can we deviate from "the rules" before it appears that we have no idea what we're doing?

Bending the rules

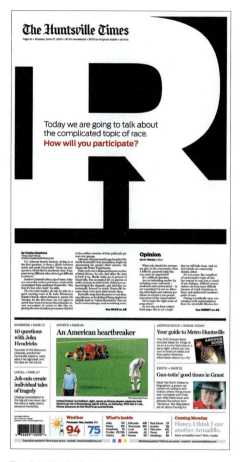

Tough to illustrate How does one visualize the difficult topic of racism accusations within a community? That's what Paul Wallen Jr. asked himself as he brainstormed how to design this front page. Since the story revolves around conversations on the issue, he gravitated toward the oversized "R" and wrote the headline so it was directed toward the reader.

Go big, or go home Sam Hundley, a special projects designer at The Virginian-Pilot, explains the method behind this madness: "My idiotic lark of the 2010 Christmas season: draw 1,001 doodles and design a spread around it. Forty 9X12-inch sheets with 25 ink drawings on each one makes an even 1,000. I planned on taking 20 days to complete this: that's 50 drawings (two sheets) a day, but I finished in 17 days." These two pages wrapped around the front and back sections of the features section of the newspaper.

Many designers—one newspaper. *A newspaper looks consistent on a day-to-day basis because designers stick by the general rules of a stylebook—with typography, color, grids, etc. There are some days, though, when designers decide to break the rules and create something different that will make readers pay more attention, smile more, interact more. But you have to choose those over-the-top days with a journalistic eye, and remember that the content always drives the design.*

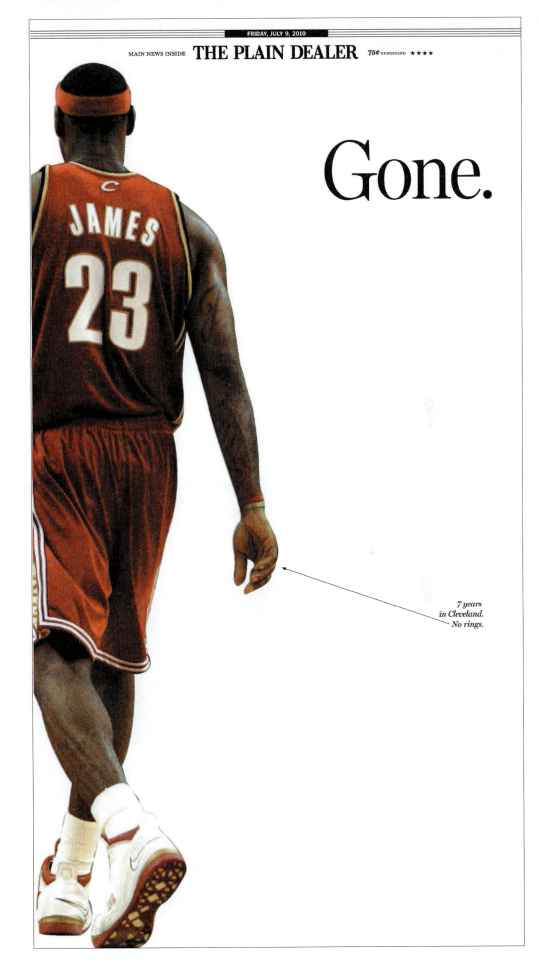

Gone.

*7 years
in Cleveland.
No rings.*

Go big, or go home It was big news in Cleveland—huge news, in fact—when LeBron James decided to leave the Cavaliers and play for the Miami Heat. The Plain Dealer's Design and Graphics Director Michael Tribble and Deputy Design Director for News Emmet Smith put their heads together to come up with this simple concept of James exiting the page—with the sparse, and literal, headline of "Gone." The small words pointing to James' finger read, in almost a whisper: "7 years in Cleveland. No rings." Pulitzer Prize winner Gene Weingarten of The Washington Post called this page "one of the greatest front pages in the history of newspapers." It's on these big news days where doing something drastically different can really work.

The Stewart variations

Newspaper design is a creative craft. And that's especially true on feature pages, where you start with the basic rules of page layout, then nudge and stretch them as far as your time, imagination and sense of taste will allow.

For instance, here's a design exercise on the next few pages that demonstrates the range of options designers can choose from. Suppose you're a designer for this daily Living page. Today's cover will be entirely devoted to one celebrity story, which means you have a lot of space to fill.

Our story is a profile of comedian Jon Stewart, host of the popular TV show "The Daily Show With Jon Stewart." It's a long piece, so you can jump as much text as you like. But there's only one publicity photo available (below, right).

So how will you crop this photo? Arrange the text? Write and display the headline? Take a few minutes to sketch out a solution on your own. After you've done that, take a closer look at 12 Stewart variations over the next few pages.

CAST YOUR VOTE

After studying these dozen Stewart variations, think about what's working and what's not on each page. Which one do you prefer? To help you analyze each option, we've included a scorecard like the one below. Examine each page, then write the grades that seem appropriate.

YOUR OPINION

Headline	B
Photo treatment	C+
Style & flair	A-
Overall appeal	B

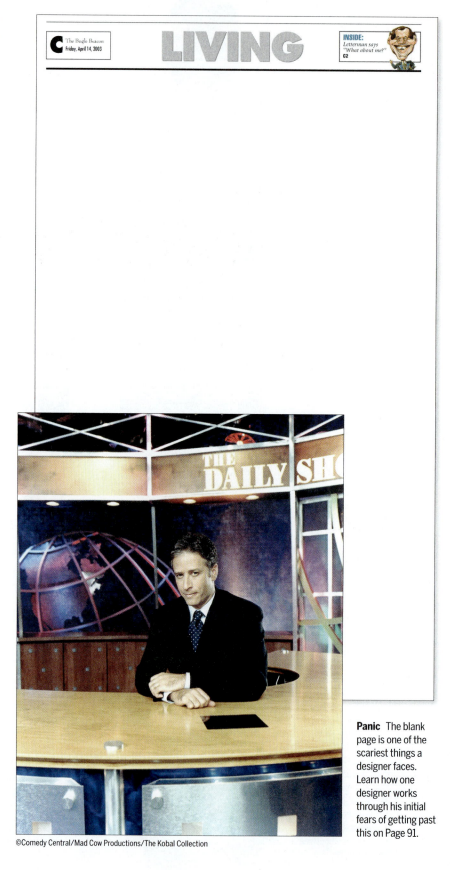

The Bugle Beacon
Friday, April 14, 2003

LIVING

INSIDE:
Letterman says "What about me?"
C2

©Comedy Central/Mad Cow Productions/The Kobal Collection

Panic The blank page is one of the scariest things a designer faces. Learn how one designer works through his initial fears of getting past this on Page 91.

The Stewart variations

①

This no-nonsense news approach simply parks the photo in the top two legs of a 3-column layout. It works, but it's dull. The page is swimming in text. And that banner headline is flat and lifeless—fine for a news story, but too bland for a feature. The good news: This design could be done in a real hurry. The bad news: The page is no fun. There's nothing here to grab readers.

YOUR OPINION

Headline

Photo treatment

Style & flair

Overall appeal

②

We've made the photo more vertical—a more dynamic shape—and anchored it in the middle two legs of a very symmetrical design. We've made the headline bolder and more fun, though it's still a wide horizontal banner. We've indented around two liftout quotes and a reader-friendly TV fact box. Overall, though, the design remains quite conservative and text-heavy.

YOUR OPINION

Headline

Photo treatment

Style & flair

Overall appeal

③

Here, we've decided to try a bolder, more colorful display headline, using all-caps red type with a fuzzy drop shadow. The headline alone transforms the page into a much feistier feature. The photo now fills half the page, too. That would be too big for a typical news page—but is it acceptable for features? All in all, you can see this page is much bolder than the previous two.

YOUR OPINION

Headline

Photo treatment

Style & flair

Overall appeal

④

Let's move the photo back to the middle of the page and try a few more symmetrical designs like the one above. In this example, the headline is centered above the photo and uses color for effect. The photo has been cropped much more tightly, focusing on Stewart's face. Note, too, how we force readers to jump across that photo from one leg to the other: a bad idea, or does it work?

YOUR OPINION

Headline

Photo treatment

Style & flair

Overall appeal

The Stewart variations

5

Here we've moved the headline down, boxing it into the "dead space" in Stewart's chest. Or IS there such a thing as dead space in a photo? (Many photographers and editors would argue that there isn't.) Notice, too, how the text stairsteps down the page as it wraps. Is that awkward? And does the text become too wide at the bottom—or is that OK to do for just a few lines?

YOUR OPINION

Headline

Photo treatment

Style & flair

Overall appeal

6

Placing a headline so far down the page may not work on Page One— but is it OK here? Will it be clear to readers that they should begin reading at the top of the left-hand leg? (That's one good reason to start the story with an initial cap.) Notice, too, that we've cut out the top of Stewart's head. Is that an acceptable treatment for a feature photo? If so, can we cut him out even more?

YOUR OPINION

Headline

Photo treatment

Style & flair

Overall appeal

7

In the previous example, we cut out part of Stewart's head. Now we've cut him out completely. Is that permissible? And how about moving him to the bottom of the page? That can be risky. When you park a big photo below the text, it often looks like an ad or intrudes into other stories. But here, with Stewart's head poking into the text, it anchors the page pretty well.

YOUR OPINION

Headline

Photo treatment

Style & flair

Overall appeal

8

We've tried a few new tricks here: First and foremost, we've carefully cropped and positioned the photo so we'll have room to reverse the headline out of that dark background beside Stewart. Down below, we've placed a box on the photo and inserted text there. Notice how the stylish headline treatment makes this package seem more like something you'd see in a magazine.

YOUR OPINION

Headline

Photo treatment

Style & flair

Overall appeal

9

Let's get conceptual. Since Stewart was celebrating his 10th anniversary when this story came out, why not make more of the number 10? Here, we've built it into the headline AND the sidebars. The first sidebar is a collection of jokes. The second is a guide to Stewart's books and videos. It's always wise to provide readers with useful tools as often as you can.

YOUR OPINION

Headline

Photo treatment

Style & flair

Overall appeal

10

How far are you willing to push those Photoshop effects? We'd argue that Stewart is a comedian—so it's appropriate to bend the rules a bit. But is the headline type too corny? Is the Stewart-popping-out-of-the-TV too wacky? It's a risky design, but one with a more aggressive attitude. And your ultimate goal, remember, is to grab readers and lure them into the story.

YOUR OPINION

Headline

Photo treatment

Style & flair

Overall appeal

11

Here's another design that relies upon a conceptual graphic effect, and it all starts with the word SLANT. Slanting the page is a comic effect—just as Stewart slants the news for comic effect. That's the best argument you could make to convince a reluctant editor to use this treatment: The design is driven by the story's content. It's not just a nutty layout.

YOUR OPINION

Headline

Photo treatment

Style & flair

Overall appeal

12

Here's another treatment that's driven by the story's content. Loyal Jon Stewart fans know he's passionately patriotic even though he's fiercely anti-establishment. (And this aggressive red, white and blue flag-themed design mimics the parodic style he used in his book "America.") But compared to the previous examples, there's not as much text on this page. Is that a problem?

YOUR OPINION

Headline

Photo treatment

Style & flair

Overall appeal

Wraparounds & skews

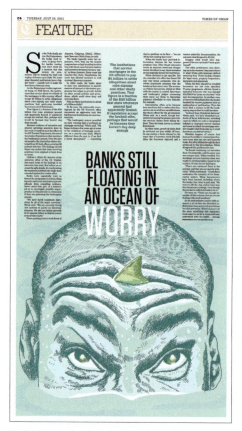

Sort-of wrap Snaking a lot of text around an image can sometimes affect readability. So, instead of creating a straight-up wraparound, look at other options, like we see in the page above. The text here is still modular, but the different leg lengths give it a wraparound feel. The main headline at the bottom of the two middle columns fills the space in an effective way.

As we've previously seen—both in the Stewart variations and in the swipeable feature formats in Chapter 2—text isn't always locked into rigid gray rows. It can, instead, dodge around liftout quotes, flow around photos and indent around logos and bugs. When a column of text does that, it's called a *wraparound.* (Some papers call it a *runaround.* And when it snakes along a jagged piece of art, it's often called a *skew.*)

Wraparounds can be used with a variety of graphic elements:

Mugs Liftout quotes Headlines Art or photos

Until a few years ago, wraparounds were common in books and magazines, but not in newspapers. That's because they required a lot of time, patience and tricky typesetting codes. But with the advent of page-layout software, type wraps have become a graphic gimmick that's useful for both feature stories *and*—when used with taste and restraint—hard news.

Wraparounds add flair and flexibility to story designs in four ways:
▶ They let you place graphic elements in the middle of a layout without disrupting the flow of the text.
▶ They let a story's artwork interact more closely with its words.
▶ They give you the option of breaking away from using all rectangular shapes on the page, so everything doesn't look too boxy.
▶ Best of all, they allow you to run graphic elements at their optimum sizes, rather than wedging everything into rigid column widths.

As you can see here, wraparounds help you use space more efficiently by letting photos and text interact more tightly:

Squared off
In the layout at right, we've cropped to the edge of the photo frame. But unless we crop into the fighter's leg (which wouldn't be a wise move, in this case), we're forced to create a layout that's mostly empty white space (since the background is just that ... mostly empty white space.)

More organic
This layout at left, however, fits two legs of type where only one fit before. How? By treating the photo as a cutout, poking both sides of it into the text. Body copy has now filled in the space where there was once white space (that didn't add to the photo's content).

Wraparounds & skews

◆ When you indent an illustration or photo (or even a pullout) into a column of text, try to run at least three lines of text above and below the indented art (as we do at the top here). If you run less than that, readers may not even see that small amount of text above or below the art (see below).

When a pullout or a pullquote sort of takes over the text next to it (just by it's sheer volume), you need to back off a bit. Pull on your editing cap and rev up your chain saw: It's time to edit, edit, edit. If you find that you simply can't shorten what you hope to pull out of a story, then start looking for something else to extract that will work even when standing alone, like this text does here. So ... are you exhausted yet as you slog through this long, obnoxious pullout? Yeah—thought so. We're exhausted just by writing it. Seriously.

◆ Allow at least a 1-pica gutter between the edges of the art and the text (as we do here).

◆ In most cases, run text at least 6 picas wide (that's our width right here). With really small text, you might get away with 5 picas wide, the text has to be readable—that's the bottom line. But also keep in mind how tiring it is to read a deep, skinny totem pole of text (like you see here). Try to keep the amount of thin, indented legs you use to a minimum. Not only are they more difficult to read, they just look a little weird. (See what we mean?)

GUIDELINES FOR WRAPS AND SKEWS

▶ **Don't overdo it.** Any graphic gimmick will annoy readers if they see it too often, and wraparounds can be *very* gimmicky. That's why big, dramatic wraps are usually reserved for special centerpiece features.

Think of it this way: The text of a story is a road the reader travels; a wraparound is like a pothole in the road. Steering around one pothole is tolerable, but who wants to drive a road that's *loaded* with potholes?

▶ **Anchor the text block** as solidly as you can. Then start poking art into it at carefully spaced intervals. As soon as the art starts overwhelming the text, back off. (Take a look at this page. It uses several wraps—but they're shrewdly positioned along this solid column of text.)

In other words, don't let wraps create chaos. Align the text legs solidly on the page grid *first*, then carefully position skews as appealingly as you can.

▶ **Keep text readable.** Severe indents and sloppy spacing undermine your design (see box at right for details).

▶ **Maintain contrast** between the main text block and the object that's poking into it. As you can see here, the sidebar box at right is screened and set off with a drop shadow—and note how the art in the sidebar acts as a buffer between the sidebar text and this main text block.

▶ **Don't cut out photos** if it damages the image's meaning or integrity. That makes photographers quite angry. (For more on photo cutouts, turn the page.)

▶ **Smooth out your skews** as much as you can. Abrupt jerks in the width of the text are awkward-looking—and can be awkward to read, too.

▶ **Choose sides carefully.** As it turns out, skews on the *right* side are preferable to skews on the *left*. Check out the example at the bottom of the page and judge for yourself.

And finally—as we've stressed many times before—try not to force readers to jump back and forth across any simple or ingenious your layout will get confused, lost or annoyed. Take this example, for instance. the designer, that you're sup- then jump across this image of —but most readers will try to get frustrated, then give up Don't believe it? Go back and as if you're a typical clueless graphic element. No matter how may seem to you, your readers Is it worth the risk? It may seem obvious to me, posed to start reading each line, Zippy the Pinhead to finish it read each column separately, without ever getting this far. read the left leg of text there reader and see how you do.

Here's a block of text with a skew along its *left* edge. It looks appealing, but notice the way your eyeballs keep bouncing back and forth as you finish one line, then search for the beginning of the next one. That gets annoying pretty quickly, and it has the potential to turn readers off.

But when text skews along the *right* edge, as it does here, it's not nearly as difficult to read. Even though each line ends in a different place, your eye always knows exactly where to go to begin the next line. It's like an exaggerated rag right. Skew on the right if you have a choice.

Display headline guidelines

Troubleshooting

Q **Some art directors say you should never use "gimmicky" headline fonts—that you should never deviate from your paper's font palette. Is that right?**

Never say never. It's true that you should avoid spraying fonts willy-nilly around your newspaper. (You should also avoid fonts with silly names like Willy-Nilly.) After all, you don't want your paper looking like a circus poster.

Or do you? Suppose you're running a feature story on clowns, for instance. Which of these headlines is most appropriate?

Top: This junky typeface and the garish colors makes this headline look amateurish and garish.
Middle: A headline like this on a feature page could be just fine, or dull, depending on the context.
Bottom: Circus type? This could pull one's eye away from photos on the page—or it could draw readers in.

Bottom line: Yes, "gimmicky" fonts can look ugly, sloppy and clichéd. But with the right topic and the right style, moving away from your paper's type palette can look fresh and appropriate. It boils down to taste and strong design—*not* which typefaces you use.

D on't overdo it. Sure, noodling around with type is oodles of fun. But don't turn your pages into circus posters. Use restraint. Reserve display headlines for special occasions: big feature stories, special news packages or photo spreads.

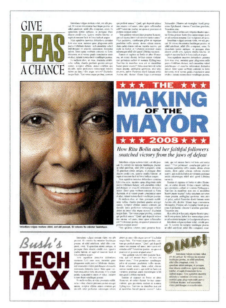

Too much Sure, it's a matter of personal taste. But if you park display headlines in every corner of the page, it'll look like rebel bands of typographers seized control of your newsroom. When you put too much emphasis on decoration, you distract your readers.

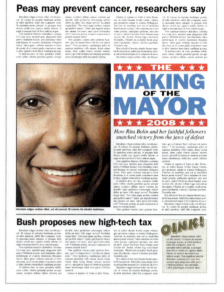

About right Here, we've saved the flashy type for where we need it most: in the lead story and that small feature in the bottom corner. Because the other stories are standard news items, they get standard headlines. This typography helps readers sort the news.

▸ **Match the tone of the story.** Be sensitive to your topic. Use bold, expressive type when it's appropriate—but don't impose it on topics that require more understated, dignified type (below, right).

A disconnect For serious subjects like the one above, it's not a good idea to use playful typefaces in the headlines.

More appropriate The serif typeface like the one above has a more dignified feel to it than what's at left and is a better choice in this case.

▸ **Keep it short and punchy.** To give a display headline maximum impact, build it around one or two key words or a clever, catchy phrase. Think of popular movie titles (*Jaws, Star Wars, Ghostbusters, Snakes on a Plane*) and keep your story titles equally tight. Wide, wordy headlines may be fine for hard news stories—

BABY BUNNIES SPREAD EASTER JOY

—but phrases like that may seem heavy or threatening on feature pages.

So play with the story topic to draw out a short, punchy title. Then play with the phrasing to decide where the graphic emphasis should go.

Display headline guidelines

No. No. No. Too many typographical tricks will instantly brand you as an amateur. Check out the common mistakes beginning designers make, below:

Novelty type Sorry, but some typographic clichés are hopelessly corny. Silly or gimmicky type can instantly make you look like an amateur.

Special effects Tilting, tinting, gradient-screening—a little goes a long way. It's fun to do, but it just adds noise and distraction to the page.

Sharing letters Sharing jumbo letters can be confusing. (SUNDAY CHOOL?) Beginning and ending a word with enlarged caps too often looks clumsy.

Rules and bars The stacks in this headline go on and on and on. Too many rules, bars and words make headlines dense and stripey.

▶ **Grid it off.** That's design jargon for aligning your type neatly into the story design. Wild, ragged words that float in a free-form, artsy way just add clutter and noise. And noise annoys readers. Instead, enlarge, reduce, stretch or stack words so they're solidly organized.

Noncohesive This headline floats too much. It's not anchored. The leading looks awkward and uneven—and worse, none of the words align. It calls too much attention to itself. On a busy page, this headline would just add to the confusion.

Cohesive Each of these headlines is neatly stacked. The top one aligns flush right; the bottom one lines up along both sides. Some words have been resized to ensure a clean fit. Note how in each headline the second line manages to avoid the descender of the "g".

As you manipulate the words, watch for natural breaks in phrasing. Will key words play better wide? Narrow? Centered? Stacked vertically, a headline may work best all caps. And you may want to run a word or line in a different weight or font (be careful, though) for emphasis or variety.

Lowercase As you can see in this feature headline, many lowercase characters don't stack well vertically; the contours of the ascenders and descenders leave uneven gaps that are difficult to fill smoothly.

Lowercase with adjustments The words in this headline flow around the uneven ascenders and descenders. Notice how the "f" and the "y" flow together; notice how the dot of the "i" has been replaced by the word "of."

All caps Above, the key words now use all caps to provide more solid, even contours. Unlike lowercase letters, all caps are even along the top and bottom, so you're really working with words that are shaped like rectangles.

▶ **Go easy on gimmicks.** We've all seen terrific typography on movie posters, beer bottles and CD covers. But those are designed by highly paid professionals. Your daring headlines may look clumsy—or illegible—if you choose goofy fonts, run headlines sideways, create artsy hand-lettering. So beware of gimmicky type. Do you really want readers to think you're a flake?

Color

For decades, newspaper editors stubbornly insisted that color was fine for the Sunday funnies, but *news* pages should be black and white and read all over. But in the '80s, after USA Today launched, newspapers finally realized that color isn't just decoration; it attracts readers as it performs a variety of design functions:

The flag
This cyan tint makes USA Today's logo immediately recognizable. Each of the paper's section fronts is branded with its own color, too: the Sports header is red, Money is green and Life is purple.

Typography
Notice how color is used to make special type elements pop: the red for Wild-card Weekend along the top, the purple, red and black logo for the centerpiece story. Even those bullets on the Newsline briefs are color-coded to each section of the paper.

Photography
Prior to 1980, photojournalism was primarily a black-and-white craft. But at most modern publications, color photos on section fronts are mandatory. Color reproduction is more difficult and expensive, but that cost is offset by the appeal color photos have and the added information they convey.

Illustrations
Newspapers have been colorizing art ever since they started printing the Sunday funnies more than a century ago. On this page, you can see two common uses for color illustrations: creating images for use in graphics (like the woman at right), and producing special logos (the Weekend Edition label above the left rail, for example).

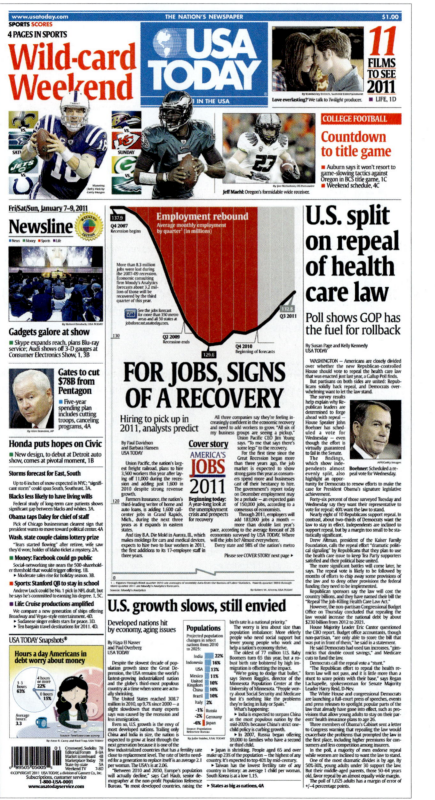

Promos and teasers
Front-page promos have two jobs to do: attract attention and guide readers inside. The best way to attract attention, obviously, is to run lively, compelling color images—especially faces of well-known celebrities. Most newspapers dedicate the top portion of Page One to promos using color photos and color type.

Color screens
Adding a screen to the background of a story is an effective way to give it extra emphasis. Notice how the gray screen gives the lead story just a little more visual emphasis.

Infographics
Charts, graphs and maps rely on screens and rules to separate elements and enhance readability. And adding color makes them even more effective, as you can see in that centerpiece story about employment. Large-scale color infographics can become the centerpiece of a page, particularly when no photos are available. Small, color infographics (like the population chart) provide essential data, as well.

Advertisements
More and more papers now run color ads on Page One. This particular front page doesn't have an ad, but there's surely one on the back page of this section, since sharing color printing positions with advertisers defrays the newsroom cost of color production.

Color

At right is a duotone, a photo that's reproduced using both black and a spot color. As you can see in the enlargement below, the duotone combines different-sized black and blue screened dots to create the blue-gray effect.

SPOT COLOR Ordinarily, printers use just one color of ink: black. But for a little extra money, they'll add a second ink to the press—a *spot color*—to let you print pages in a new hue.

(For even more money, you can add several spot colors to your paper. But unless you can coax an advertiser into sharing the color and footing the bill, you could blow your whole printing budget on a few colorful pages.)

Any single color—green, orange, turquoise, mauve, you name it—can print as a spot color (just check out the Pantone options in your design software). But because readers are so accustomed to basic black and white, any added color has instant, dramatic impact.

So proceed with caution. Some "hot" colors (pink, orange) are more cartoony than "cool" ones (blue, violet)—so choose hues that suit your news. If you do decide you want a little color pizzazz on your pages, think about using *accent* colors. These can be bright, bold, and brash—but also overpowering if used in the wrong places. Used in small doses, though, they won't overpower the rest of the page. Small labels or pullout information, for example, can work quite well with a touch of over-the-top color, such as a fire-engine red, or even pure magenta and cyan.

Spot colors Like basic black, these can print as either solid tones or tints. Here, for instance, are some screen percentages for a spot blue:

10% BLUE	30% BLUE	50% BLUE	100% BLUE

Black You add richness and variety to spot colors by mixing in black:

20% BLUE+ 10% BLACK	100% BLUE+ 30% BLACK

Pastels These work best for background screens, while solid tones are best for borders and type:

THIS IS 100% BLUE / 20% BLACK TYPE OVER A 10% BLUE SCREEN WITH A 100% BLUE BORDER

4-color photo At right is a full color photograph that has been reproduced using all four of the process colors. The image below combines different-sized cyan (blue), magenta (red), yellow and black screened dots to create the effect of full color.

PROCESS OR FULL COLOR But what if you want to print *all* the colors—the whole rainbow? You could add hundreds of separate spot inks, but that would cost a fortune (and you'd need a printing press a mile long). Instead, we can create the effect of full color by mixing these four *process* colors:

CYAN MAGENTA YELLOW BLACK

By layering these four colors in different densities, a printing press can create almost any hue.

Publishing process color costs more—not only for the extra ink, but for the production work that's needed to prepare and print pages. Though desktop-publishing hardware and software have streamlined the process, the end result is still the same: color images must ultimately be separated into those four process colors, then recombined as the presses roll. (See Page 218.)

COLOR TIP Don't use color on jump lines. If you have the opportunity at your paper to make corrections at the end of the night (because your paper puts out more than one edition), chances are that you'll only be able to make changes on the *black* plate. Altering anything on the other, color plates costs extra—and should be avoided.

Process colors These can print as either solid tones or screens. Here, for instance, are the four process colors reproduced as 20 percent screens:

20% CYAN	20% MAGENTA	20% YELLOW	20% BLACK

Values Combining different values of process colors creates new hues:

50% CYAN, 50% YELLOW	10% CYAN, 40% MAGENTA, 50% YELLOW

Pastels These work best for background screens, while solid tones are best for borders and type:

50% CYAN / 100% MAGENTA TYPE OVER A 20% MAGENTA / 30% YELLOW SCREEN WITH A 100% CYAN BORDER

Adding color to a page

Troubleshooting

Q At our newspaper, we mix colors in an unorganized and inconsistent way. How do we develop a handsome, reliable color palette?

Good color doesn't just happen. It takes careful research and patient testing, *on* newsprint and *on* your press. (Remember, there's a world of difference between the colors you see on your computer monitor and the colors your press actually prints on paper.)

Every newspaper needs an official color guideline. To develop it, it's important to test different hues in things like maps, charts and headlines to find an array of colors that truly complement each other while performing every necessary duty.

To develop a color palette of your own, try this approach:

▸ **Get out of your office and into the community.** Look at the colors all around you and take note of the buildings, landmarks, geography, foliage, etc. Miami Beach (sun and palm trees) has a *completely* different color feel than, say, Syracuse, N.Y., (very little sun, and, therefore, no palm trees).

▸ **Get your hands on a Pantone ink book from a printer,** or collect paint chips from your local paint or hardware store to get some ideas.

▸ **Create a working color palette on your computer.** Start by assigning a "job" to every color. Do you have a range of neutrals (grays and tans, for example), accents (maybe deep reds and oranges), cool and warm colors? Remember, you can use tints of these same colors to add variety and visual layering to your palette.

▸ **Be sure your paper's color palette choices are part of the stylebook guidelines.** When too many designers are choosing colors on a whim, the newspaper will look inconsistent. Messy. Unprofessional. A less-is-more approach works best.

"We've got spot purple on this page if we want it."* Ohhhh, what a dangerous temptation that is. What a quick way to turn a nice newspaper into junk mail. Yes, color can be a blessing—or a curse. It can delight your readers or destroy your design. Using color successfully requires tight deadlines. Quality control. Extra money. Extra planning.

So plan for color. Don't treat it like a surprise gift. And above all:

▸ **Go easy.** Resist your initial urge to go overboard. Don't splash color around the page just to get your money's worth. Remember, black and white are colors, too—and newspapers have managed to look handsome for centuries without adding extra inks.

▸ **Don't use color for color's sake.** Remember, it's a news paper. Not the Sunday funnies. If you're deciding whether to run a color photo of circus balloons or a black-and-white photo of a bank holdup, choose the image that's meaningful—not just pretty.

▸ **Beware of colorizing false relationships.** Color creates connections, even where none actually exist. Put a *red* headline, a *red* chart and a *red* ad on the same page, and that tint may unite them all in the reader's mind. That can be misleading (depending upon the layout).

Colors speak to each other. So if you don't want to connect unrelated elements, try not to brand them with the same hue.

▸ **Be consistent.** Don't run a purple flag one day, a green flag the next; blue subheads here, red ones there. Give your pages a consistent graphic identity by standardizing colors wherever they're appropriate. Use the chart below to plan ahead.

Limited palette This feature page at right from The Washington Times demonstrates that color doesn't need to be excessive to be effective. The designer, working with a limited color palette, has carefully balanced the color elements on this page.

WHERE TO ADD SPOT COLOR

THESE WILL USUALLY WORK IN COLOR:*

▸ Illustrations	▸ Photos (full-color only)	▸ Ads
▸ Charts, maps and infographics	▸ Nameplates	▸ Rules, headers and art in classified ads
	▸ Logos and sigs	

THESE WILL OFTEN WORK IN COLOR:*

▸ Display headlines (for big feature stories)	▸ Lift quotes, initial caps (best if used in conjunction with color headlines or color illustrations)	▸ Signposts: teasers, headers, indexes, etc. (but avoid competing with similar colors on the page)
▸ Photo duotones (for special feature stories)	▸ Decorative rules/bars	▸ Boxed subheads within a feature story
▸ Boxed stories/sidebars (light screen tints only)	▸ Borders around photos	

THESE WILL RARELY WORK IN COLOR:*

▸ Photographs (printed with just one spot color)	▸ News headlines	▸ Boxed or screened hard news stories
	▸ Text type/cutlines	

Depending upon your choice of tint, and whether the color creates misleading relationships between unrelated elements on the page.

Adding color to a page

USE RESTRAINT Adding color to a black-and-white page is a tricky thing. Where should it go? How much is too much? For best results, remember that a little goes a long way. It would be unrealistic to dictate where color can or cannot be used—but as these examples show, some choices generally succeed more than others:

Basic black It may be gray, but it's not dull: By combining a variety of rules, bars and graphic elements, it presents an attractive mix of contrasts. It doesn't need extra decoration; any color we add should probably be functional, not decorative.

Ad colors In the race to add color to this page, the advertiser got there first. And since that red ad is so distinctive and loud, any red we add to the news design may seem related to that ad. That's a problem. To maintain a distinction between news and advertising, you can choose to use a minimum of editorial color. Here, we've applied red only to the header—and we've added 20 percent black to it, to give it a hue that's different from that ad.

Spot color Without color in that ad, we're free to colorize our editorial layout. Still, we've used restraint. We've applied spot color for organization, not just decoration. Red bars in the header and news briefs help anchor the layout; red bars in the bar graph make the information easily discernible. And the lead photo is now a duotone—permissible because it's a feature photo, not hard news.

Gratuitous color We've made some poor choices here—and now the page looks silly. Pink screens taint the credibility of the news. Red headlines and liftout quotes lose integrity. Red rules and boxes distract readers, calling attention to unimportant design elements. And that red photo? It shows how poorly photos print using only process color. The page is weak—and worse, those colorized news elements all seem related, somehow, to Mike's Bikes.

Color guidelines

Patriotic This Fourth of July trivia page on the right was done on the run: The designer had no art, no budget and no time to play. But this clever solution uses only type and few colors to turn a functional layout into a patriotic pattern. The red, white and blue colors instantly communicate the theme of the story.

Cliché This page suffers from poor color choices. Green and purple —not a very popular color combo—are run as solid tones, and the lack of contrast makes the headline tough to read. The color green was probably meant to suggest money (see the dollar sign in the headline?), but the overall effect is not working very well at all.

This is 10-point type over a 100% cyan screen. Because the background tint is so intense, the type is hard to read.

This is 10-point type over a 10% cyan screen. Because the background tint is pale, the type is easy to read.

This is 10-point type over a 10% magenta/ 15% yellow screen. Because the color is pastel, the type is easy to read.

This is 10-point type over a 60% cyan / 60% magenta screen. Because the type is reversed and bold, it's easy to read.

COLOR SMARTS Like typography, color will completely set the tone of a page—and the entire publication. The choice of colors must be handled with great thought and care. For information on how to choose a color palette, see Page 214.

▶ **Use appropriate colors.** Colorize pages the way you'd decorate your living room. And unless you live in a circus tent, that means choosing comfortable hues (blue and tan, for instance) more often than harsh ones (pinks or bright greens). The integrity of a news story will be damaged if wacky colors surround it, and the impact of a page will be negative if readers are turned off by your color choices.

Colors convey moods. "Hot" colors (red, yellow) are aggressive. "Cool" colors (blue, gray) are more relaxing. So make sure your colors produce the effect you want. And remember, too, that certain color combinations have unshakable associations. For example:

Red = blood, Valentine's Day.

Green = money, St. Patrick's Day.

Red + green = Christmas, Mexico.

Brown = Uh, let's just say a stinky brown can flush away a solid page design.

Like it or not, these color clichés are lodged in your readers' brains. So make these colors work for you—not against you.

▶ **Keep background screens as neutral and light as possible.** When we examined background tints back on Page 207, we saw how difficult it is to read text that's buried beneath a dark screen. Well, it's a problem whether the background is black, blue, brown or any dark color. Whenever you run text in a sidebar, chart or map, keep all underlying screens as light as you can. (These will usually be below 20 percent, but actual numbers vary from press to press. Check with your printer to see what the lightest printable percentages are.)

If you must add type to a dark screen, reverse it in a font that's big or bold enough to remain readable even if the printing registration is poor.

Color guidelines

In register This color photo printed correctly. The color inks are properly balanced, so the colors are rich and true. The four color plates are properly aligned, so the image is crisp and well-focused.

Out of register This photo reveals the dangers of poor color production. The inks look washed out and badly balanced. And because the four plates are so far out of alignment, the image looks fuzzy — barely legible. If your color printing looks like this, you're better off using black and white.

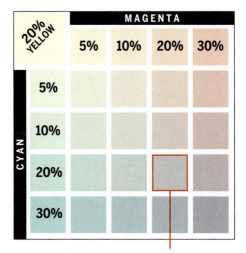

Color chart This shows how process inks look when they're combined. This portion of a chart, for instance, shows the tints you get when you add magenta and cyan to 20 percent yellow. The box highlighted above shows the tint that results from mixing 20 percent yellow, 20 percent magenta and 20 percent cyan.

▶ **Don't overreach your technology.** Color production is difficult to do well. It's costly. It's time-consuming. And in the hands of a sloppy printer, it's extremely disappointing. So it pays to learn your limits.

Illustrations that look gorgeous on a computer monitor often turn to mud on newsprint. Color photos look worse than black-and-whites when the inking is poor or the registration is off (i.e., the color plates print out of alignment, as you see at left).

So use color conservatively until you're certain of the results you'll get. And beware of small, detailed graphics or headlines that demand perfect color registration to succeed—or you'll face legibility problems like this:

THIS HEADLINE REGISTERS THIS HEADLINE DOESN'T

▶ **Watch the volume level of your colors.** Want your page to look like a Hawaiian shirt? That's what'll happen if you use too many solid tones or too many different colors. So go easy when you colorize. Use bold, vivid colors for accent only, in key locations (drawings, feature headlines, reverse bars). Elsewhere, for contrast, use lighter screens or pastel blends. And if you're designing with full color, try color schemes that accent one or two hues—not the whole rainbow.

Decorative colors are like decorative typefaces. In small doses, they attract; in large doses, they distract.

▶ **Consult a color chart before you create new colors.** Some papers fail to mix colors and end up running all their color effects in basic blue, red and yellow. As a result, they look like a comics section: loud and unsophisticated.

But suppose you want to beef up your blue by adding a little black to it. How much black should you add? Ten percent? Fifty percent? Or suppose you want to mix magenta and yellow to make orange. Should you simply guess at the right recipe— say, 20 percent magenta + 50 percent yellow?

Don't guess. Don't trust what you see on a computer monitor, either—a lot can change between your computer and the pressroom. Instead, ask your printer to give you a color chart (lower left), which shows how every color combination looks when printed. You can even create your own chart—but be sure it's printed on the same paper your newspaper uses, so all your hues are true.

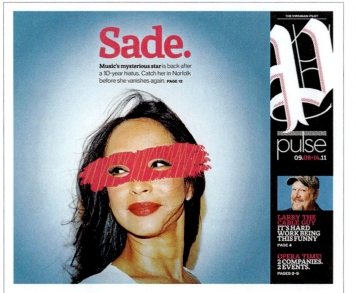

Accent On this page from The Virginian-Pilot, the designer created a playful effect by sketching a magenta mask over the subject's face, then using the same bright color in the main headline. For this entertainment section front, the vivid use of this color works well.

Printing full color

How do you print full-color art and headlines using just four different-color inks? The technology is complex, but the process is simple. Here's how it works for a typical color image:

ORIGINAL IMAGE

Step one: The artist draws this color illustration on a computer using an illustration program. As she draws, she creates customized colors in the software's color palette and evaluates the results on her color monitor. (If she's smart, she calibrates her monitor so the colors on her screen match the colors as they will actually print.) When she finishes drawing, she'll transmit this image as a digital file. If this were a drawing on paper, it would need to be separated into process colors by a digital scanner, which uses color filters to digitize the image so it can be printed.

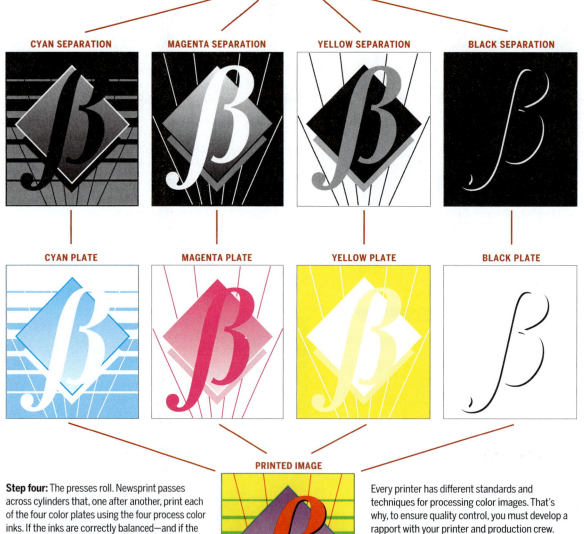

CYAN SEPARATION MAGENTA SEPARATION YELLOW SEPARATION BLACK SEPARATION

Step two:
The image is output to a high-resolution printer called a typesetter (or imagesetter). The typesetter separates the image into the four process colors, producing film negatives, called "separations," for each color using only black lines and dots.

CYAN PLATE MAGENTA PLATE YELLOW PLATE BLACK PLATE

Step three:
Those four different color separations must now be copied again, reproduced onto flat, flexible plates for the printing press—one for each color of ink. When the press starts to roll, each color plate will print the images shown here on the right.

PRINTED IMAGE

Step four: The presses roll. Newsprint passes across cylinders that, one after another, print each of the four color plates using the four process color inks. If the inks are correctly balanced—and if the newsprint is properly aligned as it passes through the press—then the colors will be accurate and the image will be sharply focused, or "registered." And only examination under a magnifying glass will show how dots of those four process-color inks create the illusion of full color.

Every printer has different standards and techniques for processing color images. That's why, to ensure quality control, you must develop a rapport with your printer and production crew.

Redesigns

S ooner or later, your paper will need new logos. A special themed page. A new section. A major typographic face-lift. Or a complete organizational overhaul.

So where will you begin? Where will you find ideas? How will you know what needs changing? How will you decide on the best typefaces and formats? And more importantly, *who* will decide? Will it be up to the designer? The editor? A redesign committee? The readers?

Long ago, newspapers never worried about these things. They'd go years—*decades*—without upgrading any of their design components. It didn't matter to the subscribers, so it didn't matter to the editors, either.

But in today's competitive marketplace, every product must remain as fresh as possible. That's why cars are redesigned every year. Department stores redecorate every five years. And many magazines get cosmetic makeovers every three or four years.

It's essential for newspapers to regularly reinvent themselves, too. And though any redesign project can seem overwhelming at first, here's a chapter of advice and inspiration to help things run smoothly.

CHAPTER CONTENTS

▶ **Redesigning your newspaper:**
What IS a redesign? Here are some steps to doing one successfully 220

▶ **Evaluating your newspaper:**
The newspaper design report card—a way to identify your strengths and weaknesses 222

▶ **Gathering examples:**
Borrowing design ideas from America's best-designed papers 224

▶ **Compiling a shopping list:**
A checklist to help you decide which design components you'll repair or replace 225

▶ **Building prototypes:**
Tips on building sample pages that test your redesign ideas 226

▶ **Testing & promotion:**
Learning how your readers feel—and showing them what you're up to 228

▶ **Writing a stylebook:**
Codifying the styles and formats for your paper's design elements 229

▶ **Launching & following up:**
Refining your new look once it's in place 230

▶ **Redesign gallery:**
A before-and-after study of three papers 231

LIVERPOOL JOHN MOORES UNIVERSITY
LEARNING SERVICES

What do we mean by a *redesign*? For newspapers, this could mean anything from advanced tweaking to a complete overhaul. Let's take a before-and-after look at a number of papers that have reworked their typography, grid and design philosophies.

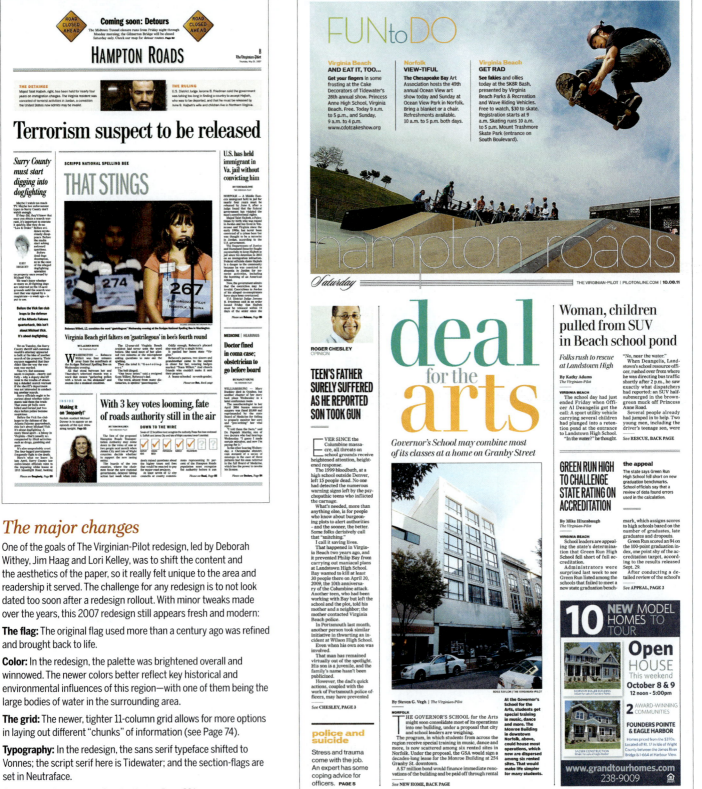

The major changes

One of the goals of The Virginian-Pilot redesign, led by Deborah Withey, Jim Haag and Lori Kelley, was to shift the content and the aesthetics of the paper, so it really felt unique to the area and readership it served. The challenge for any redesign is to not look dated too soon after a redesign rollout. With minor tweaks made over the years, this 2007 redesign still appears fresh and modern:

The flag: The original flag used more than a century ago was refined and brought back to life.

Color: In the redesign, the palette was brightened overall and winnowed. The newer colors better reflect key historical and environmental influences of this region—with one of them being the large bodies of water in the surrounding area.

The grid: The newer, tighter 11-column grid allows for more options in laying out different "chunks" of information (see Page 74).

Typography: In the redesign, the sans serif typeface shifted to Vonnes; the script serif here is Tidewater; and the section-flags are set in Neutraface.

See more redesign examples starting on Page 231.

Redesigning your newspaper

The late '80s The Oregonian had been stodgy for decades—and this redesign pushed as far as the back-then editors would allow. The flag was retooled. A column of briefs ran down the page every day. Summary decks were introduced. (The headlines and decks had to use Helvetica; the publisher was afraid readers would object to any newer font.)

The mid-'90s This redesign adds the energy that was missing before. The flag is engaging and bold, with colorful promos (and an emphasis on the THURSDAY). An 11-column grid helps organize the increased graphic traffic. And the headlines have become Franklin Gothic Condensed—still bold but definitely an improvement over the clunkier Helvetica used on the page at left.

2000 This redesign was driven by a change in paper size. Like many papers, The Oregonian reduced its width by an inch to save newsprint. Its new editor wanted a more classic, dignified, elegant feel, which is reflected in the Minion headlines, italic decks, wider gutters and reduced number of graphics and promos. This day's page design offers a classic symmetry.

Revamping your bylines? Ah, that's easy. Jazzing up your liftout quotes? No problem—that's fun. But launching a bigger project, where you overhaul a page, a section or *an entire newspaper,* is sometimes a perilous journey populated with panicky publishers, stubborn staffers and hypercritical readers.

Nobody likes change. But every newspaper needs to reinvent itself regularly. And if you can proceed in an organized manner, you can spare everybody (your staff *and* your readers) unnecessary grief.

You've just spent the last couple of hundred pages learning how to assemble a newspaper. Now, in the pages ahead, we'll show you how to take a newspaper apart—and how to piece it together again—as we walk you through the basic steps to a newspaper redesign:

▸ **Evaluate your newspaper** to identify your strengths and weaknesses.

▸ **Gather examples** of other newspapers to provide ideas and inspiration.

▸ **Make a shopping list** of elements you need to change.

▸ **Build prototypes** that explore a variety of design alternatives.

▸ **Test it** by showing it to staffers or readers and assessing their reactions.

▸ **Promote it** with ads or stories that explain the changes to your readers.

▸ **Write a stylebook** that contains detailed guidelines for all the changes.

▸ **Launch it.** *Gulp!* Good luck!

▸ **Follow through** with critiques, discussions and design feedback.

◂ **2011** More than a decade later, the paper is even narrower. The flag has been streamlined with simpler promos to inside stories. The stories are presented in a clean, no-nonsense way.

Evaluating your newspaper

Every newspaper is unique—and so is every newspaper staff. Some excel in photography. Some write award-winning stories. Some create graphic wizardry. So how would you assess *your* staff? Before tinkering with your format, take inventory. Make sure your staff agrees on what's working, what's broken and where a redesign should take you. This do-it-yourself design checkup will help you itemize your newspaper's strengths and weaknesses.

NEWSPAPER DESIGN

REPORT CARD

Answer each question by marking the corresponding box **yes** (worth two points), **somewhat** (worth one point) or **no** (zero points). You can earn up to 10 points per category or 100 points overall.

		no (0 pts.)	somewhat (1 pt.)	yes (2 pts.)	score/comments
Headlines and type	Do news headlines intrigue, inform and invite readers in?	☐	☐	☐	
	Do feature headlines project a friendly, appealing personality?	☐	☐	☐	
	Do decks summarize and sell stories to readers in a hurry?	☐	☐	☐	
	Do headlines and text use an effective mix of styles and weights?	☐	☐	☐	
	Are all typographic details consistent and professional-looking?	☐	☐	☐	
Photographs	Are photos active and engaging (rather than dull and passive)?	☐	☐	☐	
	Are images cropped, sized and positioned effectively?	☐	☐	☐	
	Are photos sharp and well-composed?	☐	☐	☐	
	Are key photos in color — and is the color well-balanced?	☐	☐	☐	
	Do enough photos appear throughout the entire paper?	☐	☐	☐	
Graphics and artwork	Do maps, charts and diagrams supplement text where necessary?	☐	☐	☐	
	Is graphic data meaningful, accurate and understandable?	☐	☐	☐	
	Are sidebars and agate material typographically well-crafted?	☐	☐	☐	
	Is artwork polished and professional-looking?	☐	☐	☐	
	Is there witty/provocative art on the opinion page?	☐	☐	☐	
Special page designs	Are special pages active, attractive and well-balanced?	☐	☐	☐	
	Are display elements — art and type — given bold treatment?	☐	☐	☐	
	Are headers and logos polished and eye-catching?	☐	☐	☐	
	Is color used effectively in photos, graphics, standing elements?	☐	☐	☐	
	Do themed pages use distinctive packaging, formats or grids?	☐	☐	☐	
Inside pages	Is the content organized in a logical and consistent way?	☐	☐	☐	
	Do layouts use modular shapes with strong dominant elements?	☐	☐	☐	
	Is there a mix of briefs and analysis throughout the paper?	☐	☐	☐	
	Is each page's contents labeled with a consistent header style?	☐	☐	☐	
	Are jumped stories well-labeled and easy to find?	☐	☐	☐	

O n
c
p
optional. '

WHICH

Headli

All the "big
must be l
readable.
all text el
be easily
another—
want leave
something

Design

Through a
spacing ar
can keep t
page highl

Conter

The orderi
important
want ease
their news
find thing:

Other

NEWSPAPER DESIGN
REPORT CARD

Answer each question by marking the corresponding box **yes** (worth two points), **somewhat** (worth one point) or **no** (zero points). You can earn up to 10 points per category or 100 points overall.

no (0 pts.) · somewhat (1 pt.) · yes (2 pts.) · score / comments

Category	Question	no	somewhat	yes	score/comments
The basic fixtures	Are liftout quotes used often and effectively?	☐	☐	☐	
	Are margins and spacing uniform and appropriate?	☐	☐	☐	
	Are column logos and sigs attractive, helpful and consistent?	☐	☐	☐	
	Do rules, boxes and screens effectively organize material?	☐	☐	☐	
	Are bylines and jump lines well-designed and -positioned?	☐	☐	☐	
Volume and variety	Does the front page cover an interesting variety of topics?	☐	☐	☐	
	Have major stories been packaged with short, effective sidebars?	☐	☐	☐	
	Do key pages highlight special topics of high reader interest?	☐	☐	☐	
	Is there an appealing mix of live news and regular features?	☐	☐	☐	
	Do stories appeal to a broad range of tastes and temperaments?	☐	☐	☐	
Ads and newspaper promotions	Do front-page promos catch the reader's eye in a lively way?	☐	☐	☐	
	Did you offer any contests or giveaways? Sponsor any events?	☐	☐	☐	
	Is your Web address easy to find?	☐	☐	☐	
	Are ads well-designed? Arranged in neat, unobtrusive stacks?	☐	☐	☐	
	Have you given readers reasons to anticipate your next issue?	☐	☐	☐	
User-friendliness	Is there a complete index in a consistent, obvious spot?	☐	☐	☐	
	Are some stories interactive (quizzes, tips, Q&A's, checklists)?	☐	☐	☐	
	Do you run complete calendars (for meetings, sports, events)?	☐	☐	☐	
	Is it clear how to reach key staffers (by phone, fax, letter, e-mail)?	☐	☐	☐	
	Do you solicit reader input throughout the newspaper?	☐	☐	☐	
Personality	Does your paper's personality match that of its target audience?	☐	☐	☐	
	Are regular columnists given mug shots? Anchored consistently?	☐	☐	☐	
	Is the paper's flag distinctive and sophisticated?	☐	☐	☐	
	Are there any surprises on Page One?	☐	☐	☐	
	Will anything in today's paper incite reactions from readers?	☐	☐	☐	

THE GRADING SCALE

90-100: Outstanding! A top-notch publication.

70-89: Good, but could still use new ideas and improvements.

50-69: Average—possibly dull. Time to think about a redesign.

Below 50: Sorry, but you're behind the times. Your readers are probably bored. You need to consider a major overhaul.

YOUR TOTAL SCORE →

Testing & promotion

Troubleshooting

Q We can't afford to hire researchers to conduct focus groups or mail surveys. Are there cheaper alternatives?

Sure. You can always mail out your own questionnaires, host round-table chats with readers, even stop people on the street to ask why they just grabbed a paper. But remember, the more informal your methods, the less accurate your results.

Here's an intriguing idea for an unscientific yet revealing reader survey: Recruit five to 10 ordinary readers. Ask them to look at the next few editions of your paper, and circle with a felt-tip pen what they *actually read* (see example, below). It may be just a headline. Just a photo caption. Or just the first two paragraphs of a story. (By reading, we mean "paying meaningful attention to." If someone glances at a headline about Bosnian import quotas, then glances away, that wouldn't qualify as actual *reading*.) And when they're done, have them return the complete papers to you.

What will you learn? You may find that certain types of stories are extremely popular—or universally ignored. You may detect demographic trends (do older readers read one way, younger readers another?). You may discover that few readers last more than three inches into any story—yet they're attracted to side-bars and briefs.

Remember, this survey isn't flawless. But at the very least, posting these marked-up pages on your newsroom wall is a great way to stimulate discussion and kick off brainstorming.

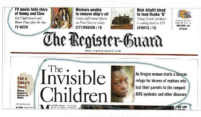

Mark it up Ask a handful of readers to indicate what they pay attention to in your newspaper.

Testing A behind-the-scenes look at a focus-group discussion in Seattle. Participants are often unsure exactly what's being tested—or who might be sitting behind that one-way mirror, watching them react to page prototypes.

Think you know what your readers want to read? The kinds of graphics and colors they prefer? The news they actually *use*?

Well, you can guess (which most editors think they're pretty good at), or you can ask your readers directly. And a redesign gives you a perfect opportunity to watch real readers react to your work.

Professional researchers probe public opinion in two ways:

▸ **Reader surveys:** Most publications research reader habits through surveys conducted over the phone, posted online or printed in the paper. If you're testing a new design, you can distribute a prototype first, then follow up with a questionnaire (*"What changes have you noticed?" ..."Is it better than what you're getting now?"..."Do you like THIS comic?"...*).

▸ **Focus groups:** These may not be as statistically accurate as large-scale reader surveys, but they let you gauge readers' opinions and emotions in ways that surveys can't. Focus groups allow you to watch readers interact with the paper, whether you're observing participants through a one-way mirror—in an attempt to keep the process as objective as possible—or engaging them in an informal roundtable discussion.

MOUNTING A PROMOTIONAL CAMPAIGN

Any time you monkey with your newspaper—adding new features, deleting or relocating old ones—you've got to let your readers know. After all, it's *their* paper. And since they'll have opinions about you everything you do, you might as well try to drum up some enthusiasm (or at least convince them that you know what you're doing). Whether you're a big daily or a student monthly, your audience consists of these three groups:

▸ **Loyal readers:** They're your faithful followers, and they're intimately familiar with your newspaper. So if you make sudden changes, they'll feel confused or betrayed if you don't clue them in ahead of time.

▸ **Occasional readers:** They know who you are, and they know what they need from you. They may frequently grab you for some specific reason (sports scores, classified ads, movie times). But they might read you more often if you convince them it's worth it.

▸ **Non-readers:** Maybe they're not interested in you. Maybe they don't like you. Or maybe they just don't know about you. With the right ad campaign, however, you could win them over.

So how will you sell your redesign to each of these three groups? If you promote your new look—and explain it in ads like the one on the next page—you'll generate a buzz among readers and non-readers alike.

Writing a stylebook

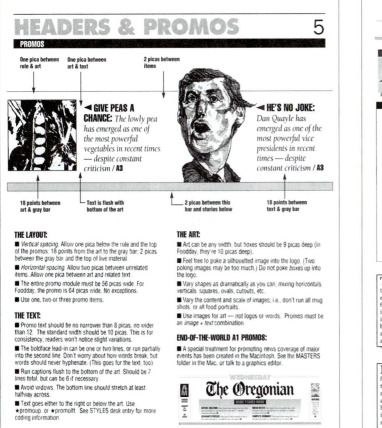

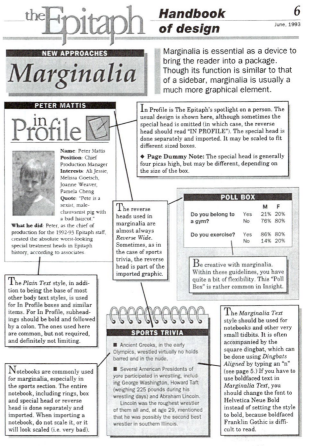

Breaking it down This sample page from The Oregonian design stylebook explains how to produce the daily promos on Page One. Note the detailed guidelines for sizing the art, positioning the text, spacing each element. Fine-tuning these details in advance can help goof-proof any newspaper.

Being clear Back in the 1990s, The Epitaph in Cupertino, Calif., unveiled one of the most innovative designs of any high school newspaper. Their 11-page stylebook codified all major components of the design, from decks and dingbats to the marginalia on the Sports page explained here.

Explaining the changes When rolling out a redesign, editors often inform their readers so that they're not blindsided the next time they pick up their newspaper. For one of its redesigns, The Oregonian opted to run a splashy full-page promotional ad, which included highlights of the changes and coupons along the bottom to entice readers to check out the paper.

You've just redesigned your newspaper. It's perfect. Gorgeous. A newspaper *the very angels in heaven read one unto another.*

It could happen.

But what becomes of all those complicated headline codes and logo formats if you get hit by a bus? How will other staffers figure out how to make all those logos, bylines, liftout quotes and pie charts look as gorgeous as you did?

Answer: Create a design stylebook.

If you're a reporter or editor, you're probably familiar with writers' stylebooks, those journalistic bibles that prescribe when to capitalize words like *president* or abbreviate words like *avenue.* Newspapers need design stylebooks, too, to itemize the do's and don'ts of their designs, to catalog all the tools in their typographic toolbox.

Stylebooks aren't intended to stifle creativity. They're meant to save time, so that staffers on deadline don't waste energy wondering, "How dark is that screen in our logos?" or "Are we allowed to use comic sans in headlines?"

The best stylebooks are detailed and complete, like those shown above. As you proceed through the redesign process, create a stylebook entry for each new format that explains where it goes, when it's used, how it's coded, where it's stored—whatever answers designers will seek in the future.

Redesign gallery

TIMES-NEWS, TWIN FALLS, IDAHO This 17,500-circulation newspaper underwent a significant redesign, which included changing the flag—a daring move, since the paper's nameplate plays such a strong role in the branding of the publication.

The major changes

This redesign, by Josh Awtry and Colin D. Smith, was created with flexibility in mind. "We reduced the spectrum of choices to what matters: content," says Smith.

The flag: To keep visual clutter to a minimum, black was the choice for the reversed flag (20 percent cyan and 100 percent black).

Typography: The serif display typeface was Quiosco. The new typeface families: Chronicle Display (serif) and Archer (sans serif).

Color: The introduction of a single accent color—a deep reddish-orange—adds pop where readers least expect it: in the subheads, labels and some pullouts. Because of reproduction concerns, this accent color was created by using just two color plates.

Redesign gallery

The redesign went beyond the front page—every section, including those inside—were scrutinized and in some cases, reorganized. One priority was to create a stand-alone four-page Nation & World section, which meant the entire front part of the paper could focus more on local and regional news.

The grid: The grid used to be 5 columns on section fronts. With the redesign, and narrower page widths, this changed to a 9-column grid to allow for the option of using single-column elements that are still legible. The addition of extra space between stories replaces vertical rules, which helps to simplify pages overall. Because of ad sizes, inside pages remain on a 6-column grid.

The elements: In the redesign, Awtry and Smith used what they called "fold-outs." (Smith describes this as a sort of "visual origami.") Labels and overlines, for example, were folded over rules, and section folios had elements folding both over and beneath them. All this introduced a more kinetic, visually-layered approach.

Photography: There's much more emphasis on showcasing photographs, especially on the Nation & World section front. In other parts of the paper, photos are played well, to push the local angle.

Inside pages: The inside pages are as carefully crafted as the section fronts. The key, says Smith, was to make all design elements as standard as possible, so that whatever choices the designers made on a page, it was visually appealing. Note the use of black and gray bars, and the screened box in the lower left-hand corner: these small touches, along with the varying contrast in headlines, help add more visual depth to the page.

Content: "We used the redesign as an impetus to launch real content changes," Awtry says. "The design made it easier to do big stories well, and helped align the newsroom in thinking of the front page not one as made of a lead story and a centerpiece, but one geared toward magazine-style "cover stories" that were issue-oriented and enterprise-focused."

Redesign gallery

INDIANA DAILY STUDENT, BLOOMINGTON, IND. The staff of this free, independent and mass-circulated student newspaper shook things up and gave every aspect of this paper a bold, fresh look—during a time when the paper was converting to a narrower web width on the press.

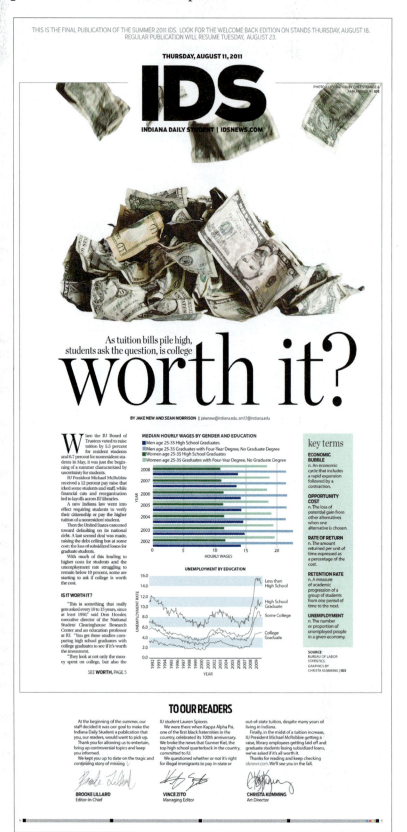

The major changes

This redesign, led by Indiana University student Danielle Rindler, is a clear example of how a paper can move beyond a more conventional style and try something altogether new:

The flag: Flexibility was a big part of changing the nameplate. The new format allows designers to incorporate more alternative story forms and teasers higher up on the page. Also, the more modern and bold nameplate appeals to more college readers.

Typography: "Before" typefaces: Retina, Benton Modern and Times New Roman (body copy). "After" typefaces: condensed versions of Boomer, Chronicle Display, Minion Pro and Utopia (body copy).

Color: To ensure consistency from semester to semester, the color palette was tightened and included crimson and cream (the school colors), as well as light blue, dark blue, gold and brown.

The page grid: Before the redesign, the entire paper was designed on a 6-column grid. Since ad stacks are based on this grid, that structure stayed the same for inside pages. An inch of width was lost after the redesign, and 6 columns proved to be too narrow for the front page and section fronts. Those particular pages are now designed on a 5-column grid.

Appendix

On the fast track

CONTENTS

▶ **Exercise answers:**
Answers to questions
in this book about the
fundamentals, story design,
page design, and photos
and art............................236

▶ **Glossary:**
A comprehensive list
of terms relevant to
design, technology
and technique................ 248

▶ **Index**254

▶ **Acknowledgments:**
Essential components
(headlines, text, photos,
cutlines) used to
build pages259

▶ **Credits:**
Designers, graphic artists,
photographers whose
work appears in this
book, and their respective
publications....................260

Think you've got the basics under your belt? Find the answers to the exercises in this book and see just how much you've learned and what you have to work on.

Feel free to flip through the glossary terms to refresh your lingo. Before you know it, you'll feel right at home stepping into any newsroom, any time, ready to design any page.

You can find the questions for these answers on Page 42

1 What you see here is a 72-point headline. Remember, you measure type from the top of an ascender to the bottom of a descender—and even that measurement may not always correspond to the exact point size.

2

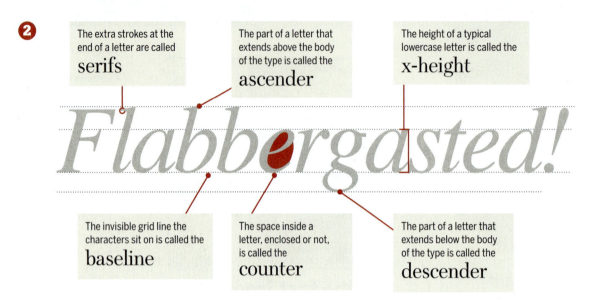

The extra strokes at the end of a letter are called
serifs

The part of a letter that extends above the body of the type is called the
ascender

The height of a typical lowercase letter is called the
x-height

The invisible grid line the characters sit on is called the
baseline

The space inside a letter, enclosed or not, is called the
counter

The part of a letter that extends below the body of the type is called the
descender

Flabbergasted!

3 The weight of the headline below is bold and the point size is 36.

Whasssssssupppppppp?

4 Below, there are at least three things that we've done to the line of type above:

Whasssssssssupppppppp?

- We've *italicized* the type.
- We've *loosened the tracking* so there's more space between each letter.
- We've *changed the style to serif* (from sans serif).

5 The following characteristics apply to the text in this box:

- The 21-point text is serif style.
- The leading is tight (17 points).
- The tracking is tight.
- Sentence is written in upper and lower case.
- Alignment is flush left.

Here is another typographic brain-teaser.

6
- The type is now all caps.
- Alignment is now centered.
- The type is reversed.
- The tracking has been increased.

HERE IS ANOTHER TYPOGRAPHIC BRAIN-TEASER.

7 There are *72 points* in one inch.

8 *Kerning* is when you adjust the space between a pair of letters.
Tracking is when you adjust the horizontal space between multiple letters.

9 The following applies to the text in the column on the right:

- Uses bullets to highlight each new category.
- Uses boldface type for each new category.
- Adds a few points (3) of extra leading between categories.
- Uses a hanging indent.

> ▪ **Best picture:** "The Artist"
> ▪ **Best actor:** Jean Dujardin in "The Artist"
> ▪ **Best actress:** Meryl Streep in "The Iron Lady"

10 Here are the key typographic components for this headline:

- *Larry* is flush left, 36-point Georgia.
- The *ampersand* is flush left, 111.8-point Georgia Italic. Its baseline rests below the base line of the word *"Curly,"* and it has been moved behind the word *"Moe."*
- *Moe* uses 122.5-point Helvetica Neue Condensed Bold. The tracking is on the tight side. The letters are screened to 50 percent black.
- *"Curly"* is flush right, 50-point Georgia Italic. The set width (scaling) is 100 percent. The tracking is a little tight. Kerning has been adjusted slightly between the letters.

11 Drawing a dummy, as we've explained, isn't an exact science. But if you measured those components carefully, you'd draw a dummy like this:

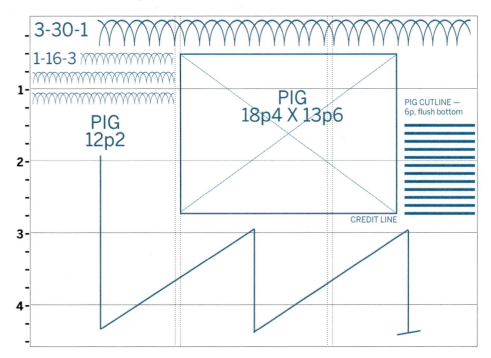

Exercise answers (Story design)

You can find the questions for these answers on Page 71

1 A 5-inch story should be dummied either in one leg 5 inches long or in two legs 2.5 inches long. You should avoid dummying legs shorter than 2 inches (too short), which rules out a 3-column layout for this story.

• Though styles vary from paper to paper, this story might use a 1-column, 30-point, 3-line headline (1-30-3) on Page One, and a 1-column, 18-point, 3-line headline (1-18-3) or a 1-column, 24-point, 3-line headline (1-24-3) at the bottom of an inside page.

• On Page One, this 2-column layout might use a 2-column, 30- or 24-point headline at two lines deep (2-30-2 or 2-24-2). At the bottom of an inside page, it would become a 1-line 18-point headline across two columns (2-18-1 or 2-24-1).

2 Your three best options are a 1-column format, a 2-column format and a 4-column format. (In the 4-column format, the mug could be dummied at either the right or left side.)

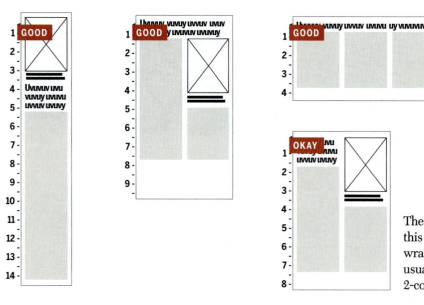

The story also would work using this 2-column format. But raw-wrap headlines can be risky; it's usually safer to use the other 2-column solution.

In a 3-column layout, the headline would need to run above the photo, with roughly a half-inch of text below the photo. That's not enough; you must dummy at least 1 inch of text in every leg. For this layout to work, you need either more text or a smaller mug indented into any of the three legs.

3 The layout has the following problems:

▸ This story seems to begin in the second column. To avoid this, avoid dummying photos between the headline and the start of the text.

▸ The headline wraps clumsily around that left-hand mug. Ordinarily, all lines in a banner headline be the same width. (Here, both lines should be 4 columns wide.) Most publications run all headlines either flush left or centered.

▸ Mug shots shouldn't be scattered through the story, but grouped as evenly as possible. The two middle legs might work best in this layout.

▸ Mug shots should run at the top of each leg of text, not at the bottom.

4 Because this is the day's top story—and because that image looks more dramatic the bigger it runs—you should run the photo at least 3 columns wide. (A 2-column treatment of that photo would weaken its impact and make the story seem relatively insignificant.) But because it's a busy news day, you can't afford to devote too much real estate to this story—you'd crowd out other news, which is what would happen if you ran the photo 5 or 6 columns wide. So the best approach is one that uses the photo either 3 or 4 columns wide. Here are the most common, dependable design options:

This vertical design uses the photo 3 columns wide, which means about 5 inches deep. A solid, reliable solution.

This horizontal design also uses the photo 3 columns wide. The text fits snugly alongside the photo, and everything squares off cleanly.

Another good solution using the photo 3 columns wide, with an L-shaped text block. With a shorter story, those legs under the photo might be too shallow.

This design runs the photo 4 columns wide. The photographer will vote for this, since the big photo has drama and impact. But it does take up lots of space.

4 The best solution is **B.** It's well-balanced and correctly organized. What's wrong with the others? In example **A,** the entire midsection of the page is gray and type-heavy, while the top of the page uses two small, weak headlines that could mistakenly be related to that big photo. In example **C,** the photo is ambiguous (it could belong either to the story alongside or below) and headlines nearly collide. In example **D,** the lead photo is ambiguous again, and both photos are bunched together.

5 Many page designers park promo boxes and indexes in the bottom right corner of the page, as "page-turners" that send you on into the paper. Using that philosophy, our first solution (below left) would be preferable. But if you choose to use the promo box as a graphic element to break up those gray stories, you could slide it toward the middle instead (below right). In either case, it works best at the very bottom of the page.

6 If the lead photo is strong, you should play it as big as possible—and in this case, there's room to run it 4 columns wide at the top of the page. Once that photo, headline and text are anchored, your options become limited for those other two stories. This solution balances the art, mixing horizontal and vertical shapes. The small story is boxed to keep the headlines from butting—but that's OK, since it's a "bright" feature that warrants special treatment.

7 The solution at right is clearly the better of the two. It avoids any nasty collisions between stories (though those two headlines in the middle of the page do butt a bit—if you prefer, you can box the short feature on the right). That story with the mug shot is the only one that needed to be trimmed to fit; it lost an inch and a half.

Though those two left-hand legs run a bit deep, it's acceptable. To lessen the problem, you could either add a deck or park a liftout quote about halfway down (either in the right-hand leg or, even better, between the two columns, with the text wrapping around). Either way, you'd need to trim an inch or so from the text.

You could argue whether the layout at left succeeds or not—but since some designers will try it, we'd better discuss it.

The problem, of course, is in the upper-left corner: the juxtaposition of that mug shot and the lead story's headline. Is it confusing? Yes. Would it work better if we ran a column rule between those two butting stories or boxed the lead story? Maybe. But readers might still think that mug shot is connected to the headline beside it— which it isn't.

To make the text fit, we had to trim 3 inches from that left-hand leg. And, as you can see, we padded the lead story a little by adding a liftout quote and a deck.

You can find the questions for these answers on Page 143

1 The two strongest images—the ones that say "woman jockey" in the most arresting way—are the race photo and the tight portrait. The other two should be supporting photos. They're informational, but not really interesting enough to dominate the page. Here are three likely layouts using the race photo as the lead. If you've created a radically different page, congratulations—but check the guidelines starting on Page 134 to be sure you haven't made some mistakes.

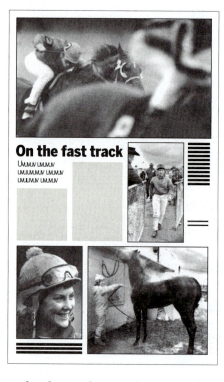
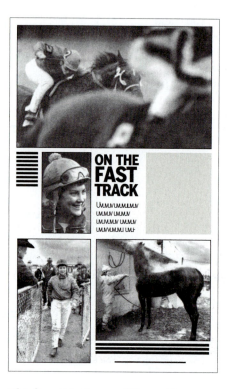
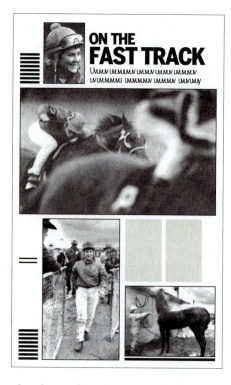

In this design, the race photo is used as the lead shot and runs across the top of the page, sharing a cutline with the photo below. (That's a photo credit floating below the cutline in the right margin.) The other two photos are stacked across the bottom of the page.

Note how the page is divided into three horizontal layers. In the second layer, the photo and text could have swapped positions, with that photo at the left side of the page—but then we'd have two similarly sized photos parked one atop the other. To avoid that, we could transpose the two bottom photos—but then the mug shot would be looking off the page. This layout, then, balances its elements well and avoids violating the directionality of the mug.

This layout isn't very different from the one at left. The race photo runs big across the top; together, the four photos form a "C" shape with the story tucked in the middle. (The page at left forms a backward "C.")

The sidesaddle headline treatment provides an alternative to the more standard approach used at left. The headline and deck form one wide column; the text sits beside it. (That leg is pretty wide. It could be indented or run as two legs instead.)

One final note: All three of these layouts close with the shot of the jockey washing her horse. Does that seem like an appropriate "closer"? Or would we make a stronger exit by closing with the shot of the jockey walking off the track, splattered with mud?

This design, like the one at left, uses the small portrait to set up the headline; pairing those two elements shows instantly who is on the fast track. The cutline beside the mug also describes the action in the lead photo below.

The other two photos stack along the bottom of the page, with the photo credit floating in the left margin.

Note how headline, text and two vertical photos are all given an extra indent.

If there's a drawback to this layout, it's that it uses a big headline, a big deck, big photos—and a small amount of text. At some papers, editors may prefer to downsize those photos and increase the amount of copy.

Exercise answers (Photos and art)

These layouts represent three common design approaches using the portrait of the jockey as the dominant photo. That portrait is strongly directional. As a result, your options are more limited, since, in this case, it's best to position the lead photo looking into rather than off of the page.

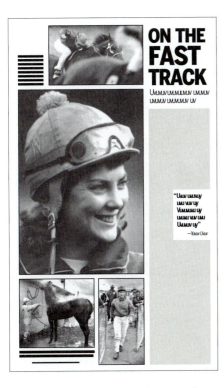

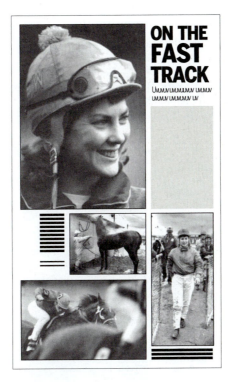

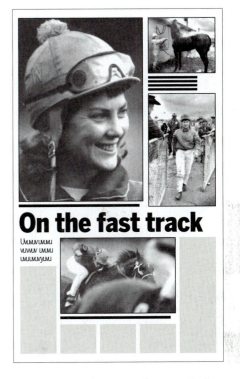

Getting all four photos to fit properly is tricky when you're working around a directional dominant photo. In this case, the race photo is used as a scene-setter at the top of the page. The lead portrait runs below it, sharing a cutline. The other two photos fit in the space below the lead photo.

Some would say this is a very clean design, with the art aligning on one side of the page, the text running in one leg alongside. Others might find it too off-balance, with a preponderance of weight on the left side.

That leg of text is a bit too deep. We're relieving the gray by indenting a liftout quote halfway down.

Here, the lead photo runs at the top of the page, and the other photos arrange themselves in the rectangular module below. Note how the shapes and sizes of the photos vary. This helps to avoid static, blocky configurations.

If there are drawbacks to this design, they would be:

▸ The excessive white space along the left edge of the page, around the cutline and photo credit. That's hard to avoid, however. It's hard to size that horse-washing photo much wider. The cutline, too, is about as big as it should be.

▸ The small amount of text. Playing these photos as big as they are doesn't leave much room for the story. This is a very photo-heavy layout.

Here's a page that gets a bit crowded at the top but seems to work anyway. Three photos are grouped together in a tight unit; the race photo, however, is set apart from the rest for extra emphasis (and to give the page more of a "racing" feel).

The racing photo also could have been dummied in the right-hand three columns instead of the center three; in that case, a 2-line, 2-column deck would have been preferable. But as it is, this design produces a more symmetrical page.

2 Several additional images would enhance this selection of photos. Among them:

▸ A stronger racing shot—one with clearer details and a greater sense of motion, perhaps shot from a more dramatic angle. Pulling back and showing more horses in the race would help give a sense of the scope of the race and a sense of place.
▸ More emotion—whether it be about the thrill of victory, or the agony of defeat. Or anything in between, for that matter. These four photos fail to capture any athletic dramatics.
▸ An interaction shot, showing how this jockey relates to her colleagues in a male-dominated sport.
▸ Detail shots—whips, boots, saddles, even trophies—especially some racing apparel or artifact that's unique or meaningful to this jockey.
▸ A stronger "ender," or closing shot that would help the reader exit the story.

3 Here are some of the major problems on these pages. Remember: When it comes to page design, tastes can be very subjective. You don't have to agree with every nitpick, but you should understand the principles that underlie our design guidelines.

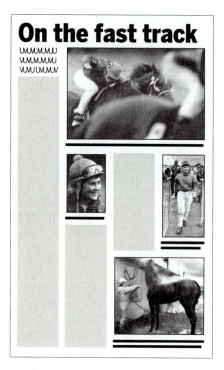

The text snakes around the photos in a clumsy, unattractive way—and that first leg of text is way too deep. There's no white space designed into this page, which results in a layout that feels fragmented and uninviting, more like an ordinary news page than a special photo spread. And that feeling is reinforced by the sizes of the photos. The lead photo isn't quite dominant enough, and there's no sense of interplay among the rest of the images.

The lead photo faces off the page. If this page design were flopped, that problem could have been avoided. But there's still a problem with that big cutline blob in the center of the page. It's unclear which photo or photos it belongs to. (Does the bottom photo have a cutline?) There's too much trapped white space in the middle of the page. There's also too much white space above the headline. Finally, those two legs of text may be too thin—one wider leg would be better.

Overall, this page looks handsome, but there are some subtle problems. It's divided into three very separate chunks: 1) big photo, 2) gray text and 3) small photos. There's no interplay between elements; in fact, this seems like a formulaic page design that you could plug any photos into. In addition, there's no white space, and the shapes are too blocky and static. It's also difficult to determine which cutline describes the center photo in the bottom row.

4 Cropping can be a subjective, emotional thing. So we sent this Tiger Woods photo to 50 professional photographers, editors and designers across the country to see how the "experts" would handle it. As you might have predicted, many moaned and groaned about the "lame, crappy picture." ("I'd hire a new photographer if this is his/her only shot," said one.) But here's what most decided:

54% This, or something close to it, was the most popular solution. Tiger is big enough to have impact, yet we see the diversity of his fans, too (the local aspect of the photo). Some of our participants complained that this shape was too dull and squarish. But others liked how this crop observed the "rule of thirds": a compositional principle that recommends positioning key elements one-third of the way in from the photo's edges.

23% This is certainly a dramatic shape. But it omits most of the onlookers; if the story is about Tiger's huge following, aren't they a key element? Beware, too—the image will get fuzzy if you try to enlarge Tiger too much.

13% This crop is virtually full-frame. We've cropped in a little on the sides and bottom, down a bit from the top. Many of those who chose this crop did so to avoid ending up with a big square, although a few argued that *this* is the way the photographer shot the scene—with Tiger in the middle, and greenery all around—so to respect the photographer, you should leave the shape alone. (One designer decided to crop this as an extreme horizontal, running the full width of the page, by slicing right through the necks of the spectators. Try it and see what you think.)

The remaining 10 percent cropped even tighter to create a closeup of Tiger. As we looked at the winning crop (above left), we couldn't help noticing all that green, treesy dead space next to Tiger. Would it work if we put the headline there? So we tried it, sent our new solution back to the experts and asked them to vote:

A: *Love it. Run it.*
B: *It's OK, but not the best solution.*
C: *No way. Keep your stinkin' type off the photos.*

Putting headlines on photos is still a controversial act in most newsrooms, as you can see by the breakdown of the voting:

Love it. Run it—50 percent of our respondents approved of the new headline. "Ten years ago I might have answered no way," said one designer. "But times have changed. Readers are more sophisticated about type on photos."

"No reader will be bothered by the type on the photo," said another. "Only photographers might take offense."

It's OK, but not the best solution—25 percent quibbled about the headline size, font, color, gradient, etc., proving once again that *there is no greater force known to man than the desire to change someone's layout.*

No way—25 percent. Many of these were photographers. Most, however, said they might approve the idea if this were a feature story—but not if it were breaking news.

Glossary

To liven up this text-heavy glossary, we've added a gallery of some unique and surprising pages. The "Blue Rose" page, below, was designed by Linda Shankweiler. Tim Harrower says, "Back when I first started in newspapers, this was my favorite page—the one that inspired me to be a newspaper designer."

The Morning Call, Allentown, Penn.

"These were the early years of poster-like, single-subject feature pages. The editor says we're doing a story called 'In Search of the Blue Rose'—have at it! No Macs, lots of amberlith, antique presses and a patient composing room. All of us from those days at The Morning Call have fond memories of the magic that happens with the powerful chemistry and synchronized vision of the word people with the visual people."

— Linda Shankweiler, designer

Agate. Small type (usually 5.5 point) used for sports statistics, stock tables, classified ads, etc.

Air. The negative (or white) space used in a story design.

All caps. Type that uses only capital letters.

Alternative Story Form. A way to tell a story other than using straight narrative text.

Application. A computer software program that performs a specific task: word processing, page layout, illustration, etc.

Armpit. An awkward-looking page layout where a story's banner headline sits on top of a photo or another headline.

Ascender. The part of a letter extending above the x-height (*as in b, d, f, h, k, l, t*).

A.S.F. Alternative Story Form.

Attribution. A line identifying the source of a quote.

Banner. A wide headline extending across the entire page.

Bar. A thick rule. Often used for decoration, or to contain type for subheads or standing heads.

Bar chart. A chart comparing statistical values by depicting them as bars.

Baseline. An imaginary line that type rests on.

Baseline shift. A software command that allows you to raise or lower the baseline of designated text characters.

Bastard measure. Any non-standard width for a column of text.

Bleed. A page element that extends to the trimmed edge of a printed page.

Blend. A mixture of two colors that fade gradually from one tint to another.

Blog. A Web log; an online journal that provides commentary and/or links to related websites.

Body type. Type used for text (in newspapers, it usually ranges from 8 to 10 points).

Boldface. A heavier, darker weight of a typeface; used to add emphasis.

Border. A rule used to form a box or to edge a photograph.

Box. A ruled border around a story or a visual element.

Broadsheet. A full-size newspaper, measuring roughly 11 by 24 inches.

Browser. A software program (such as Firefox or Safari) that enables users to view Web pages over the Internet.

Bug. Another term for a sig or logo used to label a story; often indented into the text.

Bullet. A type of dingbat, usually a dot (•), that is used to highlight items listed in the text.

Bumping/butting heads. Headlines from adjacent stories that collide with each other on a page. Also called *tombstoning*.

Byline. The reporter's name, usually found at the beginning of a story.

Callouts. Words, phrases or text blocks used to label parts of a map or diagram (also called *factoids*).

Camera-ready art. The finished page elements that are ready for printing.

Caps. Capital or uppercase letters.

Caption. A line or block of type providing descriptive information about a photo; this term is used interchangeably with *cutline*.

Centered. Art or type that's aligned symmetrically, sharing a common midpoint.

Character. A typeset letter, numeral or punctuation mark.

CMYK. An acronym for cyan, magenta, yellow and black—the four ink colors used in color printing.

Column. A vertical stack of text; also called a leg.

Column inch. A way to measure the depth of text or ads; it's an area one column wide and one inch deep.

Column logo. A graphic device that labels regularly appearing material by packaging the writer's name, the column's name and a small mug or drawing of the writer.

Column rule. A vertical line separating stories or running between legs within a story.

Compressed/condensed type. Characters narrower than the standard set width; i.e., turning this M into M.

Glossary

Continuation line. Type telling the reader that a story continues on another page.

Continuous tone. A photo or drawing using shades of gray. To be reproduced in a newspaper, the image must be converted into a *halftone*.

Copy. The text of a story.

Copy block. A small chunk of text accompanying a photo spread or introducing a special package.

Copyright. Legal protection for stories, photos or artwork, to discourage unauthorized reproduction.

Crop. To trim the shape or composition of a photo before it runs in the paper.

Cutline. A line or block of type that provides descriptive information about a photo.

Cutoff rule. A horizontal line running above or under a story, photo or cutline to separate it from another element above or below it.

Cutout. A photo where the background has been removed, leaving only the main subject; also called a *silhouette*.

Deck. A small headline running below the main headline; also called a *drop head* or *subhead*.

Descender. The part of a letter extending below the baseline (as in *g, j, p, q, y*).

Dingbats. Decorative type characters (such as bullets, stars, boxes, etc.) used for emphasis or effect.

Display headline. A non-standard headline (often with decorative type, rules, all caps, etc.) used to enhance the design of a feature story, photo spread or news package.

Doglegs. L-shaped columns of text that wrap around art, ads or other stories on the page.

Dot screen. A special screen used to produce tiny rows of dots, thus allowing newspapers to print shades of gray.

Dots per inch (dpi). The number of electronic dots per inch that a printer can print—or that a digital image contains. The higher the dpi, the more precise the resolution.

Double truck. Two facing pages on the same sheet of newsprint, treated as one unit.

Downstyle. A headline style that capitalizes only the first word and proper nouns.

Drop head. A small headline running below the main headline; also called a *deck* or *subhead*.

Drop shadow. A thin shadow effect added to characters in a headline or applied to visual elements.

Dummy. A small, detailed page diagram (or sketch, thumbnail) showing where all the elements go.

Duotone. A halftone that uses two colors, usually black and a spot color.

Dutch wrap. Text that extends into a column alongside its headline; also called a *raw wrap*.

Ear. Text or graphic elements on either side of a newspaper's flag.

Ellipsis. Three periods (...) used to indicate the omission of words.

Em. An old printing term for a square-shaped blank space that's as wide as the type is high; in other words, a 10-point em space will be 10 points wide.

En. Half an em space; a 10-point en space will be 5 points wide.

Enlarge. To increase the size of an image (or even text).

EPS. A common computer format for saving scans, especially illustrations (short for *Encapsulated PostScript*).

Expanded/extended type. Characters wider than the standard set width: i.e., turning this M into **M**.

Family. All the different weights and styles (italic, boldface, condensed, etc.) of one typeface.

FAQ. Frequently asked questions.

Feature. A non-hard-news story (a profile, preview, quiz, etc.) often given special design treatment.

Fever chart. A chart connecting points on a graph to show changing quantities over time; also called a *line chart*.

File size. The total number of electronic pixels needed to create a digital image, measured in kilobytes. The more pixels an image uses, the more detail it will contain.

Filler. A small story or graphic element used to fill space on a page.

The Charleston Gazette, W. Va.

"Charleston's East End neighborhood was about to host its second annual Zombie Walk. Harold Camping was in the news, 2012 was fast-approaching, and Charleston lies just inside the 'danger zone' of nearby Chemical Valley. It seemed a zombie apocalypse was only a matter of time.

"For the centerpiece I took the comic book approach. I touched on the shopping mall aspect of 'Dawn of the Dead,' took a jab at the local politicians (Zombies at the capital? Well that's nothing new ...), and poked a little fun at an oft-hated sculpture at the heart of town—the Hallelujah sculpture at the Clay Center for the Arts & Sciences. A lot of people think it looks like a heap of space wreckage.

"The survival guide and the humor had a local focus, and our readers seemed to really enjoy it."

— **Kyle Slagle,** designer

Glossary

THE PLAIN DEALER TOP WORKPLACES 2010

75 companies people love to work for ... and why they love to.

The Plain Dealer, Cleveland, Ohio

"The Best Workplaces assignment is one that I have been given several times now. I enjoy it immensely. I usually brainstorm a bit and then approach David Kordalski (assistant managing editor/visuals) about my concepts.

"With the 'gear guy,' I was simply trying to capture a bit of exuberance. I liked the combination of the seemingly unrelated images of gears and joy.

"To me, the quirky, lanky figure has almost a scarecrow essence to it. Perhaps that held some appeal for folks, because reader reaction was quite positive. I try to be always aware that the images we create draw both intentional and inadvertent associations. The more conscious you can become of this, the more you can use it to strengthen your art."

— **Andrea Levy,** illustrator

Flag. The name of a newspaper as it's displayed on Page One; also called a *nameplate.*

Float. To dummy a photo or headline in an empty space so that it looks good to the designer, but looks awkward and unaligned to everyone else.

Flop. To create a backward, mirror image of a photo or illustration.

Flush left. Elements aligned so they're all even along their left margin.

Flush right. Elements aligned so they're all even along their right margin.

Folio. Type at the top of an inside page giving the newspaper's name, date and page number.

Font. All the characters in one size and weight of a typeface (this font is 10-point Times).

Four-color. The printing process that combines cyan (blue), magenta (red), yellow and black to produce full-color photos and artwork.

Frames. Web design tools that divide pages into separate, scrollable modules.

Full frame. The entire image area of a photograph.

GIF. *Graphic Interface Format,* a common format for compressed Web images, especially illustrations and graphics.

Graf. Newsroom slang for "paragraph."

Graph. Statistical information presented visually, using lines or bars to represent values.

Grayscale. A scan of a photograph or artwork that uses shades of gray.

Grid. The underlying pattern of lines forming the framework of a page; also, to align elements on a page.

Gutter. The space running vertically between columns.

H and J. Hyphenation and justification; the computerized spacing and aligning of text.

Hairline. The thinnest rule used in newspapers.

Halftone. A photograph or drawing that has been converted into a pattern of tiny dots. By screening images this way, printing presses can reproduce shades of gray.

Hammer head. A headline that uses a big, bold word or phrase for impact and runs with a small, wide deck below.

Hanging indent. Type set with the first line flush left and all other lines in that paragraph indented (this text is set with a 10-point hanging indent).

Header. A special label for any regularly appearing section, page or story; also called a *standing head.*

Headline. Large type running above or beside a story to summarize its content; also called a *head,* for short.

High-resolution printer. An output device capable of resolution from 1,200 to 5,000 dots per inch.

Hyphenation. Dividing a word with a hyphen at the end of a line.

Image. In Web design, any photo, illustration or imported graphic displayed on a page.

Image size. The physical dimensions of the final scanned image.

Import. To bring an electronic image into a computer software program.

Indent. A part of a column set in a narrower width. The first line of a paragraph is usually indented; columns are often indented to accommodate art, logos or initial caps.

Index. An alphabetized list of contents and their page numbers.

Infographic. Newsroom slang for "informational graphic"; any map, chart or diagram used to analyze an event, object or place.

Initial cap. A large capital letter set at the beginning of a paragraph.

Inset. Art or text set inside *other* art or text.

Italic. Type that slants to the right, *like this.*

Java. A programming language that features animation.

JPEG. A common format for compressed Web images, especially photos. Created by the *Joint Photographic Experts Group* and pronounced "jay-peg."

Jump. To continue a story on another page; text that's been continued on another page is called the *jump.*

Glossary

Jump headline. A special headline treatment reserved for stories continued from another page.

Jump line. Type telling the reader that a story is continued to or from another page.

Justification. Mechanically spacing out lines of text so they're all even along both right and left margins.

Kerning. Tightening the spacing between letters.

Kicker. A small, short, one-line headline, often underscored, placed above a larger headline.

Laser printer. An output device that prints computer-generated text and graphics, usually at a lower resolution than professional typesetters.

Layout. The placement of art and text on a page; to *lay out* a page is to design it.

Leader. A dotted line used with tab stops.

Lead-in. A word or phrase in contrasting type that precedes a cutline, headline or text.

Leading. Vertical spacing between lines of type, measured in points.

Leg. A column of text.

Legibility. The ease with which type characters can be read.

Letter spacing. The amount of air between characters in a word.

Liftout quote. A graphic treatment of a quotation taken from a story, often using bold or italic type, rules or screens. Also called a *pull quote*.

Line art. An image comprised of solid black and white—no gray tones, as opposed to a *grayscale image*.

Line chart. A chart connecting points on a graph to show changing quantities over time; also called a *fever chart*.

Lines per inch (lpi). The number of lines of dots per inch in a halftone screen. The higher the lpi, the more precise the image's resolution will be.

Logo. A word or name that's stylized in a graphic way; used to refer to standing heads in a newspaper.

Lowercase. Small characters of type (no capital letters).

Margin. The space between elements.

Masthead. A block of information, including staff names and publication data, often printed on the editorial page.

Mechanical. The master page from which printing plates are made; also called a *paste-up*.

Measure. The width of a headline or column of text.

Modular layout. A design system that views a page as a stack of rectangles.

Moire. An eerie pattern that's formed when a previously screened photo is copied, then reprinted using a new line screen.

Mortise. Placing one element (text, photo, artwork) so it partially overlaps another.

Mug shot. A small photo showing a person's face.

Nameplate. The name of a newspaper as it's displayed on Page One; also called a *flag*.

Offset. A printing process, used by most newspapers, where the image is transferred from a plate to a rubber blanket, then printed on paper.

Orphan. A short word or phrase that's carried over to a new column or page; also called a *widow*.

Overlay. A clear plastic sheet placed over a pasted-up page, containing elements that the printer needs to screen, overprint or print in another color.

Overline. A small headline that runs above a photo; usually used with stand-alone art.

Pagination. The process of generating a page on a computer.

Photo credit. A line that tells who shot a photograph.

Photo construct. Visual devices that photographers use within their photos so that the images are more effective and have greater impact.

Pica. A standard unit of measure in newspapers. There are 6 picas in one inch, 12 points in one pica.

Pixel. The smallest dot you can draw on a computer screen (short for "picture element").

Omaha World-Herald, Omaha, Neb.

"Since readers don't spend as much time with the newspaper around the holidays, we look for ways to give them a surprise. The image of the flag from Fort McHenry was a nice hook, and we had done designs like this in the past with some success. It was a plus that everyone agreed there should be no other photos on the page."

— **Tim Parks,** designer

The Palm Beach Post, Florida

"Every year, Brennan King, the illustrator for both of these pages, creates a holiday cover for TGIF. His illustrations are subtle, often whimsical and always enjoyable and unique to Florida. They are beautiful. I kept the type simple and understated to play up his illustration, because anything else would have been overkill."

— **Jenna Lehtola,** designer (bottom page); Brennan King, illustrator

Rebecca Vaughan, designer (top page)

Point. A standard unit of measure in printing. There are 12 points in one pica, 72 points in one inch.

Process color. One of the four standard colors used to produce full-color photos and artwork: cyan (blue), magenta (red), yellow or black.

Proof. A copy of a pasted-up page used to check for errors. To check a page is to *proofread* it.

Pull quote. Another name for *liftout quote.*

Pyramid ads. Advertisements stacked up one side of a page, wide at the base but progressively smaller near the top.

Quotes. Words spoken by someone in a story. In page-design jargon, a *liftout quote* is a graphic treatment of a quotation, often using bold or italic type, rules or screens.

Ragged right. Type that is not justified; the left edge of all the lines is even, but the right edge is uneven.

Raw wrap. Text that extends into a column alongside its headline; also called a *Dutch wrap.*

Refer (or reefer). A line or paragraph, often given graphic treatment, referring to a related story elsewhere in the paper.

Register. To align different color plates or overlays so they're perfectly positioned when they print.

Resolution. The quality of digital detail in an image, depending upon its number of dots per inch (dpi).

Reverse. A printing technique that creates white type on a dark background; also called a *dropout.*

RGB. An acronym for *Red, Green, Blue*—a color format used by computer monitors and video systems.

Roman. Upright type, as opposed to slanted (italic) type; also called *normal* or *regular.*

Runaround. Text that wraps around an image; also called a *wraparound* or *skew.*

Sans serif. Type without serifs. (What you see here is sans serif type.)

Saturation. The intensity or brightness of color in an image.

Scale. To reduce or enlarge artwork or photographs.

Scaling. The overall spacing between characters in a block of type.

Scanner. A computer input device that transforms printed matter (photos, illustrations or text) into electronic data.

Screen. A pattern of tiny dots used to create gray areas; to screen a photo is to turn it into a *halftone.*

Serif. The finishing stroke at the end of a letter; type without these decorative strokes is called *sans serif.*

Server. A computer used for storing and sending users the pages that make up a website.

Sidebar. A small story accompanying a bigger story on the same topic.

Sidesaddle head. A headline placed to the left of a story, instead of above it; also called a *side head.*

Sig. A small standing head that labels a regularly appearing column or feature.

Silhouette. A photo where the background has been removed, leaving only the main subject; also called a *cutout.*

Skew. Text that wraps around a photo or artwork; also called a *wraparound* or a *runaround.*

Skyboxes, skylines. Teasers that run above the flag on Page One. If they're boxed (with art), they're called *skyboxes* or *boxcars;* if they use only a line of type, they're called *skylines.*

Solid. A color (or black) printed at 100 percent density.

Spot color. An extra color ink added to a page; also called *flat color.*

Spread. Another term for a large page layout; usually refers to a photo page.

Stand-alone photo. A photo that doesn't accompany a story, usually boxed to show it stands alone; also called *wild art.*

Standing head. A special label for any regularly appearing section, page or story; also called a *header.*

Style. A newspaper's standardized set of rules and guidelines. Newspapers have styles for grammar, punctuation, headline codes, design principles, etc.

Glossary

Subhead. Lines of type, often bold, used to divide text into smaller sections.

Summary deck. A special form of deck, smaller and wordier than most decks, that sums up the main points of a story.

Table. A graphic or sidebar that stacks words or numbers in rows so readers can compare data.

Tabloid. A newspaper format that's roughly half the size of a broadsheet newspaper.

Tab stops. Predetermined points used to align data into vertical columns.

Teaser. An eye-catching graphic element, on Page One or section fronts, that promotes an item inside; also called a *promo*.

TIFF. One of the most common computer formats for saving scans (an abbreviation of *Tagged Image File Format).*

Tint. A light color, often used as a background tone, made from a *dot screen.*

Tombstoning. Stacking two headlines side by side so that they collide with each other; also called *bumping* or *butting heads.*

Trapped white space. An empty area, inside a story design or photo spread, that looks awkward or clumsy.

Trapping. A slight overlapping of color plates to prevent gaps from appearing during printing.

Tripod. A headline that uses a big, bold word or phrase and two smaller lines of deck squaring off alongside.

Typeface. A family of fonts – for instance, the Futura family, which includes Futura Light, Futura Italic, Futura Bold, etc.

Underscore. To run a rule below a line of type.

Uppercase. Type using capital letters.

Web. Short for the World Wide Web, or WWW.

Weight. The boldness of type, based on the thickness of its characters.

Well. Ads stacked along both edges of the page, forming a deep trough for stories in the middle.

White space. Areas of a page free of any type or artwork.

Widow. A word or phrase that makes up the last line of text in a paragraph. (See *orphan.)*

Wraparound. Text that's indented around a photo or artwork; also called a *runaround* or *skew.*

X-height. The height of a typical lowercase letter.

The National Post, Toronto.

"I designed this page, and Barry Hertz was the Arts and Life editor. Kagan McLeod illustrated this on deadline. He captured Elizabeth's beauty and magic with bold and elegant strokes. After placing the illustration on the page we decided to let the illustration mourn Elizabeth by itself without type. The red section flag usually holds index items for the section. We removed the index and simply ran a deck indexing our coverage of only her."

— **Gayle Grin,** managing editor of design and graphics

ActionScript, 20
Adobe Illustrator, 20
Adobe InDesign, 20
ads, 100–101
 color, 212
 laydown, steps in, 100
 stacks, 100, 101
agate type, 30
alternative story forms (A.S.F.'s),
 165–186
 bio boxes, 165, 167
 charts/graphs, 165, 174, 176–177
 checklists, 165, 170
 diagrams, 165, 182–183
 fast-fact boxes, 165–166
 functions of, 163, 165
 glossaries, 165, 169
 lists, 168–169
 maps, 165, 184–185
 public opinion polls, 165, 174
 Q & A, 165, 171, 194
 quizzes, 165, 172–173, 194
 quote collections, 165, 175
 ratings, 165, 179
 step-by-step guides, 165, 181
 tables, 165, 178
 timelines, 165, 180, 186
 See also graphics
Arizona Republic, The, 8, 88
art
 images, web sites for, 139
 pages with, 84–85
 pages without, 46–47, 78–83
 See also illustrations;
 photographs
Art Explosion, 139
Art Parts, 139
Asbury Park Press, The, 12
ascender, 23
Associated Press, 118

banner headlines, 28, 101
bar charts, 165, 176, 191
baseline, 23
bastard measure
 benefits of, 81
 fitting stories with, 99
 functions of, 19, 31
berliners, 13, 77
Berner, Alan, 117
Bickley, Bethany, 141
bio boxes, 165, 167
bleed, images, 51
body copy. *See* text

boldface lead-in, 35
boldface type, 19, 30
borders
 around photos, 110, 128
 boxed stories, 67, 80
Boston Globe, The, 8, 11, 159
Boston Herald, The, 6
boxed stories
 alternative story forms (A.S.F.'s),
 166–167
 border style for, 67
 rules, using, 157
 situations for use, 80, 101
broadsheets
 dummy, 40
 grid for, 74
 headlines, 29
 style, 6, 7, 13
 tabloidization of, 13
Buffalo News, The, 9
bugs, 148–149
bullets, 3, 159, 168
bylines, 18, 154, 156

Cain, J. Damon, 75
callouts, 182–183
captions. *See* cutlines
caricatures, 140
cartoons, editorial, 10, 140
Casper Star-Tribune, 187
charts, types of, 165, 174, 176–177,
 190–191
checklists, 165, 170
Chicago Tribune, 113
Cincinnati Enquirer, The, 77
clip art, 139
Cole, Carolyn, 112
Collegian, The, 29
color, 212–218
 adding to page, tips for, 213–217
 design functions of, 212
 palette, developing, 214, 217
 process/full color, 213, 218
 spot color, 213–215, 214
Columbus Dispatch, The, 77, 172
column logos, 148
combo grid, 75
comics, 8
commentary drawings, 140
Concord Monitor, 7
copyright, art/images, 142
counter, 23
credit lines, 19, 155

cropping
 guidelines for, 126–127
 photos, 48, 52, 118
CSS3, 20
cutlines, 34–37
 functions of, 18, 26, 34, 110
 with mug shots, 48, 50
 with photo spread, 136
 placement, 35
 shared, 36–37
 type styles for, 35
cutoff rule, 19
cutouts, photo, 19, 204

Daily Graphic, The (New York), 4
Daily Universe, The, 9
Dallas Morning News, 12, 140
data maps, 184
Day, The, 74
decks
 summary decks, 153
 using, guidelines for, 152
 See also subheads
Denver Post, The, 14, 75
descender, 23
Detroit Free Press, 11, 192
diagrams, 165, 182–183
dictionaries, 169
digital journalism
 benefits of, 14–15
 journalists' tools, 20
 See also mobile devices
dingbats, 159
display headlines, 208–211
 creating, tips for, 210–211
 dummying, 209
 functions of, 18
dogleg layout, 47, 51, 101
dots-per-inch (dpi), 124, 125
double trucks, 76, 81, 102–103
dummies, 38–41
 broadsheets, 40
 display headlines, 209
 drawing, 38–41
 elements of, 39
 tabloids, 41

editorial cartoons, 10, 140
editorial pages, 10
enterprise stories
 features of, 12
 online, 15
Epitaph, The, 229
Evans, Harold, 157

explanatory maps, 184
EyeWire, 139

Facebook, 16
factoids, 166, 182–183, 186
fast-fact boxes, 165–166
Fayetteville Observer, 8
feature sections, 8
fever lines, 165, 176, 177
Final Cut Pro, 20
flags, 18, 146, 212
flush right/left type, 30
focus groups, 228
folios, 19
fonts, 22
Franklin, Benjamin, 140
front page. See Page One
full color, 213, 218

Gainesville Sun, The, 131
gang cutlines, 37
Gannaway, Preston, 116
Garcia, Mario, 13
Gazette, 158
Globe and Mail, The, 15
glossaries, 165, 169
Goheen, Tim, 177
graphics, 186–194
 compiling/editing data, 190
 constructing, tips for, 191
 packages, creating, 186–189
 software tools for, 20
 staff, training in, 178
 with typography/layout, 188,
 192–194
 unconventional presentations.
 See special effects
graphs/charts, types of, 176–177
Green Bay Press-Gazette, 140
grids, 74–78
Guardian, The, 13
Gutenberg, Johannes, 21
gutters, 19

Haag, Jim, 91, 220
half-column mug shots, 48–49
halftones, 123
hammers, 28
Hampton, Vieta Jo, 64
Handelsman, Walt, 140
hanging indents, 30
Harper's Index, 169
headers. See signposts (sigs)
headlines, 27–29

American newspapers,
 history of, 4–5, 28
butting, 79, 82, 85
decks and summaries, 152–153
display headlines, 208–211
functions of, 18, 26, 27
for graphics/sidebars, 192
jump headlines, 19, 160
with photo spread, 133, 136
size, and position on page, 29
spacing guidelines, 156
typeface, tweaking, 25
types of, 28, 47
writing, 27, 93
Heller, Joe, 140
Hogue, Michael, 140
horizontal photos
 impact of, 33, 52
 story layout with, 51–55, 68–69
horizontal story layout, 46–47,
 49, 54
Houston Chronicle, 193
HTML5, 20
Hundley, Sam, 196
Huntsville Times, The, 6, 10, 13, 63,
 141, 145

icons, 149
illustrations
 American newspapers,
 history of, 140
 color, 212
 photo illustrations, 139
 software tools for, 20
 spot, 141
 uses of, 140–141
inches
 of columns, 31
 points and picas per, 20, 22
index, 18
Indiana Daily Student, 10
 redesign of, 234
infographics
 charts/graphs, 165, 176–177
 color, 212
 format, choosing, 176
 functions of, 6, 18, 162–165
 maps, 165, 184–185
 See also alternative story forms
 (A.S.F.'s)
information center style, 7
initial caps, 18, 159
insets, 205

inside pages, 100–103
 ads, 100–101
 design guidelines, 101
 double trucks, 76, 81, 102–103
 packaging, 83
interactivity, digital newspapers,
 14–16
italic type, 30, 171

Jacobson, Alan, 13
Javascript, 20
Journal & Courier, 77
JPEG, 124
jumps
 jump headlines, 19, 160
 jump lines, 18, 19, 39, 99, 160, 213
 using, guidelines for, 99, 160
justified type, 30, 35

Kelley, Lori, 220
Kentucky Enquirer, The, 77
kerning, 24–25
key words, for jump headlines, 160
kickers, 28

labels, 18
Lafayette, Ind., 13
Lapham, Lewis, 169
Las Vegas Sun, 89
launch, for redesigned paper, 230
leading, 22, 24–25, 30
Ledger Independent, The, 89
liftout quotes, 150–151
 attention-getting, 3
 dummying, tips for, 151
 functions of, 19, 150
 guidelines for, 150
 with mug shots, 50, 150
line charts, 177
lists, 165, 168–169
 itemizing, dingbats for, 159
 and tables, 178
Little Hawk, The, 230
locator maps, 184–185
logos, 147–149
 column, 148
 functions of, 18, 147
 series, 149
Los Angeles Times, The, 5, 112
L-shaped text layout, 51, 55, 58, 63

McDougall, Angus, 64
Maestro Concept, 188
magazine cover style, 7

Mahon, Grant, 77
maps, 165, 184–185
　creating, tips for, 185
　types of, 184
mastheads, 10
measurements, terms/tools for, 20
Midland Daily News, The, 131
mobile devices
　and tabloidization of broad-
　　sheets, 13
　user experience, importance of,
　　16
modular layout
　for ads, 100
　headlines in, 49
　improving, tips for, 86–87, 101,
　　104
　meaning of, 6, 67
Morris, Chris, 141
mortises, 65, 69, 118, 205
Mrozowski, Nick, 90
mug shots
　for columnist, 148
　defined, 18
　half-column, 48–49
　with liftout quotes, 50, 150
　story layout with, 48–50, 65
multimedia, 14–15

nameplates, 18
Naples Daily News, The, 53, 129
National Post, 194
Newsday, 140
News-Journal, 102
　redesign of, 231
newspapers
　alternative story forms (A.S.F.'s),
　　165–186
　American, history of, 4–5, 21, 28,
　　109, 140
　cutlines, 34–37
　design terms related to, 18
　digital. See digital journalism
　downsizing trend, 13
　dummies, 38–41
　graphics, 186–194
　headlines, 27–29
　illustrations, 140–141
　infographics, 161–165
　page design, 73–105
　photographs, 32–33, 110–139
　redesigns, 220–234
　special effects, 196–218
　story design, 46–70
　text, 30–31

typography, 21–25
　See also specific topics
New York Daily Graphic, 109
New York Times, The, 47, 114, 164

Oklahoman, 9
online newspapers.
　See digital journalism
opinion pages, 10
Oregonian, The, 172, 229
　redesign of, 221
Oregon Journal, 5
Orlando Sentinel, The, 186
orphans, 160
overlines, 128

packaging
　functions of, 6, 7
　graphics packages, 186–189
　guidelines for, 83
page design, 26–37, 73–105
　ads, 100–101
　cutlines, 34–37
　fitting stories on page, 98–99
　grids, 74–78
　headlines, 27–29
　inside pages, 100–104
　modular layout, 86–87
　Page One, 88–97
　pages with art, 84–85
　pages without art, 78–83
　photographs, 32–33
　poor juxtapositions, avoiding, 104
　principles of, 105
　text, 30–31
Page One, 88–97
　creating, case study, 91–97
　design styles, 7, 89–90
　devices used on, 18–19
　flag, 146
　menu on, 7
　photos for, 91, 93–94
　story choices for, 88–90
　story elements, 91
paginated, 20
Palm Beach Post, The, 135, 163
paragraph indents, 30
Pennsylvania Gazette, 140
Philadelphia Inquirer, The, 4, 183
photo credits, 19, 155
photographs, 32–33, 110–139
　American newspapers, history
　　of, 4–6, 109
　choosing, criteria for, 54, 56, 60,
　　63, 110

color, 212
compelling, elements of, 112–117
credit lines, 155, 156
cropping, 48, 52, 118, 126–127
cutlines, 26, 34–37
digital, editing, 121
dominance on page, 59–60,
　84–85, 134, 136
faces in, size of, 65, 70, 110
halftones/screens, 123
horizontal, 33, 51–55, 68–69
in layout of story.
　See story design
mug shots, 18, 48–50, 65
for Page One, 91, 93–94
photo columns, 129
photo constructs, 111
photo illustrations, 139
photo spreads, 130–137
resizing, 122
rule of thirds, 111
scanning, 124–125
shapes, 33
small, uses of, 70
software tools for, 20, 124–125
square, 33, 52
stand-alone, 128
studio shots, 138
techniques to avoid, 142
unconventional presentations.
　See special effects
vertical, 33, 52, 56–58, 66–67
vertical/horizontal combos, 61–66
weak, improving, 118–119
　See also specific topics
Photoshop, 20, 124–125
photo spreads, 130–137
　creating, case study, 132–133
　design guidelines, 130–131,
　　134–137
pica pole, 20
picas
　points per pica, 20
　spacing guidelines, 156
pie charts, 165, 176, 177, 190–191
Plain Dealer, The, 141, 197
point size
　headlines, 29
　points per inch, 20, 22
　points per pica, 20
　spacing guidelines, 156
　to tailor type, 24
Portland Press Herald, 46
present tense, 27
Press-Enterprise, The, 115

promos, 158, 212
promotional campaign, for redesigned
 paper, 228
pronunciation guides, 169
proportion wheel, 20
prototypes, for redesigned paper,
 226–227
Publick Occurrences, 4
public opinion polls, 165, 174

Q & A, 165, 171, 194
quizzes, 165, 172–173, 194
quote collections, 165, 175

rail, 89
ratings, 165, 179
raw wrap headlines
 configuration of, 28
 on pages without art, 82
 story layout with, 47, 50, 55, 58, 63,
 65, 68
reader surveys, 228
Reading Eagle, 190
read-in lines, 128
redesigning paper, 220–234
 assessing paper for, 222–223, 225
 case studies, 220–221, 231–234
 examples, finding, 224
 launch, 230
 promotional campaign, 228
 prototypes, building, 226–227
 public opinion polls on, 228
 stylebooks, use of, 229
 websites, informative for, 224
refers, 18, 158
resizing photos, 122
retrofitting, 13
reverse type, 18, 206–207
Richmond Times-Dispatch, The, 154
rule of thirds, 111
rules
 common uses, 157, 178
 pros/cons of, 104
Ryan, Buck, 188

St. Louis Post-Dispatch, 193
St. Petersburg Times, The, 7, 27, 70
Salt Lake Tribune, The, 12, 29
San Diego Union-Tribune, The, 11, 184
San Francisco Examiner, The, 76
San Jose Mercury News, The, 11
sans serif type, 22, 30, 35
scaling (set width), 25
scanning, images, 124–125

screens, 123, 137, 206–207
 color, 212, 216
Seattle Times, The, 117, 129
Sentinel-Tribune, The, 79
series logos, 149
serif type, 22, 23, 35
sidebars, 167, 171
 functions of, 19
 See also alternative story forms
 (A.S.F.'s)
sidesaddle headlines
 configuration of, 28
 story layout with, 47, 55, 58, 65
signposts (sigs), 148–149, 158
 functions of, 19, 149
skews, 202–203
slammers, 28
slugs, 39
smartphones, 16
Smith, Emmet, 197
social media, journalists' use of, 16
software
 desktop publishing, 20
 for photos, 20, 124–125
spacing, 156
special effects, 196–218
 color, 212–218
 display headlines, 208–211
 insets, 205
 mortises, 205
 photo cutouts, 204
 screens/reverses, 206–207
 Stewart variations, 198–201
 wraparounds & skews, 202–203
special sections, design styles, 12
sports section, 9
spot color, 213–215
spot illustrations, 141
spot-news photos, 53
square photos
 impact of, 33, 52, 70
 story layout with, 52, 70
stacks
 ads, 100, 101
 photos, 62, 66, 68, 69
stand-alone photos, 34, 128
standing heads
 functions of, 19, 147
 See also signposts (sigs)
Star Tribune, 16, 89
step-by-step guides, 165, 181
Stewart variations, 198–201
story design, 46–70
 dogleg layout, 47, 51
 with dominant photos, 59–60

horizontal layout, 46–47, 49, 54
 with horizontal photos, 51–55, 68–69
 infographics. See alternative story
 forms (A.S.F.'s); graphics
 modular layout, 49, 67
 with mug shots, 48–50, 65
 pages without art, 46–47
 with square photos, 52
 swipeable formats, 56, 58, 62, 65, 67
 text shapes, 51
 with vertical/horizontal
 photo combos, 61–66
 vertical layout, 46–48, 54, 62, 65–68
 with vertical photos, 52, 56–58,
 66–67
strokes, 23
stylebooks, 192, 229
subheads
 American newspapers, history of, 4
 attention-getting, 3
 functions of, 18, 19, 159
 See also decks
summaries, 153
Sun-Sentinel, The, 10, 84, 149, 186, 208
surveys, 174, 228
Sweda, Chris, 113

tables, 165, 178
tabloids
 American, history of, 5–6
 dummy, 41
 grid for, 76
 headlines, 29
 style, 6, 13
teasers, 18, 158, 212
text, 30–31
 blocks, shapes for, 51
 breaking up, devices for, 78–82, 159
 for columns, measuring, 31
 functions of, 19, 26
 narrative, alternatives to.
 See alternative story forms
 (A.S.F.'s)
 on pages without art, 78–83
 with photo spread, 136
 spacing guidelines, 156
 too much, avoiding, 78, 162, 164
 visual interest, creating, 30
themed pages, 11
third effect, 61
3V format, 77
TIFF, 124
timelines, 165, 180, 186
Times, The (Beaverton), 103
Times-News, redesign of, 232–233

Times of Oman, 8, 208
Times-Picayune, The, 131
tracking, 24–25, 30
Tribble, Michael, 197
tripods, 28
Twitter, 16
typefaces, 22–24
typography, 21–25
 display headlines, 208–211
 fonts/typefaces, 22–23
 graphics with, 188, 192–194
 history of, 21
 point size, 22
 spacing, 156
 stylebooks, use of, 192
 successful, tips for, 21
 tailoring/tweaking, 24–25
 terms related to, 23, 24

underscore, 157
USA Today, 6, 212
U-shaped text layout, 51, 55, 58

vertical photos
 impact of, 33, 52
 story layout with, 56–58, 66–67
vertical story layout, 46–48, 54, 62,
 65–68
video software tools, 20
Virginian-Pilot, The, 7, 25, 47, 74, 88,
 91–97, 116, 129, 193, 196, 217
 redesign of, 220
visual data. *See* alternative story forms
 (A.S.F.'s); graphics; infographics
visual hooks, 79, 81, 166

Web, online newspapers.
 See digital journalism

Weingarten, Gene, 197
white space
 inside boxes, 80
 photo spreads, 133, 137
Wikipedia, 16
Winter, Damon, 114
Withey, Deborah, 220
World-Herald, 191
wraparounds, 202–203

X-height, 23

YouTube, 16

Zaleski, Mark, 115

Acknowledgments

The authors are sincerely grateful to the following friends and colleagues:

Editing and feedback: Eagle-eyed Wally Benson. Eternal thanks to Patty Kellogg and John Hamlin, without whose support this book would never have been born.

The cover: A special thanks to Bethany Bickley for her invaluable suggestions, collaboration and handiwork.

Art and photography: Joe Spooner, Bill Griffith, Ashley Cappellazzi, Wesley Watson, Greg Kahn, Edmund D. Fountain, Carolyn Cole, Chris Sweda, Damon Winter, Mark Zaleski, Preston Gannaway, Alan Berner, Maddie Meyer, Joel Hawksley, Rachel Mummey, Erica Yoon and Kelsey Grau.

Contributors of pages and words: Tim Goheen, Jim Haag, Jim Denk, Steve Gibbons, Paul Wallen Jr., Tracy Collins, Steve Dorsey, Tim Frank, Paul Nelson, Denis Finley, David Kordalski, Grant Mahon, Mark Edelson, Kyle Slagle, Gayle Grin, Tim Parks, Andrea Levy, Ron Johnson, Adonis Durado, Karen Okamoto, Josh Awtry, Colin D. Smith, Danielle Rindler—and to *all* the designers, illustrators and editors who graciously and enthusiastically contributed visual elements for this book.

The team at McGraw-Hill: Susan Gouijnstook, Deb Hash, Melissa Leick, Maureen Spada, plus everyone else who worked behind the scenes. And a hearty thank you to the eternally patient and persevering Sonia Brown.

Cheerleaders: faculty members and students at the School of Visual Communication at Ohio University, and of course, Jody Grenert.

Credits

INTRODUCTION

1: Photo by Julie Elman

2: Photo by Julie Elman

3: Spaceman photo by Tim Harrower.

4: These media files are in the public domain in the United States. This applies to U.S. works where the copyright has expired, often because its first publication occurred prior to Jan. 1, 1923.

5: Reprinted courtesy of Los Angeles Times (top); reprinted courtesy of The Oregonian (bottom)

6: Reprinted courtesy of The Huntsville Times/ Paul Wallen, Jr., designer

7: Reprinted courtesy of Concord Monitor/Clay Wirestone, designer (left); reprinted courtesy of The Virginian-Pilot/Jon Benedict, designer (center); reprinted courtesy of St. Petersburg Times (right)

8: Reprinted courtesy of Times of Oman (top left); reprinted courtesy of The Fayetteville Observer/ Merry Eccles, designer (center); reprinted courtesy of The Arizona Republic/Adrienne Hapanowicz, designer (right); reprinted courtesy of The Boston Globe/Martin Gee, designer (bottom)

9: Reprinted courtesy of Oklahoman/Bill Bootz, designer (left); reprinted courtesy of The Buffalo News/Vince Chiaramonte, designer (center); reprinted courtesy of The Daily Universe, Brigham Young University/Brandon Judd, designer (right)

10: Reprinted courtesy of The Huntsville Times (left); reprinted courtesy of Indiana Daily Student (center); reprinted courtesy of The Sun-Sentinel (Ft. Lauderdale, Fla.) (right)

11: Reprinted courtesy of The San Diego Union-Tribune/ Tara Stone, designer (left); reprinted courtesy of The San Jose Mercury News (center); reprinted courtesy of The Boston Globe/Ryan Huddle, designer (right); reprinted courtesy of Detroit Free Press/Jean Johnson, designer (bottom)

12: Reprinted courtesy of Asbury Park Press/Tim Frank, designer (left); reprinted courtesy of The Salt Lake Tribune/Colin D. Smith, designer (center); reprinted courtesy of The Dallas Morning News/Michael Hogue, designer (right)

13: Reprinted courtesy of The Huntsville Times/ Paul Wallen, Jr. (left); reprinted courtesy of Journal & Courier/Henry Howard and Karen Taylor, designers (center); reprinted courtesy of

Philadelphia Daily News/ John Sherlock, designer (right)

14: Reprinted courtesy of The Denver Post Online/ www.denverpost.com (right); reprinted courtesy of The Denver Post (left)

15: Reprinted courtesy of The Globe and Mail Online/www.theglobe andmail.com (right)

16: Tablet photo, The McGraw-Hill Companies, Inc.; app screenshot reprinted courtesy of The Star Tribune (top); smartphone, The McGraw-Hill Companies; social media icons reprinted courtesy of Facebook and Twitter.

CHAPTER 1

17: Background photo by Julie Elman; reprinted courtesy of The Virginian-Pilot

18: © Photodisc (top left, top center and center); © Rim Light/PhotoLink/ Getty Images (top right); © Royalty-Free/Corbis (center left); © Barbara Penoyar/Photodisc (center right); © Bettman/ Corbis (bottom left)

19: Reprinted courtesy of The Oregonian

20: Design instruments, © Photodisc; computer photo, Mark Dawson, photographer; page on computer, reprinted courtesy of The Virginian-Pilot/Jon Benedict, designer

21: Library of Congress

22: © Typofi/Stock.xhng (top left); courtesy of Julie Elman (bottom left)

25: Reprinted courtesy of The Virginian-Pilot/ San Hundley, designer

26: © Sidali Djarboub/ AP Photo

27: Reprinted from Weekly World News

28: This media file is in the public domain in the United States. This applies to U.S. works where the copyright has expired, often because its first publication occurred prior to Jan. 1, 1923.

29: Reprinted courtesy of The Salt Lake Tribune/ Colin D. Smith, designer (top); reprinted courtesy of the Collegian/Hilary Coles and Sabastian Wee, designers (bottom)

32: Photo by Alfred Eisenstaedt/Pix Inc./Time & Life Pictures/Getty Images (top left); photo by Eddie Adams/© AP Photo (left center); Kennedy Space Center/ NASA (left center); photo by Alex Fuchs/AFP/Getty Images (bottom); photo by Dorothea Lange/ Library of Congress Prints and Photographs Division Washington,

D.C., 20540 [LC-DIG-fsa-8b29516] (right)

33: © Photo by Drew Angerer (top); reprinted courtesy of The Tampa Tribune/ Carol Parker, designer bottom left; © Jessica Hill/AP Photo (bottom center); © Peter Hoffman, photographer (bottom right)

34: Photo by Kraig Scattarella/The Oregonian

35: Courtesy of Julie Elman (left); reprinted courtesy of The Virginian-Pilot (right)

36: All photos courtesy of Julie Elman

37: Reprinted courtesy of The Huntsville Times/ Bethany Bickley

38: Reprinted from The Orange County Register

39: Reprinted courtesy of The Oregonian

44: Photo by Kraig Scattarella/The Oregonian

CHAPTER 2

45: Background photo by Julie Elman

46: Reprinted courtesy of Portland Press Herald

47: Reprinted courtesy of The Baltimore Sun

48: © Todd Williamson/ WireImage/Getty Images

50: Randy L. Rasmussen/ The Oregonian

51: © Rim Light/PhotoLink/ Getty Images

52: Reprinted courtesy of St. Louis Post-Dispatch (left); reprinted courtesy of San Francisco Chronicle/Frank Mina, designer (top right); reprinted courtesy of Republican American/Scott Griffin, designer (bottom right)

53: Greg Kahn, photographer (top); reprinted courtesy of Naples Daily News (bottom)

54: Reprinted courtesy of The Virginian-Pilot (top); McGraw-Hill Companies, Inc./Jill Braaten, photographer (center and bottom)

56: © Larry Marano/Getty Images (left); reprinted courtesy of St. Petersburg Times/Jennifer DeCamp, designer (right)

57: © Ingram Publishing

59: Kelsey E. Grau, photographer

60: Reprinted courtesy of The Sacramento Bee

61: Photo by Max Gutierrez/ The Oregonian (top left); photos by Robert E. Shotwell/The Oregonian (top right and bottom left); photo by Holley Gilbert/ The Oregonian (bottom right)

62: Photo by Robert E. Shotwell/The Oregonian (left); photo by Max Gutierrez/The Oregonian (right)

63: Reprinted courtesy of The Huntsville Times

(left); photo by Robert E. Shotwell/The Oregonian (center); photo by Max Gutierrez/The Oregonian (right)

64: Photo by Max Gutierrez/ The Oregonian (left); photo by Robert E. Shotwell/The Oregonian (right)

65: Reprinted courtesy of The Oregonian

66: Photos by Robert E. Shotwell/The Oregonian

67: Photo by Max Gutierrez/ The Oregonian (top); photo by Holley Gilbert/ The Oregonian (bottom)

68: Photo by Max Gutierrez/ The Oregonian (left); photo by Holley Gilbert/ The Oregonian (right)

70: © Barbara Penoyar/ Getty Images (left); © Royalty-Free/Corbis (center); photo by Edmund D. Fountain/ St. Petersburg Times (right); reprinted courtesy of St. Petersburg Times (bottom)

71: Photo by Steve Nehl/ The Oregonian

72: Photos by Ross Hamilton/The Oregonian

CHAPTER 3

73: Background photo by Julie Elman; reprinted courtesy of The Orange County Register

74: Reprinted courtesy of The Day (left); reprinted courtesy of The Virginian-Pilot (right)

75: Reprinted courtesy of The Denver Post

76: Reprinted courtesy of The San Francisco Examiner/Brooke Robertson, designer

77: Reprinted courtesy of Reading Eagle (left); reprinted courtesy of Journal & Courier/ T.J. Maxfield, Illustrator (right)

78: Reprinted courtesy of Las Vegas Sun/Kyle Ellis, designer

79: Reprinted Courtesy of The Sentinel-Tribune (Bowling Green, Ohio)

84: Reprinted courtesy of The Sun-Sentinel

86: Reprinted from The Orange County Register

87: Reprinted from The Orange County Register

88: Reprinted courtesy of The Virginian-Pilot/Sam Hundley, designer (left); reprinted courtesy of The Arizona Republic (right)

89: Reprinted courtesy of StarTribune (left); reprinted courtesy of Las Vegas Sun/Spencer Holladay, designer (bottom); reprinted courtesy of The Ledger Independent/Ian Lawson, designer (right)

90: Reprinted courtesy of I/Nick Mrozowski, art director

91: Reprinted courtesy of

Citizen-News (left); Jim Haag/The Virginian-Pilot (top and bottom right)

92: Reprinted from The Florida Times-Union/ www.jacksonville.com

93: Reprinted courtesy of The Virginian-Pilot/ Jim Haag, designer

94: Reprinted courtesy of The Virginian-Pilot/ Jim Haag, designer

95: Reprinted courtesy of The Virginian-Pilot/ Jim Haag, designer

96: Reprinted courtesy of The Virginian-Pilot/ Jim Haag, designer

97: Reprinted courtesy of The Virginian-Pilot/ Jim Haag, designer

99: Reprinted courtesy of The Arizona Republic

100: Reprinted courtesy of The Huntsville Times

102: Reprinted courtesy of The Daytona Beach News-Journal (Daytona Beach, Florida)/Scott Turick, designer

103: Reprinted courtesy of The Dallas Morning News (top); reprinted courtesy of The Times (Beaverton, Ore.) (bottom)

104: Reprinted courtesy of The Huntsville Times (left); The McGraw-Hill Companies, Inc./Jill Braaten, photographer (top)

107: Reprinted courtesy of The Oregonian

CHAPTER 4

109: Background photo by Julie Elman; photo by Steve Gibbons/ The Oregonian

110: Photo by Michael Lloyd/ The Oregonian (top left and bottom); photo by Randy L. Rasmussen/ The Oregonian (right)

111: Photo by Maddie Meyer (top left); photo by Joel Hawksley (top right); photo by Rachel Mummey (bottom left); photo by Erica Yoon (bottom right)

112: Carolyn Cole/ The Los Angeles Times

113: From Chicago Tribune, July 20 © 2010. Chicago Tribune. All rights reserved. Used by permission and protected by the Copyright Laws of the United States. The printing, copying, redistribution, or retransmission of this content without express written permission is prohibited.

114: Photo by Damon Winter/ The New York Times

115: Photo by Mark Zaleski/ The Press-Enterprise

116: Photo by Preston Gannaway/The Virginian Pilot

117: Photo by Alan Berner/ The Seattle Times

120: © Scott Dunlap/ iStockphoto

121: © Royalty-Free/Corbis

122: © Digital Vision/ Getty Images

123: Photo by Tim Harrower

124: Mug shot photo by Tim Harrower; scanning photos by Julie Elman

125: Mug shot photo by Tim Harrower

126: Photo by Steve Gibbons/ The Oregonian

127: Photo by Dana Olsen/ The Oregonian (top)

128: Photo by Michael Lloyd/ The Oregonian

129: Reprinted courtesy of The Seattle Times (left); reprinted courtesy of the Naples Daily News (top right); reprinted courtesy of The Virginian-Pilot (bottom right)

130: Reprinted courtesy of Midland Daily News/ Nathan Morgan, designer

131: Reprinted Courtesy of The Times-Picayune (left); reprinted courtesy of The Gainesville Sun (right)

132: Photos by Tim Jewett/ The Oregonian

133: Photos by Tim Jewett/ The Oregonian

135: © C. Sherburne/PhotoLink/ Getty Images (left); reprinted courtesy of The Palm Beach Post (right)

136: Reprinted courtesy of The Virginian-Pilot

137: Reprinted courtesy of The Herald (Jasper, Ind.)

138: © Royalty-Free/Corbis (left); reprinted courtesy of The Columbus Dispatch/Kate Collins, designer (top right); © Colin Anderson/Blend Images LLC (bottom right)

139: Reprinted courtesy of Victoria Advocate/Robert Zavala, designer (bottom)

140: Reprinted courtesy of The Dallas Morning News/ Michael Hogue, designer (top left); Newsday, Walt Handelsman cartoon "Security" (Aug. 11, 2006) © Tribune Media Services, Inc. All rights reserved. Printed with permission. (right); reprinted courtesy of Green Bay Press-Gazette (bottom left)

141: Reprinted courtesy of The Plain Dealer/Chris Morris, designer (left); reprinted courtesy of The Huntsville Times/Bethany Bickley, designer and illustrator (right)

142: © Photographer's Choice RF/Getty Images

143: Photo by Randy L. Rasmussen/The Oregonian

144: Photo by Bob Ellis/ The Oregonian (bottom)

CHAPTER 5

145: Background photo by Julie Elman; reprinted courtesy of The Huntsville Times

146: Reprinted courtesy of The San Diego Union-Tribune, USA Today, The Gainesville Sun, The Tribune and Star Tribune (flags, left to right); reprinted courtesy of Orlando Sentinel (bottom)

147: Reprinted courtesy of San Jose Mercury News (top left); reprinted courtesy of The Salt Lake Tribune (top center); reprinted courtesy of Sun-Sentinel (top right); reprinted courtesy of The Virginian-Pilot (top, middle and bottom on the left)

148: Reprinted courtesy of The Virginian-Pilot (top left); © Barbara Penoyar/ Getty Images (bottom left); reprinted courtesy of The Huntsville Times (right)

149: Reprinted courtesy of The Athens NEWS/Laura Zielinski (top left); reprinted courtesy of The Sun-Sentinel (Ft. Lauderdale, Fla.) (bottom left); logos by Jim Denk, Detroit Free Press (bottom right)

150: Photo by Gregg DeGuire/ PictureGroup via AP Images (top); © Rob Carr/AP Photo (bottom)

151: Photo by Randy L. Rasmussen/The Oregonian; reprinted courtesy of The Huntsville Times/Alyson Morris (top)

152: Reprinted courtesy of The Virginian-Pilot (bottom)

155: Mug shot courtesy of Julie Elman; Joel Davis/ The Oregonian

156: Photo by Steve Nehl/The Oregonian (top); photo by Joel Davis/The Oregonian (bottom left)

157: Reprinted courtesy of The Charlotte Observer

158: Reprinted courtesy of The Virginian-Pilot/Sam Hundley, Illustrator (top left); reprinted courtesy of The Huntsville Times (bottom left); reprinted courtesy of The Gazette (Colorado Springs) (bottom right)

159: Reprinted courtesy of The Boston Globe

160: Reprinted courtesy of The Arizona Republic

CHAPTER 6

161: Background photo by Julie Elman; reprinted courtesy of Orlando Sentinel

163: Reprinted courtesy of The Palm Beach Post

166: The National Football League registered trademark. All Rights Reserved. (top left); Illustration by Joe Spooner (bottom left); graphic by Steve Cowden, The Oregonian (right)

167: Illustration by Joe Spooner (left); Library of Congress Prints and Photographs Division [LC-USZ62-16530] (top right)

169: Reprinted courtesy of The San Jose Mercury News

170: © Jack Star/PhotoLink/ Getty Images (top); © Ingram Publishing /Alamy (bottom left); art by Joe Spooner (right and center)

171: Photo by Anthony Harvey/ PictureGroup

172: Reprinted courtesy of The Oregonian (left); reprinted courtesy of The Columbus Dispatch/Danielle Kees, designer (right)

174: © Corel Corporation (porcupine); © Alan and Sandy Carey/Getty Images (gorilla); © Corbis Royalty Free (cat)

175: Library of Congress Prints and Photographs Division [LC-USZ62-112065] (bottom right)

176: Graphic created by Ashley Cappellazzi

180: Chris Kaeser/Associated Press (top left); © J. Bell/ Associated Press (top right); © Dan Delorenzo/Associated Press (bottom)

181: Reprinted courtesy of The Oregonian (top left); © PhotoDisc (top center); © Siede Preis/Getty Images (top right); line drawings by David Sun (bottom)

182: Reprinted courtesy of The Oregonian

183: Reprinted courtesy of Orlando Sentinel/Shiko Floyd, designer (top); reprinted courtesy of The Philadelphia Inquirer/ Beto Alvarez (bottom)

184: Reprinted courtesy of The San Diego Union-Tribune/Gloria Orbegozo, designer (left); © Carrie Osgood/Associated Press (top and bottom right)

186: Reprinted courtesy of The Sun-Sentinel/Belinda Long-Ivey (left); reprinted courtesy of Orlando Sentinel (right)

187: Reprinted courtesy of Casper Star-Tribune/ Wesley Watson, designer

188: Reprinted courtesy of The Oregonian

190: Reprinted Courtesy of The Little Hawk (left); reprinted courtesy of Reading Eagle/Craig Schaffer, graphic artist (right)

191: Reprinted courtesy of The Omaha World-Herald/ Dave Croy

192: Reprinted courtesy of Detroit Free Press (left); reprinted courtesy of the Ball State Daily News (right)

193: Reprinted courtesy of The Virginian-Pilot (left); reprinted courtesy of Houston Chronicle/Jason Baum, designer (top right); reprinted courtesy of St. Louis Post-Dispatch/Reagan Branham, designer (bottom right)

194: Reprinted courtesy of National Post (left); reprinted courtesy of The Columbus Dispatch/Charlie Zimkus, designer (top and bottom right)

CHAPTER 7

195: Background photo by Julie Elman; © Royalty-Free/Corbis (top)

196: Reprinted courtesy of The Huntsville Times/ Paul Wallen Jr., designer (left); reprinted courtesy of The Virginian-Pilot/Sam Hundley, designer (right)

197: Reprinted courtesy of The Plain Dealer/Emmet Smith and Michael Tribble, designers

198: © The Kobal Collection/ Art Resource, N.Y.

199: © The Kobal Collection/ Art Resource, N.Y.

200: © The Kobal Collection/ Art Resource, N.Y.

201: © The Kobal Collection/ Art Resource, N.Y.

202: Reprinted courtesy of Times of Oman/Adonas Durado, designer (left); Letterman reprinted courtesy of Ron Coddington (right); © Royalty-Free/Corbis (bottom)

203: Zippy the Pinhead courtesy of Bill Griffith

204: Photo by Joel Davis/The Oregonian (top); reprinted courtesy of San Antonio Current (bottom)

205: © Keith Wood/Corbis (top); © Edward Rozzo/Corbis (center); © Lucidio Studio Inc./Corbis (bottom)

206: © Royalty-Free/Corbis

207: © Photodisc/Getty Images

208: Reprinted courtesy of Times of Oman/Adonis Durado, design (top left); reprinted courtesy of The Arizona Republic/Amy King, designer (top right); reprinted courtesy of The Sun-Sentinel (center and bottom)

210: © Barbara Penoyar/ Getty Images

212: Reprinted courtesy of USA Today

213: Photo by Tim Jewett/The Oregonian (top); photo by Michael Lloyd/The Oregonian (bottom)

214: Reprinted courtesy of The Washington Times

216: Reprinted courtesy of The Oregonian (left and right)

217: © Kelly Harriger/Corbis. All Rights Reserved; reprinted courtesy of The Virginian-Pilot/Jon Benedict, designer (bottom)

CHAPTER 8

219: Background photo by Julie Elman; © Royalty-Free/ Cobis (football player); © Royalty-Free/Corbis (basketball player)

220: Reprinted courtesy of The Virginian-Pilot (left); reprinted courtesy of The Virginian-Pilot/Robert Suhay, designer (right)

221: Reprinted courtesy of The Oregonian

224: Background photo by Julie Elman

226: © Royalty-Free/Corbis (basketball player); © Royalty-Free/Corbis (football player)

228: Courtesy of The Register-Guard (Eugene, Ore.) (left); photo courtesy of Gilmore Research Group, Seattle, Wash., and Portland, Ore. (right)

229: Reprinted courtesy of The Oregonian (top left and bottom); reprinted courtesy of The Epitaph (Cupertino, Calif.) (top right)

230: Reprinted courtesy of Little Hawk (Iowa City, Iowa)

231: Reprinted courtesy of The News Journal (Wilmington, Del.)

232: Reprinted courtesy of Times-News (Twin Falls, Idaho) (left); reprinted courtesy of Times-News (Twin Falls, Idaho)/Josh Awtry and Colin D. Smith, designers (right)

233: Reprinted courtesy of Times-News (Twin Falls, Idaho)/ Josh Awtry and Colin D. Smith, designers

234: Reprinted courtesy of Indiana Daily Student (left); reprinted courtesy of Indiana Daily Student/Danielle Rindler, designer (right)

APPENDIX

235: Background photo by Julie Elman; Photos by Randy L. Rasmussen/ The Oregonian

240: Photos by Ross Hamilton/ The Oregonian

244: Photos by Randy L. Rasmussen/The Oregonian

245: Photos by Randy L. Rasmussen/The Oregonian

246: Photos by Randy L. Rasmussen/The Oregonian

247: Photo by Bob Ellis/ The Oregonian

248: Reprinted courtesy of The Morning Call, Allentown, Penn./Linda Shankweiler, designer

249: Reprinted courtesy of The Charleston (W.Va.) Gazette/ Kyle Slagle, designer

250: Reprinted courtesy of The Plain Dealer/ Andrea Levy, illustrator

251: Reprinted courtesy of Omaha World-Herald/ Tim Parks, designer

252: Reprinted courtesy of The Palm Beach Post/ Rebecca Vaughan, designer, and Brennan King, illustrator (top); reprinted courtesy of The Palm Beach Post/ Jenna Lehtola, designer, and Brennan King, illustrator

253: Reprinted courtesy of National Post/ Gayle Grin, designer, and Kagan McLeod, illustrator